The World of Wade® Figurines and Miniatures

Ian Warner & Mike Posgay

4880 Lower Valley Road, Atglen, PA 19310 USA

Copyrights

All figurines or miniatures that are covered by trademarks, copyrights or logos, and used in this book, are for identification purposes only. All rights are reserved by their respective owners. Copyrights of journals, magazines or other publications mentioned in this book are reserved by their respective owners or publishers. The Wade name and its trading style are registered copyright designs and are used by permission.

Alice in Wonderland series. © MacMPub
Andy Capp and Flo. © Mirror Group Newspapers Ltd.
Arthur Hare Series. © C & S Collectables.
Betty Boop. © King Features Syndicate Inc., Fleischer Studios Inc. ™ Hearst Holdings Inc.
Bisto Kids. © RHM Foods Ltd. & Applied Creativity.
Brew Gaffer & Sydney Teafolk. © Lyons Tetley.
Dougal. © Serge Danot/AB Productions. Licensed by Link Licensing Ltd.
Eddie Stobart Haulage Truck photo. ©Northern Counties Photographers.
Felix the Cat. ©1997 FTC Prod. Inc. Licensed by El Euro Lizenzen Munchen.
Fred Figurines © & ™ Campbell Grocery Products Limited. All rights reserved.
Huckleberry Hound Series 1986. © Hanna-Barbera Productions Inc.
Huckleberry Hound Series 1997. © 1997 H.B. Prod. Inc. © G&G Collectables.
Jack the Ripper. © S & A Collectables Limited.
Jim Beam Figurines and Happy Little Guys Series. © R. Ellis
Mr. Men & Little Miss. © Mrs. Roger Hargreaves.
Noddy Series. © Darrell Waters Ltd.
Noddy Set 1998. © D.W. 1949/90 Licensed by BBC. WL Ltd.
Nursery Rhyme Collection. © D.T. Enterprises.
K.P. Friars. © "K.P. Foods."
Peter Pan is the registered trade mark of Great Ormond Street Hospital Children's Charity.
Pogo. © Walt Kelly.
Popeye Series. © King Features Synd. Inc. © David Trower Enterprises.

Red Rose Tea. © Brooke Bond Foods Ltd. and © Redco Foods Inc.
Rule Beartannia. © Jerome Walker
Rupert Bear. © Express Newspapers plc. Licensed by A.H.E/ Nelvana.
Salada Tea. © Kellogg Salada Canada Inc.
Sam & Sarah. © Mabel Lucie Attwell Estate.
Snoopy & Woodstock. © UFS Inc.
St. Bruno Tobacco. © Imperial Tobacco Limited.
St. Michael Edward Bear. © M & S 95 4818
Sooty & Sweep. © Sooty International Ltd. Licensed by Chatsworth Enterprises Ltd.
Superman and all related characters, names and indicia are trademarks of DC Comics © 1999.
"The Beano" figures. © D.C. Thomson & Co. Ltd.
Thomas the Tank Engine and Friends 1985 - 1987. © Kaye & Ward Limited. © Britt Allcroft Limited.
Thomas the Tank Engine and Friends 2002. ©Gullane (Thomas) Limited 2002.
Tiny Treasures Series. © DC Comics.
"Tom & Jerry." © Loew's Incorporated. © Metro-Goldwyn-Mayer Inc.
"Tufty. " © Cotswold Collectables © RoSPA Enterprises Ltd.
TV Pets. © Cooper Features Ltd.
Viz Comic Characters. © John Brown Publishing House of Viz.
Wagon Train. ©1959 Universal City Studios, Inc.
Walt Disney Figures. © Walt Disney Productions.
Westminster Piggy Banks. © National Westminster Bank.
Wind in the Willow Series. © EHS 2000
Womble Characters. © Elisabeth Beresford/ Film Fair Ltd.
World of Survival. © Survival Anglia Limited.

Copyright © 2002 by Ian Warner & Mike Posgay
Library of Congress Card Number: 2002113622

All rights reserved. No part of this work may be reproduced or used in any form or by any means—graphic, electronic, or mechanical, including photocopying or information storage and retrieval systems—without written permission from the copyright holder.
"Schiffer," "Schiffer Publishing Ltd. & Design," and the "Design of pen and ink well" are registered trademarks of Schiffer Publishing Ltd.

Designed by "Sue"
Type set in Korinna BT

The authors encourage Wade collectors to send in information and color photographs of items not illustrated in this book. To contact the authors, write:
P.O. Box 93022
499 Main Street South
Brampton, Ontario
Canada L6Y 4V8

ISBN: 0-7643-1793-8
Printed in China
1 2 3 4

Published by Schiffer Publishing Ltd.
4880 Lower Valley Road
Atglen, PA 19310
Phone: (610) 593-1777; Fax: (610) 593-2002
E-mail: Schifferbk@aol.com
Please visit our web site catalog at **www.schifferbooks.com**
We are always looking for people to write books on new and related subjects. If you have an idea for a book please contact us at the above address.

This book may be purchased from the publisher.
Include $3.95 for shipping.
Please try your bookstore first.
You may write for a free catalog.

In Europe, Schiffer books are distributed by
Bushwood Books
6 Marksbury Ave.
Kew Gardens
Surrey TW9 4JF England
Phone: 44 (0) 20 8392-8585; Fax: 44 (0) 20 8392-9876
E-mail: Bushwd@aol.com
Free postage in the U.K., Europe; air mail at cost.

Dedication

We dedicate this book to Iris Lenora Carryer, a lady who was born with potting in her blood. As the eldest daughter of the late Sir George Wade, Iris had a keen interest in potting from a very early age, learning how to work clay at her grandfather's knee.

Iris and her late husband, Henry Straker Carryer, have been of tremendous help with our books on Wade pottery for which we are sincerely grateful. As well as her in depth knowledge of pottery, Iris also has a superb sense of humor with memorable tales of her early days around the potteries.

All Wade collectors owe a debt of gratitude to Iris, for it was she who originated the famous Whimsies during the dark days of low employment in the potteries. It was also Iris and her late husband who made the Irish Wade so famous and collectible.

Thank you, Iris.

Contents

Foreword ... 4
Introduction .. 5
The Official International Wade Collectors Club ... 6
What to Look for When Purchasing Wade Items .. 7
Acknowledgments .. 8
Wade Potteries, Marks, and Backstamps ... 10
Chapter 1. Wade Figures by George Wade & Son Ltd. circa 1927 - 1941 21
Chapter 2. Dog Figurines by George Wade & Son Ltd. circa 1927 - mid 1930s 42
Chapter 3. Animal and Bird Figurines by George Wade & Son Ltd.
 circa 1935 - mid 1950s .. 44
Chapter 4. Wadeheath Ware circa 1927 - 1939 .. 50
Chapter 5. Animal Figurines by George Wade & Son Ltd. and Wade Heath &
 Company Limited circa mid 1930s - late 1950s .. 54
Chapter 6. Nursery Rhyme Figurines by George Wade & Son Ltd. and Wade
 Heath & Company Limited circa 1949 - 1991 ... 59
Chapter 7. Miniature Figurines by George Wade & Son Ltd. circa 1948 - late 1970s ... 63
Chapter 8. Animal Figurines by George Wade & Son Ltd. circa 1958 - 1988 73
 Disney "Hat Box" Series 1956 - 1965 .. 83
Chapter 9. Whimsies 1953 - 1959 .. 89
 Whimsies 1971 - 1984 ... 93
 Whimtrays 1958 - 1988 ... 101
 Whimsie-Land Series 1984 - 1988 .. 103
Chapter 10. Whimsey-on-Why Village Sets 1980 - 1987 ... 105
 Whimsey-in-the-Vale 1993 .. 108
 Village Store Series 1982 - 1986 .. 109
 Painted Ladies Series 1984 - 1986 ... 110
Chapter 11. Figurines and Miniatures by Wade (Ulster) Ltd., Wade (Ireland) Ltd., and Seagoe
 Ceramics Ltd. ... 111
Chapter 12. Premiums and Promotions by George Wade & Son Ltd. and Wade Ceramics
 Limited mid 1960s - 2002 ... 122
Chapter 13. Figurines from the 1990s - 2002 ... 139
Chapter 14. Wade Limited Editions .. 150
Chapter 15. Wade Private Commissions ... 171
Chapter 16. Wade Promotional Items .. 216
Chapter 17. Figural Money Banks Miscellaneous Posy Bowls and Dishes 232
Bibliography .. 250
Index .. 251

Foreword

Being involved in the world of collecting Wade is interesting to say the least, and each day brings more products to test everyone's knowledge, time, and patience in finding out when, where, and how many were produced. Put this together with keeping up with all the new products being launched and it takes some organising.

The *World of Wade* books are an invaluable source of information to anyone who is interested in the ceramics made by Wade over the last 190 years. Not only do the books offer an insight into the history of the company, but, more importantly to collectors, the books make it easier to identify the prospective purchase by giving the issue dates, colour pictures and backstamp details.

I, for one, admire Ian and Mike's dedication to Wade, the hours and hours of research and photography that are needed to produce one book alone are immense. To have the enthusiasm to produce four books is outstanding. I am sure that this new book will be well used by collectors in their quest to find out all the information possible about their collection.

Jenny Wright
Collectors Club Manager
Wade Ceramics Limited

©Pottery Gazette

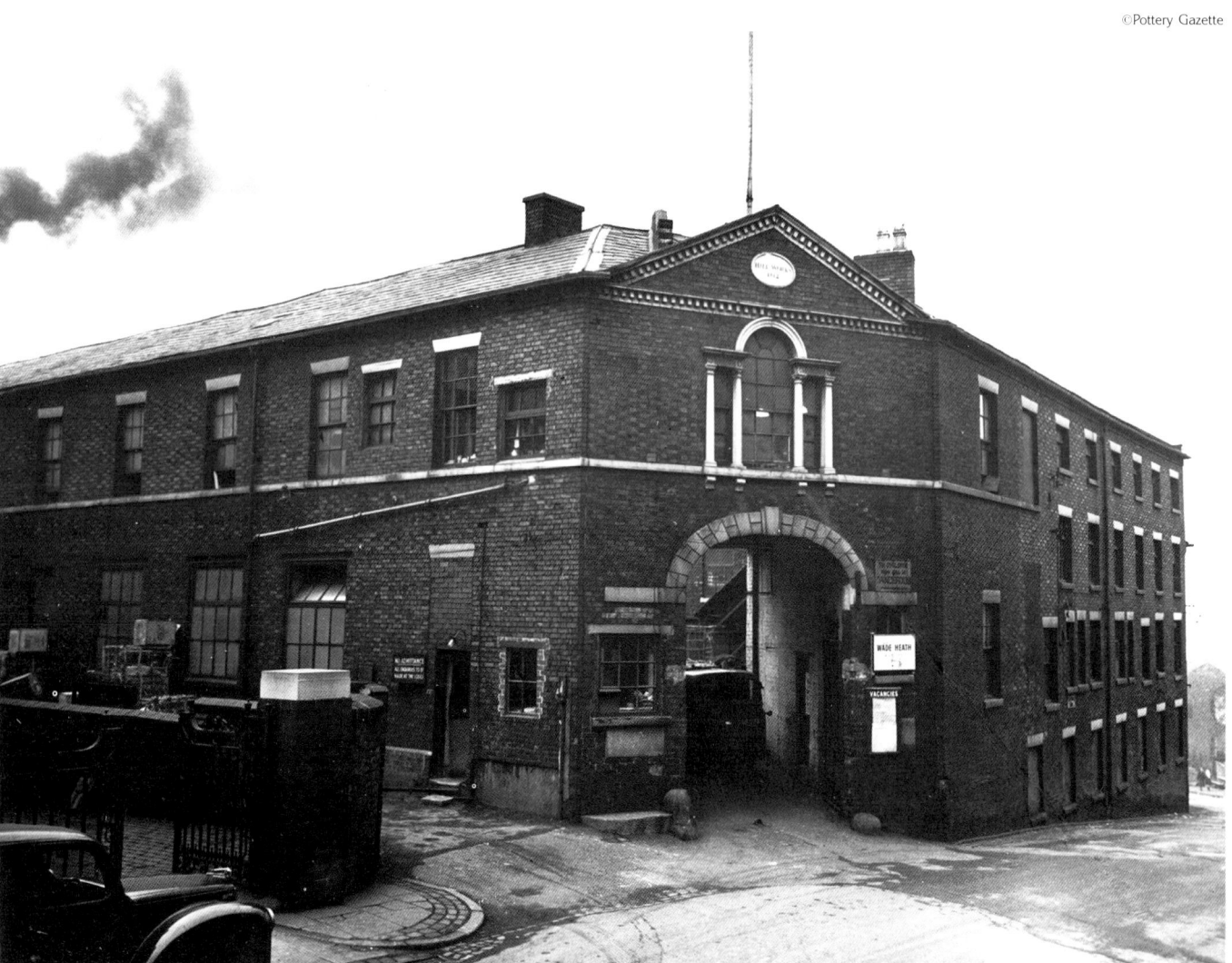

Royal Victoria Pottery, circa 1951

Introduction

Wade Ceramics Limited has a long and complicated history starting in 1867 when the first Wade pottery, *Wade and Myatt*, was established by Joseph Wade. In 1882, after numerous changes in ownership and names, the pottery became known as *Wade and Sons*. Around this time, another Wade pottery was formed by John Wade, under the name of *Wade and Co*. In 1891, yet another Wade pottery was opened under the name of *J. & W. Wade & Co.*, which was run by William Wade and later, A.J. Wade.

In the early 1900s, *Wade and Sons*, which was then being run by George Wade, the third son of George Wade Senior, had a name change to *George Wade*. In 1919, the pottery became known as *George Wade & Son. Ltd.*, when George Albert Wade (later Sir George Wade) officially joined his father in the business.

In 1927, *Wade and Co.* and *J. & W. Wade & Co.* became private companies changing their names to *Wade, Heath & Co. Ltd.* and *A.J. Wade & Co*. The two potteries were combined in 1935, forming *The Wade Potteries Limited*. On the deaths of A.J. Wade and later George Wade, George Albert Wade took control of both *George Wade & So. Ltd.* and *The Wade Potteries Limited*.

The Irish pottery, *Wade (Ulster) Ltd.*, was incorporated in 1950 as a subsidiary of *George Wade & Son. Ltd.*, and was run by Straker Carryer and his wife, Iris, who was the eldest daughter of Sir George Wade. The pottery was involved in the production of both industrial ceramics and a wide range of giftware products. The name of the Irish pottery was changed to *Wade (Ireland) Ltd.* in 1966.

At a shareholders meeting in 1958, an agreement was reached to amalgamate the Wade potteries into one group under the name of *The Wade Group of Potteries*. After the death of G. Anthony Wade, son of Sir George Wade, and the last member of the Wade family to run the company, the Wade potteries were sold to Beauford PLC. Other than *Wade (Ireland) Ltd.*, which remained a separate entity until 1990, the other potteries became known as *Wade Ceramics Limited*. In 1990, *Wade (Ireland) Ltd.* changed its name to *Seagoe Ceramics Limited* and, in 1993, ceased the production of table and giftware to concentrate on industrial ceramics and became a separate company not connected to *Wade Ceramics Limited*.

In 1999, *Wade Ceramics Limited* was sold to the Wade management and is now a privately owned company. For a number of years *Wade Ceramics Limited* concentrated on the production of industrial ceramics, but with the formation of The Official International Wade Collectors Club in 1994, the pottery once again began to produce giftware items directed mainly toward collectors. In the past few years *Wade Ceramics Limited* has once again launched a number of giftware retail lines for sale to the general public in gift stores around the world.

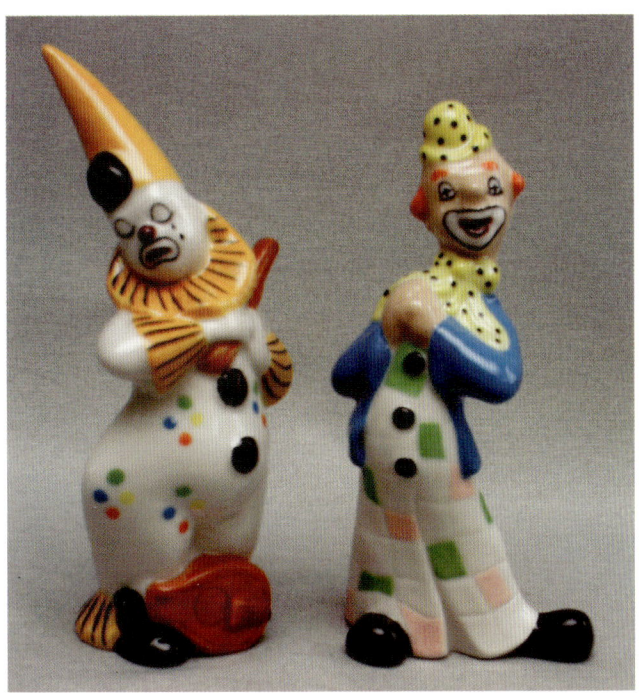

The Official International Wade Collectors Club

The Official International Wade Collectors Club, usually referred to as OIWCC in this book, was launched in 1994. The club was formed with the intention to unite Wade collectors throughout the world in their common enthusiasm for Wade products, both new and old.

Collectors who join the club receive a quarterly magazine. Issue No. 1 was published in September 1994. *The Official Wade Club Magazine* contains notices of new figurines to be released, interesting articles, letters from club members, Wade fair/show dates, and reviews in both the U.K. and the U.S.A.

Although the Wade potteries no longer have a direct connection with the Wade family, the OIWCC does. The president of the club is Jeremy Wade, the eldest son of the late Anthony Wade and grandson of the late Sir George Wade.

Members of the OIWCC receive a free exclusive figurine each year. These figurines are available only to club members. Throughout each membership year special limited edition figurines are offered to club members.

To become a member of the OIWCC, write to:

The Official International Wade Collectors Club, Wade Ceramics Limited, Royal Works, Westport Road, Burslem, Stoke-on-Trent, Staffordshire, ST6 4AP, England UK
The email address for the club is: club@wade.co.uk
The website for the club is: www.wade.co.uk

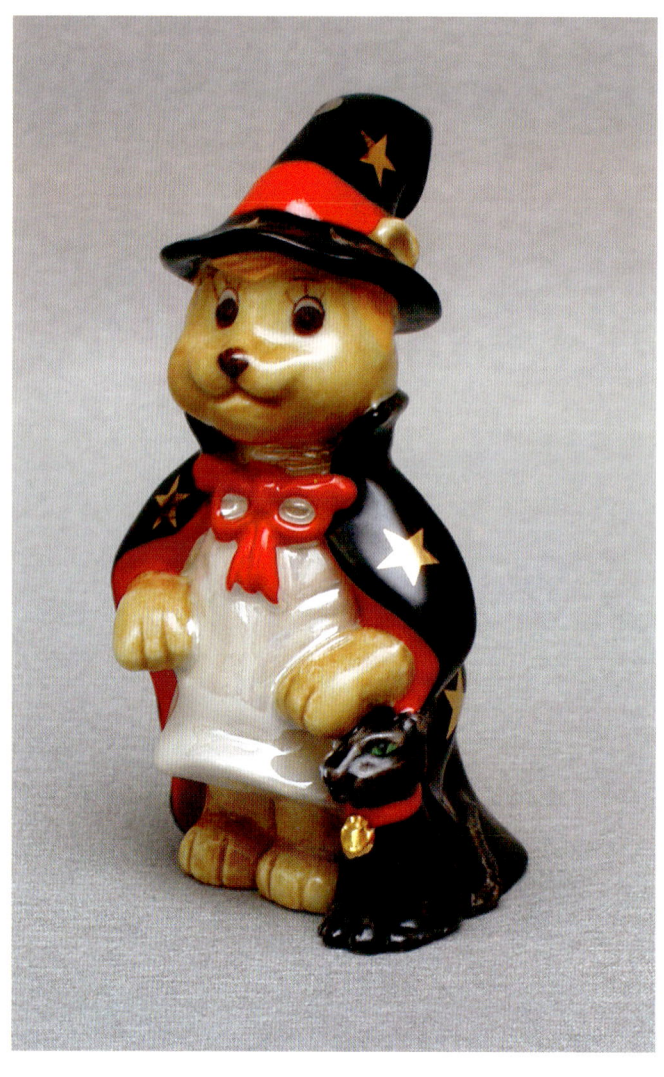

What to Look for When Purchasing Wade Items

All prices are for items in excellent condition. We prefer not to use the overworked expression "mint," as this would refer to unused items still contained in the original unopened packaging. Of course it is also possible for so-called "mint" items to be damaged between final glazing and the original packaging.

The 1930s cellulose-finished Wade figurines are very collectible, but collectors should pay prices related to the amount of flaking and repainting on any particular piece. Nowadays, rarer items have often been repaired. It is the duty of the vendor to explain this to a potential customer. Well-repaired and restored pieces are quite desirable, but should not command the price for a similar item in excellent, unrestored condition.

It is advisable for collectors to remember a few tips when looking for Wade at flea markets, car boot sales, etc. It is often quite an exciting experience to find unusual or rare Wade items at these types sales. To avoid disappointment when unpacking a "find" on arriving home, bear in mind the following suggestions:

1) Check for defects such as flaking or chips, either minor or extensive. It is amazing how easy it is to overlook damage of many sorts on dirty, unwashed items.

2) If, by any chance, there are two similar items on a table, compare them for any damage, missing glaze, flaking, etc. If there are rare or unusual items in large numbers, beware of reproductions!

3) Always buy what you really want and at prices that are realistic and suit your pocketbook. As a collector, do not buy purely for investment. Many prices have leveled off over the past few years and a number of Wade items have decreased in value due to lack of popularity or demand. Some of the rarer Wade figurines have increased in value but this does not mean they will rise indefinitely, so be cautious.

4) The miniature promotional figurines were and are produced in huge numbers with a minimum amount of quality control. Collectors must expect imperfect pieces to appear and it is often quite a challenge to find perfect pieces.

Method of Establishing Prices

The suggested prices in *The World of Wade Figurines and Miniatures* are derived from prices submitted to us by advisers and contributors from both the United Kingdom and the United States of America.

It must be pointed out that the prices quoted are average prices taken from all those that were submitted to us. These prices do not reflect specials, e.g. factory, store outlets, show specials, etc. The price survey also netted some surprises, which are attributed to the popularity, or lack thereof, of an item in a particular country. From the prices quoted to us we found that it is often the case that items popular in the U.S.A. are less popular than similar items in the U.K. or vice versa.

Remember, this is a suggested price guide only. Prices suggested are not to be interpreted literally as final dealer prices; rather it is an indication of the range around which collectors might expect to pay.

Neither the authors nor the publisher are responsible for any outcomes resulting from consulting this reference.

Prototypes and "One-of-a-Kind" Figurines

Over the past few years, many "one-of-a-kind" figurines have been issued as prizes for various draws and bran tub draws at the many Wade events in the U.K. and the U.S.A. It is almost impossible to place suggested prices for these items, so we have left them without prices. This also applies to the many very limited-issue pieces, as until they have passed through the secondary market it is very difficult to price them.

We have illustrated a number of prototypes in this book. We must note that those shown in the book were photographed either at the home of the designer or modeler, at the Wade factory, or at the place of business of the company or individual who commissioned the piece. We bring this to the attention of the collector because, over the past few years, a number of figurines have been stolen from the pottery. A large number of early Wade prototypes have legitimately been offered at auction and we have noted the prices obtained for those reported.

We advise all collectors who have the opportunity to purchase prototype figurines to check first with Wade Ceramics Limited to verify that the items offered for sale have not been stolen.

Acknowledgments

We would like to extend our sincere gratitude to the many Wade collectors and enthusiasts who have helped us over the past few years to bring this book to completion. Some have helped by supplying photographs from their collections, and some have helped with their enthusiasm and encouragement. To all of you we say thank you.

First and foremost we extend our gratitude to Mary Ashby and Alan Clark. Without the help of Mary and Alan this book would have had many omissions. We sincerely appreciate the time they spent from their busy lives photographing items from their collection and supplying us with much needed information. Mary and Alan, we extend to you are deepest gratitude for your help and encouragement.

We extend our sincere gratitude to Sylvia and Karol Ashken who, over the past few years, have allowed us to photograph many items from their collection and have entertained us and made us so welcome at their home. To both of you, thank you.

Special thanks go to David Chown and Russell Schooley of C&S Collectables in Arundel, who have been of great help supplying us with photographs and information of the extensive range of figurines made for them by Wade Ceramics Limited. Thank you both for your patience with our numerous requests for information.

We extend our warm and heartfelt thanks to Jo-Ann and Don Mandryck for allowing us to invade their house on more than one occasion, and upsetting their schedules and rearranging their furniture so that we could take photographs of items from Jo-Ann's collection.

Jenny Wright of The Official International Wade Collectors Club has always been a strong supporter of our books and we extend our gratitude to her. Jenny has helped tremendously in supplying us with information on Wade products, for which we are most grateful. We sincerely thank Kim Rowley of The Official International Wade Collectors Club for her help over the years.

A special word of thanks goes to Carole and John Murdock. Carole has long been a strong supporter of our books for which we thank her. John we thank for the time and effort he spent taking pictures for the book.

We thank Valerie and Wayne Moody for their support and encouragement and for the long days we spent at their home photographing items for their collection.

We thank Scott and Janet Ickes for inviting us into their home to photograph many items from their collection.

Our gratitude goes to Father David Cox who invited us to view and photograph items from his fine collection.

Peg and Rog Johnson have always helped and supported us with information for our books and we sincerely thank them.

We sincerely thank Andrew Key of Key Kollectables for his continued support and for helping us with pictures and items featured in this book.

We thank Ed and Beverly Rucker for welcoming us to their home in Kansas, where we photographed many items from their collection.

Since our first book was published in 1988, Ken and Margaret Neate have become our friends as well as supporters of our books. We thank them for their friendship and for welcoming us to their home to photograph their collection.

We thank David E. Richardson for allowing us to reproduce a number of photographs from our earlier books.

We are greatly indebted to Ralph Brough for all the help and support he has given us over so many years. During his days at the Wade pottery, Ralph helped us identified and date numerous products many of which have found their way into this book.

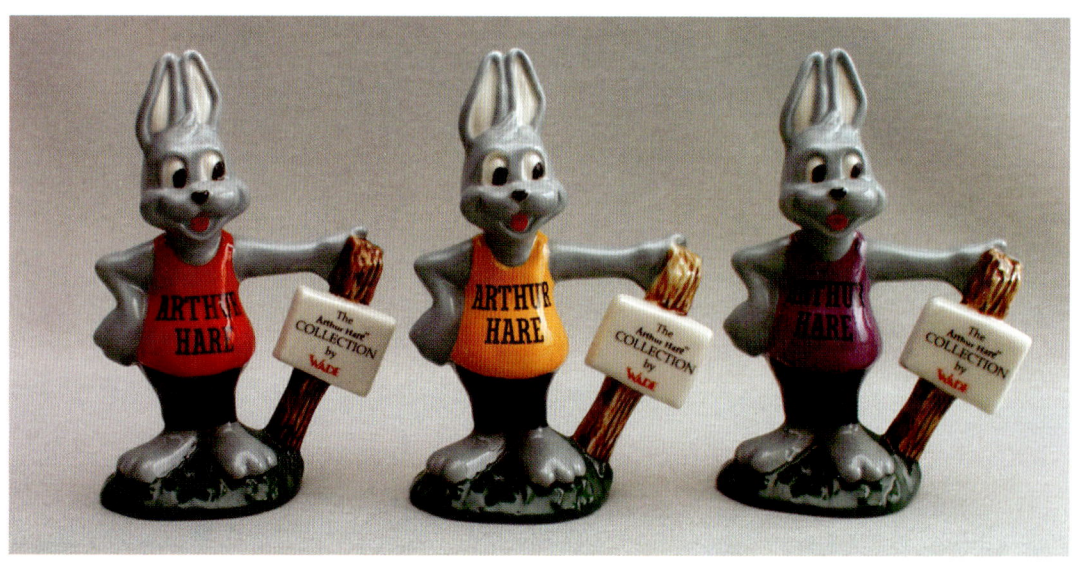

Following are just some of the many collectors and friends to whom we owe thanks for sending pictures and for their encouragement. We also thank those of you who preferred to remain anonymous :

Caryl Alcock, England
Bob & Gail Barnhart, Michigan, U.S.A.
Sarah Bernotas, New Jersey, U.S.A.
Susan Brewer, England
Peter Brooks, England
Kris Butler, England
Elaine and Adrian Crumpton, England
Ben Dawson, BJ Promotions, England
Joyce & David Divelbiss, Pennsylvania, U.S.A.
Gerry Doutre, Redco Foods, Inc.
Terry Dove, England
Linda Dunscombe, 21st. Century Keepsakes, England
June & Trevor Edlin, England
Kevin Edwards, England
Dick Ellis, Washington, U.S.A.
Janet & Mike Evans, England
Andy Evers, England
Tom Fish, Oregon, U.S.A.
Peggy A. Fyffe, Indiana, U.S.A.
M. E. Gamble, England
Zoe Gilligan, U.K. International Ceramics Ltd., England
Harry Goetz, California, U.S.A.
Mary Lee Graham, Georgia, U.S.A.
Shannon Greco, Redco Foods, Inc.
Brian Harrison, England
Vince Harvey, England
Steve Herring, S&A Collectables, U.K.
Fred & Ann Howard, England
Patty & Gary Keenan, Pennsylvania, U.S.A.
Harriet & Bruce Kellman, New York, U.S.A.
Val & Jim Kerrigan, U.K.
Nancy Kirkbride, England
Esther Kramer, Pennsylvania, U.S.A.
Dave & Dee Longfils, England
Reva & Michael Matthew, Washington, U.S.A.
Heather MacArthur, Ontario, Canada

Andrew McGregor, England
Rachel McKay, Michigan, U.S.A.
Debbie McKnight, Georgia, U.S.A.
Richard Mellor, England
Ron Merritt, Michigan, U.S.A.
Stuart Mitchell & Caroline Murray, Cotswold Collectables, England
Fatima Monteiro, England
Judi & Brian Morris, Kansas, U.S.A.
Rose Muniz, Arizona, U.S.A.
Wendell E. Pope, Redco Foods, Inc.
William L. Read, Washington, U.S.A.
David Rigg, Redco Foods, Inc.
Ginny Roberts, California, U.S.A.
Sue & Ken Roberts, England
Janet Robinson, New Zealand
Deborah Rogers, Eddie Stobart Ltd.
Bob & Marge Rolls, New York, U.S.A.
J.M.Rowles, England
Sharon Shapiro, Connecticut, U.S.A.
Libuse & Steve Smycal, Ontario, Canada
David Spaid, California, U.S.A.
Catherine Still, England
David Stratuik, Ontario, Canada
Shirley Sumbles, Indiana, U.S.A.
Fay Thompson, Ontario, Canada
Rona Trainor, Florida, U.S.A.
Del Watson, England
Mandi Webb, England
Penny Webster, Isle of Wight
Carl Wheeler, England
Sue & Phil Williams, England
Juanita & Erick Wowra, North Carolina, U.S.A.
Jo-Ann Yadrow, Oregon, U.S.A.
Mary & Steve Yager, Kansas, U.S.A.

Last, but by no means least, we thank Peter Schiffer for his help and support and Douglas Congdon-Martin for his encouragement and help in getting this book through the many stages of development. We also thank the many members of the Schiffer team who helped make this book a reality.

Wade Potteries, Marks, and Backstamps

WADE & CO.

Mark Type 04
1893
Ink Stamp

Mark Type 03
1899
Ink Stamp

Mark Type 02
1900
Ink stamp

Mark Type 01
1901
Ink Stamp

Mark Type 0
Late 1900s - Mid 1920s
Ink Stamp

Mark Type 1
Mid 1920s - 1927
Ink Stamp

WADES
ORCADIA
WARE
BRITISH MADE

Mark Type 1A
Mid 1920s - 1927
Ink Stamp

WADE HEATH & CO. LTD.

Mark Type 2
1928 - 1937
Ink Stamp

Mark Type 2A
1928 - 1934
Ink Stamp

WADEHEATH WARE
MADE IN ENGLAND
MANUFACTURED BY PERMISSION
DISNEY MICKEY MOUSE LTD.

Mark Type 2B
1934 - Late 1930s
Ink Stamp

WADEHEATH
BY PERMISSION
WALT DISNEY
ENGLAND

Mark Type 2C
Mid 1930s - Late 1930s
Ink Stamp

Mark Type 2D
1934 - Late 1930s
Ink Stamp

WADEHEATH
B
ENGLAND

Mark Type 3
1939 - 1942
Ink Stamp

*Flaxman Ware
Hand Made Pottery*
BY WADEHEATH
ENGLAND

Mark Type 4
Circa 1936
Ink Stamp

Wadeheath
Ware
England

Mark Type 5
Circa 1937
Ink Stamp

Mark Type 6
Circa 1937 - 1938
Ink Stamp

Mark Type 9
Circa Late 1930s - 1950
Ink Stamp

Mark Type 12
Circa 1950 - 1955
Ink Stamp

Mark Type 15
Circa 1947 - 1953
Ink Stamp

Mark Type 7
Circa 1938 - 1950
Ink Stamp

Mark Type 10
Circa Late 1940s
Ink Stamp

Mark Type 12A
Circa Mid 1950s - Late 1950s
Ink Stamp

Mark Type 16
Circa 1953+
Transfer

Mark Type 7A
1942 - Mid 1940s
Ink stamp

Mark Type 10A
Late 1940s
Ink Stamp

Mark Type 12B
Circa Mid 1950s - Late 1950s
Ink Stamp

Mark Type 17
Circa 1953+
Transfer

Mark Type 7B
Circa 1945 (?)
Ink Stamp

Mark Type 10B
Circa 1945 - Late 1940s
Ink Stamp

Mark Type 12C
Circa Late 1950s
Ink Stamp

Mark Type 17A
1953 - Early 1960s
Ink Stamp

WADE
HEATH
ENGLAND

Mark Type 8
Circa 1938 - 1950
Ink Stamp

Mark Type 11
Circa 1948 - 1954
Ink Stamp

Mark Type 13
Circa 1947 - Early 1950s
Ink Stamp

Mark Type 18
Circa 1953+
Transfer

WADE
HEATH
ENGLAND
A

Mark Type 8A
Circa 1942 - Late 1940s
Ink Stamp

Mark Type 11A
1947 - Mid 1950s
Transfer

Mark Type 14
Circa 1947 - Early 1950s
Ink Stamp

Mark Type 18A
Circa Mid 1950s - 1960s
Transfer

Mark Type 18B
Circa Mid 1950s - 1960s
Transfer

Mark Type 20
1985+
Transfer

WADE
MADE IN ENGLAND

Mark Type 22
Circa Early 1930s - Late 1930s
Hand Painted Ink

WADE
MADE IN ENGLAND

Mark Type 27
1958+
Molded

Mark Type 18C
Circa Mid 1950s
Ink & Transfer

GEORGE WADE & SON LTD.

Mark Type 23
Circa 1939
Ink Stamp

GENUINE
WADE
PORCELAIN

Mark Type 27A
Mid 1980s
Transfer

WADE
ENGLAND

Mark Type 19
Circa 1953+
Transfer
(George Wade & Son Ltd. also used this mark from circa 1953 on)

Mark Type 20A
1931 - Mid 1930s
Ink Stamp

Mark Type 23A
1947+
Ink Stamp

WADE CERAMICS LIMITED

Mark Type 19A
Late 1950s
Transfer

Mark Type 20B
Early 1930s - Late 1930s
Ink Stamp
(Usually found with the name of the figurine)

WADE
Porcelain
Made in England

Mark Type 24
1958+
Molded

Mark Type 27B
1990+
Transfer

Mark Type 19B
1956 - Early 1960s
Transfer

Mark Type 21
Circa Early 1930s - Late 1930s
Ink Stamp

WADE
PORCELAIN
MADE IN ENGLAND

Mark Type 25
1957 - 1981
Molded

Mark Type 27B1
2001+
Transfer
(Appears with or without: Est. 1810 England)

Mark Type 19C
Circa 1956 - Early 1960s
Transfer

Mark Type 21A
Late 1930s
Ink Stamp

WADE
MADE IN
ENGLAND

Mark Type 26
1959+
Molded

Mark Type 27B2
2001
Transfer

OIWCC Logo
Transfer
(Appears in conjunction with other Mark Types)

Mark Type 30
Mid 1954
Transfer

Mark Type 33A
1962
Molded

Mark Type 38
Mid 1970s
Impressed

WADE (ULSTER) LTD. & WADE (IRELAND) LTD.

Mark Type 31
Mid 1950s+
Molded

Mark Type 33B
1962 - 1986
Transfer

Mark Type 32
1955 +
Impressed

Mark Type 34
Mid 1960s
Molded

Mark Type 39
1965 - 1968
Impressed

Mark Type 27C
Circa 1950+
Ink Stamp

Mark Type 32A
Circa Early 1960s - 1967
Transfer

Mark Type 35
1970
Impressed

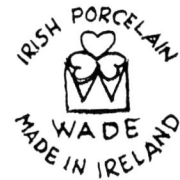

Mark Type 40
1977+
Molded

Mark Type 28
1953+
Impressed

Mark Type 32B
Circa Early 1960s - 1967
Transfer

Mark Type 36
1973
Impressed

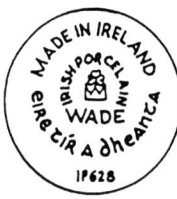

Mark Type 40A
Late 1970s
Molded

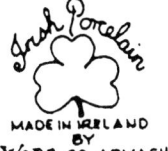

Mark Type 29
Mid 1954+
Impressed

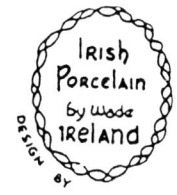

Mark Type 33
1962
Molded
(Included the name of the modeler/designer)

Mark Type 37
1970+
Transfer

Mark Type 41
1980+
Molded & Transfer

SEAGOE CERAMICS LTD.	WADE HEATH & CO. LTD. & REGINALD CORFIELD (SALES) LTD.	WADE (PDM) LTD.	SPECIAL BACKSTAMPS
 Mark Type 41A 1991 Ink Stamp	 Mark Type 42 1950 - 1957 Transfer	 Mark Type 46 1970 - 1980 Transfer	 S1 Ringtons Rose Bowl and Plant Trough 1990
 Mark Type 41B 1991+ Transfer	 Mark Type 43 1957 - 1966 Transfer (Note: Mark Type 43 similar to Mark Type 42 but with heavier lettering.)	 Mark Type 47 1980+ Transfer	 S2 Ringtons Backstamp
 Mark Type 41C 1992+ Transfer	 Mark Type 43A Circa Early - Mid 1960s Transfer	 Mark Type 48 1980 Transfer	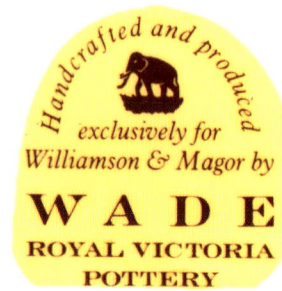 S3 Williamson and Magor Elephant Tea Caddy 1990 - 1993
 Mark Type 41D 1992+ Transfer	 Mark Type 44 1962 - 1968 Transfer	 Mark Type 49 1990+ Transfer	 S4 Open Range (Various Shapes)
 Mark Type 41E 1992+ Transfer	 Mark Type 45 1968 - 1970 Transfer		

S5
Open Range (Various Shapes)

S10
Small Size Teapot, Royal Society for the Protection of Birds 1988

S15
No Record

S6
Santa's Grotto Teapot (First produced Christmas 1989)
1989+

S11
Standard Fine Bone China Backstamp (Royal Victoria Pottery)

S16
Irish Distillers Backstamp

S7
Open Range (Various Shapes)

S12
Old Parr Flagons

S17
Belfry Hotel Coaster Dish

S8
Myrna Coffee Pot

S13
Gardner Merchant
1986

S18
Whyte & Mackay Flagon Backstamp

S9
Small Size Cider Mug (Taunton Cider)

S14
Open Range (Various Shapes)

S19
Open Range (various shapes)

15

S20
No Record

S24
No Record

S28

S21
Gordon Highlander Backstamp
for Highland Wildlife Decanter
Early 1990s

S25
Open Range (various shapes)

S26 to S35
Taunton Cider Mug Backstamps
1977 - 1989

S29

S26

S30

S22
Gordon Highlander Backstamp
for Highland Wildlife Decanter
Early 1990s

S23
One Cup China Teapots, Open
Range (three shapes)
Mid 1980s - Early 1990s

S27

S31

16

S32

S33

S34

S35

S36
Boston Tea Party Teapot, Sugar and Creamer Backstamp
Circa Mid 1970s

S37
Wilton Castle Dish

S38
English Life Mug Backstamp
1988 - Early 1990s

S39
English Life Teapot Backstamp
1988 - Early 1990s

S40
Valor Teapot Backstamp
1990

S41 to S45
Gallery Collection Flower Jugs
1995

S41

S45

S50
Ringtons Ltd
Willow Range Backstamp
1994 - 1996

S42

S46
The International Wade Collectors Club
Backstamp
Typical backstamp of early Club items

S47
Holly Hedghog Backstamp
1994

S51
Robyn Hoode Malt Whisky
1993

S52
Findlaters Scotch Whisky

S43

S48
Wimbles Backstamp

S49
Punch and Judy Backstamp

S44

S53
Bear Ambitions Teapots
1994 - 1995

S57
Lady and the Tramp Sweet Tray
Circa 1956

S61
Cockleshell Cove Collection
1990 - 1993

S54
The Christmas Collection
1991 - Mid 1990s

S58
The Ringmaster Teapot
1990

S62
White Rabbit Teapot (Boots)
1992

S55
London Life Teapots
1994 - 1995

S59
Cat Burglar Teapot
Late 1980s

S63
Dressage Teapot (Boots)
1992

S56
Feline Collection Teapots
1989 - 1990

S60
Noah's Arc Teapot
1990

S64
Fish Mug Collection
1992

An experimental pottery studio was quietly established in 1950 by Col. George Wade (later Sir George Wade) at the Manchester Pottery. Little was known in the pottery business about this venture and it was not until around 1952 that it became a matter for public knowledge. Many ideas and preliminary models were scrapped in the early stages of development, but one item that progressed through to fruition was "IVY" or, to give her her correct title, "Festival 51."

"IVY" was a symbolic figure created by Col. Wade and designer/modeler Colin Melbourne to represent their ideas and feelings for the 1951 Festival of Britain. The figure was exhibited, to much astonishment and maybe horror by the establishment, at the Festival of Britain exhibition at Kings Hall, Stoke-on-Trent.

"Festival 51" or "IVY"

Chapter 1
WADE FIGURINES

by George Wade & Son Ltd. circa 1927 - 1941

Between the late 1920s and the late 1930s, George Wade & Son Ltd. produced a variety of Classic and Art Deco figurines designed by Jessica Van Hallen, a designer and modeler specially brought in by George Wade to head up a new department to produce figural gift ware.

The Van Hallen figurines were examples of beauty and grace, combined with virility and sense of action. They proved to be extremely popular with both the buying public and the trade.

The finish of the figurines was a newly patented "Scintillite" finish referred to as a "cellulose spray." The "Scintillite" figurines were made in a similar manner to regular china until after the first firing. They were then decorated with the new finish that had a very full pallet of colorings. It was claimed that this new finish was equal to that of the usual, hard, underglaze finish. Unfortunately, this did not prove to be quite the case as, over the years, this finish often turned yellow and cracked leaving these figurines in a less than satisfactory condition.

In the late 1930s, a number of the Van Hallen figurines, such as Juliet and Romance were issued in an underglaze version. In the early 1950s, a very small number of the Van Hallen figurines were produced and finished with an underglaze decoration and presented to Wade staff on special occasions.

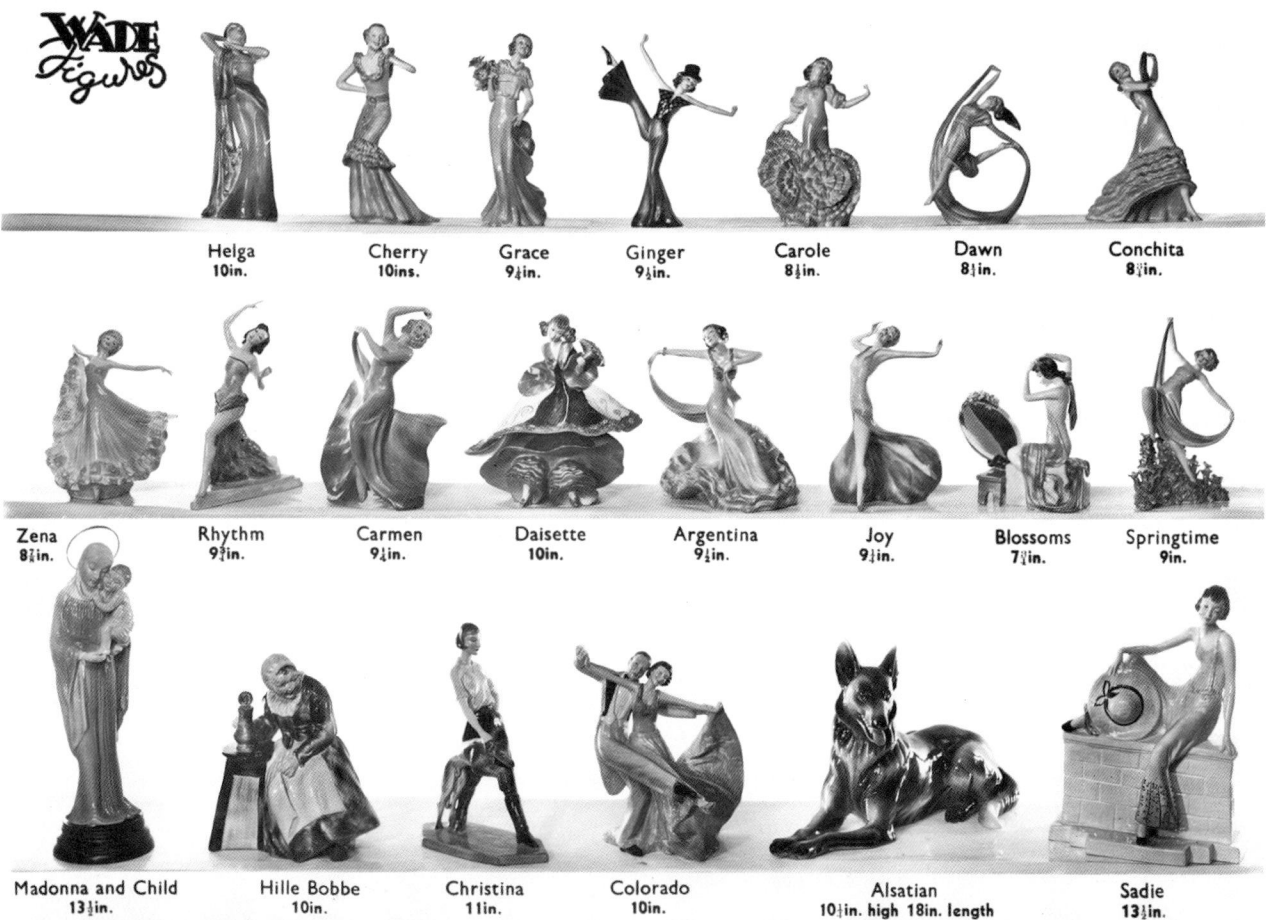

FIG.1. Figurines *circa 1927 - late 1930s (cellulose finish)*.

OLD NANNY
9-1/2" high, has an underglaze finish and is marked: OLD NANNY along with Mark Type 21A ($700, £375).

HILLE BOBBE
9-3/4" high, has a cellulose finish and is marked: WADE Figures along with Mark Type 20A ($350, £185).

Top row: 1. Joyce measures 7-1/4" high and has a cellulose finish with Mark Type 21 (without the word figure) ($350, £195). **2. Peggy** measures 6-3/4" high and has a cellulose finish with Mark Type 21 (without the word figure) ($350, £195).
Bottom row: 3. Colorado measures 10" high and has a cellulose finish with Mark Type 21 ($1100, £650). **4. Zena** measures 4" high and has a cellulose finish with Mark Type 21 ($250, £130).
5. Christina measures 11" high and has a cellulose finish with Mark Type 21 ($450, £225).

ARGENTINA
9-3/8" high by 7" across, has a cellulose finish and is marked: ARGENTINA along with Mark Type 21 ($780, £425).

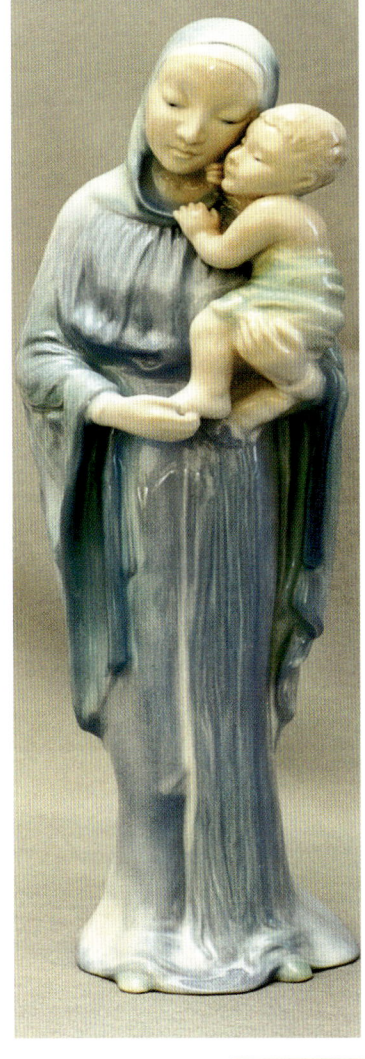

MADONNA
13" high with an underglaze finish and is unmarked ($2000, £1200).

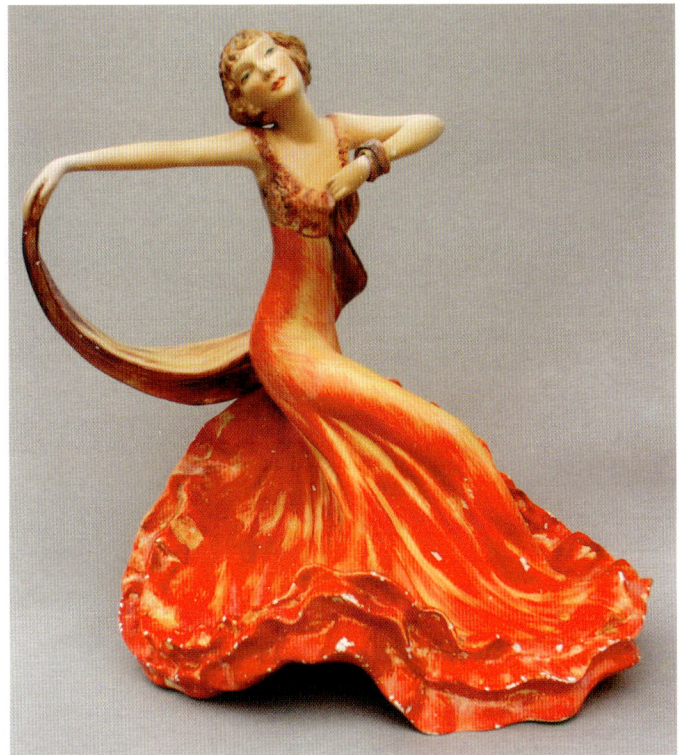

ARGENTINA
9-3/8" high by 7" across, has a cellulose finish and is marked: ARGENTINA 1 along with Mark Type 21 ($780, £425).

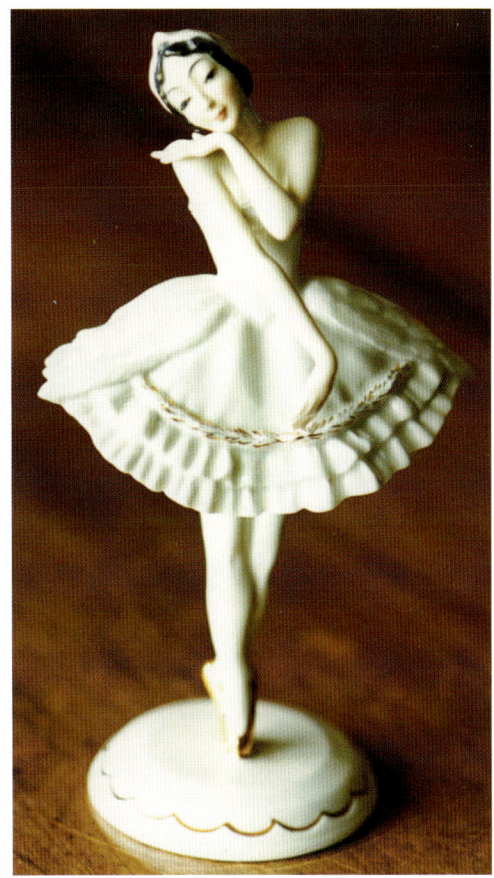

THE SWAN DANCER
8-1/4" high and has an underglaze finish with Mark Type 21A along with the name of the figurine ($950, £500).

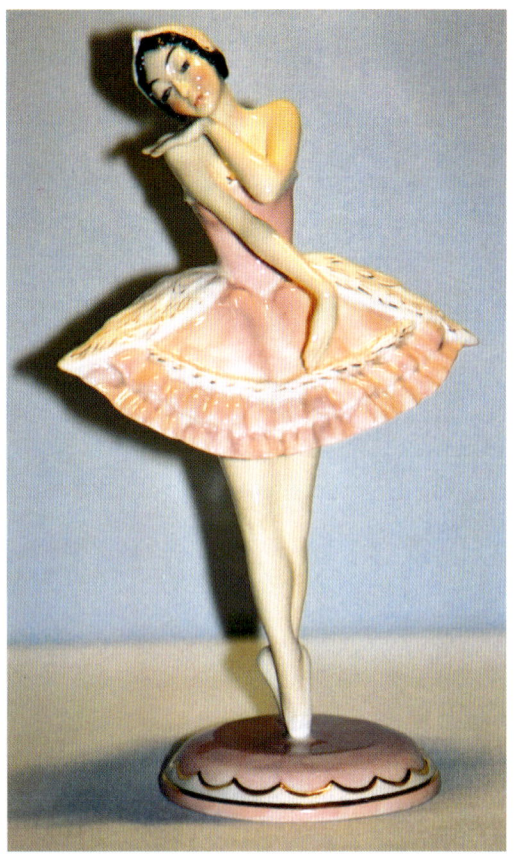

THE SWAN DANCER
Color variation ($950, £500).

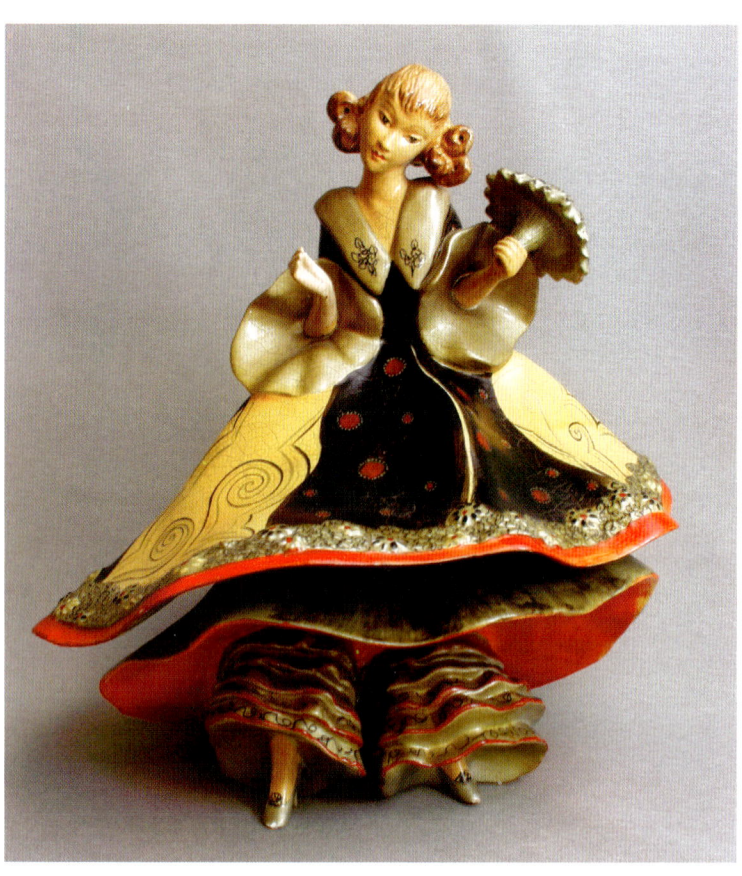

DAISETTE
9-3/4" high and has a cellulose finish with Mark Type 21 ($850, £450).

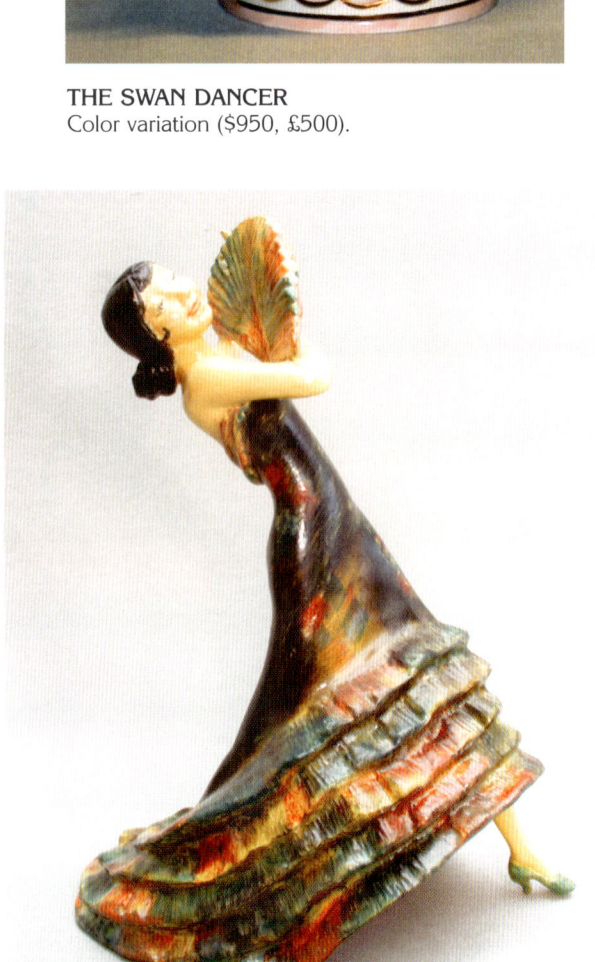

CONCHITA
8-3/4" high by 7" across, has a cellulose finish and is marked: CONCHITA 2 along with Mark Type 21 ($700, £380).

HELGA
10" high, has a cellulose finish and is marked: HELGA 3 along with Mark Type 21A ($360, £185).

CHERRY
10" high, has a cellulose finish and is marked: CHERRY along with Mark Type 21 ($425, £225).

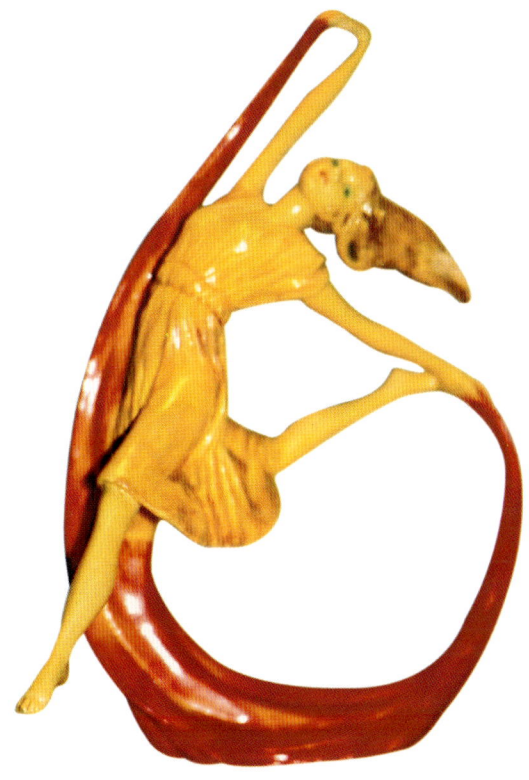

DAWN
8-1/4" high, has a cellulose finish and is marked: DAWN along with Mark Type 21 ($530, £280).

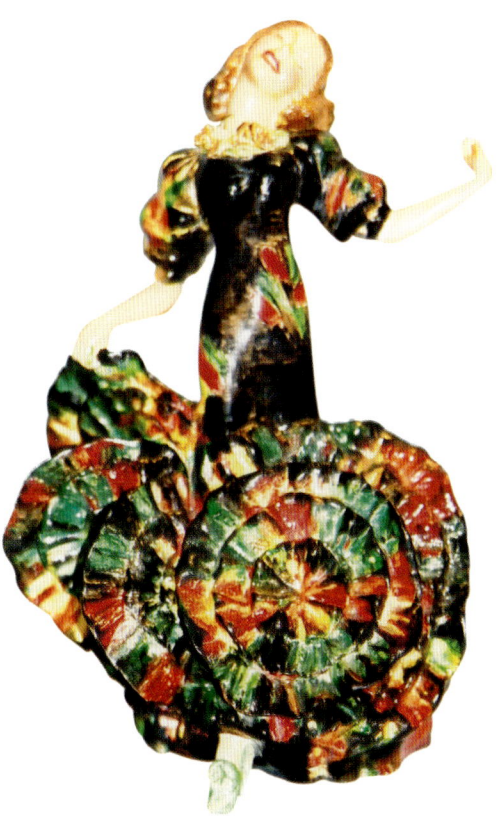

CAROLE
8-1/2" high, has a cellulose finish and is marked: CAROLE along with Mark Type 21 ($650, £350).

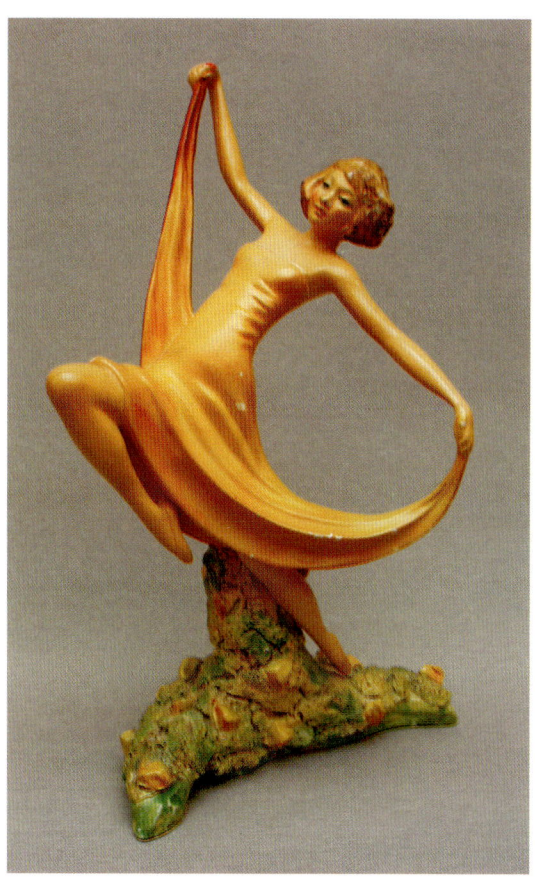

SPRINGTIME
9-1/4" high and has a cellulose finish with Mark Type 21 ($535, £280).

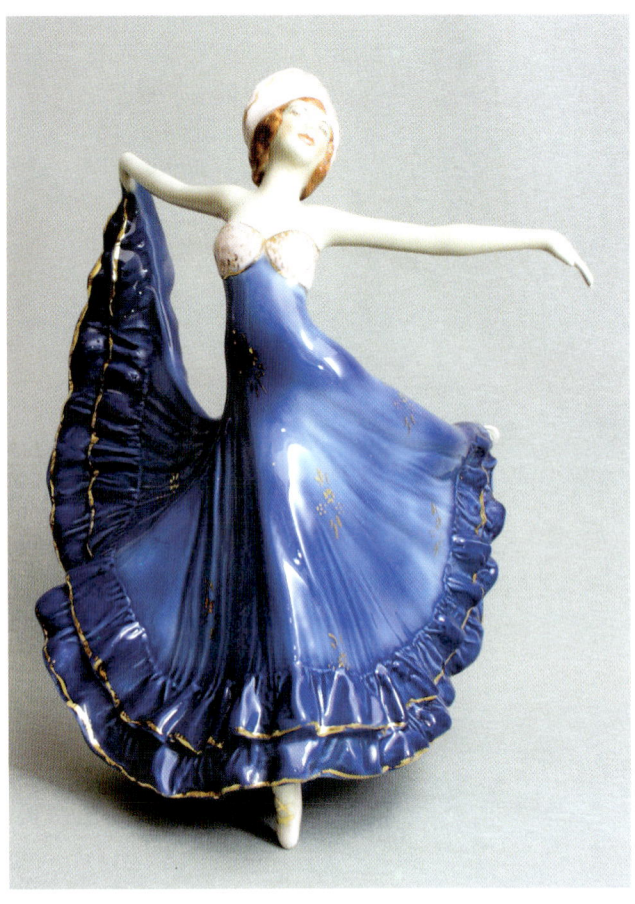

ZENA
8-7/8" high and has an underglaze finish with Mark Type 21A ($675, £375).

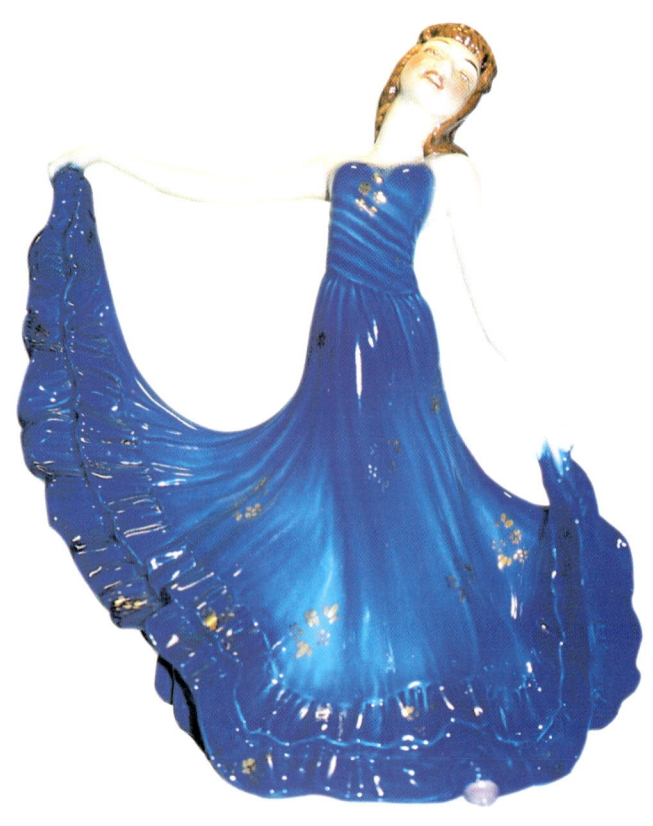

IRIS
8-1/4" high, has an underglaze finish and is marked: IRIS Wade England ($630, £350).

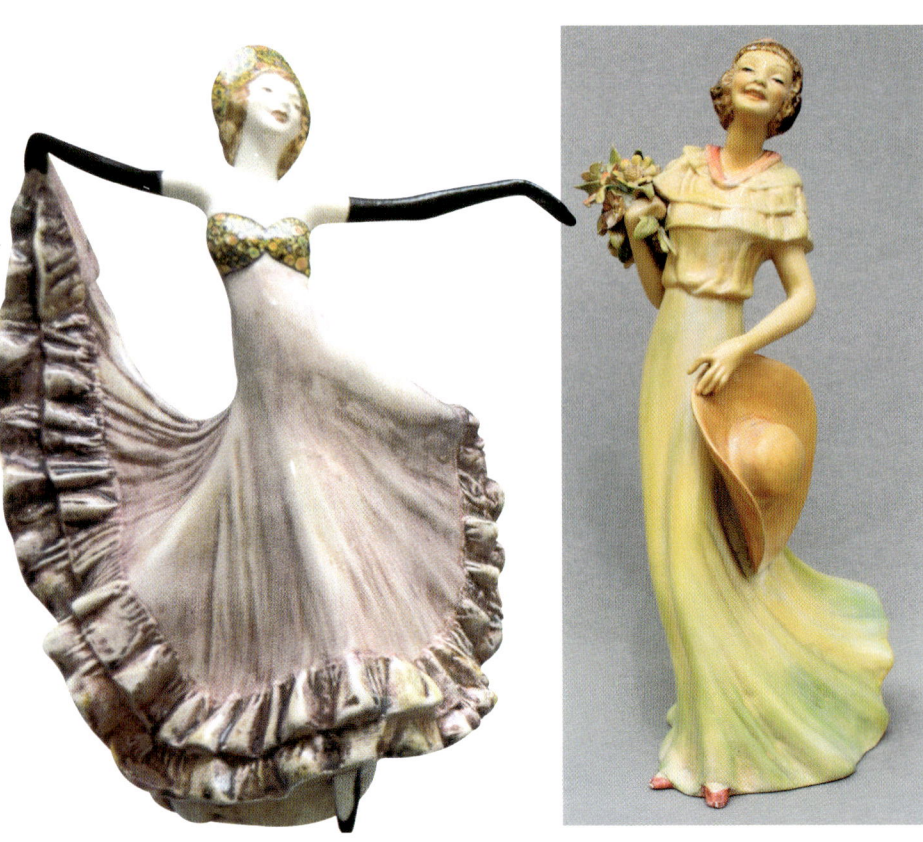

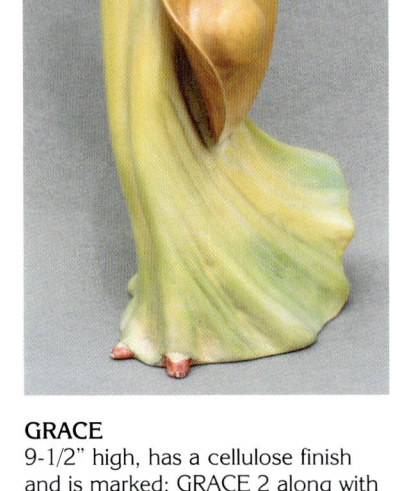

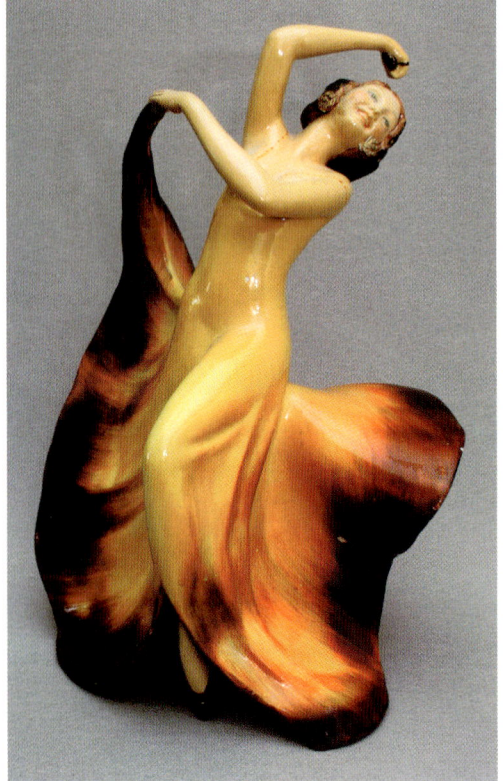

ZENA
Colour variation ($675, £375).

GRACE
9-1/2" high, has a cellulose finish and is marked: GRACE 2 along with Mark Type 21 ($360, £185).

CARMEN
9-3/4" high and has a cellulose finish with Mark Type 21 ($800, £425).

Wade figures

| Queenie 4in. | Cynthia 5in. | Tony 4½in. | José 4½in. | Betty 5in. | Strawberry Girl 5¼in. | Elf 4in. | Zena 4ins. | Pavlova 4½in. |

| Tessa 5in. | Alice 5½in. | Sunshine 6½in. | Humoresque 8½in. | Anton 5¼in. | Gloria 5¾in. | Alsatian 4¼in. high 8¼in. length |

| Jean 6¼in. | Barbara 8¼in. | Pompadour 6in. | Curtsey 5in. | Harriet 8in. | Spaniel 2½in. high 5½in. length | Joyce 7¼in. | Peggy 6¼in. |

FIG.2. Figurines *circa 1927 - late 1930s (cellulose finish)*.

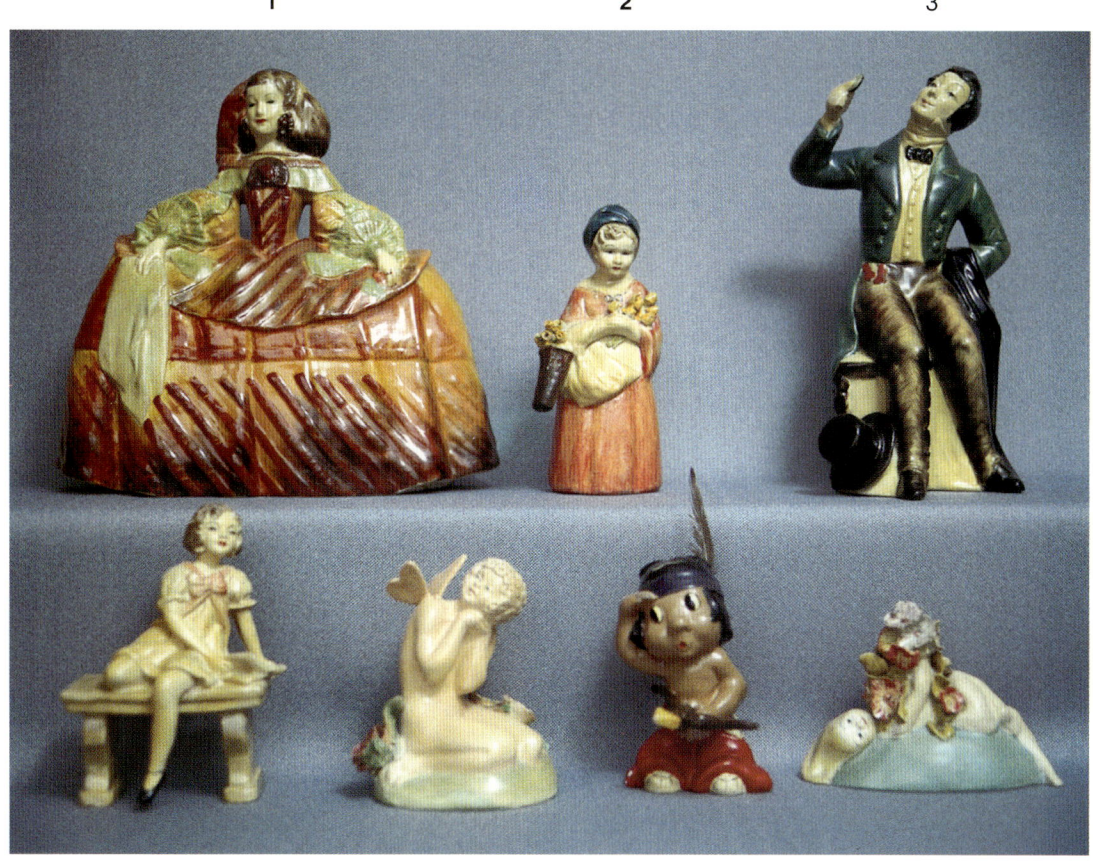

Top row (l-r): **1. Maria Theresa** measures 8" high and has a cellulose finish with Mark Type 21 ($500, £285). **2. Strawberry Girl** measures 5-1/4" high, has a cellulose finish and is marked Wade on the base ($270, £155). **3. Claude** measures 7-3/4" high and has a cellulose finish with Mark Type 20A ($560, £325).

Bottom row (l-r): **4. Tessa** measures 4-3/4" high and has a cellulose finish with Mark Type 21 ($250, £150). **5. Elf 2** measures 3-3/4" high and has a cellulose finish with Mark type 21 ($390, £225). **6. Hiawatha** measures 3-3/4" high and has a cellulose finish with Mark Type 21 ($525, £300). **7. Delight** measures 3" high and has a cellulose finish with Mark Type 20A ($460, £255).

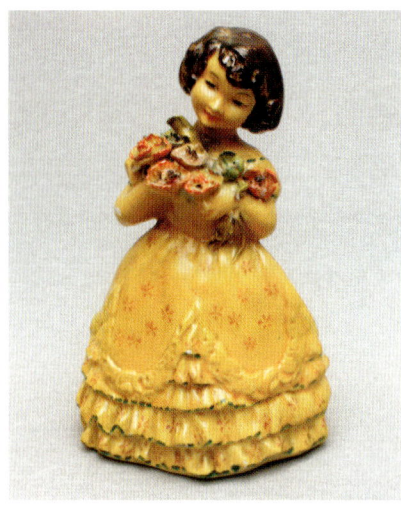

BETTY
3" high and has a cellulose finish with Mark Type 20A ($260, £145).

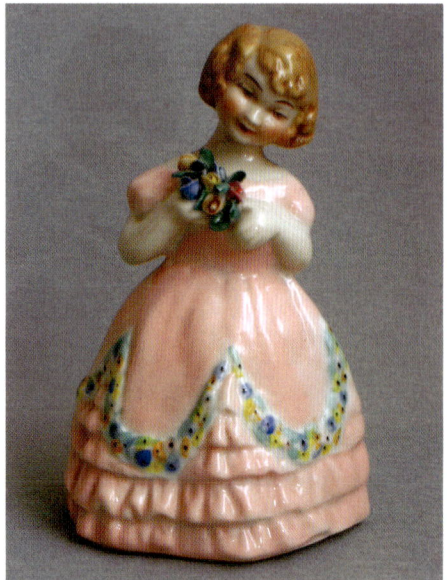

BETTY
3" high, has an underglaze finish and is ink stamped: WADE ENGLAND ($500, £260).

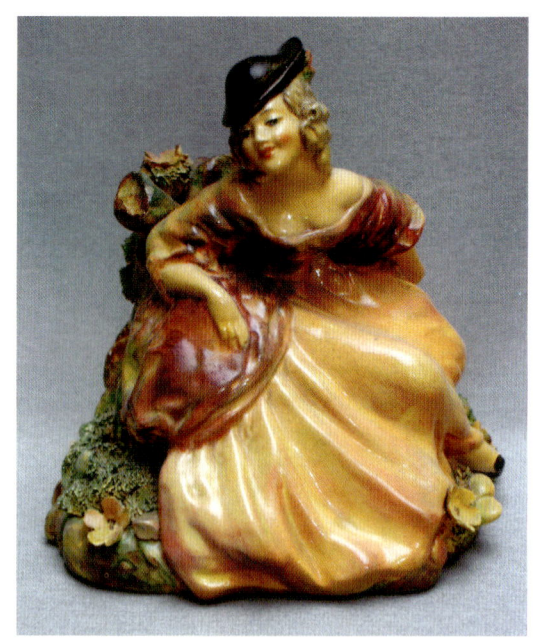

PHYLLIS
5-1/4" high by 5" across and has a cellulose finish with Mark Type 21 ($340, £185).

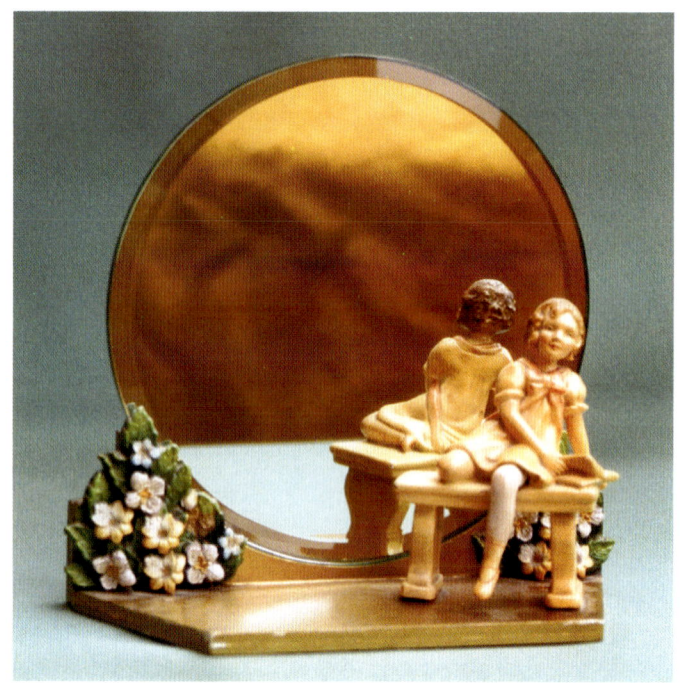

TESSA
Mirror version ($250, £150).

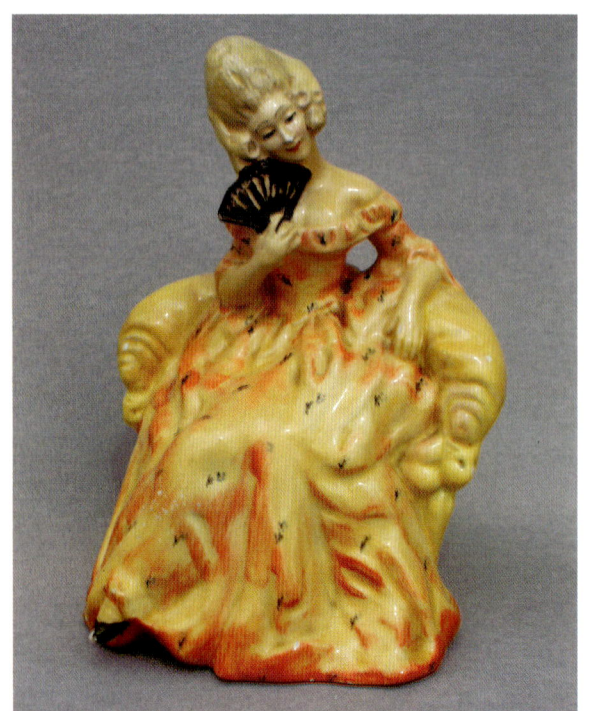

POMPADOUR
6" high, has a cellulose finish and is marked: POMPADOUR 3 Wade made in England ($340, £185).

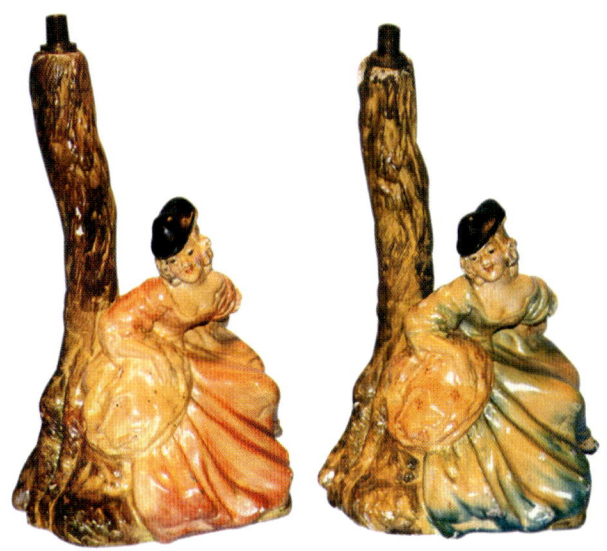

PHYLLIS
Lamp version and color variation ($290, £150).

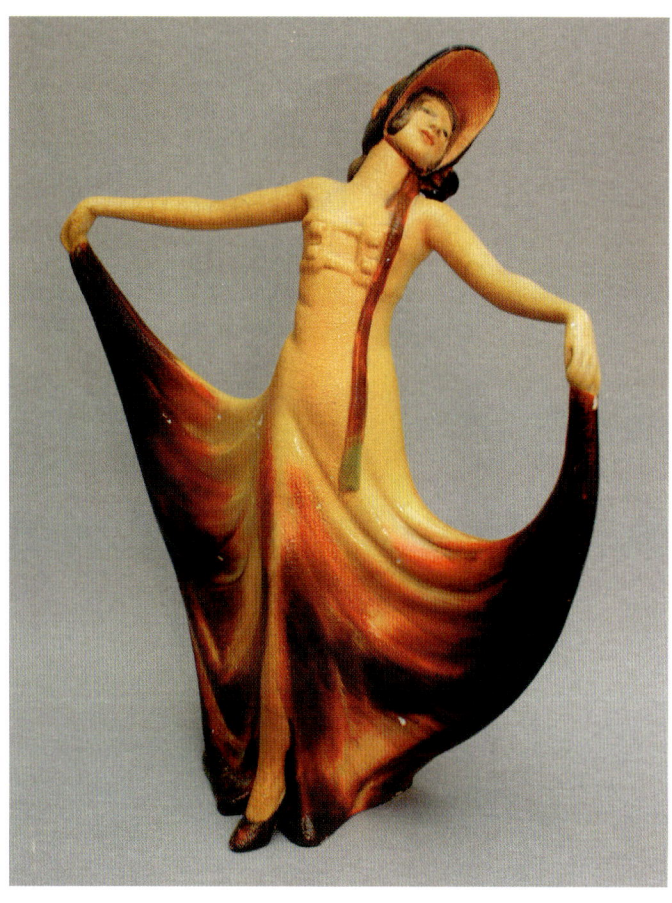

PAVLOVA
9" high by 7-1/4" across, has a cellulose finish and is marked: PAVLOVA 1940 along with Mark Type 21A ($325, £180).

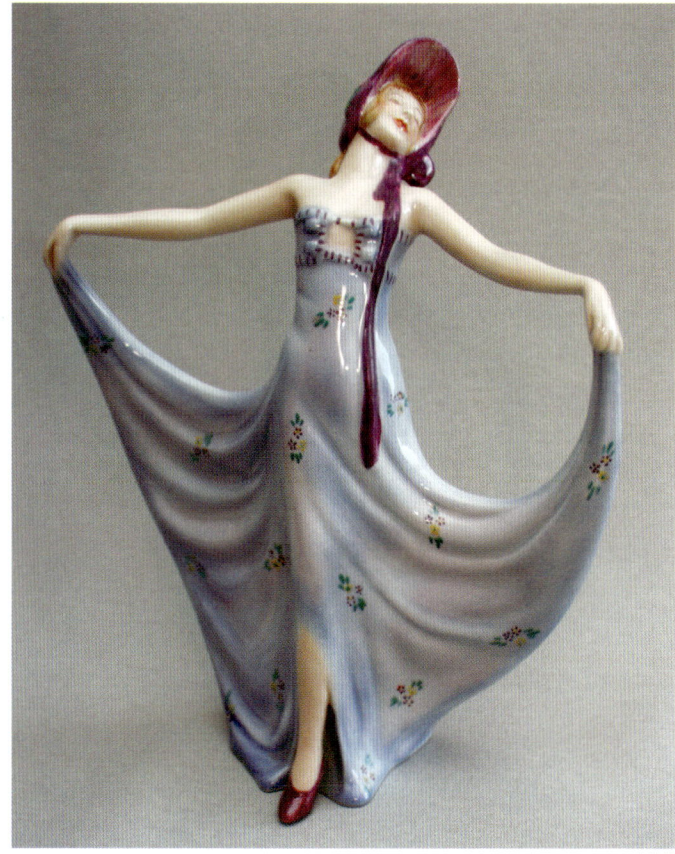

PAVLOVA
9" high by 7-1/4" across, has an underglaze finish and is marked: PAVLOVA 1940 along with Mark Type 21A ($580, £325).

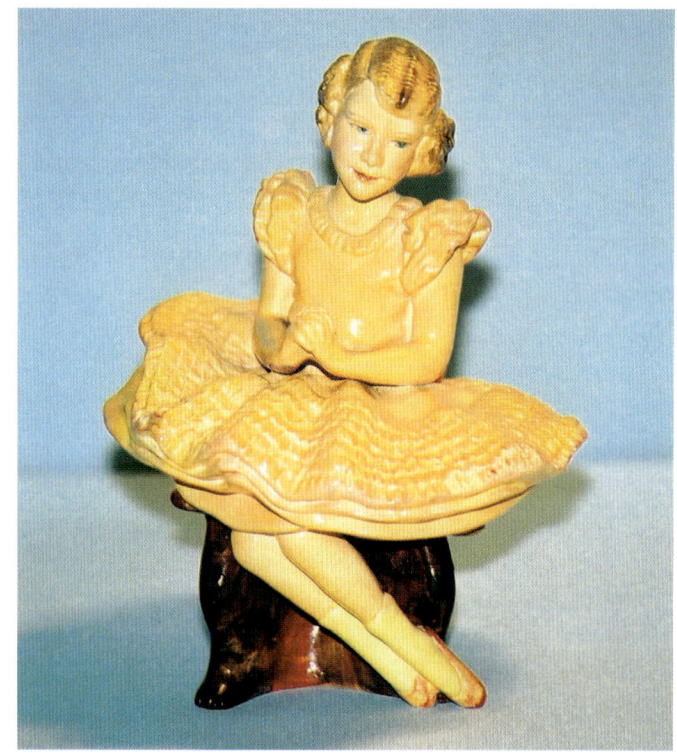

PRINCESS ELIZABETH
5-1/4" high, has a cellulose finish and is marked: HRH Princess Elizabeth Wade Made in England ($300, £175).

29

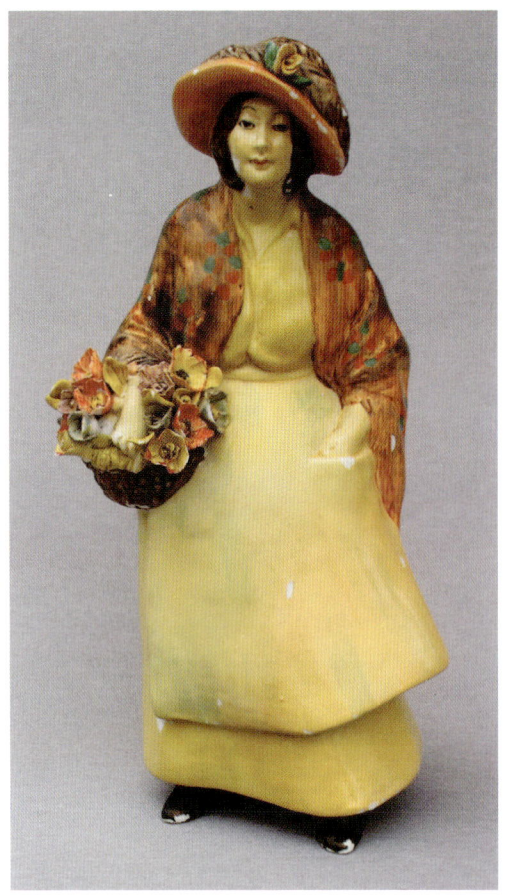

HARRIET
8" high and has a cellulose finish with Mark Type 20A Made In England ($340, £185).

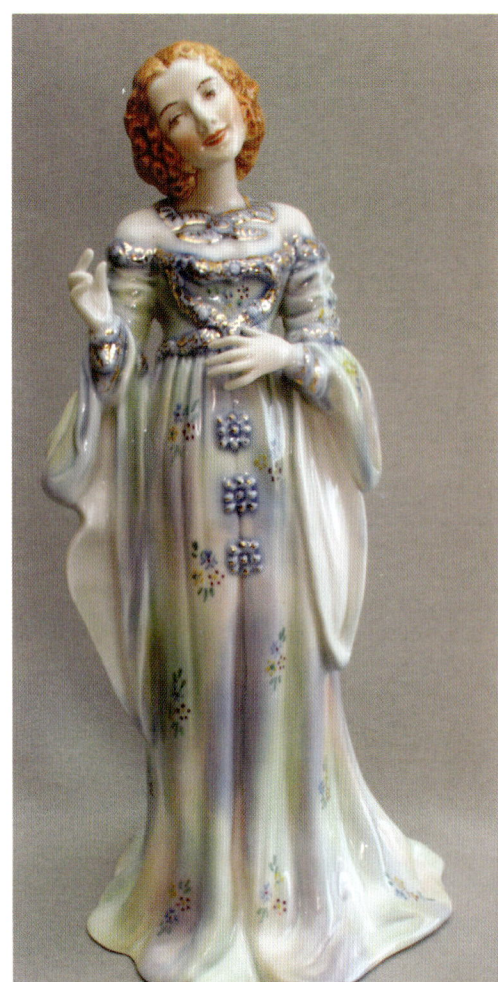

JULIET
9-1/2" high, has an underglaze finish and is marked: Norma Shearer, star of M.G.M. in the Production of "Romeo & Juliet" Made in England along with Mark Type 21 ($725, £400).

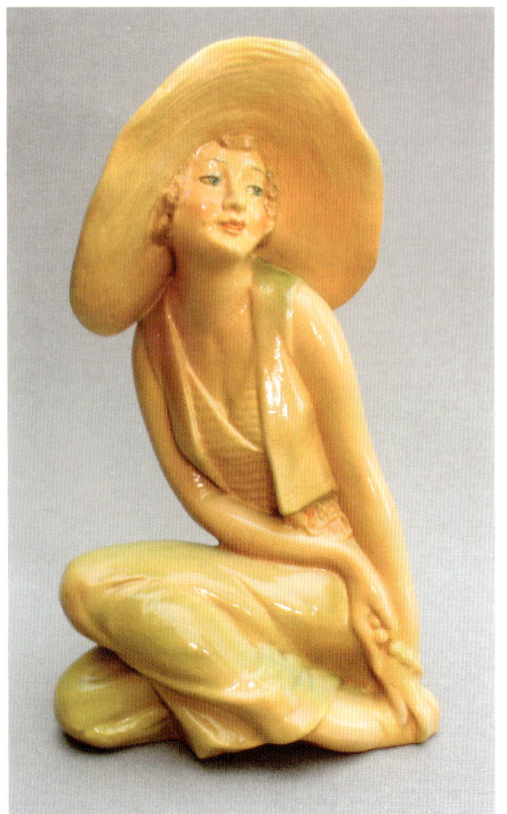

JUNE
7-1/4" high, has a cellulose finish and is marked: JUNE 2 along with Mark Type 21 ($225, £120).

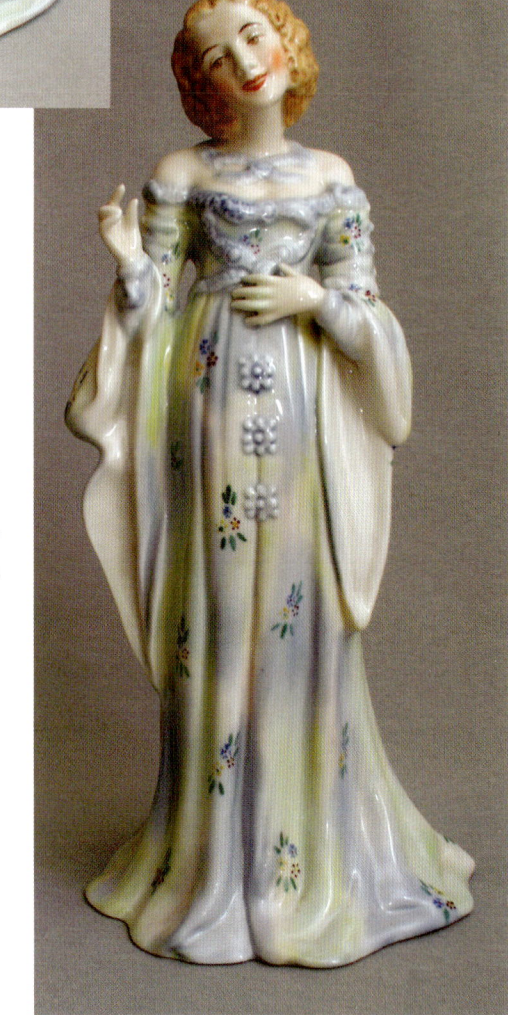

JULIET
Decoration variation ($725, £400).

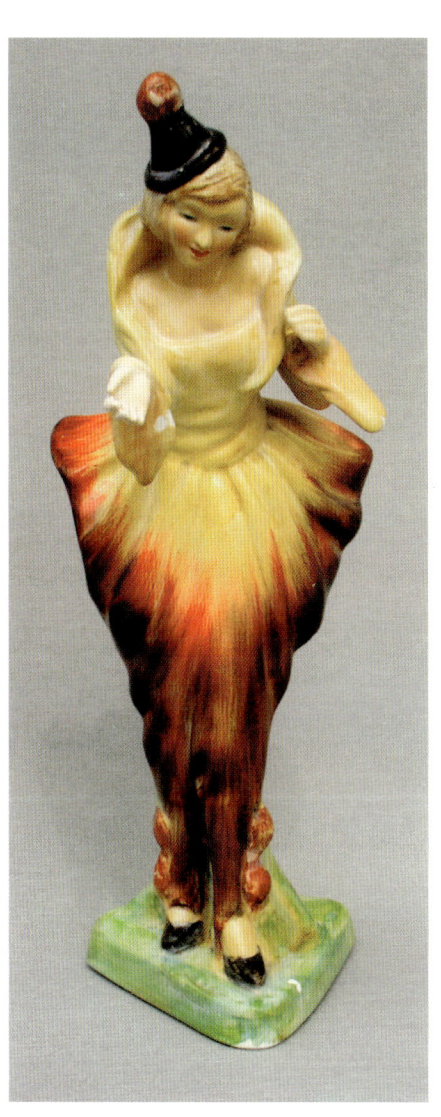

Left:
HUMORESQUE
8" high, has a cellulose finish and is marked: HUMORESQUE along with Mark Type 21 ($345, £190).

Below:
SUSAN
4-3/4" high, has a cellulose finish and is marked: SUSAN 8 along with Mark Type 21 ($340, £185).

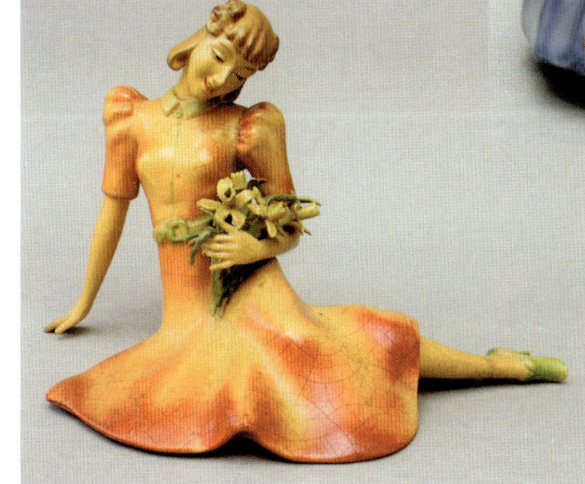

SUNSHINE
6-1/2" high by 4" across, has an underglaze finish and is marked: SUNSHINE along with Mark Type 21A ($490, £260).

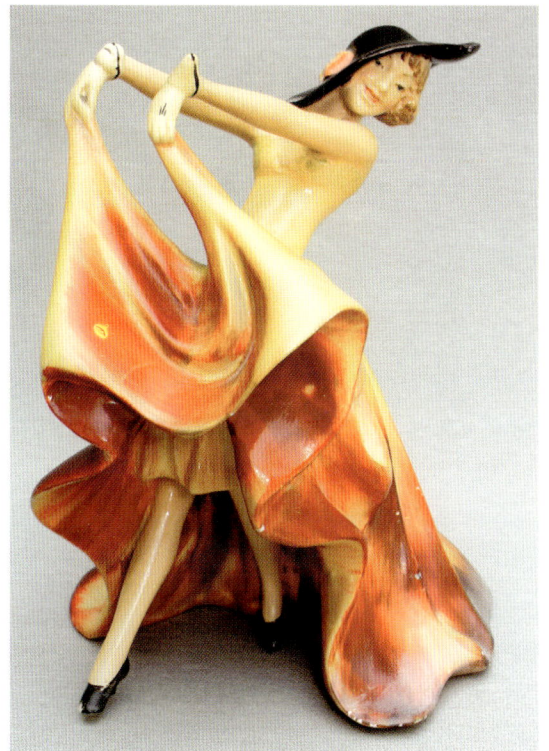

JEANETTE
6-1/2" high and has a cellulose finish with Mark Type 21 ($300, £175).

PAN (wall plaque)
8-1/4" high and has a cellulose finish with Mark Type 21 ($1025, £550).

PAN (wall plaque)
8-1/4" high and has a cellulose finish with Mark Type 21 ($1025, £550).

FROLIC (wall plaque)
8-1/4" high and has a cellulose finish with Mark Type 21 ($780, £450).

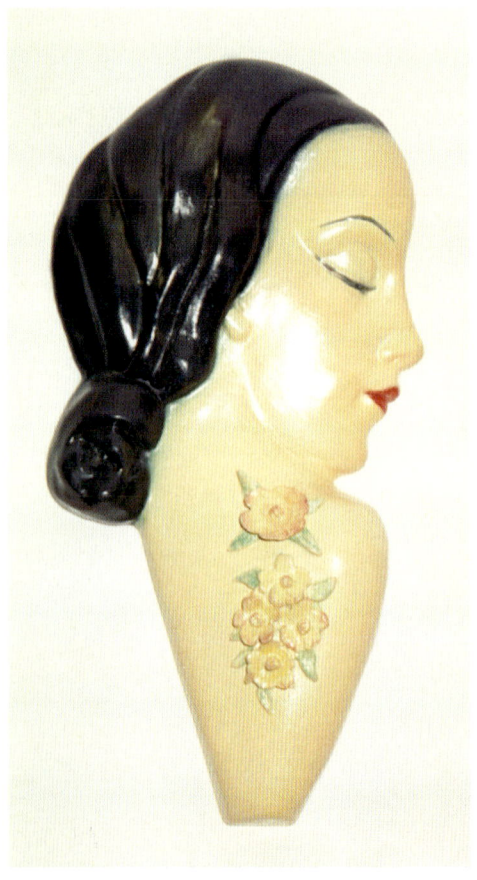

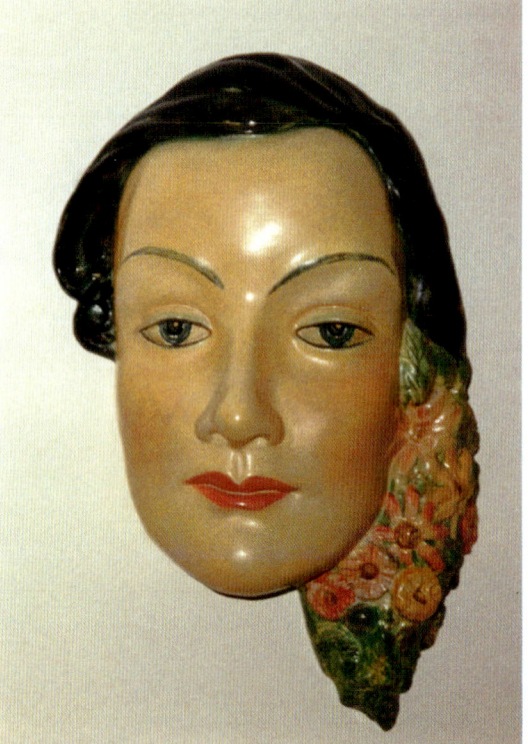

SONIA (wall plaque)
9-1/2" high and has a cellulose finish with Mark Type 21 ($780, £450).

DYLLIS (wall plaque)
7" high and has a cellulose finish with Mark Type 21 ($1025, £550).

GIRL with HEADSCARF (wall plaque)
5" high by 6" wide and has a cellulose finish with Mark Type 21 ($540, £300).

32

FIG. 3. Figurines *circa 1927 - late 1930s (Cellulose Finish)*.

ALFIE & PEGGY
6" high and has a cellulose finish with Mark Type 21 ($340, £190).

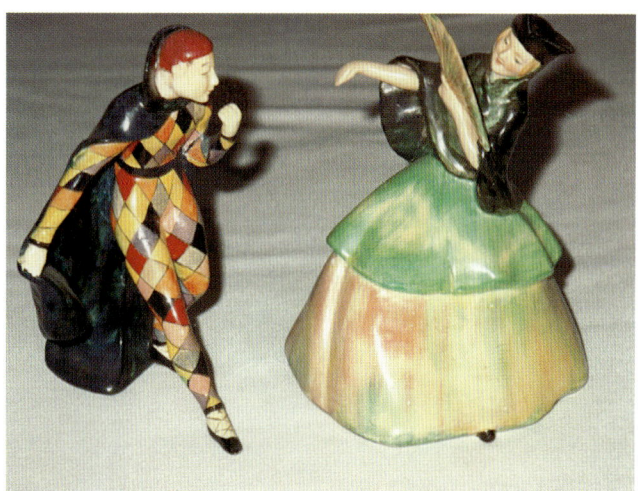

Left: Anton measures 5-3/4" high and has a cellulose finish with Mark Type 21 ($350, £195). **Right: Gloria** measures 5-3/4" high and has a cellulose finish with Mark Type 21 ($350, £195).

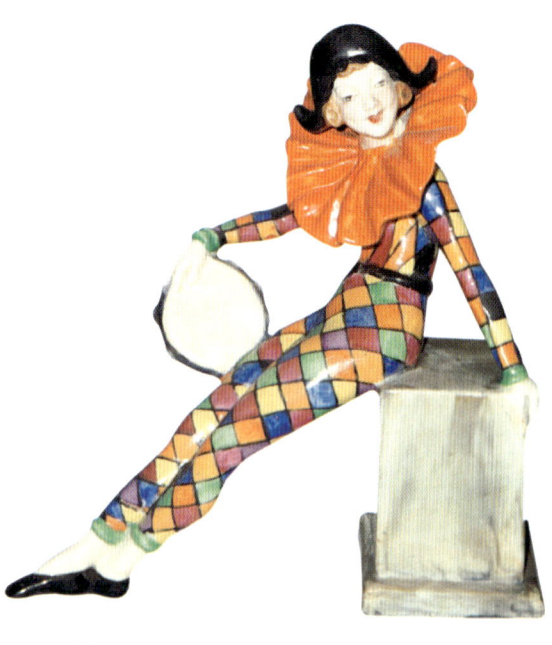

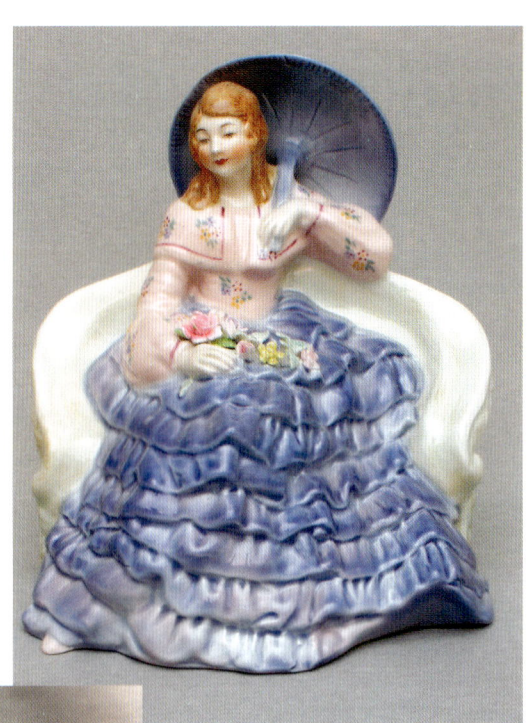

ROMANCE
6-1/2" high and has an underglaze finish with Mark Type 21A ($675, £380).

ANITA
6-3/4" high and has a cellulose finish with Mark Type 21 ($340, £185).

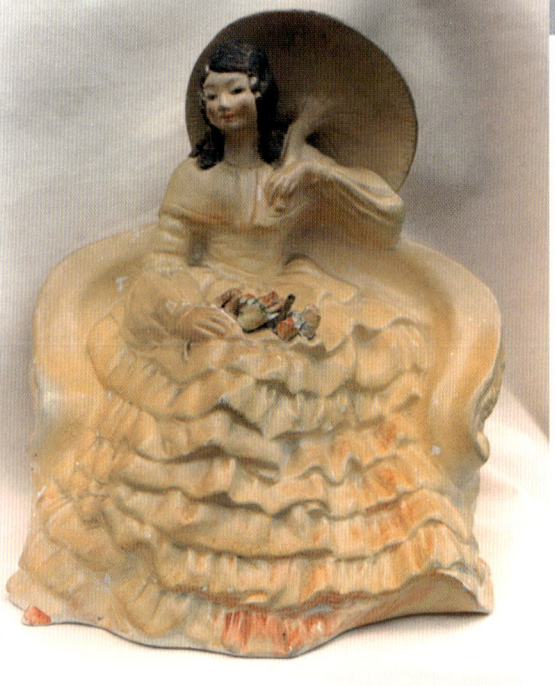

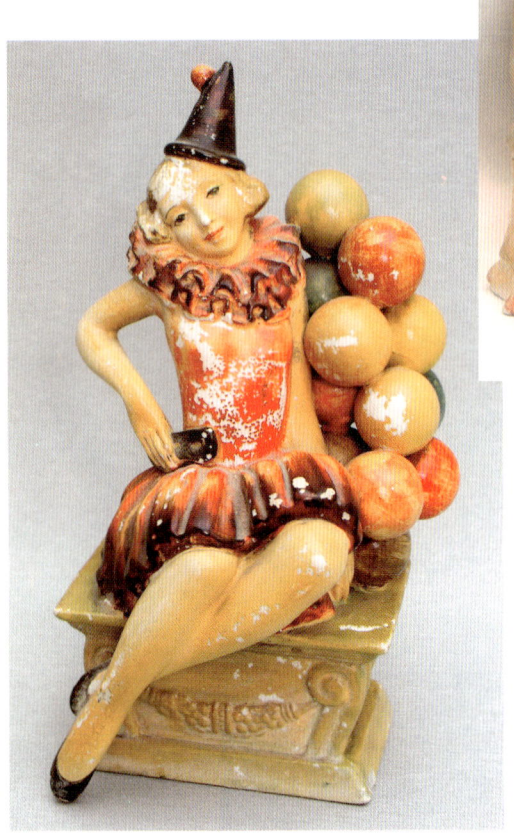

ROMANCE
6-1/2 high and has a cellulose finish with Mark Type 21A ($350, £195).

CARNIVAL
7" high and has a cellulose finish with Mark Type 21 without the "Leaping Deer." ($300, £160).

DOLLY VARDON
10-3/8" high and has a cellulose finish with Mark Type 21 ($350, £185).

BARBARA (lamp version)
8-1/4" high and has a cellulose finish with Mark Type 21 ($350, £190).

CYNTHIA
5" high, has a cellulose finish and is marked: CYNTHIA 2 along with Mark Type 21 ($275, £150).

CYNTHIA
5" high, has an underglaze finish and is marked: CYNTHIA along with Mark Type 21 ($545, £300).

Left: Tony measures 4-1/2" high, has a cellulose finish and is marked: TONY along with Mark Type 21 ($275, £150). **Right: Cynthia** measures 5" high, has a cellulose finish and is marked: CYNTHIA 2 along with Mark Type 21 ($275, £150).

GNOME with FLOWERS
3" high on a 3-1/2" by 2" base with an underglaze finish and a handwritten mark: Wade England No.3 ($90, £45).

JOSE
4-1/2" high, has a cellulose finish and is ink stamped: WADE MADE IN ENGLAND along with the name JOSE 4 ($275, £150).

GNOME with FLOWERS
2-3/4" high with an underglaze finish and has a handwritten mark: Wade England No.7 ($90, £45).

CURTSEY
5-1/8" high by 7" across, has a cellulose finish and is marked: CURTSEY 7 along with Mark Type 21 ($220, £120).

ALICE and the DODO
5-1/8" high and has a cellulose finish with Mark Type 21 along with the name: Alice 4 ($490, £275).

ALICE and the DODO
Color variation ($490, £275).

CURTSEY
5-1/8" high by 7" across, has an underglaze finish and is marked: CURTSEY along with Mark Type 21 ($480, £225).

JEAN
6-3/4" high and has a cellulose finish with Mark type 21 along with the name: Jean 12 ($340, £185).

"WELSH LADY" HANDLE
3-1/2" high and has a mark type similar to Mark Type 22 around the inside of the base. This figurine, with an underglaze finish, was originally used as a handle for a pincushion in the shape of a lady's skirt ($350, £200).

SLEEPY HEAD
4-1/4" high by 7-3/4" long, has a cellulose finish and is marked: SLEEPY HEAD along with Mark Type 21 ($425, £255).

CURLS
5-3/4" high, has a cellulose finish and is marked: CURLS along with Mark Type 21 ($425, £255).

"SPANISH LADY" HANDLE
3-7/8" high and has a mark type similar to Mark Type 22 around the inside of the base. This figurine, with an underglaze finish, was originally used as a handle for a pincushion in the shape of a lady's skirt ($350, £200).

PAGEANT SERIES, *circa late 1930s*

As illustrated in the George Wade & Son Ltd. advertisement shown in this book, the Pageant Series (see page 40) comprised the following figurines: Henry VIII, James I, Richard Lionheart, Robert the Bruce, Cardinal Wolsey, John Knox, Mary Queen of Scots, and Elizabeth I.

Left: King Henry VIII measures 4-1/2" high, has a cellulose finish and is marked on the underside of the base: Henry VIII Wade England ($600, £400). **Right: Queen Elizabeth I** measures 4-3/8" high, has a cellulose finish and is marked on the underside of the base: Queen Elizabeth Pageant Made in England, on the underside of the base ($600, £400).

King Henry VIII illustrating the mark type on base.

Queen Elizabeth I illustrating the mark type on base.

SEATED LADY
7-1/4" high. This figurine was modeled by Frank Garbutt and decorated by Georgina Lawton circa early 1950s. Only two of these underglazed figurines were produced; one for the late Sir George Wade and one for Mrs. Lawton (N.P.A.).

JOAN
5-3/4" high, has a cellulose finish and is marked with a handwritten mark around the rim of the base: JOAN Wade England (N.P.A.).

DORA
7-1/2" high with a cellulose finish and is marked: Wade Made in England DORA ($340, £185).

38

ANN
5-3/4" high, has a cellulose finish and is marked with a handwritten mark around the rim of the base: ANN Wade England (N.P.A.).

George Wade & Son Ltd. Wade Figures advertisement *circa late 1930s*

MIMI
7-3/4" high, has a cellulose finish and is marked: MIMI 3 along with Mark Type 21 ($340, £185).

39

George Wade & Son Ltd. Wade Figures advertisement *circa late 1930s*

George Wade & Son Ltd. Wade Figures advertisement *circa late 1930s*

SNOW WHITE AND THE SEVEN DWARFS, *1938*

The Snow White and the Seven Dwarfs set was issued in 1938, to coincide with the release of the animated movie produced by Walt Disney. These figurines were designed by Jessica Van Hallen. Each figurine has a cellulose finish with Mark Type 21 (without the word figure) on the base along with the name of the character.

Left: 1. Snow White measures 6-3/8" high ($450, £300).
Top row: 2. Sleepy measures 4" high ($255, £170). **3. Sneezy** measures 3-3/4" high ($255, £170). **4. Bashful** measures 3-3/4" high ($255, £170). **5. Doc** measures 4" high ($255, £170).
Bottom row: 6. Dopey measures 3-3/4" high ($255, £170). **7. Happy** measures 4" high ($255, £170). **8. Grumpy** measures 3-1/2" high ($255, £170).

SNOW WHITE AND THE SEVEN DWARFS BROOCHES, *late 1930s*

These brooches have an unusual mold mark reading Wade Burslem England along with the name of the character. To date this is the first time that an item has surfaced with this mark. It is believed that the brooches were distributed in North America only.

Snow White Brooch is 1-3/8" high by 1-1/16" wide ($1000, £680).

Left: Sleepy Brooch is 1-1/2" high by 5/8" wide ($800, £550). **Center: Doc Brooch** is 1-3/8" high by 1-1/4" wide ($800, £550). **Right: Grumpy Brooch** is 1-1/2" high ($800, £550).

DWARF SALT AND PEPPER SHAKERS *1938* 2-1/2" high, have an underglaze finish and are unmarked. Originally the shakers were supplied with a matching tray and were part of the "Snow White and the Seven Dwarfs" tableware set ($680, £370 per set).

Left:
DONALD DUCK *1937* 5" high and has a cellulose finish with Mark Type 2 ($1500, £1000).

Right:
MICKEY MOUSE *1934* 3-3/4" high with a cellulose finish and is found either unmarked or with Mark Type 2D on the base ($2250, £1500).

CHAPTER 2
DOG FIGURINES

by George Wade & Son Ltd.
circa 1927 – mid 1930s

From the late 1920s to the mid 1930s, George Wade & Son Ltd. supplemented their production of the cellulose-finished lady figurines with a line of cellulose-finished dogs. As with the lady figurines, the cellulose finish on the dogs was not a success.

In the late 1930s, a number of the dog figurines were produced with an underglaze finish and have become highly sought after by today's collectors. With the outbreak of the Second World War the underglazed large dog figurines were discontinued. Many of these early animal figurines were marked by hand-written ink marks similar to Mark Type 22.

FIG.1. Animal figurines *circa 1935 - 1940 (Cellulose Finish)*.
Top row (l-r): **1. Min. Alsatian** 4-3/4" high by 8-3/4" long, **2. Setter** 6" high by 9-3/4" long, **3. Airedale** 7" high by 8" long, **4. Spaniel** 5-1/2" high by 5" long, **5. Scottie** 4-3/4" high by 6-1/4" long, **6. Spaniel** (Playful Puppy) 2-1/2" high by 5-1/2" long.
Bottom row (l-r): **7. Borzoi** 12" high by 12-1/2" long, **8. Alsatian** 10-1/4" high by 18" long, **9. Dalmation** 8-3/4" high by 11-1/2" long, **10. Terrier** 7" high by 8" long.

ALSATIAN
4-7/8" high by 8-1/2" overall, has an underglaze finish and is marked: ALSATIAN along with Mark Type 21A ($450, £250).

SPANIEL
5-1/2" high, has an underglaze finish and is marked: SPANIEL along with Mark Type 21A ($550, £300).

AIREDALE
7-1/4" high by 8-1/4" overall, has an underglaze finish and is marked: WADE ($585, £325).

TERRIER
3-7/8" high by 4-1/2" overall, has an underglaze finish and has Mark Type 22 ($585, £325).

BULLDOG
3-3/4" high by 4-1/2" overall, has an underglaze finish and is marked: BULLDOG Wade England ($550, £300).

Chapter 3
ANIMAL AND BIRD FIGURINES

by George Wade & Son Ltd.
circa 1935 - mid 1950s

Between the mid 1930s and the start of the Second World War, a number of large bird and animal figurines were modeled for George Wade & Son Ltd. by a number of modelers including Jessica Van Hallen and Faust Lang. After the war, from the late 1940s through the mid 1950s, a number of the figurines were once again produced, mainly for export. The later figurines, using the original George Wade molds, were produced by Wade Heath & Co. Ltd. at The Royal Victoria Pottery.

FIG.1. Animal figurines *circa 1935 - 1940 (underglaze finish)*.
Top row (l-r): 1. Chamois Kid 5-1/4" high by 3-1/4" long, **2. Camel** 7-3/4" high by 6-3/4" long, **3. Ermine** 9-1/2" high by 3" long, **4. Panther** 8" high by 5" long, **5. Horse** 7-3/4" high by 6-3/4" long, **6. Large Dartmoor Pony** 4-7/8" high by 4-1/4" long.
Bottom row (l-r): 7. Giraffe 3" high by 4" long, **8. Medium Dartmoor Pony** 4" high by 4" long, **9. Lion Cub Paw up** 5-1/4" high by 7-1/4" long, **10. Lion Cub Paw down** 5-1/4" high by 7-1/4" long, **11. Otter** 4" high by 10-3/4" long.

Left: Panther measures 8" high, has an underglaze finish and is marked: PANTHER 1939 along with Mark Type 21A ($1050, £600). **Right: Brown Bear** measures 9-1/2" high and has an underglaze finish with Mark Type 21A along with the date 1939 ($1800, £1000).

POLAR BEAR
7-1/2" high, has an underglaze finish and is marked: POLAR BEAR 1939 along with Mark Type 21 ($1600, £900).

PANTHER
Color Variation ($1050, £600).

LARGE DARTMOOR PONY
4-7/8" high, has an underglaze finish and has a handwritten Mark Type 22 on the base ($360, £200).

Left: Ermine measures 9-1/4" high and has an underglaze finish with Mark Type 21A ($1050, £600). **Right: Chamois Kid** measures 5-1/4" high and has an underglaze finish with Mark Type 21A ($1050, £600).

CAPUCHIN
10" high, has an underglaze finish and is marked: CAPUCHIN 1939 along with Mark Type 21A ($900, £500).

GIRAFFE
3" high by 4" long, has an underglaze finish and has a hand written mark Wade on one front foot and England on one of the back feet ($1050, £600).

Giraffe illustrating the mark type on the feet of the figurine.

46

HORSE
8" high, has an underglaze finish and is marked: Wade England 1939 ($900, £500).

BLUEBIRDS
The small bird measures 2-1/2" high on a 2" dia. base and has a handwritten mark: Wade England No.123. The large bird measures 3-3/4" high on a 2-1/2" dia. base and has a handwritten mark: Wade England No.124 ($450 each, £250 each).

CAMEL
7-5/8" high, has an underglaze finish and is marked: Wade on the back right foot and Made in England on the back left foot ($1000, £550)

HERON
7-1/2" high, has an underglaze finish with Mark Type 10 Made in England. This figurine was in production up until the mid 1950s ($620, £350).

WOODPECKER
7" high, has an underglaze finish and is marked: WOODPECKER along with Mark Type 10 ($620, £350).

47

BUDGERIGAR with FLOWERS
7-3/4" high and has an underglaze finish with Mark Type 21A. The flower decoration was omitted from the post-war models ($620, £350).

DOUBLE BUDGERIGAR
7-3/4" high, has an underglaze finish and is marked: BUDGERIGAR 1940 along with Mark Type 21A ($825, £450).

GOLDFINCHES
Each figurine measures 4" high and has an underglaze finish with Mark Type 10 ($620 each, £350 each).

BUDGERIGAR
7-3/4" high and has an underglaze finish with Mark Type 10. This figurine was in production up until the mid 1950s ($375, £200).

COCKATOOS
Each figurine measures 6" high, has an underglaze finish and is marked: COCKATOO along with Mark Type 21A. The white bird is also marked:1940 ($900 each, £500 each).

FLICKA
4-1/2" high and has an underglaze finish with Mark Type 21A ($300, £175).

PELICAN
6-1/4" high by 7-1/4" overall and has an underglaze finish with Mark Type 10. This figurine was advertised in trade literature as a "nut dish or ashtray" and was in production up until the mid 1950s ($620, £350).

TOUCAN
6-3/4" high and has Mark Type 21 on the base ($450, £250).

Right:
GREBE
9-1/4" high and has Mark Type 21A on the base along with the wording: Wade England 1939 GREBE ($950, £500).

PARROT
10-1/2" high, has an underglaze finish and is marked: PARROT 1939 along with Mark Type 21A ($1000, £550).

OWL
5-1/2" high and is marked Wade Made in England 1941 OWL ($850, £450).

49

Chapter 4
WADEHEATH WARE

circa 1927 - 1939

During the late 1930s, Wade Heath & Co. Ltd. began the production of a range of slip cast, realistic and comic animal figurines. Many of these figurines had a single color underglaze finish and were usually back-stamped with either Mark Type 4, 5, 6 or 7. Production of these animal figurines ceased in 1939. Records indicate that the molds for these figurines were not re-used after the Second World War.

FIG.1. Wadeheath Ware Animal figurines *circa 1937-1939 (underglaze finish)*.

SITTING PUP
4" high and has Mark Type 6 on the base ($145, £80).

GIANT PANDA
6-3/4" high, has an underglaze finish with Mark Type 7. This figurine was used to promote the Wadeheath line of "Giant Panda" Nursery Ware issued to celebrate the arrival of Ming, the baby giant panda at the London Zoo in 1939 ($550, £300).

ALSATIAN
5-1/4" high by 7-1/2" long and has Mark Type 4 on the base. Note the glass eyes, an unusual feature for a Wade figurine ($225, £125).

Top: Pluto measures 4-1/2" high and has Mark Type 4 on the base ($440, £250).
Left: Pluto's Pup No.1 measures 2-1/2" high and has Mark Type 6 on the base ($440, £250).
Right: Pluto's Pup No.2 measures 4" high and is marked, on the base: Wadeheath by Permission Walt Disney England ($440, £250).

TERRIER PUP
6-3/8" high and has Mark Type 4 on the base. Note the glass eyes, an unusual feature for a Wade figurine ($225, £125).

PLUTO'S PUP NO. 3
3-7/8" high and is marked: Wadeheath by Permission Walt Disney England ($440, £250).

WADEHEATH RABBITS
The small rabbit measures 4-3/4" high and is ink stamped: Made in England ($105, £55). The medium size rabbit measures 5-5/8" high and has Mark Type 6 on the base ($130, £70). The large rabbit measures 6" high and has Mark Type 6 on the base ($160, £85).

PONGO
Color variation.

PONGO
5-1/2" high and has Mark Type 4 on the base. A number of color variations exist (Large $145, £80; Medium $145, £80; Small $90, £50).

PONGO
Color variation.

1

Top center: 1. Pup in Basket measures 6" high and has Mark Type 6 on the base ($350, £200).
Below (l-r): 2. Cheeky Duckling measures 7" high and has Mark Type 4 on the base ($350, £200). **3. Dachshund** measures 6-1/2" long by 3-1/2" high and has Mark Type 5 on the base ($350, £200). **4. "Sammy" the Seal** measures 6-1/4" long by 6-1/2" high by 6" wide and is marked on the base: Wadeheath England by Permission Walt Disney ($450, £250).

2 3 4

SCOTTIE DOG
5-1/4" high and is marked: Wadeheath Ware England ($145, £80).

OPEN MOUTHED DUCKLING
3-3/4" high and has Mark Type 6 on the base along with an impressed mold mark No.334 ($145, £90).

CROUCHING RABBIT
4-1/4" high by 5-1/2" long with Mark Type 7 on the base. This figurine is to be found in a variety of glazes ($160, £85).

BIRD VASES
Left: Small Bird Vase measures 3-1/2" high and has Mark Type 5 on the base ($65, £35). **Right: Large Bird Vase** measures 6-3/4" high and has Mark Type 4 on the base ($175, £95).

Left:
LAUGHING RABBIT
6" high and has Mark Type 6 on the base. This figurine is to be found in a variety of sizes and glazes (Small $135, £70; Medium $145, £75; Large $160, £85).

Right:
LAUGHING RABBIT
Color variations. **Left: Blue Laughing Rabbit** measures 6" high and has Mark Type 6 on the base. **Right: Brown Laughing Rabbit** measures 8" high and has Mark Type 4 on the base.

Chapter 5
ANIMAL FIGURINES

by George Wade & Son Ltd. and Wade Heath & Company Limited circa mid 1930s - late 1950s

These figurines were originally designed and modeled for the George Wade & Son Ltd. pottery prior to the Second World War. A number of these prewar molds were taken over by the Wade Heath pottery after the war and reused during the 1940s and 1950s. The majority of the Wade Heath figurines were made for export only.

THE PENGUIN FAMILY *late 1940s - mid 1950s*
These figurines are to be found in a variety of decorations with or without back stamps. Those with back stamps are marked either Made in England or have Mark Type 15 on the underside of the base. **1. Mrs. Penguin** measures 3" high and has Mark Type 15 ($220, £125). **2. Benny** measures 2-1/8" high and has Mark Type 15 ($230, £130). **3. Penny** measures 2" high and is unmarked ($230, £130). **4. Mr. Penguin** measures 3-1/2" high and has Mark Type 15 ($220, £125).

THE PENGUIN FAMILY CRUET SET
Mrs. Penguin (salt) measures 3" high and has Mark Type 15 ($135, £75). **Mr. Penguin** (pepper) measures 3-1/2" high and has Mark Type 15 ($135, £75).

THE RABBIT FAMILY *late 1940s - mid 1950s*
These figurines are to be found with or without back stamps. Those with back stamps are marked either Made in England or have Mark Type 15. **1. Fluff** measures 2" high and is unmarked ($215, £120). **2. Puff** measures 2-1/8" high and is unmarked ($215, £120). **3. Mrs. Rabbit** measures 3-5/8" high and has Mark Type 15 on the base ($220, £125). **4. Mr. Rabbit** measures 3-1/2" high and is unmarked ($220, £125).

THE PIG FAMILY CRUET SET
Mr. Pig (salt) measures 3-3/4" high and is ink stamped: Wade England ($135, £75). **Mrs. Pig** (pepper) measures 3-1/8" high and is ink stamped: Wade England ($135, £75). The tray measures 5-1/4" long by 3-1/2" wide and is unmarked ($20, £12).

THE QUACK QUACK FAMILY *circa 1952 - late 1950s*
This set of duck figurines was designed by Robert Barlow to complement the Quack Quack line of nursery ware. Records show the duck family was still in production in 1956. Each figurine is ink stamped: England. **1. Mrs. Duck** measures 2-1/2" high ($210, £120). **2. Mr. Duck** measures 2-1/2" high ($210, £120). **3. Dack** measures 1-1/2" high ($210, £120). **4. Dilly** measures 1-1/2" high ($210, £120).

THE DUCK FAMILY *late 1930s - 1950s*
1. Duck measures 3" high by 2-1/8" long and is ink marked: Wade England ($225, £125). **2. Drake** measures 3" high by 3" across and has Mark Type 22 on the base ($225, £125). **3. Drake** measures 3" high by 3" long and has Mark Type 22 on the base ($225, £125).

4. Drake and Daddy measures 3" high and is unmarked ($270, £155). **5. Drake** measures 3" high by 3" across and is ink marked: Wade England ($225, £125). **6. Drake** measures 1-3/4" high by 1-7/8" long and has Mark Type 19 on the base. This slip-cast figurine was made from George Wade molds in the mid- to late 1930s and by Wade Heath from the late 1940s to circa late 1950s ($200, £115). **7. Duck** measures 2-3/4" high by 2" across and is ink marked: Wade England ($225, £125).

CHICKS
These figurines measure 1-3/4" high by 2-1/4" long. The figurines are unmarked but date from early to late 1930s. The chicks were produced by George Wade and Son Ltd. and were not reproduced after the war ($200 each, £120 each).

ELEPHANT with TRUNK UP
2" high by 2-1/2" long. This slip cast figurine was made by George Wade and Son Ltd. in the late 1930s and was reissued by Wade Heath in the 1950s. The figurine is ink marked Wade on one front foot and England on the other front foot ($260, £150).

ELEPHANT with TRUNK DOWN
2" high by 2-1/2" long. This figurine is unmarked but can be found ink marked Wade on one front foot and England on the other front foot ($260, £150).

BABY PANDA
1-5/8" high and is unmarked. The figurine was produced by George Wade & Son Ltd. in the 1930s and is not known to have been reproduced after WWII ($220, £125).

BUNNIES
Small Double Bunnies measure 3/4" high by 1-1/4" long and are unmarked ($100, £60). **Miniature Bunny** is 7/8" high by 1-1/8" long and has Mark Type 22 ($60, £35). **Kissing Rabbits** measure 2-1/2" high and have Mark Type 15 and Mark Type 19 on the base ($110, £65).

SQUIRRELS
All figurines measure 1-5/8" high. These figurines were made from George Wade molds in the mid- to late 1930s and by Wade Heath from the late 1940s to circa 1960. They were made in a number of color glazes with the gray glaze being the most frequently found. **1. Squirrel** has Mark Type 22. **2. Squirrel** has Mark Type 10. **3. Squirrel** is unmarked. **4. Squirrel** has Mark Type 15 ($100 each, £65 each).

CHEERFUL CHARLIE & DOLEFUL DAN
circa 1947 - 1953
Both figurines measure 4" high and can be found either unmarked or with Mark Type 15. These figurines were also produced as salt and pepper shakers ($300 each, £180 each).

BEGGING DOGS
The terriers measure 3-1/8" high with Mark Type 15 on the base. The figurines were made from George Wade molds in the late 1930s and by Wade Heath in the late 1940s and early 1950s ($175, £115). The dachshund measures 3-1/8" high and has Mark Type 22 on the base ($150, £100). This figurine is not known to have been reproduced after WWII but the remaining unsold figurines were used as posy bowl composites by Wade Heath in the late 1940s.

ENGLISH SETTER
2-5/8" high by 3-3/8" overall and has Mark Type 15. This figurine was also issued by Wade Heath between the late 1940s and the mid 1950s ($260, £150).

BABY BEAR
Both figurines measure 1-5/8" high by 2-1/2" long and are unmarked. These figurines were made circa late 1930s ($175, £115).

BABY BEAR
Color Variation ($175, £115).

PLAYFUL KITTENS
These figurines were made from George Wade molds in the mid to late 1930s and by Wade Heath from the late 1940s to mid 1950s. **Top** (l-r): **1. Kitten with Ball** measures 1-1/4" high by 2" long and has Mark Type 15 ($95, £60). **2. Kitten on Back** measures 1" high by 2-7/8" long and has Mark Type15 along with the letter "B" on the base ($95, £60). **3. Kitten with Ball** measures 1-1/4" high by 2" long and has Mark Type 22 ($95, £60).
Bottom (l-r): **4. Kitten with Ball and Bow** measures 1-5/8" high by 2-1/4" long and has Mark Type 22 ($95, £60). **5. Kitten with Bowl** measures 1" high by 2-3/4" long and has Mark Type 19 ($95, £60).

PLAYFUL LAMBS & DEER
Left: Playful Lamb measures 2" high by 2-3/8" long and is stamped with Mark Type 15 ($155, £105). **Center: Miniature Deer** measures 1-1/8" high by 1-1/4" long and is unmarked ($150, £100). **Right: Playful Lamb** measures 2" high by 2-3/8" long and is stamped with Mark Type 15 ($155, £105).

LAUGHING RABBITS
Left: Laughing Rabbit measures 2-3/8" high. This figurine is unmarked but can be found with Mark Type 15 or ink-stamped Made in England. The figurine was originally produced in the mid 1930s by George Wade & Son Ltd. A number of molds were made thus variations in size exist ($70, £45). **Right: Laughing Rabbit** measures 2-3/4" high. This figurine was made by Wade Heath from a prewar George Wade mold and is back stamped Made in England ($70, £45).

MISCELLANEOUS MINIATURE ANIMALS
1. Calf measures 1-3/4" high by 1-1/4" long and is marked Made in England. This was a George Wade mold and the figurine was produced circa late 1930s. After WW II, the mold was used by Wade Heath who reissued the figure between the late 1940s and the mid 1950s ($170, £115). **2. Miniature Lamb** measures 1-1/2" high by 1-1/4" long. This is a George Wade mold ($150, £100). **3. Large Lamb** measures 2-1/4" high and is unmarked. This is a George Wade mold ($155, £105). **4. Miniature Foal** measures 1-1/2" high by 1-1/4" long and is unmarked. This is a George Wade mold ($150, £100). **5. Mountain Goat** measures 2-7/8" high by 3" long. This figurine was made by George Wade in the late 1930s and has Mark Type 22 on the base ($300, £175).

HIPPOPOTAMUS and TORTOISE *mid 1930s*
Left: Hippopotamus measures 1-3/8" high by 4-1/2" long and has Mark Type 22 on the base. This George Wade mold was not reused by Wade Heath after the war ($485, £310). **Right: Tortoise** measures 1-1/4" high by 3" long and has Mark Type 22 on the base. This George Wade mold was not reused by Wade Heath after the war ($485, £310).

CROUCHING MONKEY *circa late 1930s*
The figurines measure 2-1/2" high by 2" long and are ink stamped: Wade Made in England ($175, £115).

CROUCHING MONKEY
Color Variation ($175, £115).

CAT (standing)
1-3/4" high by 2-1/2" long and has Mark Type 19 ($250, £130).

CAT (on its side)
1-3/8" high by 2-3/4" long and has Mark Type 19 ($250, £130).

WILLIAM HARPER PROTOTYPES *mid 1950s*
Top row (l-r): **1. Pair of Cockatoos** measure 2-7/8" high by 2-3/4" across ($420, £280). **2. Owls.** The pair on the left is 2-3/8" high ($360, £240) and the single owl on the right is 2" high ($180, £120). **3. Monkey and Baby** measures 3-1/2" high ($960, £550). **4. Monkey and Baby.** This is the early Whimsie production model shown for size comparison.
Bottom row (l-r): **5. Doleful Lion** measures 2" high ($100, £60). **6. The Butlin Beaver** measures 2-1/2" high ($630, £420). **7. Long Tailed Door Mouse** measures 4-1/4" high. This model was intended to be used as a spirit container ($700, £400). **8. Cat** measures 2" high ($100, £60). **9. Babycham** measures 2-7/8" high. This figurine was based on the well-known Babycham beverage advertising character ($260, £150). For further William Harper prototypes see Miniature Figurines and figurines by George Wade & Son Ltd. circa 1948 - late 1970s.

58

Chapter 6
NURSERY RHYME FIGURINES

by George Wade & Son Ltd. and Wade Heath & Company Limited
circa 1949 - 1991

WYNKEN, BLYNKEN AND NOD, *1948 - 1958*

These figurines were based on characters from a popular children's poem. However a fourth figurine, "I've a Bear Behind," not in the poem, was added to the set. These four figurines were produced at Wade Heath & Co. Ltd. over a number of years. In the early years they were produced for export only (1948 - 1952) and later for both the export and home markets. The figurines made for export were decorated with hand-made flowers around the base and had Mark Type 10 on the base along with the name of the figurine. After 1952, the figurines were made without flowers around the base. The later versions had Mark Type 19 on the base along with the name of the figurine.

1. Wynken with Flowers measures 2-3/4" high with Mark Type 10 ($215, £145). **2. Blynken with Flowers** measures 2" high with Mark Type 10 ($215, £145). **3. Nod with Flowers** measures 2-1/2" high with Mark Type 10 ($215, £145). **4. I've a Bear Behind with flowers** measures 2-1/2" high with Mark Type 10 ($215, £145).

1 & 2. Wynken without Flowers measures 2-3/4" high with Mark Type 19. Note the two color variations ($210, £140). **3. Blynken without Flowers** measures 2" high with Mark Type 19 ($210, £140). **4. Nod without Flowers** measures 2-1/2" high with Mark Type 19 ($210, £140).

GOLDILOCKS AND THE THREE BEARS, *early 1950s - late 1950s*

Each figurine in this set has Mark Type 19 on the base along with the name of the character. These figurines were produced by Wade Heath & Co. Ltd. and advertised in the January 1953 edition of the *Pottery Gazette and Glass Trade Review*.

1. Poppa Bear measures 3-3/8" high ($375, £250). **2. Baby Bear** measures 1-3/4" high ($375, £250). **3. Mama Bear** measures 3-3/8" high ($375, £250). **4. Goldilocks** measures 3-5/8" high ($375, £250).

LITTLE JACK HORNER AND LITTLE MISS MUFFET,
early 1950s - late 1950s

Each figurine in this set has Mark Type 19 on the base along with the name of the character. These figurines were produced by Wade Heath & Co. Ltd.

Left: Little Jack Horner measures 2-1/2" high ($480, £300). **Right: Little Miss Muffet** measures 2-3/4" high ($480, £300).

TINKER, TAILOR, SOLDIER, SAILOR,
early 1950s - late 1950s

This set of eight figurines was designed by Robert Barlow. The early figurines had Mark Type 15 on the base along with the name of the character. Figurines in this set made after 1955, were back stamped with Mark Type 19 along with the name of the character.

Left:
Top: 1. Tinker measures 2-1/2" high ($265, £165). **2. Tailor** measures 2-1/2" high ($265, £165). **Bottom: 3. Soldier** measures 3" high ($265, £165). **4. Sailor** measures 3" high ($280, £175).

Right:
Top: 5. Rich Man measures 3" high ($280, £175). **6. Poor Man** measures 3" high ($265, £165). **Bottom: 7. Beggar Man** measures 2-1/2" high ($265, £165). **8. Thief** measures 3" high ($265, £165).

BUTCHER, BAKER AND CANDLESTICK MAKER,
early 1950s - mid 1950s

This set of three figurines was designed by Nancy Greatrex and produced between the early and mid 1950s. Of the three figurines, the Candlestick Maker is the most difficult to find, with the Butcher turning up more frequently. These figurines have been found with both Mark Types 15 and 19.

Left: Butcher measures 3-1/4" high ($360, £225). **Center: Baker** measures 3-7/8" high ($350, £215). **Right: Candlestick Maker** measures 4" high ($425, £260).

WEE WILLIE WINKIE WALL PLAQUES,
late 1950s - early 1960s

A set of four wall plaques produced by George Wade & Son Ltd. as decorations for children's bedrooms. Each plaque features scenes based on the Wee Willie Winkie nursery rhyme and is mold marked Made in England on the back of the plaque.

The plaque not illustrated is "Are the children in their beds, it's past 8 o'clock."

"Tapping at the windows, peeping through the locks" wall plaque measures 4-1/4" high by 5-3/8" across ($425, £250).

"**Runs through the town**" wall plaque measures 4-1/4" high by 5-3/8" across ($425, £250).

"**Upstairs and downstairs in his nightgown**" wall plaque measures 4-1/4" high by 5-3/8" across ($425, £250).

NURSERIES, *1979*

A short-lived line of five figurines was offered as a retail line in a boxed set under the name of "Nurseries." The molds for these figurines had previously been used in a Canadian Red Rose Tea promotion.

The figurines used for this retail line were Little Jack Horner, Woman in the Shoe, Old King Cole, Little Bo Peep, and Cat and the Fiddle. These figurines did not prove popular with the public and were soon withdrawn from the market. For designs and measurements, see the 1971 - 1979 Canadian Red Rose Tea promotion.

Boxed set of five Nurseries issued in 1979-1980 ($75, £40)

NURSERY FAVOURITES, *1972 - 1981*

This retail gift ware line of nursery rhyme figurines was marketed at approximately the same time period as the miniature nursery figurines used for the Red Rose Tea promotion. A number of the Nursery Favourites were similar in design to their smaller, premium counterparts, and others, although similar in characters, were of a different design.

Three of the twenty characters (Mary Lamb, Polly Kettle, and Tommy Tucker) did not appear in the premium nursery series. The Nursery Favourites were issued in four sets of five over a period of nine years, each set having a distinctive colored box containing the figurine. All figurines are mold marked "Wade England" at the back of the base.

Set 1, *1972 (green box)*
Top: **1. Jack** measures 2-7/8" high ($55, £20).
2. Jill measures 2-7/8" high ($55, £20). **3. Miss Muffet** measures 2-5/8" high ($55, £20).
Bottom: **4. Jack Horner** measures 1-7/8" high ($50, £20). **5. Humpty Dumpty** measures 1-3/8" high ($30, £20).

61

Set 2, *1973 (blue box)*
Top: **6. Willie Winkie** measures 1-3/4" high ($26, £18). **7. Mary Lamb** measures 2-7/8" high ($55, £25). **8. Polly Kettle** measures 2-7/8" high ($55, £30).
Bottom: **9. King Cole** measures 2-1/2" high ($55, £25). **10. Tom Piper** measures 2-3/4" high ($52, £25).

Set 3, *1974 (yellow box)*
Top: **11. Little Boy Blue** measures 2-7/8" high ($50, £30). **12. Mary Mary** measures 2-7/8" high ($65, £30). **13. Cat & Fiddle** measures 2-7/8" high ($55, £30).
Bottom: **14. Queen of Hearts** measures 2-7/8" high ($65, £30). **15. Tommy Tucker** measures 3" high ($55, £30).

Set 4, *1976 (purple box)*
Top: **16. Puss-in-Boots** measures 2-7/8" high ($55, £40). **17. Three Bears** measures 2-7/8" high ($65, £45). **18. Goosey Gander** measures 2-5/8" high ($160, £85).
Bottom: **19. Bo-Peep** measures 2-7/8" high ($120, £80). **20. Old Woman in the Shoe** measures 2-1/2" high ($150, £80).

NURSERY FAVOURITES, *1990 - 1991*

A limited reissue of five of the Nursery Favourite figurines was made by Wade for the U.S.-based Gold Star Gifthouse. These figurines, although from the same molds as the original issue, are all marked with the year of manufacture, thus enabling collectors to differentiate between the originals and the reissues. The figurines issued in 1991 may also be found with a diamond shaped ink stamp on the underside of the base enclosing the letters GSG.

Top: **1. Polly Kettle** measures 2-7/8" high and is mold marked: Wade England 90 ($35, £22). **2. Tom Piper** measures 2-3/4" high and is mold marked: Wade England 90 ($40, £22). **3. Mary Mary** measures 2-7/8" high and is mold marked: Wade England 90 ($40, £25).
Bottom: **4. Old Woman in the Shoe** measures 2-1/2" high and is mold marked :Wade England 91. Note that the little dog is not colored as is the dog in the original 1976 issue ($85, £55). **5. Goosey Gander** measures 2-5/8" high and is mold marked: Wade England 91 ($85, £55).

THREE BEARS
Brown color variation from the Nursery Favorites Set 4.

Chapter 7
MINIATURE FIGURINES

by George Wade & Son Ltd.
circa 1948 - late 1970s

NOVELTY ANIMAL FIGURINES, 1955 - 1960

A set of five die-pressed, comic animal figurines produced by George Wade & Son Ltd. When originally issued these figurines had circular black/gold labels marked "Genuine Wade Porcelain MADE IN ENGLAND."

Top: 1. **Dustbin Cat** measures 1-3/4" high ($160, £95).
2. **Jonah and the Whale** measures 1-1/2" high by 2" long. This figurine is the most difficult to find in the set ($1450, £850). 3. **Jumbo Jim** measures 1-3/4" high ($190, £110).
Bottom: 4. **Kitten on the Keys** measures 1-3/4" high ($225, £130). 5. **Bernie and Poo** measures 2" high by 3" long ($150, £85).

"TREASURES" THE ELEPHANT TRAIN, 1956

The first in a proposed series which was to be developed over a number of years but never materialized. The set comprises five elephants graduated in size ranging from 2" high by 2-3/8" long to 3/4" high by 1-1/2" long. All figurines are marked with a blue WADE ENGLAND transfer type mark.

THE ELEPHANT TRAIN
The production set ($900, £450).

THE ELEPHANT TRAIN
Prototypes.

BERNIE AND POO
Mold variation. This figurine measures 2-1/8" high by 3" overall and is transfer marked: Wade Made in England. This figurine with the upright tail is very rare ($750, £500).

MINIKINS, 1956 - 1959

These miniature animal figurines, designed by William Harper, were issued in three series over a three year period. A number of the figurines were made in both a white and beige finish. The tiny figurines have smooth bases and are not marked. The figurines range between approx. 7/8" high to 1-1/4" high.

63

SERIES "A" 1956
The series consisted of four shapes of cats and rabbits and for each of these shapes there were two different pairs of eyes and expressions, and two different styles of decoration ($30 each, £16 each).

SERIES "B" 1957
The second series consisted of a cat, rabbit, bull and a cow. They were decorated with either areas of shading applied to the beige body or with flowers, hearts and arrows or musical notes ($30 each, £16 each).

SERIES "C" 1958
The third series comprised a pelican, dog, donkey and a fawn. The figurines were decorated with bright colors and motifs such as anchors and flowers ($30 each, £16 each).

MINIKINS
Prototype from set "B." The production model is on the right.

SNIPPETS. 1956-1958

A series of porcelain ships and figurines made by George Wade & Son Ltd. modeled in the form of paper "cut-out" type figurines. The designs for the first set in the series were based on famous sailing ships. The designs in the second set were based on the fairy tale, Hansel and Gretel.

SET 1, 1956
Left: Mayflower measures 2-3/8" high by 2-1/2" wide and has a transfer mark: Wade "Snippet" No.1 "Mayflower" Real Porcelain Made in England ($85, £50). **Center: Santa Maria** measures 1-3/4" high by 2" wide and has a transfer mark: Wade "Snippet" No.2 "Santa Maria" Real Porcelain Made in England ($75, £45). **Right: Revenge** measures 1-1/2" high by 1-3/4" wide and has a transfer mark: Wade "Snippet" No.3 "Revenge'" Real Porcelain Made in England ($70, £40).

SET 2, 1957
Left: Gingy measures 1-3/8" high and has a transfer mark: Wade "Snippet" No.6 "Gingy" Real Porcelain Made in England ($250, £135). **Center: Gretel** measures 2-1/4" high and has a transfer mark: Wade "Snippet" No.5 "Gretel" Real Porcelain Made in England ($160, £95). **Right: Hansel** measures 2-1/2" high and has a transfer mark: Wade "Snippet" No.4 "Hansel" Real Porcelain Made in England ($160, £95).

DRUM BOX SERIES, *1956 - 1959*

A set of five animal figurines designed by William Harper and produced by George Wade & Son. Ltd. None of the figurines is mold marked, but they originally had the "Genuine Wade Porcelain" label. Each figurine was marketed in a round, decorative box in the form of a drum.

Top: 1. Jem measures 2" high ($100, £55). **2. Dora** measures 2-1/4" high. This figurine is the most difficult to find in the series ($140, £80). **3. Clara** measures 2" high ($100, £55).
Bottom: 4. Harpy measures 2" high ($100, £55). **5. Trunky** measures 2-1/8" high ($100, £55).

ALPHABET TRAIN, *1958 - 1959*

This educational and ornamental children's set was produced by George Wade & Son Ltd. The engine and cars are decorated with letters of the alphabet on the sides and either letters or numbers on the roofs of the cars. Sets were also made with illustrations of famous London scenes on the sides of the cars.

The engine is approx. 1" high by 2" long and the cars, 3/4" high by 1" long ($850, £475).

ALPHABET TRAIN ENGINE AND CAR
Single glaze, undecorated versions.

NODDY SET, *1958- 1960*

A series of four figurines based on characters from Enid Blyton's series of children's books. This set was produced by George Wade & Son Ltd. The figurines in this set are unmarked but may originally have had paper labels.

1. Big Ears measures 2-7/8" high ($220, £135). **2. Mr. Plod** measures 2-1/2" high ($150, £80). **3. Miss Fluffy Cat** measures 2-5/8" high ($95, £50. **4. Noddy** measures 2-7/8" high ($395, £225).

NODDY PROTOTYPES
The following prototypes were modeled for Wade by William Harper in the 1950s. All figurines are slip cast and unmarked.
1. Miss Fluffy Cat measures approx. 2-1/2" high ($475, £270).
2. Noddy measures approx. 2-1/2" high ($615, £350). **3. Noddy** measures approx. 2-1/2" high ($615, £350). **4. Mr. Plod** measures 2-3/8" high ($475, £270). **5. Big Ears** measures 2-3/4" high ($475, £270).

MABEL LUCIE ATTWELL CHARACTERS, *1959*

A set of two porcelain figurines produced by George Wade & Son Ltd. based on Mabel Lucie Attwell illustrations. These two figurines were designed by Paul Zalman and are mold marked "Wade Porcelain - Mabel Lucie Attwell © Made in England."

Sarah measures 3" high by 4" long ($270, £155). **Sam** measures 3-1/8" high by 3" long ($270, £155).

BIG EARS AND NODDY MONEY BANK
Prototype money bank measures 4-3/4" high by 4-1/2" long. This was modeled by William Harper (N.P.A.).

THE BRITISH CHARACTER SET, *circa 1959*

A set of four figurines based on typical characters, merchants, and professionals found in the city and east end of London. The figurines have applied circular black/gold labels marked "Genuine Wade Porcelain MADE IN ENGLAND." Over the years, many of the labels have been removed, however this does not reflect on the value of the figurine.

1 2 3 4

1. **Lawyer** measures 2-7/8" high ($235, £135). 2. **Pearly King** measures 2-3/4" high ($190, £110). 3. **Pearly Queen** measures 2-7/8" high ($190, £110). 4. **Fish Porter** measures 3-1/8" high ($225, £125).

BIG EARS MONEY BANK
This underglazed finish money bank was based on the Big Ears and Noddy money bank. It is not known to have been in full production ($435, £250).

PEARLY QUEEN AND FISH PORTER
Color variations.

WILLIAM HARPER PROTOTYPES, *mid 1950s*

William Harper was one of the most prolific of all modelers and designers at the George Wade & Son Ltd. pottery during the 1950s. Bill joined Wade in 1954 and during his tenure produced designs for some of the most popular Wade gift ware items. Probably the best selling items included many of the early Whimsies, the Tortoise Family, and the Disney "Blow Up" figurines. In the late 1990s, many of Bills prototypes were sold at auction. It is useful to see illustrations of some of his work to authenticate items sold on the secondary market.

1. Girl on Motor Scooter measures 3" high by 2-3/4" long and is unmarked ($665, £380). **2. "I'm Hep"** measures 1-1/2" high and is slip cast and unmarked ($310, £175). **3. Irish Leprechaun** measures 1-1/2" high by 1-5/8" long and is unmarked ($90, £50). **4. Big Ears and Noddy in a Motor Car** measures 3" high and is unmarked ($525, £300). **5. Air Line Pilot** measures 2-1/2" high and is slip cast and unmarked ($310, £175). **6. Pogo** measures 2-3/4" high and is slip cast and unmarked ($310, £175).

CANTERBURY TALES
All the figurines in this series are slip cast and unmarked. **1. "The Reeve"** measures 3-1/2" high ($550, £315). **2. "The Squire"** measures 3-1/2" high ($550, £315). **3. "The Nun's Priest"** measures 3-1/2" high ($550, £315). **4. "The Nun's Priest"** measures approx. 4-1/2" high ($625, £355). **5. "The Prioress"** measures 3-1/2" high ($550, £315).

CARTOON CHARACTERS
Cartoon Boy measures 2-3/4" high, is slip cast and unmarked ($420, £240). **Flook** measures 2" high, is slip cast and unmarked ($420, £240). These two figurines are from the same cartoon series.

ZOO LIGHTS, *1959*

These miniature candle holders measure 1-3/4" wide by 1-3/4" deep and are mold marked with Mark Type 25 in the recessed base. The Zoo Lights were produced with a variety of decorations but mainly to hold figurines from the discontinued line of early Whimsies. These mini candle holders were also used to hold other miniature figurines such as metal decorations. The metal figurines were not made by Wade but were applied to the candle holders by others. The mini candle holders are to be found in either pink, yellow, black, or blue.

Top: 1. Cockatoo from the 1958 Zoo Set (Set 8) of the Early Whimsies ($40, £20). **2. Camel** from the 1958 Zoo Set (Set 8) of the Early Whimsies ($40, £20). **3. Husky** from the 1956 Polar Set (Set 6) of the Early Whimsies ($40, £20).
Bottom: 4. West Highland Terrier from the 1957 Pedigree Dogs Set (Set 7) of the Early Whimsies ($40, £20). **5. Baby Polar Bear** from the 1956 Polar Set (Set 6) of the Early Whimsies ($40, £20). **6. Boxer** from the 1957 Pedigree Dogs Set (Set 7) of the Early Whimsies ($40, £20).

ZOO LIGHT WITH BABY
2" high with Mark Type 25 ($90, £50).

ZOO LIGHTS WITH METAL FIGURINES
1. Horse measures 2-3/4" high ($25, £15). **2. Pelican** measures 2-1/4" high ($25, £15). **3. Rooster** measures 2" high ($25, £15).

4. Cat measures 2-1/2" high ($25, £15).

EXOTIC FISH WALL PLAQUES *late 1950s*
A set of four wall plaques each measuring 3-3/4" long by 2-1/2" wide and mold marked: Wade porcelain Made in England ($325 each, £185 each). The actual decoration of these plaques may vary from one set to another.

T.T. TRAY *1959 - 1960*
This ashtray commemorates the Tourist Trophy motorcycle races held on the Isle of Man. The ashtray measures 2-3/4" high and is marked with Mark Type 19 on the underside of the base ($220, £125).

TV PET SERIES, *1959 - 1965*

A series of ten animal figurines made by George Wade & Son Ltd. based on the Adventures of TIM'S television characters of the 1950s and 1960s. Each figurine was packaged in a differently colored gift box decorated to resemble a television set.

The first set, issued in July/August 1959 comprised Fifi, Bengo, Pepi, and Simon. Mitzi and Chee-Chee were issued in November 1959, and Bruno Jnr. and Droopy Jnr. in 1961. Finally in 1965, Percy and Whisky completed the series.

None of the figurines is mold marked but all originally had paper labels.

Top: **1. Bengo** measures 2-3/8" high ($85, £35). **2. Simon** measures 2-3/8" high ($85, £30). **3. Pepi** measures 2-1/8" high ($95, £45). **4. Fifi** measures 2-5/8" high ($45, £25). **5. Mitzi** measures 2" high ($85, £42).
Bottom: **6. Chee-Chee** measures 2-1/4" high ($75, £30). **7. Bruno Jnr.** measures 2-1/4" high ($110, £55). **8. Droopy Jnr.** measures 2-1/4" high ($110, £55). **9. Percy** measures 1-1/2" high ($110, £55). **10. Whisky** measures 2-1/8" high ($215, £105).

ANGEL DISH, CANDLE HOLDERS & FIGURINES, *1959 - 1960s*

The Angel figurines set consisted of three miniature angels in various poses either standing, sitting, or kneeling. The figurines were sold either separately, applied to dishes similar to the Whimtrays or attached to miniature candle holders. The Angel figurines have been found with green, pink, yellow, and blue glazes. All figurines are unmarked.

Left: Kneeling Angel Figurine measures 1-3/8" high ($90, £40).
Center: Sitting Angel Figurine measures 1-3/8" high ($90, £40).
Right: Standing Angel Figurine measures 1-1/2" high ($90, £40).

ANGEL CANDLE HOLDER
approx. 2-1/4" high on a black, triangular base, 2" each side and is mold marked Wade on the underside ($100, £45).

ANGEL DISH
2" high and are mold marked "Angel Dish" Wade Porcelain Made in England ($100 each, £45 each).

A Wade advertisement as it appeared in the October 1960 issue of *Pottery Gazette and Glass Trade Review*. The range of Teenage Pottery is illustrated on the left hand side of the advertisement.

BEATLES PLAQUES, *circa early - mid 1960s*

These prototype plaques were sampled by George Wade & Son Ltd. but never went into production. All plaques are unmarked.

1 2 3 4

1. George Harrison Plaque measures 2-1/2" in dia. **2. John Lennon Plaque** measures 2-1/8" in dia. **3. Ringo Starr Plaque** measures 2-1/4" in dia. **4. Paul McCartney Plaque** measures 2-1/4" in dia.

TEENAGE POTTERY OF POP STARS, *early 1960s*

A 1961 Wade catalogue lists four different 1950s pop stars featured on guitar-shaped brooches and heart-shaped trinket boxes or caskets. The four stars were: Cliff Richards, Tommy Steele, Frankie Vaughan, and Marty Wilde. Two of these characters, Marty Wilde and Cliff Richards were also available as cameo plaques.

Top: Frankie Vaughan Heart Shaped Casket measures 1-5/8" high by 3-1/2" across and has Mark Type 25 on the underside of the base ($155, £90). **Bottom: Marty Wilde Heart Shaped Casket** measures 1-5/8" high by 3-1/2" across and has Mark Type 25 on the underside of the base ($155, £90).

TEENAGE POTTERY BROOCHES 1960
This set of four Teenage Pottery Pins represents **Tommy Steele**, **Frankie Vaughn**, **Marty Wilde** and **Cliff Richards**. The brooches measure 2-5/8" long and are marked with a transfer mark similar to Mark Type 25 ($300 each, £175 each).

TEENAGE POTTERY
This prototype cameo of **Left: Frankie Vaughan** measures 2-3/4" high by 1-3/4" wide and is unmarked ($300, £175). This cameo never went into production. **Right: Marty Wilde** measures 2-3/4" high by 1-7/8" across and is unmarked. This item is usually found applied to an oval-shaped plaque ($300, £175).

WADE "WILDFOWL," 1960

A set of four, large duck wall plaques made by Wade Heath & Co. Ltd. The figurines are marked "Wildfowl by Wade of England" along with the name of the figurine.

The ducks in the set are: **1. Shoveller Drake** measures 7-1/2" by 9" overall ($300, £175). **2. Pintail** measures 9-1/2" by 8" overall ($300, £175). **3. Mallard Drake** measures 9" by 9-1/2" overall ($300, £175). **4. Shoveller** measures 6-3/4" by 7-3/4" overall ($300, £175).

SEA LION CORKSCREW, 1960

The Sea Lion forms the base with the multicolored removable ball being the handle of the corkscrew.

Sea Lion Corkscrew measures 5-3/4" high to the top of the ball handle. This item originally had a Wade paper label ($110, £60).

HANNA - BARBERA CARTOON CHARACTERS, *late 1962*

In the fall of 1962, Wade introduced three cartoon characters of Huckleberry Hound, Yogi Bear, and Mr. Jinks. These figurines are unmarked but were originally issued with paper labels.

Left: Huckleberry Hound measures 2-3/8" high ($145, £75). **Center: Yogi Bear** measures 2-1/2" high ($150, £80). **Right: Mr. Jinks** measures 2-3/8" high ($145, £75).

FROG AND RUDDY DUCK, *early 1950s - late 1970s*

FROG *early 1950s* **and RUDDY DUCK** *late 1970s*
Left: Frog measures 1-1/2" high and is marked: Wade England ($200, £150). This is only one frog from a series of four. **Right: Ruddy Duck** measures 1-3/8" high by 2-1/4" long. The duck is hollow and unmarked and was produced in a limited number of 3,400 pieces for the Slimbridge Wildfowl Trust ($455, £260).

"OLD MAN" *circa mid 1980s*
These prototype figurines measure 3-3/4" high and have a transfer type mark: Wade Made in England on the base ($260, £150).

PENGUIN *circa mid 1980s*
3-7/8" high. This salt or pepper shaker prototype never went into production and is unmarked (N.P.A.).

SPIRIT CONTAINERS, *circa 1961*

In the early 1960s, Henry Stratton & Co. Limited, commissioned Wade to produce a series of containers for their liquor product. The chick, three penguins and cockatoos were modeled by William Harper.

1 2 3 4

1. Penguin (large) measures 4-7/8" high ($85, £50). **2. Penguin** (medium) measures 4-1/4" high ($75, £45). **3. Penguin** (small) measures 3-7/8" high ($70, £40). **4. Baby Chick** measures 3-5/8" high and has a Genuine Wade Porcelain black and gold label ($70, £40).

Left: Cockatoo measures 5-1/4" high ($165, £85). **Right: Cockatoo** measures 4-3/4" high and is signed: B. Harper ($260, £175). These figurines originally had the Genuine Wade Porcelain black and gold label.

Panda Liquor Container measures 3-1/2" high ($70, £40). **Penguin** Liquor Container measures 4-3/8" high ($75, £45). Both have a paper label reading: British Apricot Wine - Not Less Than 26% proof. Spirit. W.L.S. Ltd. Torquay. Date of issue and modeler of the apricot wine containers is not known at this time.

CHILD STUDIES, *1962*

The set comprised four figurines representing English, Irish, Scottish, and Welsh children in national costumes. These figurines can be found either unmarked or marked Wade England. The Irish girl and the Scottish boy are also to be found undecorated.

1. **English Boy** measures 4-3/4" high ($600, £350). 2. **Irish Girl** (with undecorated face) measures 4-1/2" high ($875, £500). The decorated version of the Irish girl is approx. $1000, £600. 3. **Scottish Boy** measures 4-3/4" high ($600, £350). 4. **Welsh Girl** measures 5-1/4" high ($600, £350).

TOM AND JERRY, *1973 - 1979*

A set of two figurines based on the popular cartoon series. Both figurines are mold marked "Wade England ©M.G.M." on the edge of the base.

Left: Tom measures 3-5/8" high ($85, £50). **Right: Jerry** measures 1-7/8" high ($75, £45).

THOMAS THE TANK ENGINE AND FRIENDS, *1985 - 1987*

In late 1985, George Wade & Son Ltd. introduced four new models to their gift ware line based on the extremely popular children's T.V. series "Thomas the Tank Engine and Friends." The T.V. series was based on two books titled *Three Railway Engines* and *Thomas the Tank Engine*. Both books were authored by the Rev. W. Audrey. The T.V. series was narrated by Ringo Starr.

Models of the "Fat Controller" were proposed and sampled for this series. At least three variations of the "Fat Controller" exist. These variations are different in both size and decoration.

Top: "Percy" Money Bank measures 7" long by 3-1/2" wide by 4-1/2" high ($285, £150). Earlier models were unmarked but later issues were marked Wade England along with a copyright mark. **Left: Fat Controller** measures 2" high ($440, £250). This prototype figurine is hollow and unmarked. **Right: "Percy"** miniature is a slip cast version of the money bank measuring 1-1/2" long by 7/8" wide by 1-1/8" high and is transfer marked: Wade Made in England ($140, £80).

Left:
Top: "Thomas" Money Bank measures 6-1/2" long by 3-5/8" wide by 4-3/4" high ($285, £150). Earlier models were unmarked and the later issues were marked Wade England along with a copyright mark. **Bottom: "Thomas"** miniature is a slip cast version of the money bank measuring 1-5/8" long by 7/8" wide by 1-1/4" high and is transfer marked: Wade Made in England ($140, £80).

Chapter 8
ANIMAL FIGURINES

by George Wade & Son Ltd., circa 1958 - 1988

THE TORTOISE FAMILY, 1958 - 1988

This series of various sized tortoises, from tiny baby figurines to large jumbo sizes, were extremely popular and had a long production life. With the introduction of "Papa" tortoise in 1958, a new type of glaze finish was used by Wade and given the name "Scintillite." This type of finish was achieved by using a soluble blue color under an amber glaze. The "Scintillite" type finish was also used for many other lines of gift ware. Between 1964 and 1965 a few thousand of both sizes of the baby tortoise were issued in a green glaze.

1. **Jumbo Tortoise** was introduced to the tortoise line in 1973. The shell forms a removable lid exposing a good-sized dish. The overall size with shell/lid in place measures 6" from head to tail by 4" wide by 2-3/8" high and is mold marked: Wade Porcelain Made in England on the base ($95, £40). **2. "Papa" Tortoise** was introduced in 1958. This figurine has a removable shell/lid. The figurine measures 4" from head to tail by 2-3/4" wide at the feet by 1-5/8" tall. It has an impressed mold mark "Wade Porcelain Made in England" along with the figure 1 which would indicate the mold number ($35, £16). **3. Baby Tortoise** was introduced in 1960. This figurine measures 3" from head to tip of tail by 2-1/8" wide at the feet by 1-1/4" high and is mold marked: Wade Porcelain Made in England ($15, £8). **4. Baby Tortoise** was introduced in 1960, along with its companion, but slightly larger, baby tortoise. This figurine measures 2" from head to tail by 1-1/2" wide at the feet by 7/8" high and is mold marked: Wade Porcelain Made in England ($15, £8).

GREEN TORTOISE, circa 1964 - 1965

These hard to find, green tortoises were issued by Wade in a very limited quantity. This experimental color version of the popular tortoise range did not sell well and was soon withdrawn from production.

Left: Baby Tortoise measures 1-1/4" high by 3" long and is mold marked: Wade Porcelain Made in England ($45, £25). **Right: Baby Tortoise** measures 7/8" high by 2" long and is mold marked: Wade Porcelain Made in England ($45, £25).

TORTOISE TOOTHBRUSH HOLDER
4" long by 2-3/4" wide by 1-5/8" tall and is mold marked "Wade Porcelain Made in England." This figurine has a removable shell/lid ($35, £16).

SLOW K AND SLOW FE TORTOISE circa 1969 - 1970
Slow K measures 1-1/4" high by 3" long. This figurine was produced as a promotional item for the pharmaceutical firm Ciba Geigy to promote their slow release potassium product ($75, £55). **Slow Fe** measures 1-1/4" high by 3" long. This figurine was produced as a promotional item for the pharmaceutical firm Ciba Geigy to promote their slow release iron product ($75, £55). A similar size tortoise was also produced with the wording "Devil's Hole Bermuda."

TORTOISE ASHBOWLS, *1965 - 1984*

Three sizes of ash bowls were produced by Wade utilizing the tortoise figurines as decoration to add interest to the bowls. All bowls were produced using the scintillite finish described under the tortoise family.

Left: Large Round Tortoise Bowl with the larger baby tortoise as decoration was made between 1965 and 1975. The bowl measures 7-1/4" in dia. by 2" high and is marked: Wade Porcelain Made in England ($70, £45). **Right: Small Round Tortoise Bowl** with the smaller baby tortoise as decoration was issued in 1976, and withdrawn from production in 1984. The bowl measures 5-3/4" in dia. by 1-5/8" high and is marked: Wade Made in England ($45, £30).

Rectangular Tortoise Ash bowl measures 1-1/4" high by 6" long by 4-1/4" across. This unusual rectangular shaped ash bowl is unmarked ($70, £45).

PEKINGESE DOGS *early 1960s*
These prototype figurines were modeled for Wade but never went into production. The figurines are slip cast and unmarked. **Left: Pekingese** measures 2-5/8" high by 3-1/8" overall (N.P.A.). **Right: Pekingese** measures 3" high by 2-1/4" overall (N.P.A.).

Dachshund measures 2-1/2" high by 3-1/2" long and is unmarked (N.P.A.). This prototype dog was modeled for George Wade & Son Ltd. but never went into production.

WALT DISNEY BULLDOG *circa 1960s*
This smiling bulldog measures 3-7/8" high and is marked: Wade Porcelain. Copyright Walt Disney Productions. Made in England ($325, £175).

ANIMAL "BLOW UPS," *circa 1962*

These three "Blow-Ups" were based upon animals from the 1953 - 1959 Whimsies and were modeled by William Harper, as were the early Whimsies. The figurines are not marked but originally had a "Wade Genuine Porcelain" paper label.

Left: Baby Polar Bear measures 3-3/4" high by 4" overall ($330, £190). **Center: Polar Bear** measures 6" high by 5-3/4" overall and is signed: Bill Harper ($330, £190). **Right: Baby Seal** measures 4-3/4" high by 5" overall ($350, £200).

HAPPY FAMILIES, *1961- 1965 and 1978 - 1986*

The Happy Families series, designed by Leslie McKinnon, was first issued starting in 1961. Each set features a large size parent figurine accompanied by two baby figurines. In a three year period, 1961 to 1965, five sets were issued. These were the Hippo, Tiger, Giraffe, Rabbit, and Mouse families. The series was reintroduced in 1978 and ran to 1986.

Of the five original families, four were reissued but the Tiger family was dropped from the line. The last two families to be added to the line were the Dog and Cat families. Most figurines are found with a red or black transfer back stamp: "Wade Made in England." Some of the figurines, usually the babies, can be found unmarked. Unless noted otherwise, all figurines are from the 1978 - 1986 issue.

HIPPO FAMILY
1. Parent Hippo is 1-1/8" high ($20, £12). **2. Baby Hippo** measures 5/8" high ($12, £8). **3. Baby Hippo** measures 1" high ($12, £8).

TIGER FAMILY 1961 - 1965
4. Baby Tiger is 1/2" high ($70, £30). **5. Parent Tiger** measures 1-3/4" high ($100, £45). **6. Baby Tiger** measures 1/2" high ($70, £30).

GIRAFFE FAMILY
7. Parent Giraffe measures 2-5/16" high ($30, £10). **8. Baby Giraffe** measures 5/8" high ($15, £8). **9. Baby Giraffe** measures 1-9/16" high ($20, £9).

MOUSE FAMILY
10. Baby Mouse measures 1-1/16" high ($18, £10). **11. Parent Mouse** measures 2" high ($15, £14). **12. Baby Mouse** measures 1" high ($18, £10).

MOUSE AND RABBIT 1962 - 1965
13. Baby Mouse 1962 - 1965 issue ($36, £20). **14. Parent Mouse** 1962 - 1965 issue ($50, £28). **15. Baby Mouse** 1962 - 1965 issue ($36, £20). **16. Baby Rabbit** 1962 - 1965 issue ($36, £20). Note the color differences between the early and later issues.

RABBIT FAMILY
17. Parent Rabbit measures 2" high ($25, £14). **18. Baby Rabbit** measures 1-1/4" high ($18, £10). **19. Baby Rabbit** measures 1-1/8" high ($18, £10).

FROG FAMILY
20. Baby Frog measures 1" high ($12, £10). **21. Parent Frog** measures 7/8" high ($20, £12). **22. Baby Frog** measures 5/8" high ($12, £10).

OWL FAMILY
23. Parent Owl measures 1-3/4" high ($25, £12). **24. Baby Owl** measures 1" high ($18, £8). **25. Baby Owl** measures 7/8" high ($18, £8).

PIG FAMILY
26. Parent Pig measures 1-1/8" high ($25, £14). **27. Baby Pig** measures 9/16" high ($18, £10). **28. Baby Pig** measures 5/8" high ($18, £10).

75

DOGS AND PUPPIES SETS, *1969 - 1982*

Starting in 1969, a retail line of miniature dogs accompanied by two puppies of the same breed made its appearance in the Wade range of gift ware. Five sets of dogs and puppies were issued in a total of ten boxes. The first six boxes were colored blue with the wording of "Whimsies" above the breed name. The remaining four boxes were colored red, but this time the word "Whimsies" was replaced by "Dog Series." Unless noted otherwise all figurines had a Wade paper label with the wording "Wade Made in England."

DOG FAMILY
29. Puppy measures 1-1/4" high ($24, £15). **30. Parent Dog** measures 2" high ($55, £35). **31. Puppy** measures 1-1/4" high ($24, £15).

CAT FAMILY
32. Kitten measures 1-3/8" high ($32, £20). **33. Parent Cat** measures 1-7/8" high ($64, £40). **34. Kitten** measures 1-1/4" high ($32, £20).

SET 1, *1969*
1. Adult Alsatian measures 2-1/2" high ($30, £9). **2. Alsatian Puppy** measures 1-1/4" high ($16, £8). **3. Alsatian Puppy** measures 1-3/4" high ($16, £8).

ELEPHANT FAMILY
35. Baby Elephant measures 1-3/4" high ($18, £10). **36. Parent Elephant** measures 1-1/4" high ($25, £12). **37. Baby Elephant** measures 1" high ($18, £10).

SET 2, *1969*
4. Adult Cairn measures 2-1/2" high ($30, £10). **5. Cairn Puppy** measures 1-3/8" high ($16, £8). **6. Cairn Puppy** measures 1-1/2" high ($16, £8).

ZEBRA FAMILY
This prototype Zebra Family was designed and modeled by Wm. Harper but never went into production (N.P.A.).

SET 3, *1973*
7. Adult Red Setter measures 2-1/4" high ($30, £12). **8. Red Setter Puppy** measures 1-1/2" high ($16, £6). **9. Red Setter Puppy** measures 1-1/2" high ($16, £6).

76

10 11 12

SET 4, *1979*
10. Adult Corgi measures 2-1/4" high and is mold marked: Wade England ($45, £25). **11. Corgi Puppy** measures 1-1/8" high and is mold marked: Wade England ($25, £18). **12. Corgi Puppy** measures 1-5/8" high and is mold marked: Wade England ($25, £18).

13 14 15

SET 5, *1979*
13. Adult Yorkshire Terrier measures 2-1/8" high and is mold marked: Wade England ($75, £45). **14. Yorkshire Terrier Puppy** measures 1-1/2" high ($55, £30). **15. Yorkshire Terrier Puppy** measures 1-3/8" high ($55, £30).

CAT AND PUPPY DISHES, *1974 - 1981*

During the run of the Dog and Puppy sets, an addition was made to this line of gift ware by the manufacture of basket-shaped dishes into which the ten puppies were mounted. These dishes were given the name "Puppy Dishes." During the same period, a figurine of a cat, larger in size than the puppies, was also made and mounted in a similar basket. This was known as the "Cat Dish." For the size of puppies refer to the "Dogs and Puppies" sets. The size and shape of the dishes is similar for all puppies and cat being oval shaped and measuring 2-7/8" long by 2-1/2" across. All dishes are mold marked: "Wade England."

Top: Cat Dish measures 2-3/8" high ($40, £15). **Bottom: Whimsie Kitten Dish** this was not a production piece. The attempt to develop a Cat and Kitten dish series using the Whimsie kitten never materialized.

Red Setter Puppy Dish ($28 each, £10 each).

Alsatian Puppy Dish ($28 each, £10 each).

Cairn Puppy Dish ($28 each, £9 each).

Yorkshire Terrier Puppy Dish ($40 each, £18 each).

77

DOG PIPE RESTS, 1973 - 1981

In 1973, Wade introduced a set of five pipe rests featuring large dogs from the "Dogs and Puppies" series. The pipe rests had slightly "off" circular bases measuring 3-1/4" in dia. by 3/4" deep. Each pipe rest bears the wording "Wade England" molded onto the underside of the base.

2 1 3

4 5

1. **Cairn Terrier** ($38, £22). 2. **Corgi** ($38, £22). 3. **Red Setter** ($35, £20). 4. **Alsatian** ($30, £17). 5. **Yorkshire Terrier** ($80, £45).

HORSE SETS, 1974 - 1981

In 1974, Wade introduced a set comprising a farm cart horse along with two foals. None of the figurines was mold marked, but they were issued with paper labels. A second set, again comprising a farm cart horse with two foals was issued in 1978. This second set is mold marked "Wade England" around the base.

SET 1, *1974*
Left: **Foal** measures 1-7/8" high by 2" overall ($20, £7). Center: **Horse** measures 2-3/4" high by 3" overall ($25, £8). Right: **Foal** measures 1-3/8" high by 2" overall ($18, £6).

SET 2, *1978*
Left: **Foal** measures 1-1/2" high by 1-5/8" overall ($30, £25).
Center: **Horse** measures 2-1/2" high by 2-3/4" overall ($38, £25).
Right: **Foal** measures 1-1/4" high by 1-7/8" overall ($30, £25).

CHAMPIONSHIP DOGS, 1975 - 1981

In 1975, Wade introduced a set of five mid-size, quality, underglaze-colored figurines based on purebred dogs. Each dog was mounted on an oval-shaped base measuring 3-1/2" long by 2-1/4" wide. The front face of the base is mold marked "Championship Series" and "Wade England" on the back face. Originally each figurine also had an applied orange-colored paper label marked "Championship Series" and "Wade England" along with the appropriate breed of dog.

1 2 3

4 5

Top: 1. **English Setter** measures 2-3/4" high by 4-1/8" long ($115, £50). 2. **Afghan Hound** measures 3" high by 3-3/8" long ($110, £45). 3. **Collie** measures 3-1/4" high by 4" long ($125, £60).
Bottom: 4. **Cocker Spaniel** measures 2-7/8" high by 3-5/8" long ($100, £45). 5. **Old English Sheep Dog** measures 3-1/4" high by 3" long ($110, £45).

WHOPPAS, *1976 - 1981*

Starting in 1976, Wade introduced three sets of five animals each, which were marketed under the name of "Whoppas." The series remained in production until 1981. The fifteen figurines are all marked "Wade England" on the side of the base.

When the "Whoppas" were discontinued as a retail line, surplus stock was used, in 1981, as a Canadian Red Rose Tea premium promotion.

SET 1, *1976*
Top: 1. Polar Bear measures 1-1/2" high by 2-1/4" overall ($26, £9). **2. Hippo** measures 1-3/8" high by 2-1/4" overall ($26, £9). **3. Brown Bear** measures 1-1/2" high by 1-3/4" overall ($21, £10). **Bottom: 4. Tiger** measures 1-1/8" by 2-1/2" overall ($27, £10). **5. Elephant** measures 2-1/8" high by 2" overall ($30, £12).

SET 2, *1977*
Top: 6. Bison measures 1-3/4" high by 2-1/4" overall ($30, £12). **7. Wolf** measures 2-1/4" high by 1-3/4" overall ($30, £16). **8. Bobcat** measures 1-1/2" high by 1-7/8" overall ($30, £16). **Bottom: 9. Chipmunk** measures 2-1/8" high by 1" dia. base ($30, £16). **10. Raccoon** measures 1-1/2" high by 2-1/4" overall ($32, £19).

SET 3, *1978*
Top: 11. Fox measures 1-1/4" high by 2-1/2" overall ($40, £22). **12. Badger** measures 1-1/2" high by 1-7/8" overall ($40, £22). **13. Otter** measures 1-1/4" high by 2" overall ($40, £22). **Bottom: 14. Stoat** measures 1-1/2" high by 2-1/8" overall ($40, £22). **15. Hedgehog** measures 1-1/4" high by 1-7/8" overall ($42, £25).

WHOPPAS ELEPHANT
Left: Production model. **Right:** Prototype.

RAZOR BACK PIG, *early 1980s*

This pig was a limited edition of 500 figurines designed by Alan Maslankowski for the University of Arkansas whose football-team mascot is a Razor Back Pig. The red example illustrated was photographed at The Royal Victoria Pottery. Only a very few pieces were issued in the red glaze and are unmarked. The main production pieces had a charcoal grey/black glaze and were ink stamped: Wade England.

The **Razorback Pig** measures 5" high by 8" overall ($1100, £550). The Charcoal grey/black production model ($750, £375).

79

THE WORLD OF SURVIVAL, 1978 - 1982

This range of twelve high quality slip cast figurines of wild animals, issued in two sets of six, were hand-decorated in matte enamels to give them a realistic texture and appearance. The figurines were manufactured under license to Survival Anglia Limited based on their award winning television series "World of Survival."

Series 1, issued in 1978, comprised African Elephant, Tiger, Black Rhinoceros, African Lion, Polar Bear, and American Bison.

Series 2, issued in 1980, comprised Gorilla, American Cougar, Hippopotamus, African Buffalo, American Brown Bear, and Harp Seal with Pup.

Each figurine has a transfer type mark "World of Survival Series by Wade of England Copyright Survival Anglia Limited, 1976. All Rights Reserved." Due to high production costs, this series had only a limited run.

SERIES 1, 1978

AFRICAN ELEPHANT
10" long by 6" high ($500, £325).

TIGER
8" long by 3-1/2" high ($425, £275).

AMERICAN BISON
8" long by 4-1/2" high ($500, £250).

BLACK RHINOCEROS
9-1/2" long by 4-1/2" high ($400, £300).

AFRICAN LION
8" long by 4-1/2" high ($400, £250).

POLAR BEAR
8-1/2" long by 4-1/2" high ($400, £250).

80

SERIES 2, *1980*

GORILLA
5-3/4" long by 5-1/2" high ($425, £275).

AMERICAN COUGAR (Puma)
9" long by 4" high ($550, £300).

HIPPOPOTAMUS
10" long by 4-1/2" high ($315, £275).

AFRICAN (Cape) BUFFALO
9-1/4" long by 5" high ($575, £350).

AMERICAN BROWN BEAR
5-1/2" long by 4" high ($500, £325).

HARP SEAL AND PUP
9" long by 3-3/4" high ($600, £350).

THE CONNOISSEUR'S COLLECTION *1978 - 1982*

A series of twelve slip cast figurines of life-size British birds was issued in two sets of six similar in finish to the animals from "The World of Survival."

Series 1, issued in 1978, comprised Coaltit, Wren, Goldcrest, Nuthatch, Robin, and Bullfinch. Series 2, issued in 1980, comprised Bearded Tit, Kingfisher, Redstart, Yellow Wagtail, Woodpecker, and Dipper.

Each bird was modeled in its authentic setting and hand-decorated in matte enamels giving a realistic finish. This series of birds had a limited run due to high production costs. Each figurine is transfer marked "The Connoisseur's Collection by Wade of England" followed by the name of the bird with its numerical position in the series.

SERIES 1, *1978*

COALTIT
5-3/4" high
($400, £275).

81

WREN
4-1/2" high ($400, £275).

GOLDCREST
5-1/4" high ($400, £275).

BULLFINCH
7-1/4" high ($400, £275).

SERIES 2, *1980*

NUTHATCH
5-1/2" high ($400, £275).

BEARDED TIT
6-1/2" high ($450, £300).

ROBIN
5" high ($400, £275).

KINGFISHER
7" high ($450, £300).

82

REDSTART
8" high ($450, £300).

YELLOW WAGTAIL
4-1/2" high ($450, £300).

WOODPECKER
6-1/2" high ($375, £250).

DIPPER
5-1/2" high ($340, £225).

DISNEY "HAT BOX" SERIES, *1956 - 1965*

"Winners from Wade." That is how trade magazines advertised the new Wade Hat Box Series. These miniature figurines, based upon characters from Walt Disney's animated films, were packed in a small cardboard "Hat-Box" of distinguishing colors and sold separately. Some "Hat Box" figurines are found with a blue transfer mark WADE ENGLAND but originally many of them had a round black and gold label reading: Genuine Wade Porcelain Made in England.

LADY AND THE TRAMP

Between 1956 - 1965, eleven characters from Lady and the Tramp, one of Disney's most popular films first shown in 1955, were produced by George Wade & Son Ltd. as a giftware line.
Top row: 1. Am measures 1-7/8" high ($50, £30). **2. Peg** measures 1-1/2" high ($28, £15). **3. Tramp** measures 2-1/8" high ($85, £40). **4. Si** measures 1-3/4" high ($50, £30).
Middle row: 5. Scamp measures 1-1/2" high ($35, £20). **6. Lady** measures 1-1/2" high ($45, £25). **7. Jock** (no coat) measures 1-3/4" high ($62, £35). Jock with green coat ($45, £25). Jock with blue coat ($45, £25).
Bottom row: 8. Trusty measures 2-3/8" high ($45, £25). **9. Boris** measures 2-3/8" high ($62, £35). **10. Dachie** measures 1-3/4" high ($35, £18). **11. Toughy** measures 2" high ($95, £55).

83

BAMBI
In 1957, three figurines based upon characters from the 1942 animated movie, Bambi, were produced by George Wade & Son Ltd. A reproduction of Flower has been reported but not confirmed. **Left: Flower** measures 1-1/2" high ($50, £30). **Center: Thumper** measures 1-7/8" high ($50, £30). **Right: Bambi** measures 1-1/2" high ($35, £20).

FANTASIA
In 1958, one character from this 1940 animated film was made by George Wade & Son Ltd. **Baby Pegasus** measures 1-3/4" high ($62, £35).

THUMPER CANDLE HOLDER
2" along each side of the triangular shaped base and is mold marked Wade on the underside of the base ($120, £50).

101 DALMATIONS
Four figurines based upon characters from this 1961 animated film. **Top: 1. The Colonel** measures 2-1/8" high ($110, £60). **2. Sgt. Tibbs** measures 2-1/8" high ($145, £70). **Bottom: 3. Rolly** measures 1-5/8" high ($150, £75). **4. Lucky** measures 1-1/4" high ($150, £75).

DUMBO
In 1957, one character from this 1941 animated film was made by George Wade & Son Ltd. **Left: Dumbo** (William Harper prototype model) measures 1-1/2" high by 1-3/4" overall (N.P.A.). **Right: Dumbo** (production model) measures 1-3/8" high by 1-5/8" overall ($90, £40).

CRUELLA DE VIL AND DALMATIONS *circa 1996*
Cruella measures 5-1/4" high and the **Dalmations** measure 2-1/2" and 2-1/4" high respectively. The figurine of Cruella was based on the character played by Glenn Close in the 1996, Disney live action movie of "101 Dalmations." These figurines are transfer marked" Wade Made in England" but they never went into full production (N.P.A.).

THE SWORD IN THE STONE

The Merlin figurines are the most difficult to find in this set based upon characters from the 1963 animated film of the same title. Beware of reproduction figurines of Madam Mim. **Top row: 1. Girl Squirrel** measures 1-1/2" high ($150, £90). **2. Merlin as a Hare** measures 2-3/8" high ($210, £100). **3. Archimedes** measures 2" high ($150, £85).
Bottom row: 4. Madam Mim measures 1-1/2" high ($250, £110). **5. Merlin as a Turtle** measures 1" high by 1-3/4" long ($300, £170). **6. Merlin as a Caterpillar** measures 3/4" high by 1-3/4" long ($210, £115).

MERLIN AS A HARE - TRUMPS
The combination of the figurine and the base measures 3-1/2" long by 3" high ($140, £80).

"DISNEY'S" SERIES, 1981 - 1987

Starting in 1981, George Wade & Son Ltd. issued a new series of characters from Walt Disney animated films. Seven figurines were reissues from the "Hat Box" series and were: Peg, Lady, Scamp, Jock, Dachsie, Bambi, and Thumper, along with a new model of Tramp.

Four new figurines were modeled after characters from the film "The Fox and the Hound." All the "Disney's" in this series had an oval black and gold label reading: ©WALT DISNEY PRODUCTIONS, WADE ENGLAND.

ARCHIMEDES
Color variation.

THE FOX AND THE HOUND
In 1982, George Wade & Son Ltd. issued four figurines based upon characters from the 1981 Walt Disney animated film of the same title. **1. Copper** measures 1-5/8" high ($40, £25). **2. Chief** measures 1-7/8" high ($35, £20). **3. Big Mama** measures 1-3/4" high ($68, £40). **4. Tod** measures 1-3/4" high ($98, £50).

MADAM MIM
Original on the right and the reproduction is on the left.

85

DISNEY REISSUES, 1981 - 1987

The Disney reissues had an oval black and gold label reading: ©Walt Disney Productions Wade England. This label is often missing from the figurines making it harder to differentiate the earlier models from the reissues. In 1981, the Disney reissues were sold in round plastic boxes but these were soon replaced by decorative rectangular card boxes.

1 2 3

4 5 6

Top: 1. Peg ($28, £16). 2. Lady ($28, £15). 3. Jock ($35, £20). Bottom: 4. Scamp ($35, £20). 5. Tramp (new model) measures 1-7/8" high ($50, £25). 6. Bambi ($28, £15).

7 8

7. Dachsie, which was spelled Dachie in the earlier issue ($35, £18). 8. Thumper ($45, £25).

DISNEY "BLOW – UPS," 1961 - 1965

These larger, slip cast models of the famous "Hat Box" series were introduced in 1961 featuring Lady, Tramp, Scamp, and Bambi, to be followed by Jock and Dachie in 1962, and then Si, Am, Thumper, and Trusty. These figurines were popularly known as "Blow-Ups" by Wade employees. However, they were officially marketed under the name "Disneys." The figurines are found marked either "Wade Porcelain Copyright Walt Disney Productions Made in England" or "Wade Porcelain England" both of which are transfer type marks.

1 2

1: **Lady** measures 4-1/4" high ($280, £160). 2: **Tramp** measures 6" high ($480, £275).

3 4

3. **Bambi** measures 4-1/2" high ($200, £125). 4. **Thumper** measures 5-1/4" high ($525, £300).

5 6

5. **Am** measures 5-3/4" high ($250, £145). 6. **Si** measures 5-1/2" high ($250, £145).

7. Scamp measures 4-1/8" high ($235, £130). **8. Dachsie** measures 5" high ($1050, £600).

9. Jock measures 4" high ($1050, £600). **10. Trusty** measures 5-7/8" high ($310, £180).

DISNEY MONEY BANKS *1962*
A set of five money banks, with removable rubber plugs, featuring one of five Walt Disney figurines from the "Hat Box" series. Each money bank measures 3-3/4" high by 4-1/4" long by 3" wide and is unmarked. **1. Lady** ($180, £100). **2. Scamp** ($180, £100). **3. Jock** ($180, £100). **4. Lucky** ($180, £100). **5. Rolly** ($180, £100).

87

SNOW WHITE AND THE SEVEN DWARFS, *1981 - 1986*

This set of underglaze slip cast figurines were first introduced in late 1981, and withdrawn from production in December 1986. Each figurine has a transfer mark on the base reading: "WADE ENGLAND© Walt Disney Productions."

1 2 3 4

5 6 7 8

Top: **1. Snow White** measures 3-3/4" high ($180, £120). **2. Grumpy** measures 3" high ($160, £90). **3. Sneezy** measures 3-1/4" high ($155, £85). **4. Happy** measures 3-1/4" high ($160, £90). **Bottom: 5. Sleepy** measures 3" high ($155, £85). **6. Bashful** measures 3-1/4" high ($155, £85). **7. Doc** measures 3" high ($190, £125). **8. Dopey** measures 3-1/4" high ($155, £85).

SNOW WHITE
Two versions of the 1981 Snow White. The figurine on the left is the most frequently found and is referred to as Version 2 ($180, £120). The Version 1 figurine on the right differs in the tilt of the head, the lack of a red heart on the bodice and the differences in the puff sleeves ($180, £120).

1 2 3 4 5 6 7

SEVEN DWARFS *circa late 1960s - early 1970s*
This set of seven prototype figurines is slip cast and unmarked but has been authenticated as Wade models which were never produced commercially. **1. Dwarf** measures 1-5/8" high by 1-1/2" wide. **2. Dwarf** measures 1-7/8" high by 1-1/4" wide. **3. Dwarf** measures 1-7/8" high by 1-1/4" wide. **4. Dwarf** measures 1-7/8" high by 1-1/8" wide. **5. Dwarf** measures 2" high by 1-1/4" wide. **6. Dwarf** measures 2" high by 1-3/8" wide. **7. Dwarf** measures 2" high by 1-1/2" wide (N.P.A.).

CHAPTER 9
WHIMSIES

1953 - 2001

WHIMSIES, 1953 - 1959

With Wade's pre-World War II experience in the design and production of miniature ceramic animal figurines, it was a natural step to try and recreate their prewar success in this field. This new venture proved to be an outstanding success, far surpassing Wade's expectations.

The figurines, designed and modeled by William Harper, were packaged in sets of five models, with the exception of Set 5, which had only four models. The name chosen for these figurines was "Whimsies," and thus was born a name that has become synonymous with many Wade products.

Due to the necessity of keeping both the Manchester and Portadown potteries in production, the manufacture of the new "Whimsies" was divided between the two potteries with George Wade & Son Ltd. producing the odd numbered sets and Wade (Ireland) Ltd. producing the even numbered sets. All figurines are unmarked unless noted otherwise.

SET 1, *1953*
Top row: 1. Leaping Fawn measures 1-7/8" high by 1-1/2" overall and is mold marked Wade ($48, £24). **2. Horse** measures 1-1/2" high by 2-1/8" overall and is mold marked Wade ($48, £24). **3. Spaniel** measures 1" high by 1-3/4" long and is unmarked ($46, £20). **4. Poodle** measures 1-1/2" high by 1-3/4" overall and is unmarked ($45, £28). **5. Squirrel** measures 1-1/4" high by 1-7/8" overall and is unmarked ($28, £22).

SET 2, *1954*
Bottom row: 6. Bull measures 1-3/4" high by 2-1/8" overall and is transfer stamped Wade Made in England ($85, £60). **7. Lamb** measures 1-7/8" high by 1-1/4" overall and is transfer stamped Wade Made in England ($57, £30). **8. Kitten** measures 1-3/8" high by 1-3/4" overall and is unmarked ($95, £48). **9. Hare** measures 1-1/8" high by 1-3/4" overall and is transfer marked Wade Made in England ($45, £28). **10. Dachshund** measures 1-1/8" high by 1-1/2" overall and is unmarked ($92, £48).

SET 3, *1955*
Top row: 11. Badger measures 1-1/4" high by 2" overall and is unmarked ($42, £28). **12. Fox Cub** measures 1-3/8" high by 1-5/8" overall and is unmarked $79, £42). **13. Stoat** measures 1-1/8" high by 1-3/4" overall and is unmarked ($55, £42). **14. Shetland Pony** measures 1-3/8" high by 2" overall and is mold marked Made in England ($38, £24). **15. Retriever** measures 1-1/4" high by 1-7/8" overall and is mold marked Wade Made in England ($38, £24).

SET 4, *1955*
Bottom row: 16. Lion measures 1-1/4" high by 1-5/8" overall and is unmarked ($54, £34). **17. Crocodile** measures 3/4" high by 1-5/8" overall and is ink stamped Made in England ($78, £42). **18. Monkey** measures 1-7/8" high by 1-5/8" overall and is unmarked but has been found marked with an ink stamp ($38, £24). **19. Rhinoceros** measures 1-3/4" high by 2-3/8" overall and is transfer stamped Wade Made in England ($45, £24). **20. Baby Elephant** measures 1-1/4" high by 1-7/8" overall and is ink stamped Made in England ($58, £34).

SHETLAND PONY *(Set 3)*
Color variations.

SET 5, *1956*
Top row: 21. Mare measures 1-7/8" high by 2" overall and is mold marked Wade ($48, £34). **22. Colt** measures 1-7/16" high by 1-5/8" overall and is mold marked Wade ($50, £34). **23. Beagle** measures 3/4" high by 1" overall and is unmarked ($78, £42). **24. Foal** measures 1-1/4" high by 1-3/4" overall and is mold marked Wade ($50, £34).

SET 6, *1956 (Polar Set)*
Bottom row: 25. King Penguin measures 1-3/16" high by 5/8" dia. base and is unmarked ($50, £34). **26. Husky** measures 1-1/4" high by 1-1/8" overall and is unmarked ($50, £34). **27. Polar Bear** measures 1-3/4" high by 1-3/4" overall and is unmarked ($47, £30). **28. Baby Seal** measures 7/8" high by 1-1/8" overall and is unmarked ($34, £24). **29. Baby Polar Bear** measures 7/8" high by 1-1/8" overall and is unmarked ($37, £30).

MARE *(Set 5)*
Color variations.

FOAL *(Set 5)*
Color variations.

ALSATIAN *(Set 7)*
Top left: Production model. **Top right:** Prototype model.
CORGI *(Set 7)*
Bottom left: Production model. **Bottom right:** Prototype model.

30 31 32 33 34

35 36 37 38 39

SET 7, *1957 (Pedigree Dogs)*
Top row: 30. Alsatian measures 1-3/8" high by 1-5/8" overall and is unmarked ($34, £24). **31. West Highland Terrier** measures 1" high by 1-1/4" overall and is unmarked ($48, £30). **32. Corgi** measures 1" high by 1-1/4" overall and is unmarked ($45, £30). **33. Boxer** measures 1-3/8" high by 1-1/2" overall and is unmarked ($45, £28). **34. St. Bernard** measures 1-1/2" high by 1-7/8" overall and is unmarked ($59, £34).

SET 8, *1958 (Zoo Set)*
Bottom row: 35. Llama measures 1-3/4" high by 1-1/8" overall and is unmarked ($48, £24). **36. Lion Cub** measures 1" high by 1" overall and is unmarked ($38, £24). **37. Giant Panda** measures 1-1/4" high and is unmarked ($48, £24). **38. Bactrian Camel** measures 1-1/2" high by 1-5/8" overall and is unmarked ($44, £30). **39. Cockatoo** measures 1-1/8" high by 1-1/4" across the wings and is unmarked ($58, £30).

ZEBRA
1-5/8" high and is unmarked. This figurine, modeled by William Harper, was proposed for the 1958 Whimsies Zoo set but never went into production ($310, £175).

GIANT PANDA
Left: Panda measures 1-1/2" high by 1" across the base and is unmarked. This was the early premium figurine and is shown for size comparison. **Right: Giant Panda** (Set 8) measures 1-1/4" high and is unmarked ($48, £24).

91

SET 9, *1958 (North American Animals)*
Top row: 40. Snowy Owl measures 1-1/8" high by 1-3/16" across the wings and is unmarked ($55, £39). **41. Raccoon** measures 1-1/8" high by 1-1/8" overall and is unmarked ($42, £28). **42. Grizzly Bear** measures 1-7/8" high on a 7/8" dia. base and is unmarked ($66, £30). **43. Bear Cub** measures 1-1/8" high by 1-1/8" overall and is unmarked ($38, £28). **44. Cougar** measures 3/4" high by 1-7/8" overall and is unmarked ($68, £40).

SET 10, *1959 (Farm Animals)*
Bottom row: 45. Piglet measures 7/8" high by 1-1/2" overall and is unmarked ($76, £45). **46. Italian Goat** measures 1-3/8" high by 1-1/2" overall and is unmarked ($77, £45). **47. Fox Hound** measures 1" high by 1-3/4" overall and is unmarked ($77, £45). **48. Swan** measures 7/8" high by 1-1/2" overall and is unmarked ($190, £110). **49. Shire Horse** measures 2" high by 2-1/8" overall and is unmarked ($235, £140).

BEAR CUB *(Set 9)*
Color variations ($38, £28).

SHIRE HORSE *(Set 9)*
Color variation ($400, £250).

SWAN AND SHIRE HORSE REPRODUCTIONS, *1992*

In 1992, a reproduction of the early Whimsie Swan appeared on the market. The reproduction Swan has a shorter, thicker, and straighter neck with a smooth transition from head to beak. The wings are more rounded and lumpier than the original, and it has shorter, more rounded tail feathers and a lack of detail between the wings.

In the same year, a reproduction of the Shire Horse also appeared on the market. The reproduction horse is crude and is taller than the original measuring 2-1/16" high. The reproduction has a decidedly backward slant and appears as if the horse were about to fall backwards. It also has large, clumsy, and poorly formed hooves.

SWAN *(Set 10)*
Left: Swan illustrates a black version of the unauthorized reproduction. **Center: Swan** illustrates the white version of the unauthorized reproduction. **Right: Swan** is the production model.

SHIRE HORSE *(Set 10)*
Left: Shire Horse is the production model. **Right:** Shire Horse is the unauthorized reproduction.

WHIMSIES, 1971 - 1984

In 1971, after the success of the first issue of Whimsies, George Wade & Son Ltd. began issuing a second series which was to run to 1984 and comprised 12 sets of 5 figurines each. These new Whimsies were sold either individually boxed or in sets of five with each figurine in its own box. The packaging for the sets of 5 figurines was presented in different colors - dark blue, red, green, yellow, dark red, light blue, orange, magenta, medium blue, light green, brown, and finally dark blue again.

Over the years of production a number of variations occurred both in size and color. These changes in size occurred when molds had to be remade due to production problems caused by the bulky shape of the animals. It was found that the seams were splitting when the figurines were in the clay state and the only way to resolve this problem was to reduce the bulk. This size difference is most apparent with the Hippo, Bison, and Pig.

The variation in color is not hard to understand as the figurines were mass produced and there was very little quality control at that time. There were also a number of Whimsies that were made with experimental glazes and a number of these turn up on the secondary market.

All figurines, unless noted otherwise, are mold marked "Wade England" around the base.

SET 1, *1971*
Top row: 1. Fawn measures 1-3/8" high by 1-1/4" long ($5, £3). **2. Rabbit** measures 1-1/8" high by 1-7/8" overall ($5, £3). **3. Mongrel Pup** measures 1-3/8" high by 1-1/2" overall ($5, £3). **4. Kitten** measures 1-3/8" high by 1-3/8" overall and is marked "England" only ($8, £3). **5. Spaniel** measures 1-3/8" high by 1-3/8" overall and is marked "Wade" on the front and "England" on the back ($5, £3).

SET 2, *1972*
Bottom row: 6. Duck measures 1-1/4" high by 1-1/2" overall and is marked "Wade" on one side of the base and "England" on the other ($8, £3). **7. Corgi** measures 1-1/2" high by 1-1/2" overall and is marked "Wade" on the front and "England" on the back ($8, £3). **8. Beaver** measures 1-1/4" high by 1-1/4" overall ($5, £3). A variation in the mold mark occurs on this figurine. Along with the usual "Wade England" mold mark around the base it is also found with "Wade England" molded into a recess on the underside of the base. **9. Bush Baby** measures 1-1/4" high by 1-1/8" overall ($5, £3). **10. Fox** measure 1-3/8" high by 1-1/2" overall ($6, £3).

RABBIT *(Set 1)*
The rabbit is found in two variations. **Left: Rabbit Ears Together**, which was the earlier version ($12, £5) **Right: Rabbit Ears Apart**, which was the later version ($5, £3).

93

KITTEN *(Set 1)*
Left: Kitten illustrates the production model. **Right: Kitten** illustrates the prototype model.

BUSH BABY *(Set 2)*
Color and mold variations ($5, £3).

BEAVER *(Set 2)*
Left: Beaver illustrates the production model. **Right: Beaver** illustrates the prototype model.

FOX *(Set 2)*
Color variation ($6, £3).

SET 3, *1972*
Top row: 11. Bear Cub measures 1-3/8" high by 7/8" across ($5, £3). A variation in the mold mark occurs on this figurine. The earlier models were marked "Wade England" molded into a recess on the underside of the base. The later models were mold marked "Wade" at the front in between the feet and "England" on the back to the left of the tail. **12. Otter** measures 1-1/4" high by 1-1/2" overall ($5, £3). **13. Setter** measures 1-3/8" high by 1-7/8" overall ($5, £3). **14. Owl** measures 1-1/2" high by 7/8" across the base ($5, £3). A variation in the mold mark occurs on this figurine. Along with the usual "Wade England" mold mark around the base it is also found with "Wade England" molded into a recess on the underside of the base. **15. Trout** measures 1-1/8" high by 1-3/8" overall ($8, £4).

SET 4, *1973*
Bottom row: 16. Lion measures 1-3/8" high by 1-3/4" overall ($5, £3). **17. Elephant** measures 1-3/8" high by 1-3/4" overall ($20, £8). **18. Giraffe** measures 1-1/2" high by 1-1/2" overall ($5, £3). **19. Chimp** measures 1-1/2" high by 1-3/8" across ($5, £3). **20. Hippo** measures 1-1/16" high by 1-3/4" overall ($15, £6).

ELEPHANT *(Set 4)*
Color variations.

SET 5, *1974*
Top row: 21. Squirrel measures 1-3/8" high by 1-3/8" overall ($5, £3). **22. Hedgehog** measures 7/8" high by 1-3/4" overall and is mold marked "Wade England" in a recess on the underside of the base ($8, £3). **23. Pine Marten** measures 1-3/8" high by 1-1/2" overall ($5, £4). **24. Field Mouse** measures 1-1/2" high by 3/4" across the base and is mold marked "Wade" on one side and "England" on the other side of the base ($8, £4). **25. Alsatian** measures 1-1/4" high by 1-7/8" overall ($6, £3).

SET 6, *1975*
Bottom row: 26. Collie measures 1-1/4" high by 1-3/8" overall ($8, £5). **27. Cow** measures 1-1/4" high by 1-1/2" overall ($12, £5). **28. Pig** measures 13/16" high by 1-1/2" overall ($22, £6). **29. Horse** measures 1-5/8" high by 1-3/8" overall ($21, £5). **30. Lamb** measures 1-3/8" high by 1-1/8" overall ($10, £5).

HIPPO *(Set 4)*
Size Variations. Left: Hippo measures 15/16" high by 1-1/2" long ($5, £3). **Center: Hippo** measures 1" high by 1-5/8" long ($5, £3). **Right: Hippo** measures 1-1/16" high by 1-3/4" long ($15, £6).

HEDGEHOG *(Set 5)*
Color variations. The dark brown hedgehog is 7/8" high by 1-3/4" long, has two riser tabs and is mold marked: Wade England. The medium brown hedgehog is 7/8" high by 1-3/4" long, has three riser tabs and is mold marked: Wade England in a deep recess on the underside of the base. The light brown hedgehog is 15/16" high by 1-3/4" long, has larger ears and face, two riser tabs and is mold marked: Wade England in a shallow recess on the underside of the base.

HORSE *(Set 6)*
Color variation ($21, £5).

PIG *(Set 6)*
Size Variations. **Left: Pig** measures 13/16" high by 1-1/2" long ($22, £6). This was the second version. **Right: Pig** measures 1" high by 1-3/4" long ($44, £12). This was the first version.

95

Above:
SET 7, *1976*
Top row: 31. Rhino measures 7/8" high by 1-5/8" overall ($5, £5).
32. Leopard measures 7/8" high by 1-7/8" overall ($8, £5). **33. Gorilla** measures 1-1/2" high by 1-1/4" overall ($5, £5). **34. Camel** measures 1-3/8" high by 1-5/8" overall ($10, £5). **35. Zebra** measures 1-5/8" high by 1-1/2" overall ($9, £5).

SET 8, *1977*
Bottom row: 36. Donkey measures 1-1/4" high by 1-5/8" overall ($14, £9). **37. Owl** measures 1-1/2" high by 1" across the base ($22, £9). A variation in mold mark occurs on this figurine. Along with the usual "Wade England" mark around the base this figurine was also made in an earlier version, with "Wade England" molded into a recess on the underside of the base. **38. Cat** measures 1-1/2" high by 7/8" dia. base ($20, £9). **39. Mouse** measures 1-1/2" high by 1" dia. base ($12, £9). **40. Ram** measures 1-3/16" high by 1-3/8" overall ($12, £6).

Below:
SET 9, *1978*
Top row: 41. Dolphin measures 1-1/8" high by 1-3/4" overall ($38, £18). **42. Pelican** measures 1-3/4" high by 1-3/8" overall ($25, £8).
43. Angel Fish measures 1-3/8" high by 1-1/4" overall ($14, £7).
44. Turtle measures 9/16" high by 2" overall ($10, £6). This figurine is mold marked "Wade England" in a recess on the underside of the base. **45. Seahorse** measures 2" high by 3/4" dia. base ($24, £11).

SET 10, *1979*
Bottom row: 46. Kangaroo measures 1-5/8" high by 1-1/8" along the base ($14, £6). **47. Orangutan** measures 1-1/4" high by 1-1/4" across ($5, £5). **48. Tiger** measures 1-1/2" high by 1-1/8" overall ($17, £6). **49. Koala Bear** measures 1-3/8" high by 1-1/8" overall ($22, £12). **50. Langur** measures 1-3/8" high by 1-1/2" overall ($6, £5).

ANGEL FISH *(Set 9)*
Color variations.

51 52 53 54 55

56 57 58 59 60

SET 11, *1979*
Top row: 51. Bison measures 1-3/8" high by 1-3/4" overall ($15, £5). **52. Blue Bird** measures 5/8" high by 1-1/2" across the wings and is marked "Wade England" in a recess on the underside of the base ($10, £5). **53. Bull Frog** measures 7/8" high by 1" across the base and is marked "Wade England" in a recess on the underside of the base ($25, £14). **54. Wild Boar** measures 1-1/8" high by 1-5/8" overall ($9, £5). **55. Raccoon** measures 1" high by 1-1/2" overall ($16, £6).

SET 12, *1980*
Bottom row: 56. Penguin measures 1-5/8" high by 3/4" dia. base and is marked "Wade" at the front and "England" at the back of the base ($27, £15). **57. Seal Pup** measures 1" high by 1-1/2" overall ($22, £9). **58. Husky** measures 1-7/16" high by 1-1/8" overall ($22, £11). **59. Walrus** measures 1-1/4" high by 1-1/4" overall ($10, £4). **60. Polar Bear** measures 1-1/8" high by 1-5/8" overall ($22, £9).

BISON *(Set 11)*
Size variations. **Left: Bison** measures 1-1/8" high by 1-5/8" long, which is the later model ($5, £3). **Right: Bison** measures 1-3/8" high by 1-3/4" long, which is the earlier model ($15, £5).

BULL FROG
(Set 11)
Color variations.

WHIMSIES
Color variations of Squirrel, Penguin, Owl and Monkey.

BLUE BIRD AND SWALLOW
Comparison. **Left: Blue Bird** is the Whimsie bird from Set 11 and is also an all over blue color variation. **Right: Swallow** is the bird found on the tree Trunk Posy Vase and Swallow Dish of the late 1950s.

WHIMSIES
Color variations of Zebra, Ram, Gorilla and Lamb.

BLACK ZEBRA
A shrink packed black zebra on original display card ($70, £30).

FIELD MOUSE
A shrink packed field mouse on original display card.

SIMONS ASSOCIATES, *circa 1975*

In the mid 1970s, Simons Associates, Inc. of Los Angeles marketed 24 selected Whimsies that were individually shrink packed on decorative cards. For the list of figurines in this promotion refer to the illustration on the back of the display card.

Whimsie Elephant from Set 4.

Whimsie Spaniel from Set 1.

Collect all these Whimsies miniatures

little creatures from the farm, forest and jungle of solid porcelain.

Whimsies
Wade of England
Est. 1810

No.	Name
No. 1	RABBIT
No. 2	FAWN
No. 3	MONGREL
No. 4	SQUIRREL
No. 5	ELEPHANT
No. 6	SETTER
No. 7	CAT
No. 8	COLLIE
No. 9	ZEBRA
No. 10	BEAR CUB
No. 11	FIELD MOUSE
No. 12	OWL
No. 13	KITTEN
No. 14	CHIMP
No. 15	HORSE
No. 16	DUCK
No. 17	GIRAFFE
No. 18	SPANIEL
No. 19	LION
No. 20	GERMAN SHEPHERD
No. 21	LAMB
No. 22	PINE MARTEN
No. 23	CORGI
No. 24	HEDGEHOG

Illustration of the back of Simons Associates, Inc. display card.

Whimsies, Ltd.
A division of Simons Associates, Inc.
1801 Century Park East, Los Angeles, Ca 90067

WHIMSIES REISSUE, 1998 - 2000

In 1998, a set of four figurines from the 1971 - 1984 Whimsies and two figurines from Tom Smith Party Crackers were reissued in new colorways. The figurines were gift packaged in a hexagonal box. The size and mold marks of the new series (Set A) remained the same as those of the original figurines.

A second set of five 1971 - 1984 Whimsies and a Pup from a Tom Smith promotion were issued in new colorways in the year 2000. This second set (Set B) was packaged in a gift box similar to the first series.

WHIMSIES SET "A"
Top: **1. Lion** from Tom Smith Party Crackers Safari Set. **2. Raccoon** from Whimsies Set No.11. **3. Leopard** from Whimsies Set No. 7.
Bottom: **4. Hippo** from Whimsies Set No. 4. **5. Mole** from Tom Smith Party Crackers Wildlife Set. **6. Gorilla** from Whimsies Set No. 7 ($30 set, £18 set).

WHIMSIES REISSUE, 2001

Two new sets of Whimsies were issued in early 2001 in new colorways. Although these sets were referred to as "Whimsies" ten of the models were from the 1971 - 1979 Canadian Red Rose Tea Promotion of nursery figurines and two were from the Tom Smith Party Crackers. The size and mold marks of the two new series remain the same as those of the original figurines.

WHIMSIES "NURSERY" SET 1
Top: **1. Humpty Dumpty. 2. Little Red Riding Hood. 3. Old Woman in a Shoe.**
Bottom: **4. Hickory Dickory Dock. 5. Queen of Hearts. 6. Pus'n Boots** ($30 set, £18 set).

WHIMSIES SET "B"
Top: **7. Pup** from Tom Smith Party Crackers Your Pets Set. **8. Zebra** from Whimsies Set No. 7. **9. Kitten** from Whimsies Set No. 1.
Bottom: **10. Polar Bear** from Whimsies Set No. 12. **11. Beaver** from Whimsies Set No. 2. **12. Elephant** from Whimsies Set No. 4 ($30 set, £18 set).

WHIMSIES "NURSERY" SET 2
Top: 7. Little Bo Peep. 8. Tom the Piper's Son. 9. Little Boy Blue from Tom Smith Party Crackers "Tales from the Nursery."
Bottom: 10. Cat and the Fiddle. 11. Ride a Cock Horse from the Tom Smith Party Crackers "Tales from the Nursery." **12. Gingerbread Man** ($30 set, £18 set).

WHIMSIES "NURSERY" CHRISTMAS CRACKERS 2001
Top: 1. Dr. Foster. 2. Little Miss Muffet. 3. Mother Goose. 4. Wee Willie Winkie.
Bottom: 5. Jill. 6. Jack. 7. Little Jack Horner. 8. Goosey Gander ($34 set, £22).

WHIMSIES SPECIAL ISSUES

OIWCC WHITE SEAL 1996 - 1997
This color variation of the 1980 Whimsie Seal from Set 12 was issued to members renewing or joining The Official International Wade Collectors Club for the membership year 1996 - 1997 ($22, £10).

OIWCC BLUE ANGEL FISH 1998 - 1999
This color variation of the 1978 Whimsie Angel Fish from Set 9 was issued to members renewing or joining The Official International Wade Collectors Club for the membership year 1998 - 1999 ($20, £8).

BEAR CUB 2000
This all over gold glazed bear cub is similar to the 1971 - 1984 Whimsie figurine. The figurine was issued in a limited edition of 1,500 pieces given as a special gift to invited attendees of the October 2000 Wade Extravaganza held at Trentham Gardens ($10, £5).

WHIMTRAYS, 1958 - 1965

With the withdrawal of the early "Whimsies" in the late 1950s, Wade decided to use the remaining stock by producing small round "pintrays" with a small ledge on which to mount the figurines. With the addition of the Whimsie figurines to the trays, the obvious name for the trays was "Whimtray." There are many more combinations than those illustrated.

The early Whimtrays, 3" in diameter and 5/8" high, were produced in a variety of colors, yellow, green, black, blue/green, and pink. The first trays made in the Stoke-on-Trent potteries were of "Type A." The trays were all mold marked "Whimtrays" Wade Porcelain Made in England.

Sometime during the period of production the manufacturing of the Whimtrays was transferred to Wade (Ireland) Ltd. in Portadown. With the change in location of manufacture also came a change in the shape of the ledge supporting the figurines. See "Type B." The mold mark on the Irish trays was changed to Mark Type 41.

WHIMTRAY TYPES

101

1. **Cockatoo** on "Type A" made in England ($35, £14). **2. Penguin** on "Type B" tray made in Ireland ($35, £14).

3. **Llama** on "Type A" tray made in England ($35, £14). **4. Panda** on "Type A" tray made in England ($35, £14).

5. **Swan** on "Type A" tray made in England ($40, £18). **6. Boxer** on "Type A" tray made in England ($35, £14).

7. **Husky** on "Type B" tray made in Ireland ($35, £14). **8. Camel** on "Type A" tray made in England ($35, £14).

9. **Polar Bear Cub** on "Type B" tray made in Ireland ($35, £14). **10. Monkey and Baby** on "Type A" tray made in England ($35, £14).

11 & 12. Bear Cub on "Type A" tray made in England ($35 each, £14 each).

WHIMTRAYS, 1971 - 1987

Whimtrays were reintroduced with figurines from the 1971 - 1984 series of Whimsies. Only three figurines were used on black, green, and blue trays giving nine possible combinations.

Most trays bear the "Made in Ireland" trade mark however, some are found marked "Wade Made in England." All trays are "Type B" trays.

1. **Trout** made in Ireland ($25, £8). **2. Fawn** made in Ireland ($25, £8). **3. Trout** made in England ($25, £8). **4. Duck** made in Ireland ($25, £8).

102

WHIMTRAYS, *1987 - 1988*

The new Whimtrays, introduced in 1987, replaced the long-running shape of trays first introduced in 1958. The new, oval-shaped Whimtrays utilized figurines from the Whimsie-Land series. The new trays measure 4-1/2" long by 3-1/2" wide and are mold marked: Wade England.

Top: **1. Owl** ($28, £12). **2. Duck** ($28, £12). **3. Horse** (28, £12). Bottom: **4. Puppy** ($28, £12). **5. Squirrel** ($28, £12).

WHIMSIE-LAND SERIES, *1984 - 1988*

When the popular "Whimsies" series was withdrawn from the market, George Wade & Son Ltd. decided to fill the gap in their retail line with a new series of miniature figurines to be known as the "Whimsie-Land" series.

The new series was again based on animals and birds but on a slightly larger scale, more detailed in design, and more colorful than the "Whimsies." The series was not as popular as the "Whimsies" and lasted for only a few years. All figurines are mold marked "Wade England" around the base.

WHIMSIE - LAND SET 1, *1984 (Pets)*
Top: **1. Retriever** measures 1-1/4" high by 1-5/8" along the base ($16, £8). **2. Puppy** measures 1-3/8" high by 1-3/8" along the base ($9, £7). **3. Rabbit** measures 2" high by 7/8" dia. base ($32, £10).
Bottom: **4. Kitten** measures 1" high by 1-5/8" along the base ($15, £7). **5. Pony** measures 1-1/2" high by 1-1/2" along the base ($28, £10).

WHIMSIE - LAND SET 2, *1984 (Wildlife)*
Top: **6. Lion** measures 1-1/4" high by 1-7/8" along the base ($16, £9). **7. Tiger** measures 3/4" high by 1-3/4" along the base ($10, £8).
Bottom: **8. Elephant** measures 1-3/8" high by 1-3/8" along the base ($25, £10). **9. Panda** measures 1-3/8" high by 7/8" dia. base ($28, £8). **10. Giraffe** measures 2" high by 1-1/4" along the base ($32, £12).

WHIMSIE - LAND SET 3, *1985 (Farmyard)*
Top: **11. Rooster** measures 2" high by 1-1/8" along the base ($32, £12). **12. Duck** measures 1-5/8" high by 1" along the base ($27, £12). **13. Cow** measures 1-1/4" high by 1-1/4" along the base ($35, £17).
Bottom: **14. Pig** measures 1-1/8" high by 1-1/4" along the base ($15, £10). **15. Goat** measures 1-1/4" high by 1-1/8" along the base ($27, £10).

WHIMSIE - LAND SET 4, *1986 (Hedgerow)*
Top: **16. Fox** measures 1-3/8" high by 1-1/4" along the base ($38, £18). **17. Owl** measures 1-1/2" high by 7/8" along the base ($10, £7). **18. Hedgehog** measures 7/8" high by 1-1/4" along the base ($14, £7).
Bottom: **19. Badger** measures 1" high by 1-3/8" along the base ($15, £9). **20. Squirrel** measures 1-1/2" high by 3/4" along the base ($10, £7).

WHIMSIE - LAND SET 5, *1987 (British Wildlife)*
Top: **21. Pheasant** measures 1-1/4" high by 2" long ($37, £25).
22. Field Mouse measures 1-1/4" high by 1-1/2" long ($37, £25).
23. Golden Eagle measures 1-1/8" high by 1-3/4" long ($38, £25).
Bottom: **24. Otter** measures 1-1/2" high by 1-5/8" long ($28, £20). **25. Partridge** measures 1-1/2" high by 1-3/4" long ($28, £20).

WHIMSIE - LAND PONY *Set 1 (Pets)*
Color variation.

WHIMSIE - LAND TIGER *Set 2 (Wildlife)*
Color variations.

WHIMSIE - LAND PHEASANT *Set 5 (British Wildlife)*
Left: Prototype model. **Right:** Production model.

WHIMSIE - LAND OTTER *Set 5 (British Wildlife)*
Left: Prototype model. **Right:** Production model.

OWL *2001*
This "all-over" gold version of the Whimsie-Land owl was given away as a special entrance piece to collectors attending the April 2001 Trentham Gardens Wade Collectors Fair ($15, £10).

DUCK *2001*
This "all-over" pearlized version of the Whimsie-Land duck was given away as a special entrance piece to all paying visitors attending the October 2001 Trentham Gardens Wade Collectors Fair ($20, £15).

WHIMSIE - LAND KEY RINGS, *1988*

When Wade discontinued the Whimsie-Land series much of the remaining stock was made available as keyrings. The illustration shows the Duck, Puppy, Kitten, Panda, and Badger in the key ring format (N.P.A.).

CHAPTER 10
WHIMSEY-ON-WHY VILLAGE SETS

1980 - 1987

Whimsey-on-Why is the name given to a mythical English village made up of a series of miniature houses and buildings found in a typical English village.

The sets, the first of which was issued in 1980, were issued with eight models in each set except Set 5 which had only four models. Along with the miniature houses, Wade also published four issues of the "Whimsey-on-Why Chronicle." This was a "spoof" newspaper, as Wade felt that a true village should have its own paper. As well as introducing the latest "Whimsey-on-Why" village set, the "Chronicle" also announced a number of additions to the Wade gift ware line.

Nearly all models are mold marked "Wade England" on the base. The exceptions to this are: No.16 the Windmill and No. 32 the Market Hall which are not marked. Each model is numbered to identify its position in the series. A number of models were designed by Richard Wade, who based the designs on existing buildings in villages near his home.

SET 1, *1980*
Top: 1. Pump Cottage measures 1-1/8" high by 1-1/4" long ($14, £5). **2. Morgan's the Chemist** measures 1-3/4" high by 1-1/2" long ($24, £10). **3. Doctor Healer's House** measures 1-3/4" high by 1-1/2" long ($25, £10). **4. Tobacconist's Shop** measures 1-1/2" high by 1-1/2" long ($14, £5).
Middle: 5. Why Knott Inn measures 1-3/8" high by 1-1/2" long ($18, £6). **6. Bloodshott Hall** measures 2" high by 3-1/8" long ($25, £10).
Bottom: 7. St. Sabastian's Church measures 2-1/8" high by 3" long ($45, £18). **8. The Barley Mow** measures 1-1/2" high by 3" long ($35, £14).

105

SET 2, *1981*
Top: 9. Greengrocer's Shop measures 1-1/2" high by 3/4" deep ($15, £7). **10. Antique Shop** measures 1-1/2" high by 3/4" deep ($25, £10). **11. Whimsey Service Station** measures 1-1/2" high by 1-1/2" long ($25, £10). **12. Post Office** measures 1-1/2" high by 1-1/2" long ($15, £9).
Middle: 13. Whimsey School measures 1-5/8" high by 1-7/8" long ($55, £18). **14. Water Mill** measures 1-3/4" high by 2-1/2" long ($24, £12).
Bottom: 15. The Stag Hotel measures 1-7/8" high by 2-1/2" long ($24, £10). **16. Windmill** measures 2-1/4" high by 1-3/16" dia. base ($90, £44).

SET 3, *1982*
Top: 17. Tinker's Nook measures 1-3/8" high by 1" long ($12, £7). **18. Whimsey Station** measures 1-1/2" high by 1-1/2" long ($28, £18). **19. Merryweather Farm** measures 1-7/8" high by 1-7/8" long ($55, £30).
Middle: 20. The Vicarage measures 1-5/8" high by 2" long ($65, £45). **21. Broomyshaw Cottage** measures 1-5/8" high by 1-1/2" long ($15, £10). **22. The Sweet Shop** measures 1-5/8" high by 1-1/2" long ($15, £10).
Bottom: 23. Briar Row measures 1-3/8" high by 3" long ($45, £16). **24. The Manor** measures 1-7/8" high by 2-1/2" long ($25, £10).

SET 4, *1984-1985*
Top: **25. District Bank** measures 1-7/8" high by 1-1/2" long ($20, £8). **26. Old Smithy** measures 1" high by 1-3/4" long ($15, £10). **27. Picture Palace** measures 2-1/8" high by 2-1/2" long ($30, £18).
Middle: **28. Butcher's Shop** measures 1-5/8" high by 1" square ($30, £24). **29. The Barber's Shop** measures 1-5/8" high by 1" square ($30, £24). **30. Miss Prune's House** measures 1-1/2" high by 1-1/2" long ($20, £15).
Bottom: **31. Fire Station** measures 1-5/8" high by 1-3/4" long ($20, £15). **32. Market Hall** measures 1-7/8" high by 2" square ($20, £18).

SET 5, *1987*
33. School Teacher's House measures 1-3/4" high by 1-1/2" long ($40, £24). **34. Fish Monger's Shop** measures 1-5/8" high by 1" long ($40, £24). **35. Police Station** measures 1-5/8" high by 1" long ($40, £24). **36. Library** measures 2" high by 1-1/2" long ($30, £20).

WHIMSEY-in-the-VALE VILLAGE, *1993*

In February 1993, Wade Ceramics Ltd. introduced a new line of miniature houses. The new models utilized the same molds as those used for some of the Whimsey-on-Why Village houses. The applied decals were newly designed by Judith Wooten. Unlike the Whimsey-on-Why houses, the Whimsey-in-the-Vale houses are not numbered. After each model, the corresponding model from the Whimsey-on-Why series is listed.

Top: 1. St. Lawrence Church is the same model as No.7, Set 1 ($12, £10). **2. Town Garage** is the same model as No.32, Set 4 ($12, £10). **3. Vale Farm** is the same model as No.15, Set 2 ($12, £10).
Middle: 4. Boar's Head Pub is the same model as No.8, Set 1 ($12, £10). **5. St. John's School** is the same model as No.31, Set 4 ($10, £8). **6. Jubilee Terrace** is the same model as No. 23, Set 3 ($15, £10).
Bottom: 7. Antique Shop is the same model as No. 5, Set 1 ($15, £8). **8. Whimsey Post Office** is the same model as No. 9, Set 2 ($10, £8). **9. Rose Cottage** is the same model as No. 11, Set 2 ($14, £8). **10. Florist's Shop** is the same model as No. 11, Set 2 ($10, £8).

VILLAGE STORE SERIES, *1982 - 1986*

The original set comprised ten models: four storage jars, covered butter dish, covered cheese dish, and two size sets of salt and pepper shakers, a larger range-top size and a smaller size for use at the table. The smaller set of shakers was dropped from the line a year or two before the complete range was discontinued in 1986.

The storage jars were individually packaged and named with a color-coordinated label which matched the roof color of the storage jars which formed the removable lid.

1 **2** **3** **4**

STORAGE JARS
All storage jars measure 7-1/2" from base to top of chimney and are 3-5/8" square. All four containers are marked: Village Stores by Wade Staffordshire England. **1.** "**Ye Olde Tea Room**" tea caddy ($60, £35). **2.** "**Mrs. Smith, Ice Cream & Sweets**" sugar storage jar ($60, £40). **3.** "**The Coffee House**" coffee storage jar ($60, £35). **4.** "**B. Loaf, Baker & Cakes**" flour storage jar ($60, £40).

"THE CHALK AND CHEESE"
This is the covered cheese dish. The white base is 7-1/4" long by 5-1/4" wide and is unmarked. The house, in the design of an English pub, is 5" high by 6-1/4" long by 4-3/8" wide and is marked: Village Stores by Wade Staffordshire England ($60, £40).

"THE VILLAGE STORE POST OFFICE"
This is the covered butter dish. The base and lid combined measure 5" high, the roof being the removable lid. The base is 5-1/4" long by 3-3/4" wide and is marked: Village Stores by Wade Staffordshire England ($55, £45).

"POST OFFICE" *salt*
"POST OFFICE, ROYAL MAIL" *pepper*
Both of these small size shakers are from the same mold but with a different decal design even though both depict a post office. The houses measure 2-1/8" high by 1-1/4" long by 1" wide and both are marked: Wade England ($50 pair, £20 pair).

"A. SALT, GREENGROCER" *salt*
"B. PEPPER, FAMILY BUTCHER" *pepper*
Both of these large size shakers are from the same mold but with a different decal design. They measure 2-3/4" high by 2-1/8" long by 1-3/8" deep and are marked: Village Stores by Wade Staffordshire England ($55 pair, £25 pair).

"PAINTED LADIES" SERIES, *1984 - 1986*

This short lived "San Francisco Mini Mansions" set is similar in theme to the Whimsey-on-Why village sets but on a slightly larger scale. A companion piece to the Mini Mansions was a miniature Cable Car so typical of San Francisco. All models, including the Cable Car, are marked "Wade Porcelain England SF/1 through SF/6." This mark is located on the side wall of the Mini Mansions and on the back end of the Cable Car.

This series was designed and produced by Sir George Wade's daughter, Iris, and her husband Straker Carryer.

Top: 1. Pink Lady measures 2-1/4" high by 1" wide ($75, £45). **2. White Lady** measures 2-1/4" high by 1" wide ($70, £40). **3. Brown Lady** measures 2-1/2" high by 1-1/4" square ($70, £45).
Bottom: 4. Yellow Lady measures 2-1/2" high by 1-1/4" square ($60, £40). **5. Blue Lady** measures 2-7/8" high by 1-1/2" square ($60, £40). **6. Cable Car** measures 7/8" high by 1-1/2" long ($115, £90).

SPECIAL CABLE CAR
This miniature cable car is based on the cable car from the "Painted Ladies" series. One side of the car advertises White Label whisky and the other side advertises Dewars whisky. Other design variations exist ($115, £90).

110

CHAPTER 11
FIGURINES AND MINIATURES

by Wade (Ulster) Ltd., Wade (Ireland) Ltd., & Seagoe Ceramics Ltd. 1948 - early 1990s

In 1945, Colonel G. A. Wade (later Sir George Wade) was asked by the British government to create new production facilities in depressed areas of the country. In 1946, an old mill located in Portadown, Ulster (Northern Ireland) was purchased and Wade (Ulster) Ltd. was formed and incorporated on January 2, 1950.

In the early days, Wade (Ulster) Ltd. produced only industrial ceramics, but in 1952, with the death of King George VI, the coronation of Queen Elizabeth II was planned for 1953. The pottery was not equipped to manufacture gift ware, but a lathe once used for the production of insulators was retooled to produce coronation souvenir tankards. The tankards were such a success that various other lines of gift ware were proposed. The pottery then began the production of a long-lasting and extensive line of gift ware items.

Between the 1950s and 1980s the Irish pottery produced a number of figurines which included the Irish Porcelain Song Figures, the Irish Character Figures, and numerous leprechaun figurines. In 1966 the name of the Irish pottery was changed becoming Wade (Ireland) Ltd. The production of both industrial and giftware ceramics continued until 1998 when the gift ware lines were discontinued. The pottery then concentrated on the production of tableware items.

The Wade potteries were taken over by Beauford Plc in 1989 and the Irish pottery became independent with its name changed to Seagoe Ceramics Ltd. For a short time the Irish Character Figures and the Irish Porcelain Song Figures were reproduced using the original molds and a new backstamp (Mark Type 41A). In the 1990s, the pottery separated from the Wade Group and was eventually sold off.

"PEX" FAIRY, 1948 - 1950s

The figurine of a fairy was produced by Wade (Ulster) Ltd. as a promotional item for Pex Stockings. At the end of the promotion surplus figurines were mounted on a posy of porcelain flowers, which incorporated a candle holder behind the figurine and sold as gift ware items.

THE "PEX" FAIRY
2-3/8" high and originally had a black and gold paper label reading: Made in Ireland by Wade Co. Armagh. A number of color variations of the "Pex" fairy exist ($500, £260).

THE "PEX" FAIRY CANDLEHOLDER
3" high and is marked: Made in Ireland by Wade Co. Armagh ($600, £300).

POGO, 1959

This beautifully hand decorated and hard to find die-pressed figurine was modeled by William Harper from a design based on the Pogo newspaper cartoon strip.

POGO
3-1/4" high and is marked: "POGO" copyright Walt Kelly Made in Ireland 1959 ($650, £400).

LUCKY LEPRECHAUNS, circa 1956 - 1986

In the mid 1950s, Wade (Ireland) Ltd. began marketing souvenirs based on the famous Irish folk people, the Leprechauns. These figurines were made in a variety of shapes and sizes ranging from 1-1/2" high to 4" high. The miniature Lucky Leprechauns were issued in a variety of poses, plying their various trades. The early models originally had black and gold labels reading: Made in Ireland Wade, Co. Armagh. The later models were ink stamped on the base: Made in Ireland. Some leprechauns were marketed individually or in boxed sets of three and some were mounted on leaf dishes, pin trays or butterpats. A number of Wade leprechauns were also mounted on pieces of Irish marble but these combinations were produced by outside companies.

LUCKY LEPRECHAUN WITH CROCK OF GOLD
Color variations. The figurines are shape No. S. 2, measure 1-1/2" high, and maybe found unmarked or ink stamped Made in Ireland ($20, £8).

LUCKY LEPRECHAUN ON PIG
Color variations. The figurines are shape No. S. 8, measure 1-3/4" high, and maybe found unmarked or ink stamped Made in Ireland ($75, £35).

LUCKY LEPRECHAUN - COBBLER
Color variations. The figurines are shape No. S. 2, measure 1-1/2" high, and maybe found unmarked or ink stamped Made in Ireland ($20, £8).

LUCKY LEPRECHAUN ON ACORN
Color variations. The figurines measure 1-1/2" high and maybe found unmarked or ink stamped Made in Ireland ($80, £40).

LUCKY LEPRECHAUN - TAILOR
Color variations. The figurines are shape No. S. 2, measure 1-1/2" high, and may be found unmarked or ink stamped Made in Ireland ($20, £8).

PIXIE
1-3/8" high and is found with an ink stamp "Made in Ireland" or unmarked ($20, £8).

LUCKY LEPRECHAUN ON RABBIT
Color variations. The figurines measure 1-1/2" high and maybe found unmarked or ink stamped Made in Ireland ($80, £40).

LUCKY LEPRECHAUN PIN TRAYS circa 1956 -1986
Miniature leprechauns, Tailor, Cobbler, and Crock of Gold in a variety of color combinations mounted on the butter pat shape No. I.P.619. The shape number was changed to I.P.619L with the addition of the leprechauns to the butter pat ($25 each, £8 each).

LEPRECHAUN LEAF DISH
Shape No. S.3 with Mark Type 31 on the base. This oak leaf dish was made by George Wade & Son Ltd ($30, £14).

PIXIE ON SHAMROCK PINTRAY
Shape No. I.P.609P with Mark Type 29 on the base ($30, £14).

LEPRECHAUN TAILOR ON ASHTRAY
The ashtray measures 6" in dia. and has Mark Type 29 on the base ($55, £20).

"LEPRECHAUN ON ACORN" DISH
3-1/4" in dia. by 2-1/2" high and is mold marked "Wade England." This leprechaun/dish combination is quite hard to find ($30, £14).

LARGE LEPRECHAUNS
Color variations. The figurines are shape No. S.11, measure 2-3/4" high, and are ink stamped: Made in Ireland ($30 each, £25 each).

Left: Leprechaun Tailor on a Marble Base measures 2-1/8" high on a 2" by 1-1/2" marble base. The paper label on the underside of the base reads: Real Connemara Marble, Made in Ireland ($25, £10). **Right: Leprechaun Cobbler on a Marble Base** measures 2-7/16" high on a 2" by 1-1/2" marble base. The paper label on the underside of the base reads: Real Connemara Marble, Made in Ireland ($25, £10).

LEPRECHAUNS ON MARBLE BASE
3-1/8" wide by 2-1/2" deep. The paper label on the underside of the base reads: Real Connemara Marble, Made in Ireland ($25, £10).

Left: Larry is shape No. S.22, measures 4" high, and is found either unmarked or with an ink stamp Made in Ireland ($75, £55).
Right: Lester is shape No. S.22, measures 4" high, and is found either unmarked or with an ink stamp Made in Ireland ($75, £55). The only difference between Larry and Lester was the color of the glaze.

LARRY AND LESTER BOOKENDS
4-1/2" high and may be found either unmarked or marked with an ink stamp Made in Ireland ($80 each, £65 each).

PLAQUES AND MEDALLIONS, *early 1960s*

There are conflicting reports as to production dates for these medallions which were made by Wade (Ireland) Ltd. The medallions were produced for an outside company that subsequently applied them to various shaped pin boxes. A number of these plaques were amended, at the time of firing, to be used as pendants. All of these items are unmarked.

Top: 1. Plaque measures 3-1/4" in dia. ($45, £20). **2. Plaque** measures 3-3/8" by 2-3/4" ($45, £20). **3. Medallion** measures 2-3/4" by 2" ($30, £15).
Bottom: 4. Medallion measures 2-3/8" by 1-3/4" ($30, £15). **5. Plaque** measures 2-1/2" by 2" ($30, £15). **6. Medallion** measures 2-3/8" by 1-3/4" ($30, £15). **7. Medallion** measures 2-1/8" by 1-1/2" ($30, £15).

LEPRECHAUN ON A TOADSTOOL *early 1960s*
Shape No. C340, measures 4-1/2" high, and is transfer marked: Made in Ireland. This figurine was produced for a short period in the early 1960s ($55, £45).

YACHT WALL PLAQUES, *1955*

A set of three die-pressed wall plaques produced by the Irish pottery for approximately one year only. The plaques are mold marked: Made in Ireland by Wade. Each yacht wall plaque has a single hole for affixing the item to wall pins.

Left: Small Yacht Wall Plaque measures 3-3/8" high ($50, £38). **Center: Medium Yacht Wall Plaque** measures 4-1/8" high ($50, £38). **Right: Large Yacht Wall Plaque** measures 4-1/2" high ($50, £38).

LUCKY LEPRECHAUN DISPLAY
4" by 1-3/4" and is unmarked ($180, £90).

YACHT PROTOTYPE
This is a design modeled by William Harper but never went into production ($200, £100).

IRISH DUCK POSY BOWL circa mid 1950s - early 1960s 4-1/2" high by 7-1/2" long and has Mark Type 30 on the base ($100, £50).

IRISH DONKEY AND SIDE PANNIERS 1965
4" high and is transfer marked Made in Ireland. This donkey was in production for approximately one year only, circa 1965. This figurine has been found customized with various town names and used as souvenir items ($62, £40).

DONKEY AND CART POSY BOWL mid 1950s - late 1970s
Shape No. C.338, measures 6-1/4" overall by 4" high, and has Mark Type 31 on the base. Two variations of this vase exist. The earlier version has a space between the base and the underside of cart and spaces between the end of each shaft and the donkey's neck. The later version is solid in both areas described for the earlier version. It is not known exactly when this posy bowl was discontinued but it was still offered for sale in Wade (Ireland) Ltd. catalogs up until the late 1970s ($50, £30).

FLYING BIRDS, circa 1956 - 1959

In the August 1956 issue of *Pottery and Glass Trade Review* an advertisement titled the "Mourne Range" of porcelain miniatures illustrated the first set of "Flying Birds" in green and blue colors. The birds were packaged in presentation boxes of three birds of similar color. Toward the end of the run, a third, yellow colored bird was added to the line. The birds measure 1" high by 2-3/4" across the wings and were unmarked.

Left: Green Flying Bird ($20, £10). **Center:** Yellow Flying Bird ($24, £14). **Right:** Blue Flying Bird ($20, £10).

FLYING BIRDS circa late 1950s
This set consists of three Flying Birds. The birds were unmarked and each had three small holes in the back for affixing the item to the wall. The bird measures 1-1/4" high by 3" across the wingspan ($30 each, £22 each).

DONKEY AND CART POSY BOWL
This picture illustrates the differences between the two Donkey and Cart Posy Bowls. The earlier model measures 4" high and the later model measures 3-5/8" high.

115

PINK ELEPHANTS, *1959*

A series of comic elephants was produced with a variety of liquor-related comments printed on the figurines. Each elephant measures 1-1/2" high by 3" long.

Left: "Oh, my head!" is marked: Shamrock Pottery Made In Ireland ($65, £25). **Right: "Stick to water!"** is marked: Shamrock Pottery Made In Ireland ($65, £25).

"Never mix'em!" is marked: Made in Ireland ($65, £25).

BLACK IRISH ELEPHANT *1959*
1-1/2" high by 3" long and is marked: Shamrock Pottery Made in Ireland ($75, £30).

RHINOCEROS ASHTRAY, *1962*

This figure, described as a new outstanding design in ashtrays in the March, 1962 issue of *The Pottery Gazette and Glass Trade Review* has been found in two sizes.

Left: Small Rhino measures 5-1/2" high and has Mark Type 33 on the base ($160, £80). The rubber stopper in the base of the figure reads: CHEKALEKE Regd. No. 698795. **Right: Large Rhino** measures 8-1/4" high and has a shamrock leaf mark on the base ($200, £100).

IRISH COTTAGES, *1959 - 1980s*

The Irish cottage was originally introduced in the 1950s as part of the "Gifts from Old Ireland" series. Over its lengthy run, the roof of the cottage was decorated in a number of shades of yellow.

Cottage of Omagh is shape No. S.6, measures 2" high by 2-3/4" long and has an impressed mark: Shamrock Pottery Made in Ireland ($55, £25).

Top: Cottage of Dona o Hadee. Bottom: Irish Cottage. Sizes and back stamps are similar to the Cottage of Omagh ($55, £25).

Cottage and Leprechaun Tailor is shape No. S.9. This combination of shape S.6 and S.2 is mounted on a base in the shape of Ireland and was in production between 1960 and 1970 and is marked: Shamrock Pottery Made in Ireland by Wade of Armagh ($100, £85).

Cottage and Leprechaun Pot of Gold ($55, £25).

COMIC IRISH PIG, 1959

These comic pigs were originally introduced in the 1950s as part of the "Gifts from Old Ireland" series. The figurines are found with a variety of decorations.

The pigs measure 1-3/4" high by 2-7/8" overall and have a transfer mark: Shamrock Pottery Made in Ireland. The mark is decorated with two green shamrock leaves ($65 each, £25 each).

BLACK IRISH PIG 1959
1-3/4" high by 2-7/8" long and is marked: Shamrock Pottery Made in Ireland ($75, £30).

IRISH CHARACTER FIGURES, circa early 1970s - 1986

This set of nine figurines based on characters from typical Irish songs and folk tales is ink stamped "Made in Ireland." Some of the figurines have the name of the character molded into the front of the base.

Top: 1. Danny Boy is shape No. S.16 and measures 4" high ($65, £28). **2. Mother MacCree** is shape No. S.19 and measures 2-1/2" high ($40, £20). This figurine is frequently found in a light single glaze (as illustrated) as well as a multi colored glaze. **3. Molly Malone** is shape No. S.17 and measures 3-1/4" high ($50, £26). **4. Kathleen** is shape No. S.18 and measures 3-1/2" high ($48, £22). **5. Eileen Oge** is shape No. S.25 and measures 3-3/4" high ($46, £22).
Bottom: 6. Phil the Fluter is shape No. S.20 and measures 3-1/4" high ($60, £35). **7. Paddy Reilly** is shape No. S.26 and measures 3-3/4" high ($95, £65). **8. Rose of Tralee** is shape No. S.24 and measures 4" high ($52, £30). **9. Paddy Maginty** is shape No. S.21 and measures 3-1/4" high ($60, £30).

MOTHER MacCREE
Color variations ($40, £20).

DANNY BOY
Color variation sampled for Boxpak Ltd. of Belfast ($70, £30).

MOLLY MALONE
Color variation.

PADDY MAGINTY PIPE REST *late 1980s*
3-5/8" high and has Mark Type 40A on the base ($100, £60).
PHIL THE FLUTER PIPE REST *late 1980s*
3-3/4" high and has Mark Type 40A on the base ($100, £60).

IRISH CHARACTER FIGURES *(Seagoe Ceramics reissue), early 1990s*

The Irish character figures were reintroduced by Seagoe Ceramics Ltd. in the early 1990s. Although the same tools were used for the reissue, the glaze was much darker with a pronounced all-over honey glaze. Each figurine had Mark Type 41A, which, in many cases, would wash off.

Top: **1. Danny Boy** is shape No. S.16 and measures 4" high ($40, £20). **2. Mother MacCree** is shape No. S.19 and measures 2-1/2" high ($40, £18). **3. Molly Malone** is shape No. S.17 and measures 3-1/4" high ($45, £22). **4. Kathleen** is shape No. S.18 and measures 3-1/2" high ($40, £20). **5. Eileen Oge** is shape No. S.25 and measures 3-3/4" high ($40, £20). Bottom: **6. Phil the Fluter** is shape No. S.20 and measures 3-1/4" high ($60, £30). **7. Paddy Reilly** is shape No. S.26 and measures 3-3/4" high ($48, £28). **8. Rose of Tralee** is shape No. S.24 and measures 4" high ($45, £25). **9. Paddy Maginty** is shape No. S.21 and measures 3-1/4" high ($48, £28).

118

IRISH SONG FIGURES, *1962 - 1986*

Unlike the "Irish Character Figures" the "Irish Porcelain Song Figures" were very much a prestige line of most carefully manufactured and hand painted figurines. The line consisted of eleven figurines. Eight figurines measure approximately 6" high and were designed by William Harper. The remaining three figurines measure approximately 8" high and were designed by Raymond Piper. The 6" high figurines are marked "Irish Porcelain Made in Ireland" along with the name of the figurine and the name of the designer. The three 8" high figurines are only marked "Irish Porcelain Figures - Made in Ireland."

Top: **1. Little Crooked Paddy** is shape No. C.503 ($420, £295). **2. Phil the Fluter** is shape No. C.500 ($380, £300). **3. Widda Cafferty** is shape No. C.501 ($380, £325). **4. The Bard of Armagh** is shape No. C.510. ($350, £300).
Bottom: **5. The Star of the County Down** is shape No. C.505 ($350, £300). **6. The Irish Emigrant** is shape No. C.504 ($350, £300). **7. Molly Malone** is shape No. C.506 ($400, £350). **8. Mickey Mulligan** is shape No. C.502 ($375, £325).

119

Mother MacCree is shape No. C.508 ($525, £295).

Dan Murphy is shape No. C.507 ($420, £295).

IRISH SONG FIGURES *(Seagoe Ceramics reissue,)* early 1990s

The Irish Song Figures were reintroduced by Seagoe Ceramics Ltd. in the early 1990s. Although the same tools were used for the reissue, there were noticeable differences in the glaze. The reissued figurines had the Seagoe/Wade Mark Type 41A.

Mother MacCree is the reissued shape No. C.508 ($430, £245).

Dan Murphy is the reissued shape No. C.507 ($345, £245).

Left: Eileen Oge is shape No. C.509 ($380, £300). **Right: Baby** measures 4-1/4" high. Both figurines are transfer marked: Irish Porcelain Figures Made in Ireland ($380, £300).

Eileen Oge is the reissued shape No. C.509 ($315, £250).

120

LARGE ANIMAL FIGURINES, *1978 - circa 1980*

A proposed series of large animal figurines consisted of: Walrus, Bear, Koala Bear, Rhino, Elephant, Panda and possibly a Lion. The set was not connected to the earlier "Blow-Up" polar bear, polar bear cub, and seal, which were produced in the early 1960s by George Wade & Son Ltd.

1. Walrus measures 3-3/4" high by 6" long and is transfer marked: Wade Ireland ($650, £450).

2. Rhino measures 3" high by 6-3/4" long and is unmarked ($650, £450).

3. Elephant measures 3-3/4" high by 5-1/2" long and is unmarked ($650, £450).

4. Panda measures 4-1/4" high and has a transfer mark: Wade Ireland ($650, £450).

"BALLY - WHIM" VILLAGE, *1984 - 1987*

With the popularity of the English village series "Whimsey-on-Why," Wade (Ireland) Ltd. introduced a series of miniature houses typical of those found in an Irish Village. The Irish village was given the name of "Bally-Whim." Each miniature house is mold marked Wade Ireland and each model bears its number in the series.

Top: 1. Undertaker's House measures 2" high by 1-1/2" long ($30, £12). **2. Moore's Post Office** measures 1-1/2" high by 1" long ($30, £12). **3. Barney Flynn's Cottage** measures 1-1/8" high by 1-3/4" long ($30, £12).
Middle: 4. Kate's Cottage measures 1-1/8" high by 1-3/4" long ($35, £14). **5. The Dentist's House** measures 2" high by 1-3/4" long ($35, £14). **6. Mick Murphy's Bar** measures 1-3/4" high by 1-1/2" long ($35, £14).
Bottom: 7. W. Ryan's Hardware Store measures 1-1/2" high by 1-1/2" long ($35, £14). **8. Bally-Whim House** measures 2" high by 3-1/4" long ($35, £14).

CHAPTER 12
PREMIUMS AND PROMOTIONS

by George Wade & Son Ltd. and Wade Ceramics Limited, mid 1960s - 2002

In the mid 1960s, George Wade & Son Ltd. decided to enter the manufacturing side of the premiums business by producing a series of miniature animal figurines at a cost low enough to compete in the premiums market.

The production process started by the pressing of damp clay dust into steel dies. After drying, came the "fettling" process, the cleaning and cutting away of any unwanted mark or piece of clay sticking to the figurine after removal from the metal die. The figurine was then ready for decoration. First underglaze colors were hand-applied directly onto each figurine. Next the figurines were sprayed with a transparent glaze as they moved down a conveyor belt. Finally the miniatures were fired at 1,250 degrees Celsius, cooled, packaged, and distributed.

An illustration from early 1960s trade literature shows 20 different figurines comprising the "early range" of George Wade & Son Ltd. premiums. It was from this range that promotional issues for various companies were selected. Note the hard to find panda in the second row from the bottom. Many of the figurines in this "early range" were mold marked in a recess in the base.

Due to the success of the "early range" of premiums, additional figurines were added to the range. The "extended range" of 40 figurine premiums by George Wade & Son Ltd. is shown in an illustration from the Spring 1969 trade literature. Note that the panda was dropped from the range. This range of figurines was eventually developed into a full retail line of 60 miniature animals marketed under the name of "Whimsies."

MISCELLANEOUS PREMIUMS
Notable miscellaneous additions to the "extended range" were: **Left: Panda** measures 1-1/2" high ($25, £15). This panda is frequently mistaken for the panda from the 1958 Early Whimsies Set 8 (Zoo Set). **Right: Black Zebra** measures 1-5/8" high and is mold marked Wade England ($70, £30).

BROWN BEAR
Color and mold variations. **Left: Bear** measures 1-1/2" high, is mold marked Wade England and is the later version ($75, £20). **Right: Bear** measures 1-5/8" high, is unmarked and is the earlier version ($85, £30).

BALDING AND MANSELL, 1965

A series of eight figurines commissioned by Balding and Mansell to be included in boxes of Christmas party crackers marketed under the name of The Flintstones Party Crackers.

Top: 1. Rhino measures 1" high ($30, £6). **2. Tiger** measures 1-1/2" high ($30, £6). **3. Dino** measures 1-3/8" high ($30, £6). **4. Bronti** measures 1" high ($30, £6).
Bottom: 5. Bluebird measures 5/8" high ($10, £5). **6. Terrapin** measures 3/8" high ($10, £5). **7. Crocodile** measures 1/2" high ($10, £5). **8. Hedgehog** measures 7/8" high ($8, £3). The last four figurines were to be used in future promotions but the prehistoric characters were not used again.

Trade Literature from the early 1960s illustrating the early range of 20 premium figurines

Trade Literature from Spring 1969 illustrating the extended range of premium figurines

123

CANADIAN RED ROSE TEA PROMOTION, 1967 - 1973

This was the first series of miniature animals to be used as promotional items by Red Rose Tea produced by Brooke Bond Foods Ltd. This first Canadian Red Rose Tea promotion consisted of 32 figurines chosen from the "extended range" of Wade premium models. All figurines were pressed and mold marked WADE ENGLAND. The promotion was such a success that many of the figurines were later used in the retail line of "Whimsies."

The first 25 figurines in the series are identical to the 1971 - 1984 retail Whimsies with the exception of the Wild Boar. The Red Rose Tea Wild Boar is an all-over light brown glaze whereas the retail Whimsie Wild Boar has a green base. This color variation has been verified by a major Canadian dealer and numerous collectors who found the figurine in original boxes of tea. The last seven figurines were not used for the "Whimsies" line although the Frog was from the same mold but in a different colorway.

Top: **1. Fawn** measures 1-3/8" high ($5, £3). **2. Rabbit** measures 1-1/8" high ($5, £3). **3. Mongrel** measures 1-3/8" high ($5, £3). **4. Kitten** measures 1-3/8" high ($8, £3).
Bottom: **5. Spaniel** measures 1-3/8" high ($5, £3). **6. Duck** measures 1-1/4" high ($8, £3). **7. Corgi** measures 1-1/2" high ($8, £3). **8. Beaver** measures 1-1/4" high ($5, £3).

Top: **17. Giraffe** measures 1-1/2" high ($5, £3). **18. Chimp** measures 1-1/2" high ($5, £3). **19. Hippo** measures 1" high ($5, £3). **20. Squirrel** measures 1-3/8" high ($5, £3). **21. Hedgehog** measures 7/8" high ($8, £3).
Bottom: **22. Alsatian** measures 1-1/4" high ($6, £3). **23. Bison** measures 1-1/8" high ($5, £3). **24. Blue Bird** measures 5/8" high ($10, £5). **25. Wild Boar** all-over light brown (no green base) measures 1-1/8" high ($9, £5).

Top: **26. Frog** non-retail measures 7/8" high ($10, £3). **27. Butterfly** non-retail measures 1/2" high by 1-3/4" across wing span ($12, £4). **28. Poodle** non-retail measures 1-5/8" high by 1-5/8" long ($10, £4). **29. Seal** non-retail measures 1-1/2" high by 1-1/4" along the base ($10, £5).
Bottom: **30. Angel Fish** non-retail measures 1-1/4" high by 1-3/8" long ($10, £5). **31. Terrapin** non-retail measures 3/8" high by 1-5/8" long ($10, £5). **32. Alligator** non-retail measures 1/2" high by 1-1/2" long ($10, £5).

Left:
Top: **9. Bush Baby** measures 1-1/4" high ($5, £3). **10. Fox** measures 1-3/8" high ($6, £3). **11. Bear Cub** measures 1-3/8" high ($5, £3). **12. Otter** measures 1-1/4" high ($5, £3).
Bottom: **13. Setter** measures 1-3/8" high ($5, £3). **14. Owl** measures 1-1/2" high ($5, £3). **15. Trout** measures 1-1/8" high ($8, £4). **16. Lion** measures 1-3/8" high ($5, £3).

TERRAPIN
Color variations.

COLOR VARIATIONS.
1. **Bear Cub** with recessed base. 2. **Beaver** with recessed base.
3. **Bison**. 4. **Butterfly**. 5. **Hedgehog**.

CANADIAN RED ROSE TEA PROMOTION, 1971 - 1979

Due to the outstanding success of the 1967 - 1973 promotion of miniature animals, Brooke Bond Foods Ltd. decided to launch a second series of promotional figurines in their boxes of Red Rose Tea sold in Canada. The theme of the new series was based upon characters from popular nursery rhymes.

Although there was no official name for the series, it has become known as "Nurseries." This name came about when Wade launched a short-lived retail line of figurines from the promotion which was named "Nurseries." For some reason the retail line was not a success and only a presentation box of five figurines was offered in the line.

Top: 1. **Old King Cole** measures 1-1/2" high by 1-1/4" long ($10, £8). 2. **Little Jack Horner** measures 1-3/8" high by 1" across the base ($7, £5). 3. **Jack** measures 1-1/4" high by 1-1/4" long ($12, £9). 4. **Jill** measures 1-1/8" high by 1-1/4" long ($12, £9).
Bottom: 5. **Humpty Dumpty** measures 1-1/2" high by 7/8" long ($6, £5). 6. **Tom the Piper's Son** measures 1-5/8" high by 1-3/8" long ($12, £8). 7. **Little Boy Blue** measures 1-5/8" high by 1" across the base ($12, £8). 8. **The Pied Piper** measures 1-3/4" high by 1-1/8" long ($10, £6).

Top: 9. **Little Miss Muffet** measures 1-1/2" high by 1-3/8" long ($12, £8). 10. **Doctor Foster** measures 1-3/4" high by 7/8" dia. base ($12, £10). 11. **Mother Goose** measures 1-5/8" high by 1-1/4" long ($14, £12). 12. **Old Woman Who Lived in a Shoe** measures 1-3/8" high by 1-5/8" long ($8, £6).
Bottom: 13. **Goosey - Gander** measures 1-3/8" high by 1" long ($10, £6). 14. **Wee Willie Winkie** measures 1-3/4" high by 1" long ($10, £6). 15. **Little Bo-Peep** measures 1-3/4" high by 3/4" dia. base ($7, £3). 16. **The Three Bears** measures 1-3/8" high by 1-1/2" long ($28, £20).

Top: 17. **Puss in Boots** measures 1-3/4" high by 3/4" dia. base ($12, £10). 18. **The House That Jack Built** measures 1-1/4" high by 1-1/4" long ($14, £12). 19. **Little Red Riding Hood** measures 1-3/4" high by 7/8" long ($12, £6). 20. **Queen of Hearts** measures 1-3/4" high by 1" across the base ($16, £12).
Bottom: 21. **Baa Baa Black Sheep** measures 7/8" high by 1-1/8" long ($16, £14). 22. **Hickory Dickory Dock** measures 1-3/4" high by 3/4" square base ($7, £6). 23. **Ginger Bread Man** measures 1-5/8" high by 1-1/16" across ($40, £30). 24. **Cat and the Fiddle** measures 1-7/8" high by 1" across ($28, £20).

125

QUEEN OF HEARTS
Variations of heart design. **Left:** Multiple hearts ($45, £32). **Center:** Two small hearts ($16, £12). **Right:** Two large hearts ($16, £12).

MISCELLANEOUS RED ROSE TEA FIGURINES
Color variations. Old Woman, Jill, House that Jack Built, Puss in Boots, Jack, and Hickory Dickory Dock.

OLD KING COLE
Mold variations. **Left:** Space between feet. **Right:** No space between feet.

MISCELLANEOUS RED ROSE TEA FIGURINES
Color variations. Tom Piper, Old King Cole, Cat and Fiddle, Wee Willie Winkie, House that Jack Built, and Little Boy Blue.

MISCELLANEOUS RED ROSE TEA FIGURINES
Color variations. Dr. Foster, Pied Piper, Little Bo Peep, Red Riding Hood, Miss Muffet, and Queen of Hearts.

HAND PAINTED RED ROSE TEA FIGURINES
These four enamel finished figurines of Old Woman in the Shoe, Little Red Riding Hood, Little Bo Peep, and Humpty Dumpty were not produced by Wade in this finish. The bright colors were added by an outside party ($8 each, £4 each).

CANADIAN RED ROSE TEA PROMOTION, *1981*

In 1981, Brooke Bond Foods Ltd. started a new Red Rose Tea promotion using the complete range of the Wade retail line of "Whoppas." The retail line of "Whoppas" had been discontinued in 1981 so this promotion was an excellent way of disposing of extra stock. Unlike previous tea promotions where the figurine was packed in the box of tea bags, this was a "mail-in offer." Collectors had to mail a premium tab from the box of tea bags along with $1.00 to claim the figurine. This promotion was not a great success and lasted for less than one year. For illustrations of this promotion, see the 1976 - 1981 retail line of "Whoppas."

Advertisement from the April 1981 issue of *"Today"* magazine illustrating the Red Rose Tea "mail - in" offer for the Wade Whoppa figurines

CANADIAN RED ROSE TEA PROMOTION, *1982 - 1984*

In late 1982 Brooke Bond Foods Ltd. began yet another Red Rose Tea promotion. This fourth promotion comprised 23 figurines all taken from the retail line of the 1971 - 1984 Whimsies.

Top: 1. Rabbit measures 1-1/8" high ($5, £3). **2. Corgi** measures 1-1/2" high ($8, £3). **3. Beaver** measures 1-1/4" high ($5, £3). **4. Bush Baby** measures 1-1/4" high ($5, £3).
Bottom: 5. Fox measures 1-3/8" high ($6, £3). **6. Giraffe** measures 1-1/2" high ($5, £3). **7. Pine Marten** measures 1-3/8" high ($5, £4). **8. Collie** measures 1-1/4" high ($8, £5).

Top: 9. Cow measures 1-1/4" high ($12, £5). **10. Pig** measures 13/16" high ($22, £6). **11. Horse** measures 1-5/8" high ($21, £5). **12. Lamb** measures 1-3/8" high ($10, £5).
Bottom: 13. Rhino measures 7/8" high ($5, £5). **14. Leopard** measures 7/8" high ($8, £5). **15. Gorilla** measures 1-1/2" high ($5, £5). **16. Camel** measures 1-3/8" high ($10, £5).

Top: **17. Zebra** measures 1-5/8" high ($9, £5). **18. Pelican** measures 1-3/4" high ($25, £8). **19. Angel Fish** measures 1-3/8" high ($14, £7). **20. Turtle** measures 9/16" high ($10, £6).
Bottom: **21. Sea Horse** measures 2" high ($24, £11). **22. Orangutan** measures 1-1/4" high ($5, £5). **23. Langur** measures 1-3/8" high ($6, £5).

CANADIAN SALADA* TEA PROMOTION, *1984*
(* Registered Trade Mark of Kellogg Salada Canada Inc.)

From September to December, 1984, Kellogg Salada Canada Inc., began a "mail-in" offer for a series of premiums based upon six miniature houses from the popular "Whimsey-on-Why" village sets.

Top: **1. Tobacconist's Shop** from "Whimsey-on-Why" set one ($14, £5). **2. Whimsey Station** from "Whimsey-on-Why" set three ($28, £18). **3. Antique Shop** from "Whimsey-on-Why" set two ($15, £10).
Bottom: **4. Post Office** from "Whimsey-on-Why" set two ($15, £9). **5. Pump Cottage** from "Whimsey-on-Why" set one ($14, £5). **6. Greengrocer's Shop** from "Whimsey-on-Why" set two ($15, £7).

CANADIAN SALADA* TEA CADDY

This Tea Caddy, based upon the Tea Caddy from The Wade "Village Stores" canister set was offered along with the miniature houses. The design was identical to the original Tea Caddy except for a revised decal above the store front door. The decal has the word "Salada" in the center with "Salon de thé" on the left and "Ye Olde Tearoom" on the right. The decal was in both French and English to satisfy the bilingual requirements of the Canadian Government.

U.S.A. RED ROSE TEA PROMOTION, *1983 - 1985*

After market testing in Pittsburgh and the Pacific North West, Brooke Bond launched the first U.S. Red Rose Tea promotion using Wade miniatures. The series comprised 15 figurines; thirteen were chosen from the Wade Whimsies line and two were similar to Tom Smith figurines from the 1980 - 1981 Wildlife Set. For economic reasons, all the figurines had a single glaze rather than the hand painted glazes, as on the Whimsies retail line.

Top: **1. Chimp** measures 1-1/2" high ($5, £7). **2. Lion** measures 1-3/8" high ($5, £5). **3. Bison** measures 1-1/8" high ($8, £3). **4. Bush Baby** measures 1-1/4" high ($8, £6).
Bottom: **5. Owl** measures 1-1/2" high ($10, £12). **6. Bear Cub** measures 1-3/8" high ($8, £3). **7. Rabbit** measures 1-3/4" high ($8, £6). This figurine is sometimes referred to as Hare and was used in the 1980 - 81 Tom Smith Cracker set but with a different glaze. **8. Squirrel** measures 1-1/2" high ($8, £6). This figurine was used in the 1980 - 81 Tom Smith Cracker set but with a different glaze.

Top: **9. Bird** measures 5/8" high ($8, £6). **10. Otter** measures 1-1/4" high ($8, £3). **11. Hippo** measures 1" high ($5, £3). **12. Seal** measures 1-1/2" high ($8, £3).
Bottom: **13. Turtle** measures 9/16" high ($8, £4). **14. Wild Boar** measures 1-1/8" high ($8, £2). **15. Elephant** measures 1-3/8" high ($20, £12).

U.S.A. RED ROSE TEA PROMOTION, *1985 - 1995*

Following the success of the first U.S. promotion, a new series of figurines was introduced in mid 1985. Once again this set of premiums consisted of 15 figurines taken from the "Whimsies" retail line, the only difference being the single glaze, consistent with the first U.S. series. All figurines are mold marked "Wade England" around the base.

Top: **1. Koala Bear** measures 1-3/8" high ($6, £3). **2. Giraffe** measures 1-1/2" high ($5, £3). **3. Pine Marten** measures 1-3/8" high ($5, £3). **4. Langur** measures 1-3/8" high ($6, £5).
Bottom: **5. Gorilla** measures 1-1/2" high ($5, £4). **6. Camel** measures 1-3/8" high ($5, £4). **7. Kangaroo** measures 1-5/8" high ($8, £6). **8. Tiger** measures 1-7/16" high ($5, £4).

Top: **9. Zebra** measures 1-5/8" high ($6, £10). **10. Polar Bear** measures 1-1/8" high ($6, £5). **11. Orangutan** measures 1-1/4" high ($5, £3). **12. Raccoon** measures 1" high ($6, £5).
Bottom: **13. Rhino** measures 7/8" high ($6, £4). **14. Beaver** measures 1-1/4" high ($6, £5). **15. Leopard** measures 13/16" high ($5, £3).

CANADIAN RED ROSE TEA PROMOTION, *1985 - 1986*

In June 1985, Brooke Bond Inc. was taken over by Thomas J. Lipton, Inc. becoming the Canadian distributor of Red Rose Tea. The new owners followed in the footsteps of Brooke Bond and introduced another set of promotional figurines for the Canadian market. The fifteen figurines used were similar to the 1985 - 1995 U.S. Red Rose Tea promotion.

U.S.A. RED ROSE TEA PROMOTION, *1990 - 1996*

In 1990, five figurines were added to the 1985 - 1995 U.S. Red Rose Tea promotion. These figurines were similar to ones used in the 1988 - 1989 Tom Smith "Your Pets" series. All figurines are mold marked "Wade England," except for the Cock-a-Teel, which is marked "Wade Eng."

Top: **16. Puppy** measures 1" high ($7, £3). **17. Rabbit** measures 1-1/8" high ($7, £4). **18. Kitten** measures 1" high ($6, £4).
Bottom: **19. Pony** measures 1" high ($7, £4). **20. Cock-a-Teel** measures 1-3/8" high and is referred to as Parrot in the Tom Smith series ($7, £3).

129

U.S.A. RED ROSE TEA PROMOTION, 1993 - 1998

To the dismay of collectors, for their next promotion Red Rose Tea selected the circus animals first used in the 1978 - 1979 Tom Smith Circus set. There was very little difference in the glaze of these figurines except for the two monkey figurines, which had an all-over brown glaze, and the seal, which had a light gray glaze as opposed to the greenish/gray glaze of the Tom Smith seal. The two Red Rose Tea elephants are often found with a lighter blue glaze than the Tom Smith Elephants but this is hard to judge unless the figurines are set side-by-side. All figurine are marked "Wade England."

RED ROSE TEA FIGURINES
Color variations.

TIGER
Mold variations. **Left: Tiger.** Note the "ruff," the additional hair on the belly, and smaller feet on the newer version of the tiger. **Right: Tiger.** This is the earlier version of the tiger.

Top: **1. Seal** measures 1-5/8" high ($6, £4). **2. Sitting Elephant** measures 1-1/4" high ($8, £4). **3. Bear** measures 1-3/16" high ($8, £4). **4. Poodle** measures 1-3/4" high ($8, £4). **5. Male Monkey** measures 1-5/8" high ($6, £8).
Bottom: **6. Standing Elephant** measures 1-3/16" high ($8, £4). **7. Tiger** measures 1-5/8" high ($8, £4). A mold variation of this tiger exists with a small "ruff" under the jaw. **8. Lion** measures 1-5/8" high ($6, £4). **9. Female Monkey** measures 1-1/2" high ($6, £8). **10. Horse** measures 1-3/4" high ($8, £4).

U.S.A. RED ROSE TEA PROMOTION, 1996 - 1998

In 1996, Red Rose Tea added five figurines to the Circus figurine promotion. These were all new models. The two Clowns and Ringmaster are marked WADE ENG. with the Strongman and Human Cannonball marked WADE ENGLAND.

U.S.A. RED ROSE TEA PROMOTION, 1998 - 2002

Between 1998 and 2002, the U.S. Red Rose Tea promotion comprised ten figurines in the Endangered North American Animals series. Of the ten figurines, three of them, the eagle, owl, and polar bear, had been used before. The remaining seven figurines were new models for this promotion. All are mold marked WADE ENGLAND except for the Peregrine Falcon, which is marked WADE ENG.

Top: **1. Green Sea Turtle** measures 1-1/4" high by 1-3/4" long ($5, £2). **2. Wolf** measures 1-3/4" high ($5, £2). **3. Spotted Owl** measures 1-1/2" high ($5, £2). This was originally issued as part of the 1971 - 84 "Whimsies."
Bottom: **4. Sturgeon** measures 1-1/8" high by 2" long ($5, £2). **5. Bald Eagle** measures 1-1/8" high ($5, £2). This was originally used in the Whimsie-Land British Wildlife Set.

Left:
Top: **11. Strongman** measures 1-1/2" high ($8, £5). **12. Human Cannonball** measures 1-1/8" high ($8, £5). **13. Clown with Drum** measures 1-5/8" high ($8, £5).
Bottom: **14. Clown with Pie** measures 1-1/2" high ($8, £5). **15. Ringmaster** measures 1-3/4" high ($8, £5).

Top: 6. Manatee measures 1"high by 2" long ($5, £2).
7. Peregrine Falcon measures 1-3/4" high by 7/8" across the base ($5, £2). **8. Polar Bear** measures 1" high by 1" ($5, £2). This was originally used in the Tom Smith Survival Set.
Bottom: 9. Hump Backed Whale measures 5/8" high by 1" long ($5, £2). **10. Florida Panther** measures 1-3/8" high by 1-3/4" long ($5, £2).

U.S.A. RED ROSE TEA PROMOTION, *2002*

In May 2002, Redco Foods introduced a new series of figurines to be packaged in their boxes of Red Rose Tea. The theme for the new series is "Noah's Ark" and consists of seven pairs of male and female animals and a combined figurine of Noah and his wife. Also available is a larger display piece of the Ark, which is large enough to hold all the figurines on the deck. All figurines for this series are new models.

Top: 1. Noah and his wife measures 1-1/16" high and is mold marked Wade Eng ($3, £2). **2. Lioness** measures 7/8" high and is mold marked Wade England ($3, £2). **3. Lion** measures 1-1/8" high by 1-3/8" long and is mold marked Wade England ($3, £2). **4. Female Elephant** measures 1-1/8" high by 1-3/8" long and is mold marked Wade Eng ($3, £2). **5. Male Elephant** measures 1-1/2" high by 1-1/2" overall and is mold marked Wade Eng ($3, £2).
Middle: 6. Goose measures 1-3/8" high by 1-3/8" overall and is mold marked Wade Eng ($3, £2). **7. Gander** measures 1-1/4" high by 1-1/2" overall and is mold marked Wade England ($3, £2). **8. Ram** measures 1" high by 1-1/8" long and is mold marked Wade Eng ($3, £2). **9. Ewe** measures 7/8" high by 1-1/8" long and is mold marked Wade England ($3, £2). **10. Rooster** measures 1-1/2" high by 1" across and is mold marked Wade Eng ($3, £2). **11. Hen** measures 1-1/8" high by 1-1/8" overall and is mold marked Wade England ($3, £2).
Bottom: 12. Male Zebra measures 1-1/8" high by 1-1/4" overall and is mold marked Wade Eng ($3, £2). **13. Female Zebra** measures 1-1/8" high by 1-1/4" overall and is mold marked Wade England. **14. Male Rhino** measures 1-1/4" high by 1-5/8" overall and is mold marked Wade England ($3, £2). **15. Female Rhino** measures 1-1/8" high by 1-3/8" overall and is mold marked Wade England ($3, £2).

16. Noah's Ark measures 4-3/4" high by 10-3/4" long by 6-3/4" wide and is mold marked Wade England ($25, £20).

TOM SMITH & CO. LTD. PARTY CRACKERS, *1973 - 1998*

For a number of years, George Wade & Son Ltd. supplied miniature figurines to be enclosed along with party hats, snaps, and mottos to Tom Smith & Co. Ltd., manufacturers of Christmas party crackers. It was the custom for the sets of figurines to be used for a period of two years with each set having a theme which was characterized by the type of figurine used. In some cases figurines from the "Whimsies" retail line were chosen, but in many cases special figurines were molded exclusively for Tom Smith & Co. Ltd.

In late 1998, the company was bought out by Napier Industries Ltd. and to date (2002) no new sets of promotional figurines have been produced.

FIRE CRACKER PIG *mid 1970s*
1" high by 1-7/8" long. This pig was issued in a very limited edition. The hole in the rear end was meant to hold fire crackers. An elephant was also issued at this time with a small hole in the trunk to hold the firecracker ($45 each, £20 each).

ANIMATES CRACKERS, 1973 - 1975

The fantailed goldfish, bullfrog, butterfly, and terrapin were used in the 1967 - 1973 Red Rose Tea promotion. All other figurines in this set were from the retail "Whimsies" line. All figurines are marked: WADE ENGLAND.

Top: **1. Alsatian** measures 1-1/4" high by 1-7/8" overall ($6, £3). **2. Terrapin** measures 3/8" high by 1-5/8" long ($10, £5). **3. Butterfly** measures 1/2" high by 1-3/4" across the wings ($12, £4). **4. Pine Marten** measures 1-3/8" high by 1-1/2" overall ($5, £4).
Bottom: **5. Fantail Goldfish** measures 1-1/4" high by 1-3/8" long ($10, £5). **6. Bluebird** measures 5/8" high by 1-1/2" across the wings ($10, £5). **7. Bullfrog** measures 7/8" high by 1-1/8" across ($10, £3). **8. Wild Boar** measures 1-1/8" high by 1-5/8" overall ($9, £5).

SAFARI PARK, 1976 - 1977

Figurine Nos. 1, 2, 3, 4, 5, 6, 7, and 8 were similar to the 1971 - 1984 retail "Whimsies." The polar bear, although from the original Whimsie mold, is beige on a blue base rather than the original white on a blue base. The koala bear is dark grey and honey. Nos. 9 and 10 were newly designed figurines for this series. All figurines are marked: WADE ENGLAND.

CIRCUS ANIMALS, 1978 - 1979

All figurines were new for this series and were marked WADE ENGLAND on the drum-type base. This set was reissued in 1993 as a Red Rose Tea premium series. Although the figurines were identical in design, there were slight color differences.

Top: **1. Sitting Elephant** measures 1-1/4" high by 1" long ($10, £5). **2. Tiger** measures 1-5/8" high ($8, £4). **3. Standing Elephant** measures 1-3/16" high ($10, £5). **4. Lion** measures 1-9/16" high ($6, £4). **5. Bear** measures 1-3/16" high by 1" long ($8, £4).
Bottom: **6. Male Monkey** measures 1-5/8" high ($12, £10). **7. Poodle** measures 1-3/4" high ($8, £4). **8. Seal** measures 1-5/8" high by 1-1/8" long ($10, £5). **9. Horse** measures 1-3/4" high ($8, £4). **10. Female Monkey** measures 1-1/2" high ($12, £10).

POODLE
Color variations.

Left:
Top: **1. Koala Bear** measures 1-1/4" high ($26, £14). **2. Raccoon** measures 1" high ($16, £6). **3. Walrus** measures 1-1/4" high ($10, £4). **4. Kangaroo** measures 1-5/8" high ($14, £6). **5. Langur** measures 1-3/8" high ($6, £5).
Bottom: **6. Polar Bear** measures 1-1/8" high ($26, £14). **7. Orangutan** measures 1-1/4" high ($5, £3). **8. Tiger** measures 1-3/8" high ($17, £6). **9. Musk Ox** measures 1" high by 1" long ($16, £8). **10. Lion** measures 1-1/8" high by 1-3/4" long ($16, £8).

POODLE
Left: This poodle with the red enamel finished skirt is vague in its origins. From all reports it appears that it was not produced by Wade in this finish. The color was added by an outside party. **Center:** The poodle with the pink skirt was a limited edition of 100 and was a bran tub prize at an Alton Towers Wade Fair. **Right:** The poodle with the gold skirt was a limited edition of 100 and was a bran tub prize at an Alton Towers Wade Fair.

POODLE
Left: This poodle is from the Tom Smith Circus Animals set. **Center:** This poodle was a limited edition of 100 and was a bran tub prize at an Alton Towers Wade Fair. **Right:** This poodle is from the U.S. Red Rose Tea promotion and is shown for comparison of skirt colors.

BRITISH WILDLIFE, 1980 - 1981

All figurines were new for this series and are mold marked WADE ENGLAND. The Hare and the Squirrel are similar to the Rabbit (Hare) and Squirrel in the 1983 - 1985 U.S.A. Red Rose Tea promotion but with different color glazes.

FARMYARD ANIMALS, 1982 - 1983

The pig in this set is similar to the "Whimsies" retail line figurine, but with a different colorway, and the goose is similar to the "Goosey Gander" figurine from the 1971 -1979 Red Rose Tea promotion. All figurines in this set were mold marked WADE ENGLAND.

Top: 1. Dog measures 1" high by 1-3/4" long ($14, £4). **2. Bull** measures 1-1/8" high by 1-1/4" long ($14, £4). **3. Horse** measures 1-1/2" high by 1-1/4" long ($14, £4). **4. Duck** measures 15/16" high by 1-1/4" long ($14, £4).
Bottom: 5. Goose measures 1-3/8" high ($14, £4). **6. Goat** measures 1-1/2" high by 1-1/8" long ($14, £4). **7. Pig** measures 7/8" high ($14, £4). **8. Cow** measures 1-1/8" high by 1-1/8" long ($14, £4).

DUCK Color variations.

DOG Color variations.

Left:
Top: 1. Squirrel measures 1-1/2" high by 3/4" dia. base ($14, £4). **2. Badger** measures 1-1/16" high by 1-1/4" long ($14, £4). **3. Weasel** measures 1-3/8" high by 1-1/2" long ($14, £4). **4. Hare** measures 1-3/4" high by 7/8" long ($14, £4).
Bottom: 5. Mole measures 7/8" high by 1-9/16" long ($14, £4). **6. Fox** measures 1-3/8" high by 1-3/8" long ($14, £4). **7. Partridge** measures 1-1/8" high by 1-1/8" long ($14, £4). **8. Fieldmouse** measures 1-1/16" high by 1-1/8" long ($14, £4).

HORSE
Color variations.

GOAT
Color variations.

WORLD OF SURVIVAL, *1984 - 1985*

The North American Bison in this set is similar to the "Whimsies" retail line figurine, but with a different colorway, and the Harp Seal is similar to the Seal figurine from the 1967 - 1973 Red Rose Tea promotion, but in a different colorway. All figurines in this set were mold marked WADE ENGLAND.

Top: 1. Gorilla measures 1-1/2" high by 1-3/8" across ($18, £5). **2. Harp Seal** measures 1-1/2" high ($18, £5). **3. Green Turtle** measures 1-1/4" high by 1-1/4" long ($18, £5). **4. North American Bison** measures 1-1/8" high ($18, £5).
Bottom: 5. Blue Whale measures 7/8" high by 1-1/4" long ($18, £5). **6. Armadillo** measures 1" high by 1-3/8" long ($18, £5). **7. Polar Bear** measures 1" high by 1-1/4" long ($18, £5). **8. Golden Eagle** measures 1-3/4" high by 7/8" across ($18, £5).

WILDLIFE, *1986 - 1987*

All the figurines in this set were from the 1971 - 1984 retail line of Whimsies. The models used for this promotion were all single glazed. All figurines were mold marked WADE ENGLAND.

Top: 1. Koala Bear measures 1-3/8" high ($12, £4). **2. Rhino** measures 7/8" high ($6, £3). **3. Kangaroo** measures 1-5/8" high ($10, £4). **4. Orangutan** measures 1-1/4" high ($5, £3).
Bottom: 5. Dolphin measures 1-1/8" high ($18, £6). **6. Penguin** measures 1-5/8" high ($18, £6). **7. Leopard** measures 7/8" high ($6, £3). **8. Wild Boar** measures 1-1/8" high ($10, £4).

VILLAGE OF BROADLANDS, *1988*

This short-lived series, issued between January 1988 and March 1988, was based on houses from the Whimsey-on-Why Village sets. Originally, there were to have been two sets in this series, but, due to high costs, the second set was never produced.

Top: 1. The Coach House Garage is the same model as Whimsey-on-Why No.18 ($36, £18). **2. Rose Cottage** is the same model as Whimsey-on-Why No.1 ($36, £18). **3. Chapel** is the same model as Whimsey-on-Why No.13 ($36, £18).
Bottom: 4. The Village Store is the same model as Whimsey-on-Why No.9 ($36, £18). **5. Pink House** is the same model as Whimsey-on-Why No.22 ($36, £18).

YOUR PETS, 1988 - 1989

This set of eight party cracker miniature birds and animals was designed exclusively for Tom Smith. In 1990, after the exclusivity lapsed, five of the figurines (parrot, kitten, puppy, rabbit, and pony) were released for use as premiums for the 1990 - 1996 U.S. Red Rose Tea promotion. The figurines are mold marked either WADE ENGLAND or WADE ENG.

Top: 1. Pony measures 1" high by 1-7/8" overall ($7, £4). **2. Fish** measures 1" high by 1-1/2" overall ($20, £8). **3. Kitten** measures 1" high by 1-3/8" overall ($6, £4). **4. Guinea Pig** measures 3/4" high by 1-1/4" overall ($16, £7).
Bottom: 5. Parrot measures 1-3/8" high by 1-3/4" overall ($7, £3). **6. Mouse** measures 1/2" high by 1-1/4" overall ($26, £10). **7. Puppy** measures 1" high by 1-1/4" overall ($7, £3). **8. Rabbit** measures 1-1/8" high by 1-1/4" overall ($7, £4).

KITTEN
Color variations.

RABBIT *2002*
This "all over" pearlized version of the Tom Smith Your Pets rabbit was given as a gift to all paying visitors to the April 2002 Wade Collectors Fair held at Kings Hall, Stoke - on - Trent ($6, £2).

Right:
Top: 1. Cockerel measures 2" high by 1-1/4" long ($12, £5).
2. Partridge measures 1-1/2" high by 1-3/4" long ($12, £5).
3. Goose measures 1-3/8" high by 1" long ($12, £5). **4. Pelican** measures 1-3/4" high by 1-3/8" overall ($12, £5).
Bottom: 5. Eagle measures 1-3/4" high by 7/8" across the base ($14, £6). **6. Barn Owl** measures 1-1/2" high by 1" across the base ($12, £5). **7. Duck** measures 1-5/8" high by 1" along the base ($12, £5). **8. Wren** measures 1-1/2" high by 1" overall ($16, £8).

WORLD OF DOGS, 1990 - 1991

Other than the West Highland Terrier and the Bull Dog, which were new designs for this set, and the Poodle, which was from the 1967 - 1973 Red Rose Tea promotion, all figurines were from the 1971 - 1984 retail line of Whimsies. All figurines are mold marked WADE ENGLAND.

Top: 1. Poodle measures 1-5/8" high ($16, £4). **2. West Highland Terrier** measures 1-1/4" high by 1-1/4" overall ($10, £3).
3. Bulldog measures 1" high by 1-1/4" overall ($12, £4).
4. Spaniel measures 1-3/8" high ($8, £2).
Bottom: 5. Alsatian measures 1-1/4" high by 1-1/4" overall ($10, £3). **6. Husky** measures 1-7/16" high ($16, £4). **7. Mongrel** measures 1-3/8" high ($10, £3). **8. Corgi** measures 1-1/2" high ($8, £3).

BIRD LIFE, 1992 - 1993

In this set, only the Wren was a new design. The Duck, Partridge, and Cockerel were from tThe Whimsie-Land series, the Barn Owl and the Pelican were from the 1971 - 1984 Whimsies retail line, and the Goose was from both the 1971 - 1979 Canadian Red Rose Tea promotion and the Tom Smith Farmyard set.

135

SNOW LIFE, *1992 - 1997*

In this set, only the Reindeer was a new design. The Owl and Fox were from the Whimsie-Land series, and the Penguin, Polar Bear, Seal, and Walrus were from the 1971-84 Whimsies retail line. The Whale and Hare were previously used in Tom Smith sets and the Goose was from both the 1971 - 1979 Canadian Red Rose Tea promotion and the Tom Smith Farmyard set.

Top: **1. Fox** measures 1-3/8" high by 1-1/4" along the base ($14, £6). **2. Reindeer** measures 1-3/8" high by 1-3/8" overall ($14, £6). **3. Polar Bear** measures 1-1/8" high by 1-5/8" overall ($12, £5). **4. Hare** measures 1-3/4" high by 7/8" along the base ($12, £5). **5. Walrus** measures 1-1/4" high by 1-1/4" overall ($12, £5).
Bottom: **6. Owl** measures 1-1/2" high by 7/8" along the base ($12, £5). **7. Whale** measures 7/8" high by 1-1/4" long ($12, £5). **8. Penguin** measures 1-5/8" high by 3/4" dia. base ($12, £5). **9. Seal Pup** measures 1" high by 1-1/2" overall ($12, £5). **10. Goose** measures 1-3/8" high by 1" long ($12, £5).

REINDEER
Mold Variations.

Right:
Top: **1. Cat and Fiddle** measures 1-7/8" high by 1" across the base ($8, £2). **2. Lying Kitten** measures 1" high by 1-5/8" along the base ($8, £2). **3. Lion** measures 1-3/8" high by 1-3/4" overall ($6, £2). **4. Stalking Cat** measures 7/8" high by 1-3/4" long ($8, £2). **5. Puss in Boots** measures 1-3/4" high by 3/4" dia. base ($8, £2).
Bottom: **6. Kitten** measures 1-3/8" high by 1-3/8" overall ($8, £2). **7. Tiger** measures 1-1/2" high by 1-1/8" overall ($6, £2). **8. Leopard** measures 7/8" high by 1-7/8" overall ($6, £2). **9. Sitting Cat** measures 1-1/2" high by 7/8" dia. base ($8, £2). **10. Standing Cat** measures 1-7/8" high by 1-3/8" overall ($10, £4).

TALES FROM THE NURSERY, *1994 - 1997*

Other than Little Boy Blue and Ride a Cock Horse, which were new designs for this set, all other figurines were taken from the 1971 - 1979 Canadian Red Rose Tea promotion. All figurines are mold marked WADE ENGLAND.

Top: **1. Queen of Hearts** measures 1-3/4" high by 1" across the base ($6, £2). **2. Little Bo Peep** measures 1-3/4" high by 3/4" dia. base ($6, £2). **3. Cat and Fiddle** measures 1-7/8" high by 1" across the base ($6, £2). **4. Little Boy Blue** measures 1-3/4" high by 1" dia. base ($6, £2). **5. Dr. Foster** measures 1-3/4" high by 7/8" dia. base ($6, £2).
Bottom: **6. Little Jack Horner** measures 1-3/8" high by 1" across the base ($6, £2). **7. Ride a Cock Horse** measures 1-1/2" high by 1-5/8" overall ($6, £2). **8. Hickory Dickory Dock** measures 1-3/4" high by 3/4" square base ($6, £2). **9. Humpty Dumpty** measures 1-1/2" high by 7/8" base ($6, £2). **10. Tom the Piper's Son** measures 1-5/8" high by 1-3/8" across the base ($6, £2).

CAT COLLECTION, *1996 - 1997*

The Standing and Stalking Cats were new designs for this set. The Sitting Cat, Sitting Kitten, Tiger, Lion, and Leopard were from the 1971 - 1984 Whimsies retail line. The Lying Kitten was from the Whimsie-Land series and the Cat and Fiddle was from the 1971 - 1979 Canadian Red Rose Tea promotion. All figurines are mold marked WADE ENGLAND.

CAT COLLECTION
Color variations.

CHRISTMAS TIME CRACKERS, *1996 - 1997*

The six bears in this set are from the Bear Ambitions retail line, but in different colorways.

Top: **1. Admiral Sam** measures 1-5/8" high ($9, £3). **2. Artistic Edward** measures 1-1/2" high ($9, £3). **3. Locomotive Joe** measures 1-5/8" high ($9, £3).
Bottom: **4. Beatrice the Ballerina** measures 1-3/4" high ($9, £3). **5. Alex the Aviator** measures 1-5/8" high ($9, £3). **6. Musical Marco** measures 1-5/8" high ($9, £3).

HEDGEROW, *1998 - 1999*

All figurines in this set had been used previously. The Rabbit, Squirrel, Mouse, and Otter were from the 1971 - 1984 Whimsies retail line. The Hare, Mole, and Badger had been used by Tom Smith in earlier issues, and the Butterfly was from the 1967 - 1973 Canadian Red Rose Tea promotion.

Top: **1. Badger** measures 1" high by 1-3/8" along the base ($9, £3). **2. Rabbit** measures 1-1/8" high by 1-7/8" overall ($9, £3). **3. Otter** measures 1-1/4" high by 1-1/2" overall ($9, £3). **4. Hare** measures 2" high by 7/8" dia. base ($9, £3).
Bottom: **5. Mouse** measures 1-1/2" high by 1" dia. base ($9, £3). **6. Mole** measures 7/8" high by 1-9/16" long ($9, £3). **7. Butterfly** measures 1/2" high by 1-3/4" across wing span ($9, £3). **8. Squirrel** measures 1-3/8" high by 1-3/8" overall ($9, £3).

SEALIFE, *1998 - 1999*

All figurines in this set had been used previously. The Angel Fish, Dolphin, Sea Horse, Turtle, and Walrus were from the 1971 - 1984 Whimsies retail line. The Whale had been used by Tom Smith in an earlier set, the Snail was from the 1975 - 1980 Aquarium Set, and the Seal was from the 1967 - 1973 Canadian Red Rose Tea promotion.

Right:
Top: **1. Seal** measures 1-1/2" high by 1-1/4" along the base ($12, £4). **2. Snail** measures 1-1/4" high ($12, £4). **3. Dolphin** measures 1-1/2" high by 1-3/4" overall ($12, £4). **4. Walrus** measures 1-1/4" high by 1-1/4" overall ($12, £4).
Bottom: **5. Whale** measures 7/8" high by 1-1/4" along the base ($12, £4). **6. Angel Fish** measures 1-3/8" high by 1-1/4" overall ($12, £4). **7. Turtle** measures 9/16" high by 2" overall ($12, £4). **8. Seahorse** measures 2" high by 3/4" dia. base ($12, £4).

ABSOLUTELY CRACKERS, 2001 - 2002

For the Christmas season 2001 – 2002, Absolutely Crackers Ltd. issued a set of eight bird figurines, randomly placed in their boxes of Christmas crackers. The figurines used were the same models as those used for the 1992 - 1993 Tom Smith promotion, but in different colorways.

Top: 1. Eagle measures 1-3/4" high ($4, £2). **2. Owl** measures 1-1/2" high ($4, £2). **3. Duck** measures 1-5/8" high ($4, £2). **4. Goose** measures 1-3/8" high ($4, £2).
Bottom: 5. Partridge measures 1-1/2" high ($4, £2). **6. Cockerel** measures 2" high ($4, £2). **7. Pelican** measures 1-3/4" high ($4, £2). **8. Wren** measures 1-1/2" high ($4, £2).

MISCELLANEOUS PROMOTIONAL FIGURINES

Over the years that Wade has produced promotional figurines, a number of color variations of Whimsies and other miniature figurines have surfaced. Little is known about their origin other than that they were proposals for various promotions.

Left: Duck from the 1972 Whimsies Set 2 ($16, £10). **Center: Trout** from the 1972 Whimsies Set 3 ($16, £10). **Right: Goose** from the 1971 - 1979 Canadian Red Rose Tea promotion ($20, £14).

Top: 1. Koala Bear from the 1979 Whimsies Set 10 ($32, £20). **2. Sea Turtle** from Tom Smith Crackers' 1984 - 1985 World of Survival ($27, £18). **3. Gorilla** from the 1976 Whimsies Set 7 ($18, £12).
Middle: 4. Elephant from the 1973 Whimsies Set 4 ($30, £20). **5. Dolphin** from the 1978 Whimsies Set 9 ($52, £30). **6. Bison** from the 1979 Whimsies Set 11 ($18, £12).
Bottom: 7. Tiger from the 1984 Whimsie-Land Wildlife Set ($20, £14). **8. Panda** from the 1984 Whimsie-Land Wildlife Set ($22, £28). **9. Rhino** from the 1976 Whimsies Set 7 ($18, £12).

Top: 10. Trout from the 1972 Whimsies Set 3. **11. Eagle** from the 1984 - 1985 Tom Smith Crackers' World of Survival. **12. Setter** from the 1972 Whimsies Set 3. **13. Duck** from the 1972 Whimsies Set 2.
Bottom: 15, 16, and 17. Hedgehog from the 1974 Whimsies Set 5.

Chapter 13
FIGURINES FROM THE 1990s - 2002

by Wade Ceramics Limited

With the death of G. Anthony Wade in 1987, the long run of the Wade Group of Potteries with a family member at its helm came to an end. In 1989, the company was taken over by Beauford PLC and emphasis was given to the production of industrial ceramics and, for a few years, the giftware lines ceased production.

This break in the giftware lines lasted until the early 1990s when the company once again entered into the giftware market with the My Fair Ladies line of figurines.

MY FAIR LADIES SET ONE, *1990 - 1992*

As a new retail line for 1990, Wade introduced a series of slip cast figurines under the name of "My Fair Ladies." There were four designs, each decorated in two different colorways, for a total of eight figurines in the set. All figurines were modeled by Ken Holmes. The figurines are marked with a gray transfer type mark on the base reading "My Fair Ladies Wade Made in England" along with the name of the figurine.

1. Kate measures 3-7/8" high ($40, £22). **2. Rachel** measures 3-7/8" high ($40, £22). **3. Marie** measures 3-3/4" high ($40, £22). **4. Sarah** measures 3-3/4" high ($40, £22).

5. Lisa measures 3-3/4" high ($80, £65). **6. Hannah** measures 3-3/4" high ($65, £30). **7. Caroline** measures 3-7/8" high ($40, £22). **8. Rebecca** measures 3-7/8" high ($40, £22).

MY FAIR LADIES SET TWO, *1991 - 1992*

This second set of "My Fair Ladies" series had four designs, each decorated in two different colorways, for a total of eight figurines in the set. All figurines were modeled by Ken Holmes. The figurines are marked with a bright red transfer type mark on the base reading "My Fair Ladies Wade Made in England" along with the name of the figurine.

9. Belinda measures 3-3/4" high ($42, £27). **10. Anita** measures 3-3/4" high ($42, £27). **11. Emma** measures 4" high ($42, £27). **12. Natalie** measures 4" high ($40, £22).

13. Melissa measures 4" high ($70, £55). **14. Amanda** measures 4" high ($75, £55). **15. Lucy** measures 3-3/4" high ($45, £30). **16. Diane** measures 3-3/4" high ($42, £27).

MY FAIR LADIES LIQUOR CONTAINERS, *1992*

A number of each figurine from Sets One and Two of the "My Fair Ladies" figurines were purchased by Hebrides Scotch Whisky and used as whisky containers and distributed in the U.S. through a mail order catalogue company. Each figurine had an applied label on the back reading: Hebrides Scotch Whisky Glasgow 3cl 40% vol. 30ml (04896) - 549. The hole in the base, left from the slip casting process was corked and sealed with a silicon type compound. This type of sealing was not entirely successful, as the liquor tended to leak.

Left: from set one showing the applied label. ($35, £20). **Right: Melissa** from set two showing the applied label ($65, £50).

SOPHISTICATED LADIES, *1991 - 1992*

This set of four hand-decorated figurines, designed and modeled by Ken Holmes, had a very short life. Wade named this set Sophisticated Ladies, however, collectors will note that the figurines are marked My Fair Ladies along with Mark Type 27B on the base. A number of these figurines have been found with the back stamp along with the name of the figure omitted. This set has also been found undecorated, with an all-over white glaze.

1. Felicity measures 6" high ($180, £120). **2. Susannah** measures 6" high ($180, £120). **3. Emily** measures 5-3/4" high ($180, £120). **4. Roxanne** measures 5-3/4" high ($180, £120).

Sophisticated Ladies with all-over white glaze. Emily, Susannah, Felicity and Roxanne ($120 each, £80 each).

DINOSAUR SET 1, *1993*

A set of five die-pressed figurines was produced by Wade Ceramics Ltd., designed by Barbara Cooksey and modeled by Ken Holmes. All figurines are mold marked: Wade England. In 2001 a number of color variations appeared on the secondary market.

Top: **1. Protoceratops** measures 1-1/8" high by 2-3/8" long ($8, £4). **2. Tyrannosaurus Rex** measures 1-3/4" high by 2-3/8" long ($8, £4).
Bottom: **3. Camarasaurus** measures 2" high by 1-3/4" long ($8, £4). **4. Euoplocephalus** measures 1" high by 2-1/4" long ($8, £4). **5. Spinosaurus** measures 1-5/8" high by 2-3/8" long ($8, £4).

DINOSAUR SET 2, *2001*

This second set of dinosaur figurines was issued in 2001. Five of the figurines were new models but one, the Protoceratops, was from the same mold as the figurine in Set 1, but in a slightly different colorway.

Top: **1. Vulcanodon** measures 2" high by 2-3/8" long ($6, £3). **2. Saurolophus** measures 1-7/8" high by 2" long ($6, £3). **3. Corythosaurus** measures 2" high by 2-1/4" long ($6, £3).
Bottom: **4. Scutellosaurus** measures 1-1/4" high by 2-3/8" long ($6, £3). **5. Protoceratops** measures 1-1/8 high by 2-1/4" long ($6, £3). **6. Nodosaurus** measures 1-1/8" high by 2-3/8" long ($6, £3).

PROTOCERATOPS
This illustrates the color variation between the figurine from Set 1 (left) and Set 2 (right).

BEAR AMBITIONS, *1995*

Each of these die-pressed miniature teddy bear figurines has its own distinctive decoration signifying the artistic talent or hobby of the particular bear. All figurines are mold marked "Wade Eng" on the back.

Top: **1. Artistic Edward** measures 1-1/2" high ($6, £3). **2. Locomotive Joe** measures 1-5/8" high ($6, £3). **3. Alex the Aviator** measures 1-5/8" high ($6, £3).
Bottom: **4. Beatrice the Ballerina** measures 1-3/4" high ($6, £3). **5. Admiral Sam** measures 1-5/8" high ($6, £3). **6. Musical Marco** measures 1-5/8" high ($6, £3).

GREEN BEAR AMBITIONS, *1998*

A reissue of the 1995 Bear Ambitions in an overall green glaze was made for The Teddy Bears' Picnic held at Ripley Castle, England. These green Bear Ambitions were also sold in the Factory Shop.

Top: **1. Artistic Edward** measures 1-1/2" high ($6, £3).
2. Locomotive Joe measures 1-5/8" high ($6, £3). **3. Alex the Aviator** measures 1-5/8" high ($6, £3).
Bottom: **4. Beatrice the Ballerina** measures 1-3/4" high ($6, £3). **5. Admiral Sam** measures 1-5/8" high ($6, £3). **6. Musical Marco** measures 1-5/8" high ($6, £3).

ADMIRAL SAM *1998*
Color variation. This all-over blue model from the Bear Ambitions was issued for the "Bran Tub" at the San Antonio Jim Beam/Wade Fair and for a Trade Exhibition in the U.K.

ADMIRAL SAM *1998*
This hand painted multi color variation was a "one-of-a-kind."

ANDY CAPP MONEY BANK AND SALT & PEPPER, *1997 - 1998*

Wade produced a small line of tableware to celebrate the 40th anniversary of the cartoon character Andy Capp. Other than the salt and pepper, Wade also produced an Andy Capp teapot and toast rack. These items were available either direct by mail or at the Factory Shop. Both figurines are marked: Andy Capp ©1997 Mirror Group Newspapers Ltd. Wade. The name of the figurine is included in the back stamp.

The Andy Capp money bank first appeared on the cover of the August, 1998 issue of *Wade's World*. After the death of Reg Smythe, the creator of Andy Capp, Wade decided to donate one pound to cancer research for every money bank sold.

Left: Andy Capp Money Bank measures 7" high by 4-1/4" across the base, which is transfer, marked: Andy Capp ©1998 Mirror Group Newspapers Ltd. Andy Capp Wade England ($38, £22).
Center: Andy Capp (salt) measures 3-3/4" high by 1-3/4" across the base ($18, £10). **Right: Flo** (pepper) measures 4" high by 2-3/8" across the base ($18, £10).

CAMELOT SERIES, *1997*

This series was launched by Village Antiques and Gifts of Michigan, U.S.A. at the 1997 Wisconsin Jim Beam/Wade Fair. The series was also made available at the Wade Factory Shop and C&S Collectables of Arundel. All figurines are transfer marked: The Camelot Collection WADE along with the name of the figurine and the Camelot Collection logo.

1 2

3 4 5

Top: 1. Lady of the Lake measures 3-1/8" high ($45, £28).
2. Guinivere measures 4-1/8" high ($45, £28).
Bottom: 3. Lancelot measures 4-1/4" high ($45, £28). **4. Merlin** measures 4-1/8" high ($45, £28). **5. King Arthur** measures 4-1/4" high ($45, £28).

WATER LIFE COLLECTION, *1997*

Waterlife was advertised in the May 1997 edition of *Wade's World* as the first in a set of figurines to be sold as "open stock" in the Wade Factory Shop. The series has now been discontinued. The Alligator was the first item to be sold out followed closely by the Goldfish. Each figurine has a Wade Made In England transfer mark in a variety of colors. The mark is similar to Mark Type 26.

The November 1997 issue of *Wade's World* advertised the second set in the Waterlife series. This set has also been discontinued. Each figurine has a transfer Mark Type 27B.

1 2 3

4 5 6

SET 1, *1997*
Top: 1. Goldfish measures 2" high by 1-5/8" long ($18, £8).
2. Whale measures 1-3/4" high by 2-5/8" long ($14, £6).
3. Alligator measures 1" high by 2-1/2" long ($18, £8).
SET 2, *1997*
Bottom: 4. Crab measures 1-1/4" high by 2" long ($14, £6).
5. Octopus measures 2" high by 1-1/2" dia. ($14, £6). **6. Seahorse** measures 1-1/4" high by 2-3/4" long ($14, £6).

FISH WAITER *1998*
5-3/8" high and is transfer marked with Mark Type 27A. This figurine was sold through the Wade Shop, at the Buffalo Jim Beam/Wade Fair, and the Arundel Swap Meet ($34, £18).

143

HONEY BUNCH BEARS SET 1, *1998*

Wade introduced the first set of three "Honey Bunch Bears" at the Wade Fair held at Trentham Gardens in March 1998. All the figurines are slip cast and mold marked "Wade."

Left: Sitting Bear Arms Up measures 2-1/4" high ($10, £6). **Center: Sitting Bear Arms in Lap** measures 2-5/16" high ($10, £6). **Right: Sitting Bear with Honey Pot** measures 2-1/4" high ($10, £6).

HONEY BUNCH BEARS SET 2, *1998*

Wade introduced the second set of three "Honey Bunch Bears" at the 1998 Buffalo Jim Beam/Wade Fair. All the figurines are slip cast and mold marked "Wade."

Left: Lying Bear with Sunglasses measures 1-3/4" high ($10, £6). **Center: Sitting Bear One Arm Up** measures 2-1/4" high ($10, £6). **Right: Lying Bear** measures 1-7/16" high ($10, £6).

HONEY BUNCH BEARS *special colorways, 1998 - 1999*

A limited number of hand decorated "Honey Bunch Bears" was produced for sale at the 1998 *Collect it!* Fair, C&S Wade Bonanza 1998, and the 1999 San Antonio Jim Beam/Wade Fair.

Top: 1. Sitting Bear Arms Up ($20, £12). **2. Lying Bear** ($20, £12). **3. Sitting Bear with Honey Pot** ($20, £12). **4. Sitting Bear with Honey Pot** ($20, £12).
Bottom: 5. Sitting Bear Arms Up ($20, £12). **6. Lying Bear** ($20, £12). **7. Sitting Bear Arms in Lap** ($20, £12).

8. Sitting Bear Arms in Lap ($20, £12). **9. Lying Bear** ($20, £12). **10. Sitting Bear Arms Up** ($20, £12).

11. Sitting Bear Arms in Lap ($20, £12). **12. Sitting Bear with Honey Pot** ($20, £12). **13. Sitting Bear with Honey Pot** ($20, £12).

RULE BEARTANNIA, 1999

The "Rule Beartannia" series is based on characters from "The Tiny Kingdom of Teddy Bears" created by Jerome and Julie Walker of Illinois, U.S.A. The series was inspired by Jerome Walker's interest in European royalty memorabilia. The series was originally available in the U.S.A. only but later retailed in the U.K.

All the figurines are back stamped: Made in England ©Jerome Walker 1998 Wade. Each figurine also has the Rule Beartannia logo along with the name of the character.

1 **2** **3**

1. King Velveteen measures 6-1/2" high by 4-3/4" across the base ($78, £45). **2. Queen Mum** measures 6" high by 4-1/2" across the base ($60, £35). **3. Queen Bea** measures 6-1/2" high by 4-3/4" across the base ($78, £45).

4 **5** **6** **7**

4. Nanny Mary Fluffins with Princess Velveteen measures 5" high by 4" deep ($70, £40). **5. Prince George Tedward** measures 3-3/4" high by 2" dia. base ($48, £28). **6. Princess Plushette** measures 3-3/4" high by 2-1/8" dia. base ($48, £28). **7. Princess Elizabeth Tedwina** measures 4-3/4" high by 1-3/8" dia. base ($48, £28).

8. Palace Guard measures 4-1/2" high by 2" dia. base ($58, £34).

9. Beartannia Plaque measures 4 3/4" high by 4-1/2" wide and is unmarked on the back ($18, £10).

PRINCESS PLUSHETTE
This special colorway figurine was a "one-of-a-kind" prize given away at the 2001 Wade Fest in Harrisburg, Pennsylvania.

POCKET PALS, *1999*

Pocket Pals were launched in late 1999 as a new retail line. The figurines were based on the adult figurines from the Happy Families series first seen in the 1960s, and again in the 1970s. Each figurine in the new series was given a new color and name, easily distinguishing them from the earlier models.

1 2 3 4 5

6 7 8 9 10

Top: **1. Waggs the dog** measures 2" high ($10, £6). **2. Truffle the pig** measures 1-1/8" high ($10, £6). **3. Cheesy the mouse** measures 2" high ($10, £6). **4. Tusker the elephant** measures 1-1/4" high ($10, £6). **5. Stretch the giraffe** measures 2-5/16" high ($10, £6).
Bottom: **6. Slinky the cat** measures 1-7/8" high ($10, £6). **7. Hip Hop the frog** measures 7/8" high ($10, £6). **8. Paddles the hippo** measures 1-1/8" high ($10, £6). **9. Bounce the rabbit** measures 2" high ($10, £6). **10. Specs the owl** measures 1-3/4" high ($10, £6).

POCKET PAL SPECIALS, *1999*

At the time of the launch of the new range of the Wade Pocket Pals, three special limited editions were also issued. Two were available through the magazine *Collect it!*, and one was available from C&S Collectables.

Left: **Tango** was based on the Pocket Pals cat Slinky, was issued in a limited edition of 1,000, and was available only from C&S Collectables ($15, £10). Center: **Hopper** was based on the Pocket Pals frog Hip Hop, was available free only to subscribers of *Collect it!* magazine and those magazines sold through W. H. Smith ($16, £10). Right: **Woofit** was based on the Pocket Pals dog Waggs and was available only from Wade via a special "mail in" offer through *Collect it!* magazine ($25, £14).

POCKET PAL FROG PROTOTYPES *1999*
These decorated frogs were proposed for *Collect it!* magazine but never went into production.

COMIC ANIMAL FIGURINES, *2000*

In the early part of 2000, Wade introduced two figurines in a new retail line of animals in comic situations. The first two issued were Priscilla the Pig and Tubby the Bear. In August came Hattie the Squirrel and Dribbles the Dog, and in October Tinnie the Mouse and Boots the Rabbit. All figurines have a small red transfer back stamp similar to Mark Type 26.

1 **2** **3**

1. **Priscilla the Pig** measures 2-3/8" high by 2-3/8" long ($26, £15). 2. **Tubby the Bear** measures 3-1/8" high on a 1-1/2" dia. base ($26, £15). 3. **Hattie the Squirrel** measures 3-1/8" high by 2-1/2" overall ($26, £15).

4 **5** **6**

4. **Dribbles the Dog** measures 2-1/2" high by 3-3/8" overall ($26, £15). 5. **Tinnie the Mouse** measures 3-3/4" high on a 1-5/8" dia. base ($26, £15). 6. **Boots the Rabbit** measures 3-3/4" high by 3-7/8" across the base ($26, £15).

TINNIE THE MOUSE *2001*
This special colorway was a "one-of-a-kind" figurine given as a draw prize at the 2001 Harrisburg Wade Fest. The figurine is marked: Wade Made in England.

BOOTS THE RABBIT
Color variation. This was a "one-of-a-kind" draw prize figurine given away at the Swap Meet 2000 held in Arundel, West Sussex.

LITTLE HORRORS, *2001*

This retail line of ten figurines is based on designs by Mark Mason, an enthusiastic Wade collector who replied to an article in *The Official Wade Club Magazine* asking for ideas for new figurines. All figurines are marked with a gold transfer reading: Wade PP.

1 **2** **3** **4** **5**

1. **Lizzie from the Black Lagoon** measures 2" high ($10, £6). 2. **Frankie** measures 2-1/2" high ($10, £6). 3. **Witch Hazel** measures 2-1/2" high ($10, £6). 4. **Spooky** measures 2" high ($10, £6). 5. **Igor, Jr.** measures 2'" high ($10, £6).

6 **7** **8** **9** **10**

6. **Lugsie** measures 2-1/2" high ($10, £6). 7. **Where's My Mummy** measures 2" high ($10, £6). 8. **Jekyl, Jr.** measures 2-1/2" high ($10, £6). 9. **Wolfy** measures 2-1/8" high ($10, £6). 10. **Baby Bodzilla** measures 2-1/4" high ($10, £6).

JEKYL, JR.
Other face of Jekyl, Jr.

147

POKÉMON, 2001

This retail line of five figurines was issued in 2001 to augment the earlier release, by Wade, of the Pokémon breakfast dishes. At the time of release of this set, a further six figurines were planned for future release. All figurines are marked: Nintendo™ ©2001 Wade.

1. **Psyduck** measures 2-1/4" high ($16, £10). 2. **Jigglypuff** measures 1-7/8" high ($16, £10). 3. **Pikachu** measures 2-1/8" high ($16, £10).

4. **Polliwhirl** measures 2-1/16" high ($16, £10). 5. **Gengar** measures 2-3/16" high ($16, £10).

NATIVITY SET, 2001

This set of six figurines was issued as a new retail line for Christmas 2001. All figurines are marked: Wade.

1. **The King** measures 3-1/2" high ($20, £14). 2. **The Wiseman** measures 2-5/16" high ($20, £14). 3. **The Shepherd** measures 3-3/4" high ($20, £14).

4. **The Shepherd with Lamb** measures 3-3/4" high ($20, £14).
5. **The Archangel** measures 5-3/4" high ($20, £14), and
6. **Joseph, Mary and Jesus** measures 3-3/8" high ($20, £14).

TRULY, 2002

Starting in January 2002 club members of four years standing or more were eligible to buy the loyalty piece named Truly.

Truly measures 2-1/4" high and is marked: "Truly" loyalty piece 4 years continuous membership with the addition of the OIWCC logo ($18, £10).

ZOO-MAZING COLLECTION, 2002

The first figurine in the Zoo-mazing Collection was Born to be Sleepy, the first piece in the "Hip Hippos" range. Future figurines in the range will be: Born to Slide, Born to be Naughty, and Born to Daydream. These figurines were sold through the Wade Club and were available to club members. Additional models in the series were sold as a general retail line.

Born to be Sleepy measures 2-3/4" high and is marked: Hip Hippos Born to be Sleepy Wade. This figurine was first made available at the April 2002 Wade Collectors Fair held at the Kings Hall in Stoke-on-Trent ($30, £20).

3. Born to be Loved measures 2-3/4" high and is marked: Hip Hippos Wade Born to be Loved ($30, £20).

Born to be a Daydreamer measures 2-1/4" high by 3-1/2" overall and is marked: Hip Hippos Born to be a Daydreamer Wade ($30, £20).

ZOO-MAZING RETAIL COLLECTION 2002
1. Born to be Wild measures 3-1/4" high and is marked: Hip Hippos Wade Born to be Wild ($30, £20).

4. Born to be Friends measures 2-1/8" high by 3-3/4" long and is marked: Hip Hippos Wade Born to be Friends ($30, £20).

5. Born to be a Big Brother measures 3" high and is marked: Hip Hippos Wade Born to be a Big Brother ($30, £20).

Right:
2. Born to be Cool measures 2-3/4" high and is marked: Hip Hippos Wade Born to be Cool ($30, £20).

Chapter 14
WADE LIMITED EDITIONS

by Wade Ceramics Limited
early 1990s - 2002

In the early 1990s, Wade Ceramics Limited began the production of limited edition figurines. When the Official International Wade Collectors Club came into existence, the interest in limited editions increased rapidly. Many of the limited issues were directed mainly to members of the club with many of the new figurines made available only to club members.

Over the past few years, many limited issues were made available to the public at large through the numerous Wade Fairs and similar events held in various parts of the U.K. and more recently, in the U.S.A.

KNIGHT TEMPLAR, 1991

The original design for this figurine was a special order to commemorate 200 years of The Great Priory of England and Wales. The original figurine was mounted on a wooden base and had the following inscription on the face of the porcelain base: 1791 - Christi et Templi Salomoris + Ravperes Commilitones 1991. The following inscription appeared on the underside of the base: Made Exclusively for The Great Priory of England and Wales and its Provinces Overseas by Wade Ceramics to Commemorate 1791 - The Bi-Centenary - 1991.

In 1991, Wade Ceramics Ltd. produced a limited edition of 100 figurines for the Potteries Centre for members of their Wade Collectors Club. This slip cast figurine is marked with the issue number out of 100.

SURVIVAL, 1991

This large sculpture of a cheetah chasing a Grants gazelle was modeled by Alan Maslankowski. It was originally meant to be issued in a limited edition of 50 pieces, but only 6 were actually made, one of which was broken at a trade fair. Each piece is individually signed by the artist and came with a framed certificate of authenticity.

Cheetah and Grants Gazelle ($18000, £6000).

Left:
Left: Knight Templar. The original figurines presented to members of the order. The figurine measures 9-1/2" high ($400, £225). **Right: Knight Templar** measures 9-1/2" high and has Mark Type 27A on the base along with the wording: Limited Edition No. 25 of 100 Issued December 1991 ($320, £180).

CHILDREN AND PETS, *1993 - 1994*

This was the first limited edition issue by Wade Ceramics Limited in a series based on a theme of children and pets.

The figurines were designed and modeled by Ken Holmes. The first two figurines in the series were released in 1993, and the third figurine was released in 1994. Each model in the series is limited to 2,500 numbered pieces, each of which sits on a wooden plinth. Each figurine is marked: Wade Limited Editions (name of figurine) Modelled by Ken Holmes. This figurine is the (first, second or third) in a series of Wade Collectables Limited Edition of 2500.

1. "Welcome Home" measures 3-3/4" high by 4-3/4" long ($55, £35).

2. "Fireside Friend" measures 3-1/2" high by 3-1/2" wide ($55, £35).

"BURSLEM" THE FACTORY CAT *1994 - 1995*
3-1/4" high and is mold marked Wade on the base. "Burslem" was the first membership piece for collectors joining the OIWCC during the 1994 - 1995 period. This figurine was based on a real life cat that roamed the Wade premises ($150, £120).

SPANIEL DOG *1994*
3" high and is mold marked Wade on the base. This piece was a limited edition of 1000 sold at the first Wade Fair held in Birmingham in September 1994 ($165, £130).

SNOWMAN *1994*
5" high and is transfer marked: Christmas 1994 Wade Made in England. This was an exclusive issue for members of the OIWCC for the year 1994 and was a limited edition of 1,500 pieces ($75, £60).

SNOW WOMAN *1995*
4-7/8" high and is transfer marked: Christmas 1995 Wade Made in England. This was an exclusive issue for members of the OIWCC for the year 1995 and was a limited edition of 1,500 pieces ($75, £60).

3. "Togetherness" measures 4-1/2" high by 3-3/4" wide ($55, £35).

151

SNOW CHILDREN *1996*
5" high by 4-5/8" long and is transfer marked: Christmas 1996 Wade Made in England. This piece was issued on a pre-order basis only to members of the OIWCC on a one piece per member basis ($75, £60).

MR. AND MRS. SNOWMAN SALT & PEPPER *1997*
The salt shaker, **1. Mrs. Snowman** measures 3-3/4" high ($18, £10). The pepper shaker, **2. Mr. Snowman** measures 4" high ($18, £10). Each figurine has Mark Type 27B on the base. This set was not officially part of the Snow People set and was sold at the November 1997 Wade Christmas Extravaganza, Trentham Gardens.

GREY HAIRED RABBIT *1995*
3-1/2" high and is mold marked Wade on the base. This piece was a limited edition of 1,000 sold at the second Wade Fair in Birmingham in June 1995 ($130, £85).

THE THREE LITTLE PIGS AND THE BIG BAD WOLF, *1995*

In 1995, The Wade Collectors Club issued the first annual limited edition series of figurines offered to club members only. The four figurines were issued quarterly along with the quarterly Wade club magazine. Each piece is marked: 1995 with the OIWCC logo and the name of the figurine on the base.

1. House of Straw measures 4-7/8" high and was issued in February 1995 ($80, £55). **2. House of Wood** measures 4-5/8" high and was issued in May 1995 ($80, £55).

3. The Big Bad Wolf measures 5-1/2" high and was issued in August 1995 ($80, £55). **4. House of Brick** measures 5-1/8" high and was issued in November 1995 ($80, £55).

CHRISTMAS PUPPY
1995 - 1996
2-1/4" high and is mold marked Wade on the base. The puppy was the membership piece for collectors joining the OIWCC during the 1995 - 1996 period ($50, £35).

CHRISTMAS PUPPY

This was a "one-of-a-kind" figurine given as a draw prize at the 2001 Wade Fest in Harrisburg, Pennsylvania.

SMILING FROG *1996*

2-1/4" high and is mold marked Wade on the base. This figurine was issued in a limited edition of 1,250 for the 1996 Wade Fair in Birmingham ($85, £48).

GOLDILOCKS AND THE THREE BEARS, *1996*

This limited edition of four figurines was the membership series to be offered to members of the Wade Collectors Club during the 1996 membership year. Each piece is marked 1996 with the OIWCC logo and the name of the figurine.

1 2 3 4

DADDY BEAR

This was a "one-of-a-kind" figurine won at a draw at the Wade Factory Shop in August 1997.

DADDY BEAR

This was a "one-of-a-kind" figurine won at a draw at the 1997 Jim Beam/Wade Fair in Oconomowoc, Wisconsin.

DADDY BEAR

This was a "one-of-a-kind" figurine won at a draw at the 1999 Jim Beam/Wade Fair in San Antonio, Texas.

Left:
1. Daddy Bear measures 4" high and was issued in May 1996 ($50, £30). **2. Mummy Bear** measures 4" high and was issued in February 1996 ($50, £30). **3. Goldilocks** measures 3-1/2" high and was issued in August 1996 ($50, £30). **4. Baby Bear** measures 3-1/4" high and was issued in November 1996 ($50, £30).

SEATTLE "WESTIE" *1996*
3" high and has a transfer mark SEATTLE 1996 along with the OIWCC logo. The figurine was issued in a limited edition of 3,000 and was first sold at the 1996 Seattle Jim Beam/Wade Fair ($30, £35).

BLUE SCOTTIE DOG
This all over blue version of "Smudger" was a "one-of-a-kind" figurine given as a prize at the October 2000 Wade Extravaganza held at Trentham Gardens ($225, £130).

TIMID MOUSE *1996*
2-1/2" high by 3-1/2" long and is mold marked Wade. The mouse was a limited issue of 2,000 sold at the September 1996 Dunstable Wade Fair. Of the 2,000 pieces issued, 250 pieces were made available solely for overseas collectors ($85, £50).

SCOTTIE DOG
This matte finish figurine of "Smudger" was a special auction piece, auctioned off at the Christmas Extravaganza in November 1997. The figurine was accompanied by a certificate of authenticity signed by the Managing Director of Wade Ceramics.

"SMUDGER" *1996 - 1997*
3" high and is marked: Membership Special 1996 - 1997 along with the OIWCC logo. This figurine was the membership piece for collectors joining the OIWCC in 1996 ($60, £40).

NENNIE *1995 - 1996*
4-1/4" high and is transfer marked: Nennie produced exclusively for FICOL by Wade. Production was limited to 2,000 pieces. Each piece is individually numbered. Nennie was commissioned by F. Shoop as the first in a proposed series. The commission did not proceed and in 1996 Wade sold off all pieces ($55, £40).

PANTOMIME SERIES, *1997*

This 1997 limited edition of figurines was the third series to be offered to members of the Wade Collectors Club during the membership year. Each figurine was a limited edition of 4,000 pieces and was marked: 1997 along with the OIWCC logo and the name of the figurine.

1 2 3 4

1. Pantomime Horse measures 3-1/2" high and was issued in February 1997 ($25, £18). **2. Mother Goose** measures 4-1/2" high and was issued in May 1997 ($45, £30). **3. Dick Wittington's Cat** measures 4-1/2" high and was issued in August 1997 ($25, £18). **4. Pantomime Dame** measures 4-3/8" high and was issued in November 1997 ($25, £18).

DRACULA *1997*
10-3/4" high. This figurine is based on the likeness of Christopher Lee, the well known actor and star of many Hammer Films. The figurine is transfer marked: Wade Nexus Hammer 40 years Dracula Issue of 2,500 to celebrate the 40th Anniversary of Hammer Films. Wade marketed 1,250 figurines with a matte finish and Nexus (Camtrak) marketed 1,250 figurines with a high gloss finish ($150 each, £90 each).

KANGAROO *1997*
5" high and is marked: The Kangaroo 1 of 1,500 Exclusive Limited Edition for the Trentham Gardens Wade Fair ©UK Fairs Ltd. and Wade Ceramics Ltd. Fifty figurines were reserved for overseas sales and had a backstamp similar to above but reading 1 of 50 rather than 1 of 1,500 ($75, £42).

MADISON MOUSE *1997*
3-1/2" high and is marked with the OIWCC logo and the wording Wisconsin 1997. The mouse was issued for the 1997 Jim Beam/Wade Fair held in Oconomowoc, Wisconsin ($30, £20).

MADISON MOUSE *2002*
This was a "one-of-a-kind" figurine won in a draw at the 2002 Summer Wade Fest in Harrisburg, Pennsylvania.

"RUFUS" *1997*
2-5/8" by 3-1/4" long and is marked: WADE ON TOUR along with the OIWCC logo. This figurine was sold at the Wade Fairs throughout 1997 ($40, £25).

KOALA BEAR *1997*
4-1/4" high and is marked: Koala Bear 1 of 1,500 Exclusive Limited Edition for the Dunstable Wade Fair ©UK Fairs Ltd. and Wade Ceramics Ltd. The figurine was originally sold at the October 1997 Dunstable Wade Fair ($75, £42).

WADE BABY *1997 - 1998*
3-1/4" high and is marked: Membership Special 1997 - 1998 along with the OIWCC logo. This was the membership piece for collectors joining the OIWCC in 1997 ($36, £25).

OSCAR THE CHRISTMAS BEAR *1997*
4-1/4" high and is marked: Christmas Teddy 1997 along with the OIWCC logo. This was a limited edition Christmas piece of 2,500 sold to the OIWCC members on a first come first serve basis ($46, £28).

Left:
"RUFUS" *1999*
Four special colorways of Rufus were originally available at the San Antonio, Texas, Jim Beam/Wade Fair. Each figurine has Mark Type 27A along with the wording: Limited Edition 100 ($60 each, £35 each).

OSCAR THE CHRISTMAS BEAR *1998*
4-1/4" high and is marked: Oscar Special Colourway Buffalo 1998 along with the OIWCC logo. This was a special colorway issued at the 1998 Buffalo Jim Beam/Wade Fair in a limited edition of 75 pieces ($225, £150).

"OUT AND ABOUT" *1998*
3-1/2" high and is transfer marked: Wade on Tour 1998, Traveling Badger along with the OIWCC logo. This piece was first made available at the March 1998 Trentham Gardens Wade Fair ($45, £30).

ANNABEL WAITING FOR SANTA *1998*
4-1/4" high. This was a limited edition Christmas piece of 2,000 sold to the OIWCC members on a first come first serve basis ($46, £28).

TRAVELING BADGER *2002*
This was a "one-of-a-kind" figurine given as a draw prize at the 2002 West Coast Wade Collectors Fair.

TOY BOX SERIES, *1998*

This 1998 limited edition set of figurines was the fourth annual series to be offered to members of the Wade Collectors Club during a membership year. Each piece was a limited issue of 3,000 and marked 1998 with the OIWCC logo and the name of the figurine. These Toy Box figurines were designed by Sue Ames, who won a competition for the design staged by the Wade Collectors Club. Each figurine was transfer marked with the OIWCC logo along with the name of the figurine and the year 1998.

1 2 3 4

1. **Toy Soldier** measures 4-1/4" high and was issued in February 1998 ($45, £28). 2. **Amelia Bear** measures 3-1/4" high and was issued in May 1998 ($45, £28). 3. **Emily** measures 3-1/8" high and was issued in November 1998 ($45, £28). 4. **"Chuckles" the Clown** measures 4-3/8" high and was issued in August 1998 ($45, £28).

TRAVELING BADGER *2002*
This was a "one-of-a-kind" figurine given as a draw prize at the 2002 Summer Wade Fest held in Harrisburg, Pennsylvania.

"CAMPING BEAR" *1998*
4-1/2" high and is marked: Camping Bear 1998 along with the OIWCC logo. This figurine was sold at the Ripley Village Fete and the Teddy Bears' Picnic in June 1998 ($35, £22).

NEW YORK TOURIST *1998*
4-1/4" high and is transfer marked: Buffalo Fair Special 1998 along with the OIWCC logo. This piece was first made available at the 1998 Jim Beam/Wade Fair in Buffalo, New York ($30, £20).

TEDDY BEAR PLAQUE "RIPLEY" *1998*
7-1/2" high by 7-1/2" wide and is transfer marked: Wade England Ripley 1998. This plaque was issued at the Wade Village Fete and Teddy Bears' Picnic on The Castle Flats at Ripley Castle in June 1998 ($45, £25).

TRAVELING FROG *1998*
5-1/4" high and has Mark type 27A along with the words: Newark 1998. This figurine was sold by Wade at the August 1998 Newark Fair in a limited edition of 1,500 sold over the two days of the Fair, 750 for each day ($35, £25).

TEDDY BEAR PLAQUE "SWAP MEET" *1998*
7-1/2" high by 7-1/2" wide and is transfer marked: Wade Swap Meet 1998. This plaque was issued at the July 1998 Arundel Swap Meet organized by C&S Collectables and Wade Ceramics Ltd. ($45, £25).

TEDDY BEAR PLAQUE "BUFFALO" *1998*
7-1/2" high by 7-1/2" wide and is transfer marked: Wade England Buffalo 1998. This plaque was first issued at the 1998 Jim Beam/Wade Fair in Buffalo, New York ($45, £25).

"DOUGIE MAC" *1998*
6-3/8" high and is mold marked: Wade. "Dougie Mac" is the mascot for the Douglas MacMillan Hospice. To celebrate the silver jubilee of the Hospice, Wade produced this money bank to help raise money for a new daycare centre with £10.00 from the sale of each bear going to the Hospice ($55, £35).

PANDA BEAR PLAQUE *1998*
7-1/2" high by 7-1/2" wide and is transfer marked: Wade England Extravaganza 1998. This plaque was issued at the Wade Extravaganza held at Alton Towers in November 1998 ($45, £25).

"BEARS JUST WANT TO HAVE FUN" *1998*
5-1/2" high and is marked: "Bears Just Want to Have Fun" Limited Edition 500 Alton Towers Hotel Wade England. This figurine, the first in the "Baby Bear" series, was made available at the first Wade Extravaganza held at Alton Towers ($60, £40).

159

Left:
"ONCE UPON A TIME BEAR" *1998*
6-1/8" high. This money bank was marked: "Once upon a Time" Limited Edition 120 Wade England. Of these money banks, 100 were issued at the November 1998 Wade Fair at Alton Towers, and 20 were sold at the 1998 Jim Beam/Wade Fair in San Antonio, Texas ($345, £200).

"LIBRARY BEAR" *1998*
This was a "one-of-a-kind" figurine given as a draw prize at the Teddy Bear Show held at Alexandra Palace.

Right:
"LIBRARY BEAR" *1998*
6-1/8" high and is marked: The Library Bear 1998 Limited Edition of 500 Wade England. This bear was a show special at the Teddy Bear Show held at Alexandra Palace between October 31 and November 1, 1998 ($120, £80).

"OOPS" THE BEAR, *1998 - 2000*

A series of three limited edition bears issued at various Wade events between 1998 - 2000. The set featured three teddy bears suffering the signs of accidents.

Left: "Oops" measures 2-3/8" high and is marked: Oops the Bear Limited Edition 500 Wade England 1998. This figurine was the Fair Special for both the December *Collect it!* Fair and the December Arundel Christmas Bonanza with 250 pieces available at each Fair ($50, £32). **Center: "Oops the Bear"** measures 3-3/4" high and is transfer marked: Oops The Bear 1999 Limited Edition 300 Wade England. This figurine was available at the December 1999 Arundel Christmas Bonanza ($50, £32). **Right: "Oops! the Bear"** measures 2-1/8" high and is transfer marked: Oops! the Bear Ltd. Edition 250 Wade. This figurines was sold at the December 2000 Wade Christmas Bonanza ($50, £32).

OOPS THE BEAR *2001*
This figurine was a "one-of-a-kind" prize given away at the 2001 West Coast Collectors Fair in Vancouver, Washington.

MYTHS AND LEGENDS, *1998*

This series was based on myths and legends from all over the British Isles. Five figurines were first issued in early 1998 in a limited edition of 2,000 pieces each. A sixth figurine, King Canute, was later issued in a limited edition of 500. This figurine was offered free to the first 500 collectors who had ordered all five of the original figurines. All figurines are transfer marked: British Myths and Legends along with the name of the figurine and the word WADE.

1 2 3

4 5 6

OOPS THE BEAR *2002*
This was a "one-of-a-kind" figurine given as a draw prize at the 2002 Summer Wade Fest held in Harrisburg, Pennsylvania.

Above: 1. The Cornish Tin Mine Pixie measures 4-3/8" high. This figurine is based on the mine dwelling goblins of Cornwall and Devon ($45, £28). **2. St. George and the Dragon** measures 4-1/4" high. St. George is England's patron saint ($45, £28).
3. The Green Man measures 4-5/8" high. This figurine was often referred to as Jack-in-the-Green and was always a central figure in May Day celebrations ($45, £28).
Below: 4. The Mermaid measures 4-5/8" high. Based on the Mermaid who supposedly lived in the Pool of Blake-Mere in Staffordshire ($45, £28). **5. Puck** measures 4-1/2" high. Puck was the Hobgoblin made famous in Shakespeare's *A Midsummer Nights Dream* ($45, £28). **6. King Canute** measures 4-3/4" high. This model is based on the legendary English King who mistakenly thought he could turn back the incoming tide ($45, £28).

"BABY BEAR IN PAJAMAS" *1999*
5-3/4" high and is marked: Baby Bear in Pajamas Limited Edition 1000 Alton Towers Hotel Wade England. This figurine, the second in the "Baby Bear" series, was a joint venture between Wade and Alton Towers ($75, £50).

161

ROSIE THE KITTEN, *1998*

Rosie the Kitten was available only with the first 500 Goodie Boxes which were offered to members of the Wade Collectors Club in 1998.

Rosie the Kitten (honey) measures 4-1/4" high and is mold marked Wade England ($40, £25). Only 400 honey glazed figurines were randomly distributed in the Goodie Boxes. **Rosie the Kitten** (white) measures 4-1/4" high and is mold marked Wade England ($115, £75). Only 100 white figurines were randomly distributed in the Goodie Boxes.

ALICE IN WONDERLAND, *1999*

This 1999 set was the fifth annual series offered to the members of the Wade Collectors Club during a membership year. This series differed from previous years as the complete set also included the 1999 membership piece along with a special order piece issued at the end of the membership year. Other than Alice and The Queen of Hearts, each figurine was a limited edition of 2,000 pieces.

Top: 1. Alice measures 4-3/4" high. This was the membership piece for 1999 and is marked: Alice in Wonderland Collection Alice 1999 Membership Piece Made in England ©MacMPub 1999 OIWCC logo ($68, £45). **2. Madhatter** measures 4-3/8" high ($68, £45). **3. White Rabbit** measures 4-1/2" high ($68, £45). **Bottom: 4. Dormouse** measures 3-5/8" high by 4-3/8" overall ($68, £45). **5. Cheshire Cat** measures 2-1/2" high by 3-3/4" overall ($68, £45). **6. Queen of Hearts** measures 5-1/4" high by 3-1/2" dia. base ($98, £65). The Queen of Hearts was available only to members who ordered the four limited edition pieces.

"FIZZY THE FAWN," 1999

Fizzy the Fawn was available only with the first 525 Millennium Goodie Boxes which were offered to members of the Wade Collectors Club in 1999.

Fizzy (honey) measures 3-5/8" high and is mold marked Wade England ($45, £30). Only 450 honey glaze figurines were randomly distributed in the Goodie Boxes. **Fizzy** (white) measures 3-5/8" high and is mold marked Wade England ($135, £90). Only 75 white figurines were randomly distributed in the Goodie Boxes.

VAN HALLEN PENGUINS, 1999

The two penguins are from molds designed by Jessie Van Hallen in the 1950s, long after she had left George Wade & Son Ltd. These molds had been passed on to a Wade enthusiast who allowed Wade to make a limited edition of 750 penguins to be sold at the April 1999, Wade Collectors Fair held at Trentham Gardens. Each figurine is transfer marked: Wade Made in England.

Left: Penguin measures 2-3/8" high. **Right: Penguin** measures 3-3/8" high. (Boxed set of two $105, £70).

VAN HALLEN SEALS, 1999

Two more figurines from the Van Hallen Studio originally modeled in the 1950s. The seals were launched in September 1999 and also sold at the October 1999 Wade Collectors Fair in Dunstable. Both figurines are transfer marked: Wade England.

Left: Seal measures 1-1/4" high by 3" overall. **Right: Seal** measures 1-3/4" high by 2-7/8" overall. (Boxed set of two $55, £30).

VAN HALLEN SEALS

These were a "one-of-a-kind" set given away as a draw prize at the 2001 Wade Fest in Harrisburg, Pennsylvania.

VAN HALLEN CLOWNS, 2000

These two clowns were modeled by Jessica Van Hallen in the 1950s. The Wade clowns were launched at the August 2000 Arundel Swap Meet. Both figurines are transfer marked Wade Made in England.

Left: Clown with bowler hat measures 4-1/8" high. **Right: Clown** with pointed hat measures 4-1/2" high. (Boxed set of two $65, £40).

VAN HALLEN CLOWNS 2000
This set of clowns is a "one-of-a-kind." The clowns will be given out as a prize to a lucky collector at one of the Wade events.

PUPPY LOVE COLLECTION, 1999

A set of five puppies given the name "Puppy Love" sold at various Wade Fairs during 1999. All figurines are marked: "Puppy Love by Wade" on a background of a dog's paw along with the wording: Puppy Love Limited Edition 500 and the name of the figurine.

Top: 1. Henry measures 3-3/8" high. This figurine was issued at the Rosemont Illinois Trade Fair in June ($40, £28). **2. Ella** measures 2-3/8" high. This figurine was issued at The Wade Collectors Fair in October ($40, £28). **3. Stieno** measures 2-7/8" high. This figurine was issued at the August Arundel Swap Meet ($40, £28).
Bottom: 4. Sidney measures 1-3/4" high. This figurine was issued at Trentham Gardens in April 1999 ($40, £28). **5. Shelby** measures 2" high. This figurine was issued at the San Antonio Jim Beam/Wade Fair ($40, £28).

PRAIRIE DOG 1999
3-7/8" high and is marked: The Prairie Dog Texas 1999 along with the OIWCC logo. The figurine was issued at the San Antonio, Texas, Jim Beam/Wade Fair and also sold at the August 1999 Arundel Swap Meet ($38, £26).

CHRISTMAS SANTA 1999
3-1/8" high and is marked: Christmas 1999 along with the OIWCC logo. This was a limited edition of 1,500 figurines ($53, £35).

TEDDY BEAR 2000
This "one-of-a-kind" teddy bear is from the same mold as the teddy bear bookend made for Boots Drug Stores in 1988 - 1989. The teddy bear measures 6-3/8" high and has a red transfer: Wade England on the base.

MILLENNIUM BEAR *2000*
3-1/4" high and is marked: May 2000 along with the OIWCC logo. The Millennium Bear, designed by Helen Bourne, was a limited edition of 500 and first sold at the May 2000 Wade Collectors Fair in Stafford ($110, £60).

MILLENNIUM BEAR
This "one-of a kind" figurine was given as a draw prize at the 2001 Wade Fest in Harrisburg, Pennsylvania. The figurine is marked: Wade made in England.

3. **Badger** measures 5" high and was issued in May 2000 ($52, £35). 4. **Rattie** measures 4-1/2" high and was issued in August 2000 ($52, £35).

WIND IN THE WILLOWS, *2000*

This was the sixth annual series to be offered to members of the Wade Collectors Club during a membership year. The club membership piece for the year 2000 was Toad of Toad Hall. Each figurine is marked: The Wind in the Willows ©EHS 2000 along with the name of the figurine and the OIWCC logo.

5. **Weasel** measures 4-1/4" high and was issued in November 2000 ($52, £35). 6. **Rattie and Mole** measures 3-3/16" high by 4-1/4" long and was issued in December 2000. This figurine was available only to members who ordered the four limited edition pieces ($70, £45).

1. **Toad of Toad Hall** measures 4-1/4" high and was issued in February 2000. This figurine was the membership piece for 2000 ($45, £30). 2. **Mole** measures 4-1/4" high and was issued in February 2000 ($52, £35).

NEW VIC TOAD
3-1/4" high and is marked: New Vic Theatre Wade England. This figurine was similar to, but smaller than the year 2000 membership piece, Toad of Toad Hall. It was specially decorated for the New Vic Theatre ($42, £28).

ROBBIE BURNS *2000*
9-1/4" high and is back stamped: A Special Millennium Limited Edition of 2,000 by Wade Ceramics. This Millennium Tribute to Robert Burns was produced exclusively for Pride and Heritage Ltd. ($115, £75).

ROLY POLY RABBIT *2000*
3" high and has a small red transfer back stamp similar to Mark Type 26. This figurine was a limited issue of 200 pieces sold at the October Wade Extravaganza at Trentham Gardens ($40, £30).

ROLY POLY RABBIT *2000*
Special colorway "one-of-a-kind" was given as a draw prize at the Arundel 2000 Swap Meet.

QUACKER THE DUCK *2000 - 2001*
Left: Quacker the Duck measures 2-5/8" high by 2-1/8" across the base and has a small red transfer backstamp similar to Mark Type 26. This figurine was a limited edition of 500 sold at the Wade Extravaganza held at Trentham Gardens, October 2000 ($45, £28). **Right: Quackers On Ice** measures 1-3/4" high by 3-1/4" long and is marked: Wade Bonanza Arundel 2001. This figurine was a limited edition of 150 pieces ($50, £30).

"OUR LITTLE ANGEL" *2000*
3-1/4" high and is transfer marked: Christmas 2000 along with the OIWCC logo. This figurine was a limited issue of 1,000 pieces ($30, £20).

"CRUNCHIE THE FOAL," *2000*

The Foal was available with only the first 775 Goodie Boxes, distributed worldwide, which were offered to members of the Wade Collectors Club in 2000.

"**Crunchie**" (white) measures 3" high by 2-1/2" long and is mold marked Wade Eng. ($110, £68). Only 125 figurines were issued in the white glaze. "**Crunchie**" (honey) measures 3" high by 2-1/2" long and is mold marked Wade Eng. ($38, £25). Only 625 figurines were made in the honey glaze.

CINDERELLA, 2001 - 2002

This set was the seventh annual series offered to members of the Wade Collectors Club during a membership year. The club membership piece for 2001 was Cinderella followed by other figurines from the popular fairy tale.

1. Cinderella measures 4" high and is marked: Cinderella 2001 along with the OIWCC logo. The figurine was first issued in February 2001 and remained in production throughout the year ($45, £30).

2. Clorinda measures 4-1/2" high and is marked: Clorinda Cinderella 2001 along with the OIWCC logo. Clorinda, one of the "Ugly Sisters" from the Fairy Tale was the first of the four limited edition pieces in the series and was made available in February 2001 ($54, £35).

3. Thisbe measures 4-1/8" high and is marked: Thisbe Cinderella 2001 along with the OIWCC logo. This figurine was issued in May 2001 ($54, £35).

4. Prince Charming measures 3-5/8" high and is marked: Prince Charming Cinderella 2001 along with the OIWCC logo. This figurine was issued in August 2001 ($54, £35).

5. Cinderella Ready for the Ball measures 4" high and is marked: Cinderella Ready for the Ball Cinderella 2001 along with the OIWCC logo ($54, £35).

6. Fairy Godmother measures 4-3/8" high and is marked: Fairy Godmother Cinderella 2001 along with the OIWCC logo. This figurine was sold only to members who had bought all four limited edition figurines in the series and was limited to 1818 pieces ($60, £40).

CLORINDA 2002

This was a "one-of-a-kind" figurine given as a draw prize at the 2002 Summer Wade Fest held in Harrisburg, Pennsylvania.

167

"RUFFLES" THE BEAR *2001*

2-3/8" high and is mold marked: Wade. This figurine was a gift to people who had a friend joining the Wade Collectors Club during the year 2001. The friend was also given a gift of the figurine ($25, £15).

HECTOR and PEDRO, *2001*

The figurines of Hector and Pedro were sold at the April 2001 Trentham Gardens Wade Collectors Fair. These were the first two figurines in the new Wade "Cuties" series.

1. **Hector** measures 2-3/8" high and is marked: Wade. This figurine with the gold highlights was a limited edition of 25 pieces that were randomly placed in "Goodie Bags" sold at the Fair (N.P.A.). 2. **Hector** was a limited edition of 250 pieces ($45, £30).

3. **Pedro** measures 2-1/4" high by 2-3/4" overall and is marked: Wade. This figurine with the gold highlights was a limited edition of 25 pieces that were randomly placed in "Goodie Bags" sold at the Fair (N.P.A.). 4. **Pedro** was a limited edition of 250 pieces ($45, £30).

SUMO and CLARENCE, *2001*

The figurines of Sumo and Clarence were sold at the Factory Shop and at the 2001 Arundel Wade Collectors Meet. These two figurines were part of the Wade "Cuties" series.

1. **Sumo** measures 2-1/4" high and is marked: Wade. This figurine with the gold highlights was a limited edition of 25 pieces that were randomly placed in "Goodie Bags" sold at the Fair (N.P.A.). 2. **Sumo** was a limited edition of 250 pieces ($45, £30).

3. **Clarence** measures 1-3/4" high and is marked: Wade. This figurine with the gold highlights was a limited edition of 25 pieces that were randomly placed in "Goodie Bags" sold at the Fair (N.P.A.). 4. **Clarence** was a limited edition of 250 pieces ($45, £30).

POPPY and MAJOR, *2001*

These figurines were sold at the October 2001 Trentham Gardens Wade Collectors Fair and at the Factory Shop. and were the last two figurines in the Wade "Cuties" series.

1. **Poppy** measures 2-1/2" high and is marked: Wade. The figurine was a limited edition of 250 pieces ($45, £30). 2. **Poppy** with the gold highlights was a limited edition of 25 pieces that were randomly placed in "Goodie Bags" sold at the Fair (N.P.A.).

Left:
3. **Major** measures 2-1/4" high and is marked: Wade. This figurine with the gold highlights was a limited edition of 25 pieces that were randomly placed in "Goodie Bags" sold at the Fair (N.P.A.). 4. **Major** was a limited edition of 250 pieces ($45, £30).

168

NIBBLES, *2001*

These limited edition, slip cast figurines were sold at the 2001 Summer Wade Fest in Harrisburg, Pennsylvania. Each figurine has an impressed mark Wade on the base.

Left: Nibbles measures 2 3/4" high. The figurine was a limited edition of 135 pieces ($58, £38). **Right: Nibbles** with a white glaze was a limited edition of 15 figurines ($118, £75).

SKIP, *2001*

This solid, pressed, figurine was modeled after "Skip" from the Warner Bros. film "My Dog Skip." The figurine was given away with the purchase of the video only in the UK, but a small number were sold at the 2001 Summer Wade Fest in Harrisburg, Pennsylvania.

Skip measures 1-5/8" high and is mold marked Wade Eng. around the base ($12, £8).

LIL' DEVIL, *2001*

The Lil' Devil was a limited edition of 100 pieces, 99 of which were sold at the October 2001 Trentham Gardens Wade Fair. The remaining figurine was donated to "This is Collecting" auction, which was to raise money to help those involved in the September 11, 2001 tragedy in New York City.

Lil' Devil measures 3-1/2" high and is marked: Lil' Devil Ltd Etd 100 Extravaganza Special 2001 Wade ($150, £100).

SANTA'S HELPER, *2001*

Santa's Helper was the 2001 members Christmas piece. This figurine was a limited edition of 500 pieces, each with its own certificate of authenticity.

Santa's Helper measures 2-1/2" high and is marked: Santa's Helper Christmas 2001 Wade ($45, £28).

STILTON THE MOUSE, *2001*

Stilton the Mouse was packed in the first 500 orders of the 2001 goodie boxes that were offered to the members of the Wade Collectors Club. Orders for the goodie boxes had to be in by October 2001. There were 425 figurines in honey color and 75 figurines in white.

Stilton the Mouse measures 2-1/4" high and is marked: Stilton Mouse Goodie Box Special 2001 Wade ($38, £25).

PETER PAN, *2002*

The popular children's story about Peter Pan, the little boy who never grew up, was the theme for the eighth annual series of limited editions offered to members of the Wade Collectors Club during a membership year. Peter Pan is the registered trade mark of Great Ormond Street Hospital Children's Charity.

1. Peter Pan measures 4-3/8" high and is marked: Peter Pan, Peter Pan Collection membership piece 2002 The Official International Wade Collectors Club. This figurine was the membership piece for the year 2002 ($42, £28). **2. Tinkerbell** measures 3" high and is marked: Peter Pan Collection 2002 Tinkerbell Limited Edition The Official International Wade Collectors Club. This figurine was issued in February 2002 ($42, £28). **3. John** measures 3-1/2" high and is marked: Peter Pan Collection 2002 John Limited Edition The Official International Wade Collectors Club. This figurine was issued in May 2002 ($42, £28).

PIG STYLES RANGE, 2002

A new range of comic pigs was introduced at the April 2002 Wade Collectors Fair held at The Kings Hall in Stoke with the figurine, Twirly Whirley. The second figurine is to be Topsey Turvey which will be sold at the July 2002 Collectors Meet in Arundel.

1. **Twirly Whirley** measures 2-7/8" high and is marked: "Pig Styles" 2002 Ltd. Edition of 200 Wade Twirly - Whirley ($39, £25).

2. **Topsy - Turvy** measures 2-3/4" high and is marked: "Pig Styles" 2002 Ltd. Edition of 200 Wade Topsy - Turvy ($39, £25).

3. **Ceasar** measures 2-1/2" high and is marked: "Pig Styles" 2002 Ltd. Edition 200 Wade Ceasar ($39, £25).

LIL' UNCLE SAM 2002

1. **Lil' Uncle Sam** measures 3-3/8" high and is marked: Lil' Uncle Sam Ltd. Edt. 125 July 2002 Wade. This figurine, produced in a limited edition of 125 was sold at the 2002 Summer Wade Fest held in Harrisburg, Pennsylvania ($80, £55). 2. **Lil' Uncle Sam** measures 3-3/8" high and is marked: Lil' Uncle Sam Ltd. Edt. 125 June 2002 Wade. This figurine, produced in a limited edition of 125 was sold at the 2002 West Coast Wade Collectors Fair ($80, £55).

MISCHIEF THE CHIMP 2002

2-1/2" high and is marked: Wade Mischief the Chimp USA July 2002. These figurines were first sold at the July 2002 West Coast Wade Collectors Fair. **Left: Mischief the Chimp** was a limited edition of 100 figurines. **Right: Mischief the Chimp** was a limited edition of 25 figurines that were randomly packed.

LIL' EASTER TIME 2002

3-1/4" high and is marked: April 2002 Lil' Easter Bear Ltd. Edt. 125 Wade. This was a limited edition of 125 figurines sold at the April 2002 Wade Collectors Fair held at the King's Hall in Stoke - on - Trent ($95, £55).

MISCHIEF THE CHIMP 2002

This was a "one-of-a-kind" figurine given away as a draw prize at the 2002 Summer Wade Fest held in Harrisburg, Pennsylvania.

Chapter 15
WADE PRIVATE COMMISSIONS

by Wade Ceramics Limited
1989 - 2002

During the last decade Wade Ceramics Limited has produced a large number of limited edition figurines commissioned by various individuals and giftware-oriented businesses. Many of these commissions have proven to be very popular with collectors, and to this time this interest seems not to have waned.

Many limited editions were produced in very small quantities and were sold only at the many Wade events and have thus gained value on the secondary market. A number of the limited edition figurines were sold only by mail order but whether sold at an event or through the mail, most limited editions are highly sought after by Wade collectors.

C & S COLLECTABLES, 1993 - present

Established in 1986 by David Chown and Russell Schooley, C&S Collectables has become one of the major businesses to produce figurines made especially for them by Wade Ceramics Limited.

The first figurine to be produced for C&S was the original Arthur Hare. Then, in 1994, C&S commissioned their first licensed figurine and has gone on to commission many more pieces, including Betty Boop and Snoopy. The business expanded and moved in 1997, to larger quarters in Arundel, Sussex under the name of The Official Wade Collectors' Centre. It should be noted that all C&S figurines, other than the original Arthur Hare Series and The Andy Capp and Flo figurines, come with a Certificate of Authenticity.

ARTHUR HARE *1993*
5-1/4" high and is marked: Arthur Hare © C&S Collectables Wade England.
Left: Arthur Hare with the blue glaze was produced in a limited edition of 1,650 pieces ($45, £35). **Right: Arthur Hare** with the brown glaze was produced in a limited edition of 350 pieces ($70, £59).

HOLLY HEDGEHOG *1994*
3-1/2" high and is marked: Holly Hedgehog ©C&S Collectables. This figurine was a limited edition of 2,000 pieces ($45, £35).

FELICITY SQUIRREL *1995*
4-1/4" high and is marked: Felicity Squirrel 1,250 Limited Edition C&S Collectables ©1995 Arthur Hare Productions Wade England. **Left: Felicity Squirrel** was a limited edition of 1,000 figurines in the gray color. Of the 1,000 figurines, 250 grey figurines were issued with the exclusive Colorado based Collectors Corner backstamp ($45, £35). **Right: Felicity Squirrel** was a limited edition of 250 figurines in the red color. Of the 250 figurines, 6 were issued with the Collectors Corner backstamp ($90, £65).

EDWARD FOX *1997*
4-5/8" high and is marked: Edward Fox 1,000 limited edition ©C&S Collectables 1997 Arthur Hare Productions. **Left: Edward Fox** is the production model ($45, £35). **Right: Edward Fox** was a sample only in the rusty/orange glaze ($200, £150).

ARTHUR HARE MINIATURE SERIES, *1997 - 2000*

Starting in 1997, C&S Collectables began a highly successful series of miniature figurines based on the original Arthur Hare figurine.

1 2 3 4

1. Santhare Paws measures 5" high and is marked: ©1997 C&S Collectables Limited Edition with Certificate of Authenticity Modeled by Andy Moss Arthur Hare Limited Edition (C&S)™ Santhare Paws Wade England. This figurine was a limited edition of 500 sold at the 1997 Arundel Christmas Bonanza ($70, £50).
2. Chief Bravehare measures 4-3/4" high and was issued in 1998, in a limited edition of 1,000 pieces. The backstamps for the three following figurines are similar to Santhare Paws but with a change in name and edition number ($55, £40). **3. The Shareiff** measures 4-5/8" high and was issued in 1999, in a limited edition of 1,000 pieces ($55, £40). **4. P.C. Gotchare** measures 4-3/4" high and was issued in a limited edition of 1,000 pieces ($55, £40).

Left: The Jesthare measures 4-3/4" high and is backstamped: With Certificate of Authenticity ©1998 C&S 350 Special Edition C&S™ Arthur Hare The Jesthare Wade England. This figurine with the platinum base was issued in 1998, at the Brunel University Uxbridge Wade Fair ($100, £75). **Right: The Jesthare** figurine with the gold colored base was a limited issue of 350 pieces issued at the Wade, Alton Towers Christmas Extravaganza in November 1998 ($100, £75).

1 **2** **3**

1. **Collecthare** measures 4-5/8" high and is marked: With Certificate of Authenticity C&S Arthur Hare™ The Collecthare by Wade England ©1998 C&S. The figurine was issued at the 1998 Wade Christmas Bonanza in a limited edition of 400 ($60, £45).
2. **Collecthare "Jolly Potter"** measures 4-5/8" high and is marked: With Certificate of Authenticity 500 Limited Edition C&S Arthur Hare™ The Collecthare by Wade England ©1999 C&S. The figurine was issued at the Wade Collectors Fair in April 1999, in a limited edition of 500 ($60, £45). 3. **Collecthare "Wade's World"** measures 4-5/8" high and is marked with a similar backstamp to the "Jolly Potter" figurine. This was a "mail order" figurine in a limited edition of 500 pieces ($60, £45).

WizHared measures 4-5/8" high and is marked: ©2000 C&S Collectables With Certificate of Authenticity Arthur Hare™ The WizHared Modeled by Andy Moss 500 Limited Edition C&S Wade England. This figurine was a "mail order" item ($55, £40).

Harelloween measures 4-1/4" high and is marked: ©2000 C&S Collectables Arthur Hare™ Harelloween Modeled by Andy Moss 500 Limited Edition C&S With Certificate of Authenticity Wade England. This was a "mail order" figurine ($55, £40).

ARTHUR HARE TEENIES, 1999 - 2000

These figurines were miniature versions of the Arthur Hare series and were issued in limited editions. The first three figurines were limited to 300 each and sold at the 1999 Wade Christmas Bonanza in Arundel. The last two figurines were a limited to 250 figurines each and sold at the 2000 Wade Fest in Harrisburg, Pennsylvania. Each figurine measures approx. 2-1/4" high and is mold marked "Wade" on the base.

1 **2** **3**

1. **Harestronaut**. This was a sample figurine only (N.P.A.).
2. **Harestronaut** measures 4-1/2" high and is marked: Arthur Hare™ The Harestronaut by Wade England ©1999 C&S 500 Limited Edition with Certificate of Authenticity. The figurine was issued in 1999 in a limited edition of 500 pieces and was made available at the Jim Beam/Wade Fair in San Antonio, Texas and at the 1999 Arundel Swap Meet ($65, £50). 3. **Harestronaut**. This was a sample figurine only (N.P.A.).

1 **2** **3** **4** **5**

1. **Teenie Jesthare** ($25, £14). 2. **Teenie P.C. Gotchare** ($25, £14). 3. **Teenie Harestronaut** ($25, £14). 4. **Teenie Shareiff** ($25, £14). 5. **Teenie Chief Bravehare** ($25, £14).

Prototype models of Arthur Hare Teenies. **Left:** Teenie Jesthare. **Center:** Teenie Harestronaut. **Right:** Teenie P.C. Gotchare.

TRAVELHARE, *1998 - 1999*

This extremely popular series of figurines was issued over a one year period celebrating various Wade events. The figurines measure 4-1/2" high and have similar backstamps reading: ©1998 C&S Collectables Fair Special Uxbridge, Trentham Gardens, Buffalo, Arundel Swap Meet, Dunstable Modeled by Andy Moss Special Limited Edition C&S Arthur Hare™ with certificate of Authenticity by Wade England.

1 **2** **3**

1. Red Vest Travelhare was issued at Trentham Gardens in 1998 in a limited edition of 250 pieces ($150, £100). **2. Yellow Vest Travelhare** was issued in May 1998 at the Wade Uxbridge Fair in a limited edition of 250 pieces ($110, £80). **3. Purple Vest Travelhare** was also issued at the Uxbridge Fair in May 1998 in a limited edition of 250 pieces ($110, £80).

4 **5** **6**

4. Stars and Stripes Travelhare was issued at the July 1998, Buffalo Jim Beam/Wade Fair in a limited edition of 250 pieces ($100, £75). **5. Britannhare** was issued at the 1998 Arundel Swap Meet in a limited edition of 500 pieces. One hundred of these figurines were sold at the July 1998, Jim Beam/Wade Fair in Buffalo, New York ($90, £65). **6. Collect it! Travelhare** was issued at the August 1998 Newark Collect it! Fair in a limited edition of 400 pieces ($90, £65).

7 **8** **9**

7. Gold Vest Travelhare was issued as a special "mail order" item in a limited edition of 250 pieces ($80, £65). **8. Pearl Lustre Vest Travelhare** was issued at the 1998 Dunstable Wade Fair in a limited edition of 350 pieces ($80, £65). **9. Gold Base Travelhare** was a sample only and never went into production ($80, £65).

ARTHUR HARE "WIZHARED" WHIMSIE *2001*
Left: "Wizhared" Whimsie (green) measures 1-1/2" high and is mold marked Wade/C&S. This figurine was a limited edition of 250 figurines sold at the 2001 Wade Fest at Harrisburg, Pennsylvania ($17, £12). **Right:** "Wizhared" Whimsie (blue) measures 1-1/2" high and is mold marked Wade/C&S. This figurine was a limited edition of 1,750 figurines sold during April 2001 ($15, £10). Both figurines were modeled by Simon Millard.

174

ARTHUR HARE DISPLAY SPECIAL *2000*
9" high and is marked: ©2000 C&S Collectables with Certificate of Authenticity Arthur Hare Wade Collectors' Centre Special Wade England Modelled by Bob Feather. Only two of these large size Arthur Hare figurines were produced as display specials for the Official Wade Collectors' Centre in Arundel ($750, £400).

ANDY CAPP, *1994*

In 1994, C&S Collectables commissioned Wade to produce figurines of Andy Capp and his wife Flo. These cartoon characters were made famous by Reg Smythe who had drawn the characters as a cartoon strip for the *Daily Mail*.

Andy Capp
Prototype models (white only $150, £100).

175

Left: Betty Boop was a sample only (N.P.A.). **Center: Betty Boop** was a sample only ($450, £350). **Right: Betty Boop** measures 3-3/4" high and was a limited edition of 25 figurines that were given away as prizes at various Wade events ($450, £300).

1. Andy Capp measures 3" high with Mark Type 27B along with the wording: 1994 © Mirror Group Newspapers Ltd. C&S Collectables. There were 1,900 figurines produced in 1994 without the cigarette ($50, £35). **2. Flo** measures 3" high with Mark Type 27B along with the wording: 1995 © Mirror Group Newspaper Ltd. C&S Collectables. There were 1,900 figurines produced in 1995 without the cigarette ($35, £25).

3. Andy Capp was a limited edition of 110 figurines with the cigarette ($150, £100). **4. Flo** was a limited edition of 120 figurines with the cigarette ($150, £100).

BETTY BOOP, *1996 - present*

Starting in 1996, C&S Collectables began commissioning what has become a highly popular series of figurines based on the 1930s cartoon character, Betty Boop.

1. Betty Boop Wall Plaque measures 9" high by 5-7/8" wide and is marked: ©1997 King Features Syndicate, Inc. Fleischer Studios, Inc. ™Hearst Corporation 1,250 Limited Edition C&S with Certificate of Authenticity Betty Boop Classic by Wade England. This plaque was sold via mail order in 1997, by C&S Collectables ($100, £85).

Left: Betty Boop measures 3-3/4" high and is marked: ©1996 King Features Syndicate, Inc. Fleischer Studios, Inc. 2000 Limited Edition C&S Betty Boop™ by Wade England. This figurine was produced in a limited edition of 1,500 figurines and was sold by mail order in 1996, direct from C&S Collectables ($95, £75).
Right: Betty Boop measures 3-3/4" high and is marked: ©1996 King Features Syndicate, Inc. Fleischer Studios, Inc. 2000 Limited Edition C&S Betty Boop™ by Wade England. This figurine with the pearlized base was produced in a limited edition of 475 pieces and was sold at the 1997 Wisconsin Jim Beam/Wade Fair and at the 1997 Arundel Swap Meet ($110, £85).

1. Betty Boop Christmas Surprise measures 5" high and is marked: ©1996 King Features Syndicate, Inc. Fleischer Studios, Inc. ™Hearst Corporation 2,000 Limited Edition C&S with Certificate of Authenticity Betty Boop Christmas Surprise by Wade England. This figurine with the brown bag and pearlized base was produced in a limited edition of 1,750 pieces and was sold via mail order by C&S Collectables ($120, £85).

2. Betty Boop Christmas Surprise with a gold base and a green bag was produced in limited edition of 250 pieces and sold at the Collect it! Fair in December 1998 ($160, £120).

2. Betty Boop Wall Plaque measures 9" high by 5-7/8" wide and is marked: ©1997 King Features Syndicate, Inc. Fleischer Studios, Inc. ™Hearst Corporation 1,250 Limited Edition C&S with Certificate of Authenticity Betty Boop Classic by Wade England Collect it!. This plaque with the red skirt was sold in 1997 to readers of *Collect it!* magazine ($95, £75).

Betty Boop Beach Belle measures 6" high and is marked: ©1998 King Features Syndicate, Inc. Fleischer Studios, Inc. ™Hearst Corporation 2,000 Limited Edition C&S with Certificate of Authenticity Betty Boop Beach Belle by Wade England. This figurine was produced in a limited edition of 2,000 pieces and was sold in 1998 by C&S Collectables via mail order ($95, £75).

Betty Boop Bikini measures 6" high and is marked: ©1998 King Features Syndicate, Inc. Fleischer Studios, Inc. ™Hearst Corporation 2,000 Limited Edition C&S with Certificate of Authenticity Betty Boop Beach Belle by Wade England. This figurine was a sample of six, which never went into full production and was given out as a draw prize at the 1998 Jim Beam/Wade Fair in Buffalo, New York ($450, £300).

Betty Boop Southern Belle was a "one-of-a-kind" figurine ($450, £250).

Left: Betty Boop Halloween was a limited edition of 980 figurines and was sold in 1999 via mail order by C&S Collectables ($150, £100). **Right: Betty Boop Halloween** was a limited edition of 20 figurines ($350, £250). Both Betty Boop Halloween figurines measure 6" high and are marked: ©1999 King Features Syndicate, Inc. Fleischer Studios, Inc. ™Hearst Corporation/Fleischer Studios, Inc. 1,000 Limited Edition C&S with Certificate of Authenticity Betty Boop Halloween Trick or Treat by Wade England.

Left: Betty Boop Southern Belle was a limited edition of 500 pieces and was sold at the 1999 Arundel Swap Meet ($125, £85). **Right: Betty Boop Southern Belle** was a limited edition of 100 pieces and sold at the 1999 Arundel Swap Meet ($300, £200). All Betty Boop Southern Belle figurines measure 3-1/8" high and are marked: ©1999 King Features Syndicate, Inc. Fleischer Studios, Inc. ™Hearst Corporation Special Edition C&S Betty Boop Southern Belle Frankly My Dear, I don't give a Boop Miniature Movie Queens #1 by Wade England with Certificate of Authenticity.

Left: Betty Boop Liberty was a limited edition of 975 figurines and was sold in 2000 via mail order by C&S Collectables ($150, £100). **Right: Betty Boop Liberty** was a limited edition of 25 figurines ($350, £250). Both Betty Boop Liberty figurines measure 6-1/4" high and are marked: ©2000 King Features Syndicate, Inc./Fleischer Studios, Inc. ™Hearst Holdings, Inc./Fleischer Studios, Inc. 1,000 Limited Edition C&S with Certificate of Authenticity Betty Boop Liberty by Wade England.

Left:
Betty Boop Springtime measures 6-1/4" high and is marked: ©2000 King Features Syndicate, Inc./Fleischer Studios, Inc. ™Hearst Holdings, Inc./Fleischer Studios, Inc. 1,000 Limited Edition C&S with Certificate of Authenticity Betty Boop Springtime by Wade England. This figurine was a limited edition of 1,000 pieces and sold in 2000 via mail order by C&S Collectables ($125, £95).

Left: Betty Boop Ringmaster measures 5" high and is marked: Betty Boop™ Ringmaster ©2000 King Features Syndicate, Inc./Fleischer Studios, Inc. ™Hearst Holdings, Inc./Fleischer Studios, Inc. Special Limited Edition C&S with Certificate of Authenticity Wade England. **Right: Pudgy** measures 2-1/2" high and is marked: Pudgy ©KFS/FS 2000. Both figurines were limited editions of 500 each and sold at the July 2000 Arundel Swap Meet ($125 set, £95 set).

1. Betty Boop Liberty Wall Plaque measures 7" high by 6" wide and is marked: ©1999 King Features Syndicate, Inc. Fleischer Studios, Inc. ™Hearst Corporation/Fleischer Studios, Inc. Betty Boop 300 Limited Edition C&S with Certificate of Authenticity Betty Boop Liberty by Wade England. This plaque was sold in April 2000 via mail order by C&S Collectables ($135, £95).

Betty Boop Ringmaster measures 5" high and is marked: Betty Boop™ Ringmaster ©2000 King Features Syndicate, Inc./Fleischer Studios, Inc. ™Hearst Holdings, Inc./Fleischer Studios, Inc. Special Limited Edition C&S with Certificate of Authenticity Wade England ($450, £250).

2. Betty Boop Liberty Wall Plaque measures 7" high by 6" wide and is marked: ©1999 King Features Syndicate, Inc. Fleischer Studios, Inc. ™Hearst Corporation/Fleischer Studios, Inc. Betty Boop 300 Limited Edition C&S with Certificate of Authenticity Betty Boop Liberty by Wade England Collect it! Special Edition. This plaque was sold to readers of *Collect it!* magazine in 2000 ($135, £95).

Betty Boop Rose measures 5" high and is marked: Betty Boop Rose modeled by K. Homes Wade England ©2000 King Features Syndicate, Inc./Fleischer Studios, Inc. ™Hearst Holdings, Inc. 1,000 Limited Edition C&S with Certificate of Authenticity. This figurine was sold in 2000 via mail order by C&S Collectables ($150, £100).

Betty Boop Movie Queen measures 9" high and is marked: Betty Boop Premier Collection ©2001 King Features Syndicate, Inc./Fleischer Studios, Inc. ™Hearst Holdings/Fleischer Studios Limited Edition 250 C&S Wade. This was a limited edition of 250 sold in July 2001 via mail order by C&S Collectables ($325, £225).

Betty Boop Graduate U.K. measures 6" high and is marked: Betty Boop Graduate ©2001 King Features Syndicate, Inc./Fleischer Studios, Inc. ™Hearst Holdings/Fleischer Studios Limited Edition 500 C&S Wade. This figurine was a limited edition of 500 sold via mail order by C&S Collectables in October 2001. There was a second version of this figurine, Betty Boop U.S.A., which was a limited edition of 500 sold via This is collecting.com. Betty Boop Graduate U.K. had the Union Jack flag in the backstamp and Betty Boop Graduate U.S.A. had the Stars and Stripes flag included in the backstamp ($140 each, £95 each).

Betty Boop Superstar measures 5-3/4" high and is marked: Betty Boop™ Superstar 750 Limited Edition C&S ™Hearst Holdings, Inc./Fleischer Studios, Inc. ©2001 King Features Syndicate, Inc./Fleischer Studios, Inc. Wade. This figurine was sold by C&S Collectables in December 2001 via mail order ($140, £95).

Betty Boop Bust Moneybank measures 5" high and is marked: Betty Boop™ Bust Moneybank 500 Limited Edition C&S Wade ©2001 KFS/FS. This money bank was a limited edition of 500 pieces sold by C&S Collectables via mail order in December 2001 ($95, £65). There were 20 Betty Boop Bust money banks produced without the slot ($250, £150).

1. Betty Boop Valentine measures 4" high by 5" long and is marked: Betty Boop™ Valentine ©2002 King Features Syndicate, Inc./Fleischer Studios, Inc. ™Hearst Holdings/Fleischer Studios, Inc. Limited Edition 750 C&S Wade. This figurine was a limited edition of 750 pieces sold by C&S Collectables in February 2002 via mail order ($140, £100).

2. Betty Boop Valentine gold base was a limited edition of 20 figurines and was given away as draw prizes at various Wade events. The backstamp is similar to the regular figurine but the Certificate of Authenticity listed the limited edition to be 20 pieces ($400, £250).

Left: Betty Boop Queen of Hearts measures 6" high and is marked: ©2001 King Features Syndicate, Inc./Fleischer Studios, Inc. ™Hearst Holdings/Fleischer Studios Limited Edition 2000 C&S Wade. This figurine was a limited edition of 2,000 pieces sold by C&S Collectables via mail order in March 2002 ($100, £75).
Right: Betty Boop Queen of Hearts gold measures 6" high. This was a limited edition of 20 pieces. The backstamp is similar to the regular figurine but the Certificate of Authenticity listed the limited edition to be 20 figurines ($250, £150).

Left: Betty Boop St. Patrick's measures 5-1/2" high and is marked: Betty Boop™ St. Patrick's Day C&S Collectables 750 Limited Edition Wade ©2002 King Features Syndicate, Inc./Fleischer Studios, Inc. ™Hearst Holdings, Inc./Fleischer Studios, Inc. This figurine was a limited edition of 750 pieces sold by C&S Collectables via mail order in March 2002 ($140, £100). **Right: Betty Boop St. Patrick's** gold was a limited edition of 20 figurines. The backstamp is similar to the regular figurine but the Certificate of Authenticity listed the limited edition to be 20 pieces. The figurines were given away as draw prizes at various Wade events ($250, £150).

Betty Boop Elegance measures 9" high and is marked: Betty Boop™ Premier Collection Elegance C&S Collectables 500 Limited Edition Wade ©2002 King Features Syndicate, Inc./Fleischer Studios, Inc.™ Hearst Holdings, Inc./Fleischer Studios, Inc. ($150, £100).

Betty Boop Lazy Daze measures 3" high by 4-1/2" overall and is marked: ©2002 King Features Syndicate, Inc. Fleischer Studios, Inc. 750 Limited Edition C&S with Certificate of Authenticity Betty Boop Lazy Daze by Wade England. This figurine was a limited edition of 750 pieces modeled by Ken Holmes and sold via mail order ($84, £55).

Betty Boop Halloween 2002 measures 5" high and is marked: Betty Boop™ Hallowe'en 2002 Limited Edition 750 C&S Official Collectors Center Wade ©2002 King Features Syndicate, Inc./Fleischer Studios, Inc. ™Hearst Holdings, Inc./Fleischer Studios, Inc. This limited edition figurine of 750 pieces was modeled by Ken Holmes and sold via mail order by C&S Collectables ($84, £55).

ARUNDEL SPECIALS, 1997 - present

Wade Ceramics Limited in partnership with C&S Collectables, have produced a number of figurines sold at the annual Arundal Swap Meet, which was renamed Wade Collectors Meet in 2001. It has become the custom to issue one special figurine in two different colorways randomly packed for each event.

ARUNDEL BUNNY *1998*
2-1/4" high by 4-3/8" long and is mold marked: Wade England. This was a "one-of-a-kind" figurine was given away as a draw prize (N.P.A.).

ARUNDEL DUCK *1997*
3-3/4" high and is marked: The Arundel Duck August 1997 along with the OIWCC logo. The honey colored duck was produced in a limited edition of 1,400 and sold at the 1997 Arundel Swap Meet ($95, £55).

THE ARUNDEL CHICK *1999*
3" high and is marked: The Arundel Chick 1999 along with the OIWCC logo. **Left: The Arundel Chick** was produced in a limited edition of 900 and sold at the 1999 Arundel Swap Meet ($50, £30). **Right: The Arundel Chick** was produced in a limited edition of 100 and sold at the 1999 Arundel Swap Meet ($155, £100).

ARUNDEL DUCK *1997*
3-3/4" high and is marked: The Arundel Duck August 1997 along with the OIWCC logo. **Left: Arundel Duck** was produced in a limited edition of 100 and sold at the 1997 Arundel Swap Meet ($375, £250). **Right: Arundel Duck** was a "one-of-a-kind" figurine given away as a draw prize (N.P.A.).

THE ARUNDEL CAT *2000*
4-1/4" high and is mold marked: Wade. **Left: Arundel Cat** was produced in a limited edition of 900 and sold at the 2000 Arundel Swap Meet ($60, £35). **Right: Arundel Cat** was produced in a limited edition of 100 and sold at the 2000 Arundel Swap Meet ($155, £100). This figurine was produced from a mold originally made by Jessica Van Hallen.

Left:
ARUNDEL BUNNY *1998*
2-1/4" high by 4-3/8" long and is marked: The Arundel Bunny July 1998 along with the OIWCC logo, and also mold marked Wade England. **Left: Arundel Bunny** was produced in a limited edition of 1,400 and sold at the 1998 Arundel Swap Meet ($60, £35). **Right: Arundel Bunny** was produced in a limited edition of 100 and sold at the 1998 Arundel Swap Meet ($225, £150).

CARTOON FIGURINES, 1998 - 2001

Starting in 1998, C&S Collectables has produced, under license, a number of figurines based on popular animated and strip cartoon characters.

THE ARUNDEL CAT *2000*
4-1/4" high and is mold marked: Wade. All three figurines are "one-of-a-kind" and were bran tub prizes at the August 2000 Arundel Swap Meet (N.P.A.).

MR. MAGOO *1998*
3-7/8" high and is marked: Mr. Magoo C&S 1,000 Limited Edition ©1998 UPA Pictures, Inc. with Certificate of Authenticity Wade England ($65, £55). Of the original 1,000 figurines, 40 were made with a gold base and were sold at the Ripley Castle Teddy Bears Picnic in 1998 ($140, £100).

THE ARUNDEL CAT *2000*
4-1/4" high and is mold marked: Wade. Both figurines are "one-of-a-kind" and were bran tub prizes at the August 2000 Arundel Swap Meet (N.P.A.).

GARFIELD *1999*
3" high and is marked: With Certificate of Authenticity C&S 500 Special Edition Wade England. These figurines were sold "via mail order" by C&S Collectables ($75, £55).

THE ARUNDEL PUPPY *2001*
2-7/8" high and is marked: Collectors Meet 2001 along with Mark Type 27B1 on the base. **Left: Arundel Puppy** was a limited edition of 900 and sold at the 2001 Arundel Wade Collectors Meet ($60, £30). **Right: Arundel Puppy** was a limited edition of 100 sold at the 2001 Arundel Wade Collectors Meet ($165, £95).

ORINOCO *1999*
Left: Orinoco measures 4-3/4" high and is marked: The Womble™ Orinoco by Wade England C&S 1,000 Limited Edition with Certificate of Authenticity ©Elizabeth Beresford/Film Fair Ltd. 1999. This figurine was produced in a limited edition of 750 ($60, £40). **Right: Orinoco** measures 4-3/4" high and is marked: The Womble™ Orinoco by Wade England C&S 1,000 Limited Edition with Certificate of Authenticity ©Elizabeth Beresford/Film Fair Ltd. 1999. This figurine, with a gold base, was produced in a limited edition of 250 pieces ($70, £50).

THE ARUNDEL PONY *2002*
3-1/4" high by 4-1/4" overall and is marked: Wade Collectors Meet 2002. **Left: Arundel Pony** was a limited edition of 900 and sold at the 2002 Arundel Wade Collectors Meet ($60, £30). **Right: Arundel Pony** was a limited edition of 100 figurines sold at the 2002 Arundel Wade Collectors Meet ($140, £85).

SNOOPY AND WOODSTOCK *1999*
Left: Snoopy measures 2-3/4" high and is marked: C&S ©UFS, Inc. Wade England ($70, £50). **Right: Woodstock** measures 2-1/2" high and is marked: C&S ©UFS, Inc. Wade England ($70, £50). Both figurines were produced in a limited edition of 1,000 and sold, as a pair, via "mail order" by C&S Collectables.

SNOOPY KENNEL MONEY BANK *2001*
This is a sample model ($150, £100).

SNOOPY HUGGING WOODSTOCK *2000*
2-5/8" high and is marked: C&S ©UFS, Inc. Wade England. This figurine was produced in a limited edition of 1,000 and sold via "mail order" by C&S Collectables ($80, £50).

CHARLIE BROWN AND LINUS *2001*
Left: Charlie Brown measures 3-3/8" high and is marked: C&S ©UFS, Inc. Wade. **Right: Linus** measures 2-7/8" high and is marked: C&S ©UFS, Inc. Wade. Both figurines were limited editions of 500 each and sold by C&S Collectables via mail order ($110 set, £85 set).

SNOOPY HAPPY HOLIDAYS *2000*
3-7/8" high and is marked: C&S ©UFS, Inc. Wade England Modeled by C. Roberts Peanuts Celebrations. This figurine was produced in a limited edition of 1,000 and sold via "mail order" by C&S Collectables ($65, £45).

SNOOPY KENNEL MONEY BANK *2001*
4-7/16" high by 2-7/8" wide and is marked: C&S ©UFS, Inc. Peanuts Wade England Modeled by C. Roberts. This money bank was sold by C&S Collectables via mail order ($65, £40).

THOMAS THE TANK ENGINE MONEY BANK *2001*
3-3/4" high by 3" wide by 3-3/4" deep and is marked: Thomas the Tank Engine Money Bank ©Gullane (Thomas) Limited 2001 C&S Collectables 500 Limited Edition Wade. The money bank was sold by C&S Collectables via mail order ($95, £75).

184

THOMAS THE TANK ENGINE *2002*
2" high by 3" long and is marked: ©Gullane (Thomas) Limited 2002 C&S Wade. Thomas and Percy were sold as a pair in a limited edition of 500 in June 2002 ($90/pair, £60/pair).

SANTA'S FLIGHT *2000*
Santa's Flight measures 2-7/8" high by 3-3/4" overall and is marked: Santa's Flight™ Wade Christmas Bonanza 2000 Wade England 250 Limited Edition ©2000 C&S Collectables with Certificate of Authenticity. This figurine was sold at the December 2000 Christmas Bonanza held at the Collectors Centre in Arundel ($55, £45).

PERCY *2002*
2" high by 3" long and is marked: ©Gullane (Thomas) Limited 2002 C&S Wade.

Santa's Flight with gold wings was a limited edition of 10 figurines given away as draw prizes ($150, £100).

TOWN CRYER BEAR *2001*
1. Town Cryer Bear measures 2-5/8" high and is marked: Arun Bear™ Town Cryer Arundel Wade Collectors' Meet August 2001 C&S 250 Limited Edition. The base is also marked with Mark Type 27B1 ($65, £45).

FAT CONTROLLER *2002*
1-1/2" high and is marked: ©Gullane (Thomas) Limited 2002 C&S Wade. This figurine was a limited edition of 500 pieces ($43, £30). There were twenty Fat Controller figurines produced with a gold base ($110, £75)

2. Town Cryer Bear Special Edition ($130, £100).

185

ANIMALAND, 2001

A new series of slip cast figurines produced by Wade Ceramics Limited exclusively for C&S Collectables to be sold by mail order in limited editions of 250.

BEAR CUB 2001
Left: Bear Cub measures 2-1/2" high and is marked: Baby Bear Cub Wade 250 Limited Edition C&S Wade's AnimaLand. This figurine was sold by C&S Collectables via mail order in April 2001 ($60, £45). **Right: Bear Cub** with the gold base was a limited edition of 25 pieces given as draw prizes ($180, £120).

SNOWY OWL 2001
Left: Snowy Owl with the gold base was a limited edition of 25 pieces given as draw prizes ($130, £95). **Right: Snowy Owl** measures 2-3/4" high and is marked: Snowy Owl Wade 250 Limited Edition C&S Wade's AnimaLand. This figurine was sold by C&S Collectables via mail order in July 2001 ($60, £45).

OTTER 2001
Left: Otter measures 2" high and is marked: C&S Wade AnimaLand Otter Collectors Meet Special 12th. August 2001 Limited Edition 250. The base is also marked with Mark Type 27B1. This figurine was sold at the August 2001 Collectors Meet in Arundel ($60, £40). **Right: Baby Otter** measures 1-1/2" high and is marked: Wade England Arundel July 2001. This figurine was given away at the gate to paying visitors ($10, £6).

Right:
Otter with the gold base was a limited edition of 20 pieces given as draw prizes ($130, £95).

ELEPHANT 2002
3-1/4" high and is marked: C&S Wade's AnimaLand Elephant 250 Limited Edition Wade. This figurine was sold via mail order in February 2002 ($45, £30). There was a limited edition of 20 white elephants given as draw prizes ($180, £120).

PANDA 2002
Left: Panda measures 2-1/4" high and is marked: Wade's AnimaLand Panda 250 Limited Edition C&S Wade. This limited edition of 250 figurines was sold in May 2002 via mail order ($45, £30). **Right: Panda** white was a limited edition of 20 figurines that were given as draw prizes at various Wade events ($180, £120).

TED-"E" BEAR INTERNET GUIDE 2001
1. Ted-"E" Bear Internet Guide measures 3-1/2" high and is transfer marked: Ted-"E" Special Edition C&S. The base is also marked with Mark Type 27B1. This limited edition figurine of 100 was designed by Simon Millard and sold over the Internet during the week of 11th - 17th March 2001 by C&S Collectables on their web site: www.cscollectables.co.uk ($75, £55).

2. Ted-"E" Bear Internet Guide is transfer marked Wade England on the base. This figure was a limited edition of 20 pieces which were given as draw prizes at various Wade events.

186

TED-"E" BEAR WADE HANDBOOK *2001*
3-1/2" high and was sold exclusively by C&S Collectables at the Trentham Gardens Wade Fair held in April 2001. The figurine was modeled by Simon Millard ($75, £55).

FANTASYLAND, *2002*

In the spring of 2002, C&S Collectables introduced the first figurine in a proposed series titled FantasyLand. Projected figurines in the series are the Mermaid, Pegasus, a Pixie, and a Wizard to complete the set. All figurines in the series were modeled by Ken Holmes.

MERMAID *2002*
Left: Mermaid measures 2-1/2" high and is marked: FantasyLand Wade England No. 1 Mermaid C&S 250 Limited Edition. This Mermaid was inspired by the works of Hagen-Renaker and is a limited edition of 250 figurines sold via mail order by C&S Collectables ($45, £35). **Right: Mermaid** gold measures 2-1/2" high and is marked: Wade's FantasyLand No. 1 C&S Wade Mermaid 250 Limited Edition. This figurine was a limited edition of 20 despite the backstamp reading otherwise. The Mermaid gold was given away as draw prizes at various Wade events ($140, £95).

WEST-"E" *2001*
3-3/8" high and is marked: C&S West-E Special Edition by Wade along with Mark Type 27B1. This figurine was an Internet Special sold at www.wadecollectorscentre.com ($75, £55). A black Scottie Dog version of the West-E figurine was sold at the October 2001 Wade Collectors Fair at Trentham Gardens in a limited edition of 100 figurines ($60, £40). There was a limited edition of 20 silver figurines produced and given as draw prizes ($140, £95).

PEGASUS *2002*
Left: Pegasus measures 3" high and is marked: FantasyLand Wade England No. 2 Pegasus C&S Wade 250 Limited Edition. This figurine was sold in the Summer of 2002 via mail order by C&S Collectables ($45, £35). **Right: Pegasus** gold measures 3" high and is marked: FantasyLand Wade England No. 2 Pegasus C&S Wade 250 Limited Edition. This figurine was a limited edition of 20 figurines despite the backstamp reading otherwise. The Pegasus Gold was given away as draw prizes at various Wade events ($200, £150).

FROST-"E" *2001*
3-3/8" high and is marked: Frost-E C&S Special Edition Wade. This figurine was an Internet Special sold at www.wadecollectorscentre.com during Christmas 2001 in a limited edition of 150 ($75, £50).

DONK-"E" *2002*
1. Donk-E grey measures 2-1/2" high and is marked: C&S eWade No. 4 Donk "E" Special Edition Wade. This figurine was an internet special sold at www.wadecollectorscentre.com in March 2002 in a limited edition of 125 ($70, £50). **2. Donk-E** honey (not illustrated) was sold at the April 2002 Wade Collectors Fair at Kings Hall in Stoke-on-Trent in a limited edition of 100 figurines (55, £30).

3. Donk-"E" lustre was a limited edition of 20 figurines given as draw prizes at various Wade events ($135, £95).

AQUALAND, 2002

In the summer of 2002, C&S Collectables introduced a new series of figurines under the title of AquaLand. Proposed figurines in the new series are Dolphin, Octopus, Killer Whale, Seahorse, and a Great White Shark to complete the series.

Left: Dolphin blue base was a limited edition of 20 figurines that were given as prizes at various Wade events ($140, £100). **Right: Dolphin** lustre base measures 3-1/2" high and is marked: Wade's AquaLand No. 1 Dolphin C&S Wade 250 Limited Edition. This figurine was a limited edition of 250 pieces and launched at the June 2002 U.S. West Coast Wade Fair ($36, £28).

ARUNDEL SALMON 2000
C & S Collectables of Arundel, UK commissioned Wade to produce 1,500 Pink Salmon, based on the 1-1/8" high Trout from the 1972 Whimsies Set 3 for the year 2000 Arundel Swap Meet. These figurines were given as gifts to those attending the pre-Swap Meet social evening and to paying attendees to the Swap Meet ($10, £6).

ROBINS 2001
2" high by 2-1/2" long and marked: C&S Wade 8th Dec. 2001. The robins, modeled by Simon Millard were a limited edition of 100 pairs. One figurine of the pair was decorated with a holly motif and the other figurine was decorated with an ivy motif. The figurines were sold as boxed pairs at the December 2001 Christmas Bonanza held in Arundel, West Sussex ($75, £50). There was a limited edition of 15 gold Robins produced and given as draw prizes ($140, £100).

PAIR OF SWANS 2002
Left: Lustre Swan measures 3" high and is marked: Pair of Swans Arundel 7th July 2002 C&S Wade 150 pairs Limited Edition. This figurine was modeled by Ken Holmes and issued in a limited edition of 20 pieces that were given as draw prizes at various Wade events ($115, £75). **Center: White Swan** measures 3" high and is marked: Pair of Swans Arundel 7th July 2002 C&S Wade 150 pairs Limited Edition. **Right:. Black** Swan measures 3" high and is marked: Pair of Swans Arundel 7th July 2002 C&S Wade 150 pairs Limited Edition. The White and Black Swans were sold as a pair at the July 2002 Wade Collectors Meet in Arundel ($70 pair, £40 pair).

ARUNDEL TOWN MOUSE 2002
Left: Arundel Town Mouse white measures 3-3/8" high and is marked: Arundel Town Mouse C&S Wade Arundel 7th July 2002 Official Wade Collectors Centre 200 Limited Edition. This figurine, modeled by Cyril Roberts, was first sold at the 2002 Wade Collectors Meet ($45, £25). **Right: Arundel Town Mouse** gold measures 3-3/8" high and is marked: Arundel Town Mouse C&S Wade Arundel 7th July 2002 Official Wade Collectors Centre 200 Limited Edition. This figurine was given as draw prizes at various Wade event ($150, £100).

AMERICAN EAGLE 2002
Left: American Eagle measures 3-1/2" high and is marked: American Eagle 150 Limited Edition C&S Wade July 2002. This figurine was sold at the 2002 Summer Wade Fest in Harrisburg, Pennsylvania ($45, £30). **Right: American Eagle** gold was a limited edition of 20 pieces and given as draw prizes at various Wade events ($75, £50).

SHERWOOD FOREST SERIES, *1989 - 1991*

These limited edition figurines were produced by George Wade & Son Ltd. and Wade Ceramics Ltd. for Mianco Partners of Canada (formerly POS-NER Associates) in quantities of 5,000 figurines per model. Each of the die cast figurines is mold marked MIANCO®, year of issue and Wade England.

Top: 1. Robin Hood measures 2-3/4" high and was issued in 1989 ($34, £22). **2. Maid Marian** measures 2-5/8" high and was issued in 1990 ($34, £22).
Bottom: 3. Friar Tuck measures 1-3/4" high and was issued in 1994 ($40, £26). **4. Friar Tuck** measures 1-3/4" high and was issued in 1998. Only 450 figurines were issued in this colorway ($60, £40).

Robin Hood prototypes. **Left: Robin Hood** measures 5-1/8" high and is unmarked. Figurines in this size have been produced in other colorways and have appeared on the secondary market.
Right: Robin Hood measures 2-7/8" high and is unmarked.

Maid Marian color variations. All figurines measures 2-5/8" high and are unmarked.

Friar Tuck prototype and color variations. All figurines measures 1-3/4" high and are unmarked except for the figurine in the top left hand corner, which is 2" high.

Sheriff of Nottingham prototypes and color variations. All figurines measure 2" high and are unmarked.

Y2K PINK ELEPHANTS, 2000

U.S. Wade dealers Peg and Rog Johnson of Illinois, and Father David Cox of Missouri, commissioned Wade to produce figurines for the year 2000 Wade Fair in Kansas City and for the Wade Fest 2000 in Pennsylvania. The figurine is a pink version of the 1973 Whimsie elephant with the letters Y2K on the side of the body. The letters appeared on only one side of the figurine, some on the left side and some on the right side.

Left: Y2K Elephant was issued in a limited number of 1,500 figurines that were made with the wording on the left hand side and were sold at the 2000 Kansas City Wade Fair ($10, £7). **Right: Y2K Elephant** was issued in a limited number of 500 figurines with the wording on the right hand side. These figurines were sold at the 2000 Wade Fest in Harrisburg, Pennsylvania ($15, £10).

BILLY BUNTER 2000
A "one-of-a-kind" figurine of the popular children's book character Billy Bunter. This figurine was given to Ken Roberts as a birthday gift from his wife, Sue Roberts. The figurine is 5" high and is marked: Billy Bunter "one of a kind" Wade.

BLACK TERRIER 2000
Sharon Latka commissioned Wade to produce 2,000 black glazed figurines utilizing the West Highland Terrier mold from the 1990 - 1991 Tom Smith crackers the World of Dogs set ($10, £7).

KEENAN ANTIQUES, 1995 - present

Keenan Antiques, based in Pennsylvania, U.S.A. has commissioned Wade to produce a number of models for both Christmas decorations and promotions for the Harrisburg Wade Fest.

CHRISTMAS TREE ORNAMENTS 1995 - 1997
1. Rocking Horse measures 2-1/4" high by 2-1/2" long and has Mark Type 26. This figurine was produced in 1995, in a limited edition of 2,000 ($18, £12). **2. Rocking Horse** was produced in 1996 in a limited edition of 600 and has Mark Type 26 on the base ($22, £15). **3. Santa Claus and Sleigh** measures 1-1/2" high by 2-1/2" long and has Mark Type 26 on the base. This figurine was produced in 1994 in a limited edition of 2,000 ($22, £15). **4. Train Ornament** measures 1-3/8" high by 3" long and is marked: Wade. This figurine was produced in 1997 ($18, £12). In addition to those marked simply Wade, 500 train ornaments were also made with a backstamp reading: Keenan Antiques Wade England Christmas No. 4.

BLACK POODLE 1999
This figurine was commissioned for the 1999 Wade Fest held in Harrisburg, Pennsylvania. The poodle is from the same mold as the 1967 - 1973 Canadian Red Rose Tea promotion. The black Poodle was a limited edition of 2,000 pieces ($12, £8).

KITTEN 2000
These color variations of the Kitten from the 1988 - 1989 Tom Smith set Your Pets were made for the 2000 Wade Fest in Harrisburg, Pennsylvania. **Left: Black Kitten** (Thunder) was issued in an edition of 1,200 pieces ($8, £5). **Center: Gold Kitten** was a limited issue of 100 and was only given as gifts and door prizes and was never retailed ($20, £14). **Right: White Kitten** (Lightning) was issued in a limited number of 800 pieces ($10, £8). The black and white kittens as well as being retailed were also given as gifts in the Wade Fest package.

GUINEA PIGS 2000
These color variations of the Guinea Pig from the 1988 - 1989 Tom Smith set Your Pets were made for the 2001 Wade Fest in Harrisburg, Pennsylvania. **Left: Black Guinea Pig** was a limited edition of 500 ($8, £5). **Center: White Guinea Pig** was a limited edition of 1,000 ($6, £4). **Right: Gold Guinea Pig** was a limited edition of 100 and given away as door and draw prizes and never retailed ($20, £14). The black and white guinea pigs, as well as being retailed, were also given as gifts in the Wade Fest package.

LEPRECHAUN AND WHEELBARROW 2002
Left: Leprechaun and Wheelbarrow measures 2" high and is marked: Wade. This figurine was a limited edition of 350 pieces and was first sold at the 2002 Summer Wade Fest in Harrisburg, Pennsylvania ($28, £18). **Right: Leprechaun and Wheelbarrow** gold measures 2" high and is marked: Wade. This was a limited edition of 35 figurines that were won as draw prizes ($90, £60).

MINI RABBITS 2001
These 1" high, pressed and unmarked miniature Bunnies were sold at the 2001 Wade Fest in Harrisburg, Pennsylvania. **1. Pink Bunnie** was a limited edition of 450. The intended color for the pink was cotton candy but this did not produce well and only 200 figurines were made in the cotton candy glaze ($10, £8). **2. Green Bunnie** was a limited edition of 430 ($10, £8). **3. White Bunnie** was a limited edition of 500 ($10, £8). **4. Blue Bunnie** was a limited edition of 500 ($10, £8). The pink, green, white, and blue bunnies were retailed and given as gift items in the Wade Fest package. **5. Gold Bunnie** was a limited edition of 50. This figurine was given as door and draw prizes only and never retailed ($20, £14).

MINI MICE 2002
These 3/4" high, pressed and unmarked miniature mice were first made available at the 2002 Summer Wade Fest in Harrisburg, Pennsylvania. **1. Grey Mouse** was a limited edition of 500. These figurines were included in the Wade Fest Goodie Bag. **2. Blue Mouse. 3. Beige Mouse. 4. White Mouse.** The blue, beige and white mice were a limited edition of 500 pieces each and were sold as a set along with a grey mouse ($32 set, £22 set). **5. Gold Mouse** was a limited edition of 50 and given as draw prizes ($35, £24).

LEPRECHAUN ON A SNAIL 2001
2-1/8" high by 2-1/4" overall and has Mark Type 27B1 on the base. This limited edition of 650 figurines was sold at the 2001 Wade Fest in Harrisburg, Pennsylvania ($26, £18).

MONGREL 2002
These color variations of the Whimsie Mongrel Set 1, 1971 and the Tom Smith World of Dogs 1990 - 1991 were made for the 2002 Summer Wade Fest in Harrisburg, Pennsylvania. **Left: Gold Mongrel** was a limited edition of 100 and given away as door and draw prizes and never retailed ($35, £24). **Center: White Mongrel** was a limited edition of 550 ($6, £4). **Right: Black Mongrel** was a limited edition of 550 ($6, £4). The white and black mongrels, as well as being retailed, were also given as gifts in the Wade Fest package.

KSWADER, *2000 - present*

In 2000, Ed and Beverly Rucker organized and promoted the first Kansas City Wade Fair which was held at the Armadillo Antique Mall in Grain Valley, in Missouri. For the 2001 Kansas City Wade Fair held in Kansas City, Missouri, Ed and Beverly went into partnership with Brian and Judi Morris and formed KSWader.

ARMADILLO *2000*
As the 2000 Kansas City Wade Fair was held at the Armadillo Antique Mall the item chosen for the Fair Special was the Armadillo from the 1984 - 1985 Tom Smith set The World of Survival. Two colorways of the Armadillo were produced. **Left: Brass Armadillo** was a limited edition of 1,000 pieces ($10, £8). **Right: Green Armadillo** was a limited edition of 927 pieces ($10, £8).

GREEN ARMADILLO
Color variations.

WIZARD OF OZ, *2001*

This series of figurines is based on original drawings from the 14 books by L. Frank Baum, a number of which were made famous by the film "The Wizard of Oz." The first three figurines in the series were originally sold at the 2001 Kansas City Wade Fair. All figurines were issued in a limited number of 500 figurines each.

Left: Princess Ozma measures 2-1/2" high and is marked: Oz No.1 along with Mark Type 27B1 ($55, £42). **Center: The Cowardly Lion** measures 2-1/2" high and is marked: Oz No.2 along with Mark Type 27B1 ($35, £25). **Right: Dorothy** measures 2-3/8" high and is marked: Oz No.3 along with Mark Type 27B1 ($75, £55).

WIZARD OF OZ
Color variations. Twenty five of each figurine were issued in an "all-over" white glaze. **Left: Princess Ozma** ($125, £95). **Center: The Cowardly Lion** ($25, £95). **Right: Dorothy** ($225, £175).

The Tin Woodman ($125, £95).

KSWADER FANTASY SERIES *2001*
Left: White Unicorn measures 2-1/2" high and is marked: Wade Ltd. Edt. of 250 KSWader Fantasy Series No.1. This figurine was first sold at the 2002 U.S. West Coast Wade Fair ($33, £25). **Right: Black Unicorn** measures 2-1/2" high and is marked: Wade Special Edt. of 25 KSWader Fantasy Series No.1. The black unicorns were given out as special and draw prizes ($275, £210).

Left: Dragon measures 4-1/4" high and is marked: Dragon Regular Edition KSWader Fantasy Series No. 2 Ltd. Edt. of 250 Wade Est. 1810 England. This figurine was sold at the 2002 Summer Wade Fest and via mail order ($38, £28). **Right: Dragon** special edition measures 4-1/4" high and is marked: Dragon Special Edition KSWader Fantasy Series No. 2 Special Edt. of 25 Wade Est. 1810 England. This limited edition figurine of 25 pieces was given as draw prizes and internet contest prizes ($250, £195).

The Tin Woodman measures 3-3/8" high on a 2-1/4" dia. base and is marked: Oz No.4 along with Mark Type 27B1 ($30, £24).

BJ PROMOTIONS, *1999*

Dennis the Menace, featured in the popular British comic, *The Beano,* was created in 1951 by David Law, staff artist for D. C. Thompson & Co. Ltd. This was a year later than the U.S. Dennis the Menace, created by Hank Ketchum, made his appearance in U.S. comic strips.

David Law continued to draw Dennis for *The Beano* until his death in 1970, when the task was taken over by David Sutherland. Sutherland retired in 1998 and the artistic work for Dennis was taken over by David Parkins.

Gnasher is Dennis's faithful hound. Minnie the Minx was the final model in the collection and was released in October 2000. Each figurine came with a certificate of authenticity. B. J. Promotions, who commissioned these figurines, is based in Derbyshire, England.

Left: Dennis the Menace measures 5-1/8" high with a backstamp reading: ©D.C.Thomson & Co. Ltd. 1999 Wade England Limited Edition of 1500 ($65, £45). **Right: Gnasher** measures 3-1/2" high with a backstamp reading: ©D.C.Thomson & Co. Ltd. 1999 Wade England Limited Edition of 1000 ($65, £45).

Minnie the Minx measures 5-3/8" high and is marked: ©D.C. Thomson & Co. Ltd. 2000 Wade England Limited Edition of 500. This figurine was the last model in the Beano Collection and was released in October 2000 ($75, £50).

Wade Beano Collection Key Ring. These key rings were given away free of charge with the first 1000 Dennis the Menace figurines sold ($8, £5).

COTSWOLD COLLECTABLES, *1998*

The "Tufty and his Furryfolk Friends" characters were created in 1953 by the late Elsie Mills MBE. Tufty became the focus of The Tufty Club, a nationwide network organized by The Royal Society for the Prevention of Accidents. The characters have helped young children to learn about safety for more than 40 years.

1. "Tufty" measures 5-3/4" high and has a transfer type backstamp reading: Tufty and his Furry Folk Friends by Cotswold Collectables 1998 Wade "Tufty" Limited Edition 1,500 ©ROSPA Enterprises Ltd ($68, £45).

2. "Tufty" was a limited edition of 150 figurines sold at the 1999 *Collect it!* Fair ($65, £100).

ELAINE AND ADRIAN CRUMPTON, *1993 - 1995*

The Long Arm of the Law comprised four figurines, two of which had two different colorways. The series, commissioned by Elaine and Adrian Crumpton, ran from 1993 to 1995.

Top: 1. Policeman with the painted face measures 3-5/8" high and was a limited edition of 1,600 pieces and is mold marked: Wade on the base. The figurine was issued in 1993 ($70, £45).
2. Policeman without painted face is similar to the first policeman except for the painted eyes on the face. Only 400 figurines with unpainted faces were produced ($100, £65). NOTE: Unauthorized policemen have been found with painted faces and a black uniform rather than the correct dark blue uniform and a yellow badge rather than the correct white/silver badge. These were not made by Wade Ceramics even though they have the usual Wade mold mark.
Bottom: 3. Burglar measures 3-1/4" high and is mold marked: Wade. This figurine was a limited edition of 2,000 pieces issued in 1993 ($70, £45). **4. Lawyer** measures 3" high and is transfer marked on the base: Wade Made in England. This figurine was issued in 1994 in a limited edition of 2,000 pieces ($70, £45).
5. Prisoner measures 2-3/4" high and is mold marked: Wade on the base. This figurine was issued in 1995 in a limited edition of 2,000 pieces ($70, £45). **Prisoner with brown hair** (not illustrated). A limited number of the Prisoner figurines was issued with brown hair ($75, £50).

THE POLACANTHUS MONEY BANK *1994*
3-1/8" high by 7-3/4" long and has a transfer mark: WADE surrounded by an outline drawing of The Isle of Wight. The money bank was commissioned by Margaret Strickland in 1994, in a limited edition of 2000 pieces. The design is based on the skeleton of a dinosaur uncovered on the Isle of Wight ($68, £45).

PUNCH AND JUDY COLLECTION, *1996 - 1999*

This series was originally commissioned by Peggy Gamble and Sue Styles. In 1977, after the issue of the Punch and Judy figurines, Sue Styles left the partnership, but Peggy Gamble continued the series releasing Toby and finally Judy's Ghost.

Left: Mr. Punch measures 6-1/4" high and has Mark Type S49 on the base. In 1996, 1,800 figurines were issued with a burgundy suit ($75, £50). **Center: Judy** measures 6-1/8" high and has the corgi backstamp along with the letters P&S and the wording Ken Holmes Wade. Judy was issued in 1997 in a limited edition of 1,800 pieces ($75, £50). A number of Judy figurines was also issued with a green dress. **Right: Mr. Punch** measures 6-1/4" high and has Mark Type S49 on the base. Only 200 figurines were issued in 1996 with Punch wearing a green suit ($225, £150).

Left:. Toby measures 4-3/4" high and has the corgi backstamp along with the letters P&S and the wording Ken Holmes Wade. There were 1,500 figurines issued in 1998 with a red hat ($70, £45). In addition 200 Toby figurines were issued with a green hat.
Right. The Ghost of Judy measures 5-5/8" high on a 4-5/8" by 3-1/2" base. The backstamp has the typical corgi but this time with the letters PG only and the wording: Modeled by Simon Millard Wade ($75, £50). There were 800 figurines with a gold base and 200 with a green base.

SILVER STATE SPECIALTIES, *1995 - present*

In 1995, Silver State Specialties, based in California, commissioned the first Wade Hamms Bear. The series features the bear figurines in various costumes celebrating various events. Further into the series the bears were produced in the form of salt and pepper shakers.

Left: Spade Black Jack Decanter measures 4-3/4" high by 5-1/4" across the base and is marked: SSS - 1997 along with Mark Type 27A. **Right: Club Black Jack Decanter** measures 4-3/4" high by 5-1/4" across the base and is marked: SSS - 1997 along with Mark Type 27A. The decanters were a limited edition of 1,000 each ($30 each, £24 each).

Left: Hamm's Bear "Santa's Helper" measures 4-7/8" high and has a transfer type backstamp: 1995 Wade S.S.S. This black version of the figurine was issued in 1995 in a limited edition of 2,000 pieces ($70, £50). **Right: Hamm's Bear "Santa's Helper"** 4-7/8" high and has a transfer type backstamp: S.S.S. Wade 1996 Original 1950's Hamm's Bear. This brown version of the figurine was issued in 1996 in a limited edition of 1,200 pieces ($75, £50).

Left: Hamm's Niagara Bear Blue measures 5" high and is marked: 1998 S.S.S. Hamm's Niagara Bear Wade Limited Edition 1500. This figurine was a limited edition of 500 and was issued at the 1998, Buffalo, New York Jim Beam/Wade Fair ($50, £35). **Center: Hamm's Niagara Bear Green** measures 5" high and is marked: 1998 S.S.S. Hamm's Niagara Bear Wade Limited Edition 1500 Dunstable 1998. This limited edition figurine of 500 was issued at the 1998 Wade Collectors Fair in Dunstable ($50, £35). **Right: Hamm's Niagara Bear Brown** measures 5" high and is marked: 1998 S.S.S. Hamm's Niagara Bear Wade Limited Edition 1500. This limited edition figurine of 500 was a general issue ($60, £40). Of the 1,500 figurines issued, 500 were issued in each color with certificates of authenticity.

Left: Hamm's Bear Seattle measures 5" high and is marked: S.S.S. Wade 1996. This figurine was issued in a limited edition of 2,000 at the 1996, Jim Beam/Wade Fair in Seattle, Washington ($60, £40). **Right: Hamm's Bartender Bear** measures 4-3/4" high and is marked: 1997 S.S.S. Hamm's Bartender Bear Wade. This figurine was issued in a limited edition of 2,000 at the 1997 Jim Beam/Wade Fair in Oconomowac, Wisconsin ($45, £30).

Hamm's Bear "Ted Jr." Salt and Pepper measure 3-3/4" high and are marked: S.S.S. 1999 500 prs. Wade. These figurines were first issued at the Wade Collectors Fair held at Trentham Gardens in April 1999 and then at the Summer 2000 Wade Fest held in Harrisburg, Pennsylvania. There were 400 sets issued with the Stars and Stripes on the back ($60 set, £40 set) and a 100 sets with the Union Jack on the back ($70 set, £48 set).

Hamm's Bear Sheriff Salt and Pepper measure 3-3/4" high and are marked: S.S.S. 2000 Wade England. These figurines were issued at the Wade Extravaganza at Trentham Gardens in October 2000. A limited edition of 100 sets was issued with Hamm's Light Beer on the back ($65 pair, £45 pair) and 400 sets were issued with Hamm's Beer on the back ($65 pair, £45 pair). A general issue of 500 sets with black hats was also produced in 2000 ($60 pair, £40 pair).

Hamm's Bear Sheriff Salt and Pepper White Hats. There were 50 sets issued with white hats that were numbered 501 - 550. Each dealer who bought twelve sets of the regular issue was able to buy one set of the white hats for their own collection ($230 set, £200 set).

Hamm's Indian Chief Salt and Pepper measure 3-1/2" high and are marked: S.S.S. 2001 along with Mark Type 27B1. There were 400 black bears with red head bands and Hamm's Beer on the back ($65 pair, £45 pair) and 100 black bears with red head band and Hamm's Light Beer on the back ($80 pair, £50 pair). There were also 50 brown bears issued with a turquoise head band which were sold to dealers who bought 12 sets of the regular issue bears ($225 pair, £150 pair).

UK INTERNATIONAL CERAMICS LTD., 1996 - present

Since 1996, Wade Ceramics has produced a number of "cartoon collectable ceramics" and "figural" items for U.K. International Ceramics Ltd. which were sold at both Wade Fairs and via mail - order to collectors worldwide.

1 2 3 4

THE FLINTSTONES 1996 - 1998
1. **Betty** measures 4-3/8" high ($75, £50). 2. **Barney** measures 4-1/8" high ($75, £50). 3. **Wilma** measures 5" high ($75, £50). 4. **Fred** measures 4-1/8" high ($75, £50). These first four figurines in the series were issued in a limited edition of 1,500 pieces each. Along with the name of the figurine, the backstamps read: The Flintstones™ Limited Edition of 1500 ©1996 H-B Prod Inc ©UKI Ceramics Ltd. Licensed by CPL.

5 6

5. **Pebbles** measures 4" high ($90, £60). 6. **Bamm Bamm** measures 4" high ($90, £60). The last two figurines in the series had similar backstamps as the first four figurines but were limited to 1,000 pieces each.

196

FELIX THE CAT *1997*
5-1/4" high and is transfer marked: Wade ™ & © 1997 FTC Prod. Inc. Limited Edition of 1500 © UKI Ceramics Ltd. Licensed by El Euro Lizenzen, Munchen. This figurine, modeled by Andy Moss was sold in a presentation box with a numbered certificate ($120, £80).

TOM AND JERRY *1998*
Tom measures 4-7/8" high with a backstamp reading: Wade Tom from Tom & Jerry™ ©1997 Turner Ent. Co. A.R.R. Limited Edition of 1500 UKI Ceramics Ltd. Licensed by CPL. ($80, £55).

Jerry measures 4-3/8" high with a backstamp reading: Wade Jerry from Tom & Jerry™ ©1997 Turner Ent. Co. A.R.R. Limited Edition of 1500 UKI Ceramics Ltd. Licensed by CPL. ($80, £55).

NODDY SERIES *1997 - 1998*
1. Noddy measures 4-3/8" high and is transfer marked on the base: Wade Noddy™ Limited Edition 1500 © UKI Cer. Ltd. 1997 ©D.W. 1949/90 Licensed by BBC. WL Ltd ($84, £65). **2. Big Ears** measures 5-1/2" high and is transfer marked on the base: Wade Big Ears™ Limited Edition 1500 © UKI Cer. Ltd. 1997 ©D.W. 1949/90 Licensed by BBC. WL Ltd. ($98, £65).

THE ANIMAL COLLECTION *1999*
1. Taurus the Bull measures 5-1/2" high by 7" overall. The figurine has a transfer mark on the base: Wade Limited Edition of 350 ©Wade Ceramics Ltd ©UKI Ceramics Ltd. Taurus the Bull Produced exclusively for UKI Ceramics Ltd in an Exclusive Worldwide Edition ($90, £50).

2. British Lion measures 6-1/8" high on a 2-1/4" by 4-1/4" base. The figurine has a transfer mark on the base: Wade Limited Edition of 350 ©Wade Ceramics Ltd ©UKI Ceramics Ltd. British Lion Produced exclusively for UKI Ceramics Ltd in an Exclusive Worldwide Edition. This figurine was a fair special at the South of England Official Wade Collectors Fair held at Dunstable in October 1999 ($70, £40).

3. Tessie Bear measures 4-7/8" high and is transfer marked on the base: Wade Tessie Bear™ Limited Edition 1500 © 1998 EBL Ltd. A.R.R. ©UKI Ceramics Ltd. 1998 ($80, £55). **4. Mr. Plod** measures 5-1/4" high and is transfer marked on the base: Wade Mr. Plod™ Limited Edition 1500 © 1998 EBL Ltd. A.R.R. ©UKI Ceramics Ltd. 1998 ($80, £55).

3. Shoal of Fish measures 5-1/2" high. The figurine has a transfer mark on the base: Wade Limited Edition of 350 ©Wade Ceramics Ltd ©UKI Ceramics Ltd. Shoal of Fish Produced exclusively for UKI Ceramics Ltd in an Exclusive Worldwide Edition. This figurine was a fair special at the South of England Official Wade Collectors Fair held at Dunstable in October 1999 ($70, £40).

THE WADE CLASSICAL COLLECTION, *1997*

A set of three Art Deco animal figurines limited to 1,000 sets. Due to copyright difficulties only 260 sets were sold and the remaining unsold sets were destroyed.

Left: The Deer measures 5-3/4" high on a 3-3/4" by 2" base and is marked: WADE DEER first in the series Wade Classical Collection exclusive for UKI Ceramics Production in a Limited Edition of 1000 ©Wade Ceramics Ltd © UKI Ltd. ($110, £70). **Center: The Polar Bear** measures 4" high on a 3-3/4" by 2" base and is marked: WADE POLAR BEAR second in the series Wade Classical Collection exclusive for UKI Ceramics Production in a Limited Edition of 1000 © Wade Ceramics Ltd © UKI Ltd. ($110, £70). **Right: The Monkies** measure 4-3/8" high on a 3-7/8" by 2-3/16" base and is marked: WADE MONKIES third in the series Wade Classical Collection exclusive for UKI Ceramics Production in a Limited Edition of 1000 ©Wade Ceramics Ltd © UKI Ltd. ($110, £70).

THE CATKINS SERIES, *1998 - present*

This is a series of cat figurines in various styles and costumes. Other than those illustrated, projected figurines include a Town Crier, Olympic 2000, a Witch, and a Policeman.

Left: The City Gent Catkins measures 4-1/2" high with a backstamp reading: "City Gent Catkins® 1 of 150 Exclusive Edition for Trentham Gardens 1998 Wade Fair Special Produced Solely for Overseas Wade Collectors ©UK Fairs Ltd. Wade Ceramics Ltd. Figurines sold to collectors in the U.K. had a backstamp reading: "The City Gent Catkins® 1 of 1500 Exclusive Limited Edition for Trentham Gardens Wade Fair 1998 ©UK Fairs & Wade Ceramics Ltd." This first figurine in the series was issued in 1998 ($70, £45). **Center: The Cook Catkins** measures 5-1/2" high with a backstamp reading: "Cook Catkins® 1 of 150 Exclusive Edition for Dunstable 1998 Wade Fairs Special Produced Solely for Overseas Wade Collectors ©UK Fairs Ltd & Wade Ceramics Ltd. UKWC02. Figurines sold to collectors in the U.K. had a backstamp reading: "Cook Catkins® 1 of 1500 Exclusive Edition for the Dunstable Wade Fair 1998 UKWC02 ©UK Fairs Ltd. & Wade Ceramics Ltd." This second figurine in the series was also issued in 1998 ($70, £45). **Right: Gypsy Catkins** measures 5-1/2" high with a backstamp reading: "Gypsy Catkins 1 of 100 Exclusive Edition of Trentham 1999 Wade Fair Special® Produced Solely for Overseas Wade Collectors ©UK Fairs Ltd & Wade Ceramics Ltd. UKWC03." Figurines sold to collectors in the U.K. had a backstamp reading: "Gypsy Catkins 1 of 1000 Exclusive Limited Edition for the Trentham Wade Fair 1999 UKWC03 ©UK Fairs Ltd. & Wade Ceramics Ltd." This third figurine in the series was issued in 1999 ($80, £50).

THE COOK CATKINS *1998*
5-1/2" high and has a similar backstamp as the previous Cook Catkins figurine except the limited edition was only for 500 pieces in this colorway ($80, £50).

198

CLOWN CATKINS *1999*
5-1/4" high with a backstamp reading: Clown Catkins Produced Exclusively for UKI Ceramics Ltd. in a World Wide Limited Edition of 750 Wade ©UKI Ceramics Ltd. ©Wade Ceramics Ltd. ($70, £45).

OUT FOR A DUCK CATKINS *1999*
5" high and has a backstamp reading: Out for a Duck Catkins Produced Exclusively for UKI Ceramics Ltd. in a World Wide Limited Edition of 750 Wade ©UKI Ceramics Ltd. ©Wade Ceramics Ltd. ($70, £45).

BRITANNIA *2000*
6-1/4" high and is marked: Wade England Britannia Produced Exclusively for REM Collectables in a Limited Edition of 250 to Commemorate the Millennium ($105, £60).

BLYTH CERAMICS, *1998*

Two figurines based on characters from the popular British comic *VIZ* were produced in a limited edition of 1,000 pieces for each figurine. These figurines were produced for Blyth Ceramics which is based in Northumberland, England. The figurines were produced to help celebrate the 20th anniversary of the comic book *VIZ* in 1999.

FIREMAN CATKINS AND MILLENNIUM CATKINS *2000*
Left: Fireman Catkins measures 5" high and has a backstamp reading: Fireman Catkins® Exclusive Limited Edition of 250 No. 7 in the Series Wade England ©UKI Ceramics Ltd. ©Wade Ceramics Ltd. ($70, £45). **Right: Millennium Catkins** measures 5" high and has a backstamp reading: Millennium Catkins® Exclusive Limited Edition of 250 No. 8 in the Series Wade England ©UKI Ceramics Ltd. ©Wade Ceramics Ltd. ($75, £50). These figurines were first sold at the May 2000 Wade Collectors Fair held at Stafford Showground, Stafford, England.

Left: Sid the Sexist measures 5" high and is transfer marked: Sid the Sexist Wade Viz 1998 ©John Brown Publishing House of Viz © Blyth Ceramics Limited Edition of 1000 pieces ($60, £40). **Right: San the Fat Slag** measures 5" high and is transfer marked: San from the Fat Slags Wade Viz 1998 ©John Brown Publishing House of Viz © Blyth Ceramics Limited Edition of 1000 pieces ($60, £40).

OLD FATHER TIME CATKINS
4-3/8" high and has a backstamp reading: Old Father Time Catkins Exclusive Limited Edition of 250 No. 12 in the series Wade ©UKI Ceramics Ltd. © Wade Ceramics Ltd. ($75, £50).

199

DAVID TROWER ENTERPRISES, *1997 - 2000*

The first figurines issued by David Trower Enterprises were based on the cartoon character Popeye the Sailor, followed by a series of figurines based on popular nursery rhyme characters.

THE POPEYE SERIES, *1997 - 1998*

Popeye and his friends, supposedly based on real life people, were created by Elzie C. Segar. The characters first appeared in the King Features newspaper comic strips in 1929. Popeye then went on to become even more famous in 1933, in the Paramount/Famous Studio's animated cartoon movies. Popeye is immortalized in bronze in a statue situated in Chester, Illinois.

1 2 3 4

1. Popeye measures 4-3/4" high and is transfer marked: Wade Popeye™ & © 1997 King Features Synd. Inc. Limited Edition of 2000 ©David Trower Enterprises. This figurine was issued in 1997 in a limited edition of 2,000 pieces ($75, £50). **2. Brutus** measures 5-1/4" high and is transfer marked: Wade Brutus™ & © 1997 King Features Synd. Inc. Limited Edition of 1500 ©David Trower Enterprises. This figurine was issued in 1997 in a limited edition of 1,500 pieces ($68, £45). **3. Olive Oyl and SweePea** measures 5-5/8" high and is transfer marked: Wade Olive Oyl and SweePea™ & © 1998 King Features Synd. Inc. Limited Edition of 2000 ©David Trower Enterprises. This figurine was issued in 1998 in a limited edition of 2,000 pieces ($75, £50). **4. Wimpy** measures 5-1/4" high and is transfer marked: Wade Wimpy™ & © 1998 King Features Synd. Inc. Limited Edition of 1500 ©David Trower Enterprises. This figurine was issued in 1998 in a limited edition of 1,500 pieces ($68, £45). All figurines were issued with a certificate of authenticity.

THE NURSERY RHYME COLLECTION, *1998 - 1999*

Starting in 1998, David Trower Enterprises began a series of large, slip cast figurines based on Nursery Rhyme characters. Although the characters chosen for the series had previously appeared in the 1972 - 1981 Nursery Favourites, the designs were quite different and are easily distinguished from the earlier pressed figurines.

1. Humpty Dumpty measures 5-1/2" high and is transfer marked: Humpty Dumpty From The Nursery Rhyme Collection Worldwide Limited Edition of 1000 ©1998 Wade Ceramics Ltd. ©1998 D. T. Ents. ($60, £40).

3. Little Bo Peep measures 5" high and is transfer marked: Little Bo Peep From The Nursery Rhyme Collection Wade ©1999 Wade Ceramics Ltd ©1999 D. T. Ents. ($60, £40).

2. Goosey Gander measures 5-3/8" high and is transfer marked: Goosey Gander Worldwide Limited Edition of 1000 From The Nursery Rhyme Collection Wade ©1999 Wade Ceramics Ltd ©1999 D. T. Ents. ($60, £40).

4. The Cat and the Fiddle measures 5-3/8" high and is transfer marked: Cat and Fiddle From The Nursery Rhyme Collection Wade England Worldwide Limited Edition of 250 ©2000 Wade Ceramics Ltd. ©2000 D. T. Ents. Ltd. ($60, £40).

5. Little Jack Horner measures 5 3/8" high and is transfer marked: Little Jack Horner From The Nursery Rhyme Collection Wade England Worldwide Limited Edition of 250 ©2000 Wade Ceramics Ltd. ©2000 D. T. Ents. Ltd. ($60, £40).

6. Little Miss Muffet measures 4-7/8" high and is transfer marked: Little Miss Muffet From The Nursery Rhyme Collection Wade England Worldwide Limited Edition of 250 ©2000 Wade Ceramics Ltd. ©2000 D. T. Ents. Ltd. ($60, £40).

G & G COLLECTABLES, 1994 - 1999

Starting in 1994, G & G Collectables began producing a successful series of slip cast figurines based on cartoon characters and characters from children story books.

SCOOBY DOO AND SCRAPPY DOO, 1994 - 1995

Scrappy Doo was created in 1969 by Ken Spears and Joe Ruby of Hanna-Barbera as a TV cartoon character. Scrappy Doo was introduced to the series as Scooby Doo's nephew in 1979.

HUCKLEBERRY HOUND AND FRIENDS, 1997 - 1999

In 1958, Huckleberry Hound and Yogi Bear first made their appearance in the cartoon series "The Huckleberry Hound Show" produced by Hanna-Barbera. These two characters were followed by Boo Boo, Mr. Jinks, and Dixie and Pixie.

1. Huckleberry Hound measures 5-3/8" high and is marked: Wade England Huckleberry Hound ©1998 H.B. Prod. Inc. Worldwide Edition of 1500 G & G Collectables. This figurine was released in 1998 ($98, £65).

2. Boo Boo measures 4" high and has a transfer back stamp which reads: Wade England Boo Boo ©1997 H. B. Prod. Inc. Worldwide Edition of 1500 G & G Collectables ($75, £50). **3. Yogi Bear** measures 5" high and has a similar back stamp as Boo Boo except for the name ($98, £55). Both figurines were issued in 1997.

Left: Scooby Doo measures 5-1/8" high and is transfer marked on the base: ©H/B Inc. SCOOBY DOO Limited Edition of 2000 G & G Collectables WADE England. Each figurine was individually numbered. Scooby Doo was introduced in 1994 ($98, £65).
Right: Scrappy Doo measures 3-1/2" high and is transfer marked: ©H/B Inc. SCRAPPY DOO Limited Edition of 2000 G & G Collectables WADE England ($75, £50). Each figurine was individually numbered. Scrappy Doo was introduced in 1995.

4. Mr. Jinks measures 5-1/2" high and has a back stamp which reads: Wade England Mr. Jinks ©1997 H.B. Prod. Inc. G & G Collectables. This figurine was first seen at the 1997 Dunstable Wade Fair ($90, £60). **5. Dixie** and **6. Pixie** measure 4-5/8" high and have similar back stamps to Mr. Jinks except for the names of the characters. The figurines of Dixie and Pixie were issued in 1998 ($70 each, £45 each).

201

SANTA IN A CHIMNEY *1997*
4-1/2" high on a 2-3/8" by 2-3/8" base. The transfer backstamp reads: Santa in a Chimney Limited Edition of 1000 First in a Christmas Series By G & G Collectables Wade ($65, £40). This figurine was modeled by Nigel Weaver.

THE BIG BAD WOLF *1998*
3-1/2" high and has a transfer type backstamp that reads: Big Bad Wolf Limited Edition of 1000 ©G & G Collectables and Wade ($60, £40).

LITTLE RED RIDING HOOD *1999*
3-3/4" high and has a transfer type backstamp which reads: Little Red Riding Hood Limited Edition 1000 ©G & G Collectables and Wade ($60, £40).

RICHLEIGH PROMOTIONS, *1997 - 1998*

Starting in 1997, Richleigh Promotions began the issue of a series of child figurines dressed in traditional national costumes of countries from around the world.

CHILDREN OF THE WORLD, *1997 - 1998*

Figurines 1 - 5 were issued in a limited edition of 1,000 pieces and figurines 6 - 8 were issued in a limited edition of 300 pieces. The transfer-type back stamps have the series name - Children of the World - along with the name of the character and its position in the series followed by Wade. Each figurine had a Certificate of Authenticity. The first figurine, the Japanese Girl, was issued in two different colorways.

1 2 3 4 5

1. Japanese Girl measures 4-3/8" high and was issued in 1997. This figurine was the first in the series ($55, £35). **2. Japanese Girl** measures 4 3/8" high and was issued in 1997 ($55, £35). **3. Indian Boy** measures 3" high and was issued in 1998. This was the second figurine in the series ($55, £35). **4. Spanish Girl** measures 4-3/8" high and was issued in 1998. This was the third figurine in the series ($55, £35). **5. Mexican Boy**, fourth in the series, measures 4-1/4" high and was issued in 1998 ($55, £35).

6. Eskimo Girl measures 4-1/4" high. This figurine was the fifth in the series ($55, £35).

7. Cossack Boy measures 3-3/4" high. This figurine was the sixth in the series ($55, £35).

8. Dutch Girl measures 4" high. This was the seventh figurine in the series ($55, £35).

KEY KOLLECTABLES, 1998 - present

Key Kollectables is run by the husband and wife team of Andrew and Mandy Key. During a tour of the Wade factory Andrew expressed a wish to have his own pieces made by Wade. This was realized soon afterwards by the birth of the Straw Family series. This was soon followed by train sets and other items produced under license.

The philosophy of Key Kollectables is to provide a reliable and friendly service to Wade collectors supplying them with what they want at the best possible price.

THE STRAW FAMILY, 1998 - 2000

A series of four figurines based on a mythical family of scarecrows living on an equally mythical Millfield Farm located in the English countryside. Each figurine has a transfer mark reading: Key Kollectables (name of figurine) Wade Limited Edition 2000.

1. Ma Straw measures 5" high and was issued in 1999 ($56, £40). **2. Baby Straw** measures 3-1/4" high and was issued in 2000 ($56, £40). **3. Pa Straw** measures 5-1/2" high and was issued in 1998 ($64, £45). **4. Teen Straw** measures 4-5/8" high and was issued in 1999 ($56, £40).

SUMMER TRAIN *2000*
The engine measures 2" by 1" by 1-1/8" and the carriages measure 1-3/4" by 3/4" by 1" and all pieces are mold marked: Wade England Key. The Summer Train was issued in 2000 in a limited edition of 500 sets ($70, £48).

SPRING TRAIN *2001*
The engine measures 2" by 1" by 1-1/8" and the carriages measure 1-3/4" by 3/4" by 1" and all pieces are mold marked: Wade England Key. The Spring Train was issued in October 2001 in a limited edition of 400 sets ($70, £48).

SPRING TRAIN SPECIAL *2001*
The engine measures 2" by 1" by 1-1/8" and the carriages measure 1-3/4" by 3/4" by 1" and all pieces are mold marked: Wade England Key. The Spring Train Special was issued in October 2001 in a limited edition of 100 sets ($100, £65). In order to purchase the gold version Spring Train, collectors had to also purchase the standard version Spring Train.

AUTUMN TRAIN *2002*
The engine measures 2" by 1" by 1-1/8" and the carriages measure 1-3/4" by 3/4" by 1" and all pieces are mold marked: Wade England Key. The Autumn Train was produced in a world wide limited edition of 200 sets with standard lettering and 100 sets with gold colored lettering.

FRED FIGURINES, 2001

The figurine of the Home Pride® Fred character was produced by Wade Ceramics Ltd. exclusively for Key Kollectables under license from Campbell Grocery Products Limited. Each figurine was issued with a color postcard/certificate signed personally by Andrew Key of Key Kollectables. Under terms of the license agreement the figurines were sold only in the United Kingdom.

The illustrations of the Fred figurine are reproduced by permission and ©2002 and Trademarks licensed by Campbell Grocery Products Limited. All rights reserved.

1. Fred's Tasting Time measures 4" high and is marked: Key Kollectables Fred's Tasting Time Wade with Certificate of Authenticity THIS IS NOT A TOY ©&™ Campbell Grocery Products Limited, Limited Edition of 500 pieces ($120, £80).

2. Fred At Your Service measures 4" high and is marked: Key Kollectables Fred At Your Service Wade with Certificate of Authenticity THIS IS NOT A TOY ©&™ Campbell Grocery Products Limited, Limited Edition of 500 pieces ($105, £70).

3. Fred's Christmas Surprise measures 4" high and is marked: Key Kollectables Fred's Christmas Surprise Wade with Certificate of Authenticity THIS IS NOT A TOY ©&™ Campbell Grocery Products Limited, Special Limited Edition. Orders for this figurine were accepted until December 31st 2001 at which time the edition size was set. The eventual limited edition was 763 figurines ($90, £60).

21st CENTURY KEEPSAKES, 1998 - 1999

The "Memories Collection" by 21st Century Keepsakes is a series of figurines based on a children's TV series of the 1950s called Andy Pandy. Each figurine came with a certificate of authenticity. 21st Century Keepsakes is based in Milton Keynes, England.

ANDY PANDY 1998
5" high and has a transfer type backstamp: Limited Edition 1500 Wade England along with the name of the model and the 21st Century logo ($70, £45). This figurine was issued in 1998 in a limited edition of 1,500.

LOOBY LOO & TEDDY 1999
4" high and has a transfer type backstamp: Limited Edition 1500 Wade England along with the name of the model and the 21st Century logo ($60, £40). This figurine was issued in 1999 in a limited edition of 1,500.

BILL & BEN AND LITTLE WEED 1999
4-1/2" high and has a transfer type backstamp: Bill & Ben & Little Weed Limited Edition of 500 with Gold Edged Petals Wade England along with the 21st Century logo. This figurine was issued in 1999 in a limited edition of 500 pieces ($60, £40). Not illustrated are the Bill & Ben and Little Weed in the regular limited edition of 1,500 pieces.

THE COLLECTOR, *1997 - 1999*

A series of animal figurines in various costumes under the title of "In the Forest Deep" was issued by The Collector of London, England starting in 1997.

IN THE FOREST DEEP, *1997 - 1999*

All figurines in this series except Santa Hedgehog are back stamped: In The Forest Deep Series (followed by the figurine's name) for the Collector London Limited Edition of 1000 Wade. Santa Hedgehog had a similar backstamp to other figurines except it was a limited edition of 2000.

1. Oswald Owl measures 4-3/8" high and was issued in 1997 ($75, £48). **2. Morris Mole** measures 4-1/4" high and was issued in 1997 ($75, £48). **3. Santa Hedgehog** measures 5-1/8" high and was issued in 1997 ($75, £48).

4. Bertram the Badger measures 5-1/8" high and was issued in 1998 ($75, £48). **5. Tailwarmer Squirrel** measures 4-1/8" high and was issued in 1998 ($75, £48).

6. Gentleman Rabbit measures 5-1/2" high and was issued in 1999 ($75, £48). **7. Huntsman Fox** measures 5-1/2" high and was issued in 1999 ($75, £48).

JIM BEAM / WADE, *1998 - 2002*

A number of cartoon style characters were made by Wade for the combined Jim Beam/Wade Fairs held in various locations in the U.S.A. The figurines were modeled from designs by Dick Ellis, whose drawings decorate *Beam Around The World*, the International Association of Jim Beam Bottle and Specialties Clubs newsletter.

Although Wade Ceramics Limited no longer takes part in the annual Jim Beam conventions, the pottery continues to produce limited edition figurines for the club.

I'M A WADE COLLECTOR *1998*
7" high and has the IAJBBSC logo along with the transfer backstamp that reads: Wade England 1 of 1000 Animated Character ©1998 R. Ellis. This figurine was introduced at the Jim Beam/Wade Fair in Buffalo, New York in 1998 ($70, £45).

WADE COLLECTOR PIN *1998*
2-3/4" long and has the IAJBBSC logo on the back along with the signature of the designer ©1998 R. Ellis. This pin was produced in a limited edition of 1,500 pieces ($18, £10).

"HAPPY LITTLE GUYS SERIES" CHARACTER DECANTERS, *1997*

A set of three decanters based on the little guy character designed by Dick Ellis. Production of the decanters was limited to 500 each or whatever the pre-order number was above 500. Of the three decanters the Red Jacket "Wade" decanter is the most difficult to find.

YELLOW JACKET "BEAM BOTTLE COLLECTOR" *1997*
9-5/8" high and has a backstamp reading: ©1996 R. Ellis (along with the Ellis signature) Wade. The IAJBBSC logo and the OIWCC logo appear on the back of the figurine ($110, £80).

RED JACKET "WADE" *1997*
10-1/2" high and has a backstamp reading: ©1996 R. Ellis (along with the Ellis signature) Wade. The IAJBBSC logo and the OIWCC logo also appear on the back of the figurine ($150, £115).

WHITE JACKET "BEAM BOTTLE COLLECTOR" *1997*
10" high and has a backstamp reading: ©1996 R. Ellis (along with the Ellis signature) Wade. The IAJBBSC logo and the OIWCC logo also appear on the back of the figurine ($110, £80).

"RENUZIT" MEMBERSHIP FOX *1999*
4" high and has a backstamp reading: 1999 Wade ©1998 R. Ellis (along with the Ellis signature) 1 of 350. Also included is the IAJBBSC logo. This figurine was the membership piece for 1999 ($65, £40).

FOX WITH TEXAS FLAG *1999*
4" high and has a backstamp reading: 1999 Wade ©1998 R. Ellis (along with the Ellis signature). Also included is the IAJBBSC logo. Only 160 Fox figurines with the Texas flag were available at the San Antonio Jim Beam/Wade Fair ($65, £40). One Fox figurine exists with the Texas flag reversed.

COWBOY "BEAM'S SOUR MASH" *1999*
6-3/4" high and has a backstamp reading: IAJBBSC 29th Convention, San Antonio, TX. 1999 Wade 1 of 300 ©1998 R. Ellis (along with the Ellis signature). Also included was the IAJBBSC logo. This figurine was sold at the San Antonio, Texas, Jim Beam/Wade Convention ($55, £38).

CHRISTMAS FOX *1999*
4" high and has a backstamp reading: 1999 Wade ©1998 R. Ellis (along with the Ellis signature) 1 of 140. Also included is the IAJBBSC logo. This Fox was part of the Christmas package and not sold individually to members of the club ($100, £70).

GOLD FOX *1999*
4" high and has a backstamp reading: IAJBBSC 1999 Wade ©1998 R. Ellis (along with the Ellis signature) 1 of 1. Also included is the IAJBBSC logo. This special gold glazed fox was given to the winner of "Name the Fox" contest, a contest to name the 1999 Membership piece (N.P.A.).

COWBOY "JIM BEAM" *1999*
6-3/4" high and has a backstamp reading: IAJBBSC 29th Convention, San Antonio, TX. 1999 Wade 1 of 300 ©1998 R. Ellis (along with the Ellis signature). Also included was the IAJBBSC logo. This figurine was sold at the San Antonio, Texas, Jim Beam/Wade Convention ($55, £38).

"SMILEY RYELY" MEMBERSHIP BEAR *2000*
4-3/4" high and has a backstamp reading: I.A.J.B.B.S.C. 2000 Wade ©1999 R. Ellis (along with the Ellis signature) 30th Convention Reno, NV. 1 of 300 Wade England. Also included was the I.A.J.B.B.S.C. logo. This figurine was the membership piece for the year 2000. The figurine is actually a miniature decanter with a recessed base to accommodate the cork but was not sold with the cork ($40, £28). A "one-of-a-kind" all over gold bear was given away as a prize to the member of the club who named the membership bear. The backstamp included the wording 1 of 1 (N.P.A.).

COWGIRL "BEAM'S CHOICE" *2000*
7" high and has a backstamp that reads: I.A.J.B.B.S.C. 30th Convention, Reno, NV. 2000 Wade England ©1999 R. E. Ellis (along with the Ellis signature) 1 of 350. Also included was the IAJBBSC logo. This figurine was sold at the Reno, Nevada, Jim Beam Convention ($55, £38).

MILLENNIUM BEAR *2000*
4-3/4" high with a backstamp reading: I.A.J.B.B.S.C. 2000 Wade England 30th Convention, Reno, NV. ©1999 R. E. Ellis (along with the Ellis signature) 1 of 350. Also included was the I.A.J.B.B.S.C. logo. This figurine was sold at the Reno, Nevada, Jim Beam Convention in a limited edition of 350 pieces ($50, £35).

SILVER LEGACY FOX *2000*
4" high and has a backstamp which reads: I.A.J.B.B.S.C. 2000 Wade ©2000 R. E. Ellis (along with the Ellis signature) 30th Annual Convention, Reno, NV. 1 of 350. Also included was the IAJBBSC logo. The fox figurine was once again used for the year 2000 Convention at Reno, Nevada ($45, £30).

COWGIRL "OLD GRAND DAD" *2000*
7" high and has a backstamp that reads: I.A.J.B.B.S.C. 30th Convention, Reno, NV. 2000 Wade England ©1999 R. E. Ellis (along with the Ellis signature) 1 of 350. Also included was the IAJBBSC logo. This figurine was sold at the Reno, Nevada, Jim Beam Convention ($55, £38).

MEMBERSHIP BEAR *2001*
4-1/2" high and is marked: 2001 Membership ©2000 R. Ellis (along with the Ellis signature) 1 of 225 Wade. The backstamp also included the IAJBBSC logo. This was the membership figurine for the year 2001 ($30, £20). A "one-of-a-kind" all over gold bear was given away as a prize to the member of the club who named the membership bear. The backstamp included the wording 1 of 1 (N.P.A.).

CHECKERED FLAG FOX YELLOW COAT *2001*
5-1/4" high and is marked: 2001 Indianapolis 1 of 175 ©2000 R. Ellis (along with the Ellis signature) Wade. The backstamp also included the IAJBBSC logo. These figurines were given as draw prizes at the Indianapolis, Indiana, Jim Beam Convention ($75, £50).

CHECKERED BARREL BEAR *2001*
4-1/2" high and is marked: Indianapolis ©2000 R. Ellis (along with the Ellis signature) 1 of 175 Wade 2001. The backstamp also included the IAJBBSC logo. These figurines were given away as draw prizes at the Indianapolis, Indiana, Jim Beam Convention ($50, £40).

CHECKERED FLAG FOX RED COAT *2001*
5-1/4" high and is marked: 2001 Indianapolis 1 of 300 ©2000 R. Ellis (along with the Ellis signature) Wade. The backstamp also included the IAJBBSC log. These figurines were given away as draw prizes at the Indianapolis Convention ($40, £28).

QUOTA BEAR *2001*
4-1/2" high and is marked: Indianapolis ©2000 R. Ellis (along with the Ellis signature) 1 of 100 Wade 2001. The backstamp also included the IAJBBSC logo. This figurine was given to clubs that met their quota set for memberships (N.P.A.).

CHECKERED FLAG FOX BLUE COAT *2001*
5-1/4" high and is marked: 2001 Indianapolis 1 of 300 ©2000 R. Ellis (along with the Ellis signature) Wade. The backstamp also included the IAJBBSC logo. These figurines were given away as draw prizes at the Indianapolis, Indiana, Jim Beam Convention ($40, £28).

AMERICA BEAR 2002
4-1/4" high and is marked: I.A.J.B.B.S.C. 2002 ©2001 R. Ellis (along with the Ellis signature) Wade. The backstamp also included the IAJBBSC logo. This figurine was a limited edition of 450 with all profits going to the New York Firefighters and Police Widow's Fund Charity ($85, £60).

BLACK BEAR 2002
4-1/4" high and was a limited edition of 175 figurines used as draw prizes at the 2002 Philadelphia Convention (N.P.A.).

CANNONEER FOX BLUE COAT 2002
7" high and was a limited edition of 300 figurines used as draw prizes at the 2002 Philadelphia Convention (N.P.A.). Note: Future figurines include the Cannoneer Fox Grey Coat in a limited edition of 300, a Cannoneer Fox in Red Coat in a limited edition of 175 and, a brown version of America's Bear in a limited edition of 225 to be used as the 2002 membership piece. There will also be a white version of the 2002 membership piece in a limited edition of 100. As in the past a "one-of-a-kind" all over gold version of the 2002 membership piece will be given to the member of the club who named the membership piece.

Right:
MEMBERSHIP BEAR 2002
4-1/2" high and is marked: 2002 Membership I.A.J.B.B.S.C. Wade Est. 1810 England ©2001 R. Ellis (along with the Ellis signature). This was a membership figurine for the year 2002 and produced in a limited edition of 225 pieces ($45, £30).

CAMTRAK, 1995 - 1999

The Childhood Favourites series was produced by Wade for Camtrak, based in Nottingham, England. The series comprised a number of cartoon and children's favorite TV characters.

DOUGAL 1995
3-1/4" high by 6" long and is transfer marked: CAMTRAKS' Childhood Favourites No.1 Dougal by Wade ©Serge Danot/AB Productions Licensed by Link Licensing Ltd. This figurine was issued in 1995 in a limited edition of 2,000 pieces ($60, £40). Of the 2,000 pieces, approximately 200 figurines were produced with a brown face ($80, £50).

RUPERT BEAR 1996
5-1/8" high and is transfer marked: "CAMTRAK'S Childhood Favourites by Wade No.2 Rupert ©1996 Express Newspapers plc. Licensed by A.H.E/Nelvana." There were 900 figurines issued with a green base ($125, £70). There were 100 figurines issued with a gold base ($275, £175).

PADDINGTON BEAR 1997
3-5/8" high and is transfer marked: "CAMTRAK'S Childhood Favourites by Wade No.3 Paddington ©Paddington and Company Ltd. 1997 Licensed by Copyright Wade Made in England. Paddington Bear with grey base ($90, £60). Paddington Bear with gold base ($275, £175).

RUPERT AND THE SNOWMAN *1997*
4" high and is transfer marked: "CAMTRAK'S Childhood Favourites by Wade No.4 Rupert and the Snowman Rupert Characters and ©Express Newspapers Plc 1997 Licensed by Nelvana Marketing Inc. UK Representative Abby Home Entertainment ($90, £60). This was a limited edition of 1,900 figurines of which 100 figurines were produced with gold buttons ($180, £120). In addition a limited edition of 100 figurines with a pale blue scarf was produced for the London Police Fund ($180, £120).

PADDINGTON'S SNOWY DAY *1999*
Paddington's Snowy Day with pearlized base measures 4" high and is transfer marked: "CAMTRAK'S Childhood Favourites by Wade No.7 Paddington's Snowy Day ©Paddington and Company Ltd. 1999 Licensed by Copyright. This figurine was produced in 1999 in a limited edition of 2,000 pieces ($90, £58).

Paddington's Snowy Day with gold base measures 4" high and is transfer marked: "CAMTRAK'S Childhood Favourites by Wade No.7 Paddingtons Snowy Day ©Paddington and Company Ltd. 1999 Licensed by Copyright (N.P.A.).

SOOTY AND SWEEP *1998*
Left: Sooty measures 5-1/4" high and is transfer marked: "CAMTRAK'S Childhood Favourites by Wade No.5 Sooty, Sooty™ and ©Sooty International Limited 1998 Licensed by Chatsworth Enterprises Limited. Sooty was produced in 1998 in a limited edition of 2,000 figurines ($90, £60). **Right: Sweep** measures 5-1/2" high and is transfer marked: "CAMTRAK'S Childhood Favourites by Wade No.6 Sweep, Sooty™ and ©Sooty International Limited 1998 Licensed by Chatsworth Enterprises Limited Licensed by Copyright. Sweep was produced in 1998 in a limited edition of 2,000 figurines ($90, £60).

TINY CLANGER *1999*
4" high and is transfer marked: "CAMTRAK'S Childhood Favourites by Wade No.8 Tiny Clanger ©1999 Oliver Postgate & Peter Firmin Licensed by Licensing by Design Limited ($45, £32).

S & A COLLECTABLES 1999

Based in Barking, Essex, S&A Collectables commissioned Wade to produce a figurine of the notorious 19th Century murderer from the east end of London, Jack the Ripper.

JACK THE RIPPER 1999
4-3/4" high by 4-5/8" dia. base and is transfer marked: S & A Collectables Ltd. Proudly Presents Jack The Ripper Produced in a Limited Edition of 1,000 pieces Manufactured by Wade 1999 ($70, £48).

COLLECTABLES MAGAZINE

Collectables, published by Out of the Blue Publications of Walton-on-Thames, England, commissioned Wade to produce a series of figurines based on cartoon characters and children's stories.

TINY TREASURES COLLECTION Set 1, 1999

Set 1 of Tiny Treasures was the first of a series of miniatures made by Wade for *Collectables* magazine. Each figurine is marked: D.C. Comics ©1999 along with name of the character. There is also a transfer mark on the back of each base reading: Wade Made in England.

1. **Batman** measures 2-3/16" high on a 1-1/4" dia. base and is unpainted. This is a rare figurine (N.P.A.). 2. **Batman** measures 2-3/16" high on a 1-1/4" dia. base and was produced in a limited edition of 1,939 pieces ($20, £12). 3. **Super Girl** measures 2-1/16" high and was produced in a limited edition of 1,938 pieces ($12, £8). 4. **Alfred** measures 2-1/4" high and was produced in a limited edition of 1,939 pieces ($12, £8). 5. **Lois Lane** measures 2-1/16" high and was produced in a limited edition of 1,938 pieces ($12, £8).

TINY TREASURES COLLECTION Set 2, 1999

Set 2 of Tiny Treasures was produced in a limited edition of 500 pieces for each figurine. All figurines are marked: T.T. 2 Wade.

1. **Mrs. Darling** measures 2-5/8" high ($18, £15). 2. **Peter Pan** measures 2-1/2" high ($18, £15). 3. **Mermaid** measures 2-5/8" high ($18, £15). 4. **Pirate** measures 2-5/8" high ($18, £15).

TINY TREASURES COLLECTION Set 3, 1999

Set 3 of Tiny Treasures was produced in a limited edition of 500 pieces for each figurine. All figurines are marked: Wade England T.T. 3 along with the name of the figurine.

Left: Snowman measures 2-1/2" high ($42, £35). **Right: Father Christmas** measures 2-1/2" high ($42, £35).

BATMAN BOX SET, 1999

There were 250 luxury boxed sets produced for "Out of the Blue Ceramics" containing eleven hand painted figurines from the Batman cartoon series. These sets were made available through *Collectables* magazine. In addition to the boxed sets, Batman was also available as a single item in a limited edition of 1,689 pieces. The figurines are marked: D.C. Comics ©1999 Produced for "Out of the Blue Ceramics" Limited Edition 250 Luxury Boxed Sets Wade England ($1,000, £752 boxed set).

7. The Penguin measures 5-3/4" high.
8. The Riddler measures 7-1/2" high.

1. Robin measures 5-3/8" high. **2. Bat Girl** measures 6" high.
3. Alfred measures 6-1/2" high.

9. The Batmobile measures 1-1/2" high at the fin by 6-3/4" long.

10. Poison Ivy measures 6-3/8" high. **11. Cat Woman** measures 6" high.

4. Batman measures 7-1/8" high by 5-1/4" at the base ($80, £50).

Right:
5. Mr. Freeze measures 7-3/8" high. **6. The Joker** measures 6-3/4" high.

Right:
COLLECT '99 TEDDY *1999*
4-1/2" high and is marked: Produced by Wade Ceramics Limited in Collaboration with Collectables Magazine. This figurine was produced in a limited edition of 500 and was introduced at the Wembly Exhibition Hall in October 1999 ($60, £40).

CERAMECCA ENCHANTMENT TOURS, 1999

Based in Stoke-on-Trent, Ceramecca Enchantment Tours has arranged a number of tours around the pottery area of the Midlands of England and to various international locations.

"I'M ON MY WAY" *1999*
5" high and is transfer marked: Wish You Were Here Collection I'm On My Way Ceramecca Limited Edition 750 with Certificate Wade England. This figurine was sold at the 1999 Trentham Gardens Wade Show ($60, £38).

COLLECT IT! MAGAZINE

Collect it! is advertised as "The World's No. 1 Glass Collecting Title." The magazine has sponsored numerous fairs in the UK where products of Wade Ceramics Ltd. have been in the forefront. *Collect it!* has also commissioned Wade to produce figurines for sale through the magazine.

Starting in 1998, a set of three fairy figurines was produced by Wade for *Collect it!* magazine under the name of *Collect it!* Fairies. The first figurine in the series, Collectania, was introduced at the Newark *Collect it!* Fair held in August 1998. This figurine was a limited edition of 2,500 pieces. Collectus, the second figurine in the series was introduced in October 1998, and the third figurine, Collecteenie, in January 1999.

Collect it! magazine also produced limited edition Betty Boop figurines in cooperation with C&S Collectables. For the *Collect it!* Betty Boop figurines, see the section on C&S Collectables.

Left: Collectania measures 4-1/8" high and has a transfer mark: Collectania Made Exclusively for Collect it! by Wade Limited Edition of 2,500 ($70, £30). **Center: Collecteenie** measures 2-3/8" high and has a transfer mark: Collecteenie Made Exclusively for Collect it! by Wade Limited Edition of 1,500 ($70, £30). **Right: Collectus** measures 4-1/8" high and has a transfer mark: Collectus Made Exclusively for Collect it! by Wade Limited Edition of 2,500 ($70, £30).

SPECIAL ISSUE COLLECT IT! FAIRIES
A very few sets of the *Collect it!* Fairies were produced with gold wings (N.P.A.).

COLLECT IT! BEAR CUB *2000*
This figurine was an all-over honey glaze version of the Whimsie Bear Cub and was given away in October 2000 to U.K. subscribers of the magazine ($12, £8).

ROBELL MEDIA PROMOTIONS LTD., 1997 - 1999

Between 1997 and 1999, Wade produced a limited edition of four figurines for the Mr. Men and Little Miss Club based upon characters from children's books by Roger Hargreaves. The figurines were modeled by Ken Holmes from a specially commissioned drawing by Adam Hargreaves. The figurines had a transfer back stamp reading: "Genuine Wade Porcelain Robell Produced exclusively for the Mr. Men & Little Miss Club Mr. Men and Little Miss ™ & © Mrs. Roger Hargreaves" with Mr. Happy and Little Miss logos.

1 **2** **3** **4**

1. Mr. Happy measures 4" high ($48, £30). **2. Mr. Bump** measures 3-3/4" high ($48, £30). **3. Little Miss Giggles** measures 3-3/4" high ($48, £30). **4. Mr. Snow** measures 4-3/4" high ($48, £30).

ROBERT WILLIAMSON AND PETER ELSON, 1995 - 1996

"Blow-Up" figurines of the Gingerbread Man was first sold at the 1995, Birmingham Wade Collectors Fair. The Gingerbread Children figurine was first sold at the 1996, Dunstable Wade Fair in a limited edition of 2,000. Both figurines are mold marked WADE on the base.

Left: The Gingerbread Man measures 4-1/4" high ($60, £35).
Right: The Gingerbread Children measures 3-1/4" high ($45, £28).

DMG COLLECTABLE CARS *2000*
This miniature sports car measures 5-1/4" long by 1-5/8" high and has a backstamp reading: ©1999 TVR Engineering Limited Chimaera by Wade England for DMG Collectable Cars Limited Edition 1500 ($50, £30).

WADE WATCH LIMITED

In 2001, the long established Wade Watch Limited, publishers of the quarterly newsletter, *The Wade Watch*, collaborated with C&S Collectables of England to commission Wade to produce a set of five miniature teapots. The die pressed teapots were designed in such a way that they could be used as Christmas ornaments, key chains, or be placed in shadow boxes. Three of the teapots used the Wade chintz pattern. The teapots measure 1" by 1-1/2" and are transfer marked: Wade England.

1. Chintz Butterfly. 2. Gold. 3. Chintz Thistle. 4. Chintz Sweet Pea. 5. Silver. The teapots were sold in boxed sets of five. In the U.S.A. Wade Watch Limited sold 250 sets ($50 set). In the U.K. C&S Collectables sold 250 sets (£29 set).

WESTCOAST COLLECTORS FAIR

The West Coast Collectors Fair is organized and promoted by Reva and Michael Mathew. The first fair was held in Kalama, Washington in 2000. The second fair was held in Vancouver, Washington in 2001. The 2002 fair was also held in Vancouver, Washington.

The Fair Specials for 2002 were based on the Tom Smith Eagle from the 1984 - 1985 World of Survival series and the 1992 - 1993 Birdlife series. The Eagle measures 1-3/4" high and is marked Wade England.

1. Red Eagle. 2. White Eagle. 3. Blue Eagle. 4. Black Eagle.
There were 300 sets of the Red, White and Blue Eagles sold as sets of three, one of each color ($30 set, £20 set). The Black Eagle was a limited edition of 200 pieces packed in Goodie Bags and given away as prizes ($16, £8).

215

Chapter 16
WADE PROMOTIONAL ITEMS

ASPREY & CO. DECANTER, *circa early 1930s*

The "Scotsman" whisky decanter was produced by Wade for Asprey & Co. circa the early 1930s. Wade has also produced a matching "Irishman" decanter. The design for the "Scotsman" decanter was registered at the Patent Office, Trade Mark Register under the No. 675853. The date of registration was April 2, 1920 and the applicant was Arthur William Hilling of 16 New Bond Street, London. On the same date, application was also made for registration under No. 675852. The design in the form of a line drawing represents a figural bottle of a man in farm worker type clothing with a pipe stuck in the band of the hat and a kerchief tied around the neck.

Scotsman Decanter ($400, £220).

CHARRINGTON BEERS TOBY JUGS, *early 1950s - early 1960s*

These Toby jugs were originally intended as displays for advertising. Some of these jugs have been found with a hole in the base. The purpose of the hole was to prevent this item from being used as a water jug as the inside did not have the required glaze needed for tableware. The jugs with a solid base were glazed on the inside and could be used as water jugs.

Left: Toby Ale jug measures 7-3/8" high and may be found with either Mark Type 42 or 43A on the base ($250, £160). **Right: Toby Beer** jug measures 7-3/8" high and may be found with either Mark Type 42 or 43A on the base ($250, £160).

GEORGE G. SANDEMAN & CO. LTD. *1958 - 1961*

The Sandeman figural port and sherry containers measure 8-1/2" high and have Mark Type 19 on the base. The decanter with the yellow glass contained sherry and the decanter with the red glass contained port ($60 each, £40 each).

"SIGNAL" TOOTHPASTE PROMOTION *circa late 1960s - early 1970s*

The 24 figurines used in this Lever Rexona New Zealand Limited toothpaste promotion were similar to those used in the 1971 - 1979 Canadian Red Rose Tea Promotion. One figurine was offered free with each carton of "Signal 2" toothpaste. (For illustrations see the 1971 - 1979 Canadian Red Rose Tea promotion.)

JAMES ROBERTSON & SONS, *early – mid 1960s*

A set of porcelain figurines known as Robertson's Gollies were produced by George Wade & Son Ltd. The Gollies feature the Robertson's Marmalade Trade Mark figurine playing various musical instruments. Each figurine has "Robertson" mold marked on the front of the base. None of the figurines were marked Wade. Later, less expensive versions of the Robertson's "Gollies" were produced in Europe and added to the set. The Wade figurines can be differentiated from the later models by the white porcelain base.

ROBERTSON'S GOLLIES BAND STAND
This circular Band Stand was produced by Wade to display the "Gollies" and is hard to find (N.P.A.).

FLOWERS BREWERY, *early 1960s*

This ornamental advertising item was produced in the 1960s for Flower's Beer.

All figurines are 2-5/8" high. **1.** Saxophone Player. **2.** Trumpet Player. **3.** Accordion Player. **4.** Clarinet Player. **5.** Bass Player ($225 each, £140 each).

The Flowers Brewmaster measures 5-1/4" high and has Mark Type 43 on the base ($320, £175).

The Flowers Brewmaster measures 5-1/4" high and is unmarked. This is a prototype figurine ($320, £175).

IMPERIAL CHEMICAL INDUSTRIES, *circa late 1960s*

"ICI Man" figurines were produced by George Wade & Son Ltd. for Imperial Chemical Industries. The figurines were to promote the drug Atromid-S in the U.K. and Regelan, its counterpart marketed in Germany.

Left: "ICI Man" measures 8-1/4" high and is mold marked: Wade England ICI Atromid S (N.P.A.). **Center:** "ICI Man" measures 3-1/8" high and is mold marked: Atromidin Wade England ICI ($70, £45). **Right:** "ICI Man" measures 8-1/4" high and is mold marked: Atromidin Wade England ICI (N.P.A.).

GUINNESS PROMOTIONAL FIGURINES, *1968*

In December 1968, Guinness Brewing commissioned George Wade & Son Ltd. to produce four promotional figurines based on characters featured in the *Guinness Book of Advertising*. The order was for 3,000 sets of the four figurines and 8,000 singles, (2,000 each of the four figurines). None of the figurines are marked with a Wade back stamp but all have "Guinness" mold marked on the front of the base.

1. **Tony Weller** measures 3" high ($150, £80). 2. **Tweedledum & Tweedledee** measures 2-7/8" high ($150, £80). 3. **Madhatter** measures 3-1/4" high ($150, £80). 4. **Wellington Boot** measures 3-1/2" high ($150, £80).

SHARPS EASTER EGG PROMOTION, *1970 - 1971*

Between March 27 and March 30, 1970, Sharps, an English manufacturer of candies and sweets, used a porcelain Easter Bunny, manufactured by George Wade & Son Ltd., as a promotional item. Between April 9 and April 12, 1971, the company used a porcelain figure of Bo-Peep, as a promotional item. The Bo-Peep figurine was also made by George Wade & Son Ltd.

Left: **Easter Bunny** measures 2-1/2" high and is unmarked ($36, £20). Center: **Bo-Peep** undecorated, measures 2-5/8" high and is mold marked: Wade England ($32, £18). Right: **Bo-Peep** decorated, measures 2-5/8" high and is mold marked: Wade England ($30, £16). Smaller, unauthorized reproductions of both these figurines have been found. Reproduction Easter Bunny measures 2-1/8" high. Reproduction Bo-Peep measures 2-5/16" high.

THE RANK, HOVIS McDOUGALL FOODS COMPANY

A pair of salt and pepper shakers was modeled by Wade circa mid 1970s in the image of the "BISTO-KIDS," the popular advertising characters used for promoting "BISTO" products made by the Rank Hovis McDougall Foods Company. These two figurines were modeled at George Wade & Son Ltd. in Burslem, but were manufactured by their associates, Wade (Ireland) Ltd.

Left: **Bisto Boy** pepper shaker measures 4" high ($130, £80). Right: **Bisto Girl** salt shaker measures 4-3/8" high ($130, £80). Both figurines are marked on the base: "© RHM FOODS LTD. & Applied Creativity - WADE Staffordshire."

ARTHUR PRICE OF ENGLAND

Circa late 1970s-early 1980s Wade supplied Arthur Price of England, distributors of silver—plated ware, with a number of figurines taken from the 1971-1984 line of Whimsies to be added to presentation boxes of gift ware.

ON THE FARM
This set included items from the 1975 Set 6 and the 1977 Set 8 of the Whimsies.

JUNGLE BABIES
This set included items from the 1971 Set 1, 1973 Set 4, 1975 Set 5, and the 1979 Set 10 of the Whimsies.

JAMES BUCHANAN & CO. LTD. BLACK & WHITE SCOTCH WHISKY "DOG" DECANTER *early 1960s*
7-1/2" high by 9-1/2" across and is marked: Scotch Black & White Whisky Premium Distilled, Blended & Bottled in Scotland by James Buchanan & Co. Ltd. ($300, £150).

KING BRITISH AQUARIUM ACCESSORIES LTD. AQUARIUM SET, *circa 1976 - 1980*

A set of six die cast figurines produced by George Wade & Son. Ltd. for King British Aquarium Accessories Ltd. with the intention that the items would be used as decorative ornaments to be placed in aquariums. The Lighthouse, Seahorse, Mermaid, and Bridge were purchased in September 1976 and the Diver and Snail in February 1977. Equal quantities of each model were produced over a period of 3-4 years. Of the six figurines, the Seahorse and Snail (in this order) are the most difficult to find. All items are mold marked: WADE ENGLAND.

Top: 1. Mermaid measures 2-1/2" high ($60, £40). **2. Diver** measures 2-3/4" high ($30, £16). **3. Lighthouse** measures 3" high ($60, £40).
Bottom: 4. Seahorse measures 3" high ($220, £110). **5. Bridge** measures 1-3/4" high by 3-1/4" overall ($130, £60). **6 Snail** measures 1-1/4" high ($100, £48).

WILLIAM HARPER SEAHORSE PROTOTYPES

The following five seahorses were modeled by William Harper in the late 1950s.

Right:
1. **Seahorse** measures 3-3/4" high.
2. **Seahorse** measures 4" high.
3. **Seahorse** measures 3" high.
4. **Seahorse** measures 2-3/4" high.
5. **Seahorse** measures 4-1/4" high. Note the compass embedded in the base ($420, £280).

219

JOHN McEWAN & CO. LTD. ABBOTS CHOICE DECANTER, *1982 - 1992*

Left: Liquor Bottle measures 10" high and is mold marked on the base: M - Made Exclusively for the Abbot's Choice Scotch Whisky John McEwan & Co. Ltd. Leith, Scotland Liquor Bottle, Scotland. This liquor bottle was first produced in 1982 by Wade (Ireland) Ltd. and some were still in stock in 1992 ($120, £80). A new, second mold, **Right: Liquor Bottle** was made in 1987 for Low Robertson, part of the Distillers Company Limited who were then absorbed into United Distillers as part of the Guinness Group. The bottle is mold marked on the base: 263992 Made Exclusively for Abbot's Choice Scotch Whisky John McEwan & Co. Ltd. Leith, Scotland ($120, £80).

THE THISTLE AND THE ROSE CHESS SET, *1980*

In 1980, Peter Thompson (Perth) Ltd. commissioned the Wade Pottery to produce a complete set of porcelain chess pieces. The designs were based on historical characters from the royal houses of Scotland (The Thistle) and England (The Rose). The figurines were designed by Ann Whittet and modeled by Frederick Mellor.

Originally, the principal pieces were empty and sold in a presentation box along with a bottle of Beneagles Scotch whisky and a copper finished chess board. The principal pieces were also made available individually packaged and containing 50ml of whisky. Many of these sets were distributed as a gift to first class passengers flying British Caledonian Airways.

Toward the end of the production run, boxed sets of one Principle piece filled with whisky and one solid Pawn, were distributed by Las Vegas Distributing Co. of Las Vegas, Nevada.

THE THISTLE CHESS SET
1. Scottish Tower House measures 4-1/8" high ($40, £25). **2. Sir William Wallace** measures 5-3/8" high ($40, £25). **3. Mary Queen of Scots** measures 4-7/8" high ($40, £25). **4. John Knox** measures 5" high ($40, £25). **5. King Robert the Bruce** measures 5-1/8" high ($40, £25). **6. Pawn "Thistle"** measures 3-5/8" high ($30, £18).

THE ROSE CHESS SET
7. Norman English Tower measures 4" high ($40, £25). **8. Sir Francis Drake** measures 5-1/8" high ($40, £25). **9. Thomas A Becket** measures 5-1/4" high ($40, £25). **10. Elizabeth I** measures 5-1/4" high ($40, £25). **11. King Henry VIII** measures 5-1/4" high ($40, £25). **12. Pawn "Rose"** measures 3-5/8" high ($30, £18).

PETER THOMPSON (PERTH) LTD.

Wade produced a number of miniature decanters for Peter Thompson (Perth) Ltd. of Scotland between the late 1970s and early 1980s. According to the late Bernhard Burton, who was overseeing the contract between Wade and Peter Thompson (Perth) Ltd. at that time, the only two figural decanters produced by Wade, other than the Thistle and the Rose chess set, were the brown bear and the curling stone.

BROWN BEAR
4-3/4" high and is marked: Beneagles Scotch Whisky - Peter Thompson, (Perth) Ltd. Scotland. This miniature brown bear decanter was first issued in 1981 by Wade (Ireland) Ltd. and contained BENEAGLES scotch whisky ($75, £40). Production of the brown bear ended at Wade circa 1987 when the contract was taken over by Beswick.

CURLING STONE
2-3/4" high and is mold marked: Beneagles Scotch Whisky Wade. This miniature curling stone decanter was produced by Wade (Ireland) Ltd. in 1981 for Peter Thompson (Perth) Ltd. ($45, £25).

KP FOODS LIMITED PROMOTION

This 1983 promotion comprised six miniature "Friars" and was limited to the United Kingdom only. The first figurine of the set was free but the remaining five could only be obtained by submitting proof of purchase of a certain number of potato chip packages. This is most probably the reason that the first figurine (Father Abbot) is the most easily found. The last three figurines, Bother Crispin, Brother Angelo, and Brother Francis are the most difficult to find.

All the figurines have the name of the character marked on the front of the base. All figurines are mold marked "Wade" on the back of the base.

Top: 1. Brother Crispin who "Makes Sure KP are the Crispiest Crisps ever Created" measures 1-5/8" high ($42, £25). **2. Brother Crispin** measures 1-3/4" high and is a prototype figurine.
3. Brother Francis who "Delivers KP Fast and Fresh from the Friary" measures 1-5/8" high ($42, £25). **4. Brother Francis** measures 1-3/4" high and is a prototype figurine. **5. Brother Angelo** who is the "Keeper of the Good Book of Delicious KP Recipes" measures 1-7/8" high ($42, £25).
Bottom: 6. Brother Peter who "Tends the KP Friary Potato Patch" measures 1-5/8" high ($15, £10). **7. Father Abbot** who is the "Founder of the Famous KP Friary" measures 1-3/4" high ($25, £16). **8. Father Abbot** measures 1-7/8" high and is a prototype figurine. **9. Brother Benjamin** who "Bags the Best Foods in the Land" measures 1-5/8" high ($15, £10).

NATIONAL WESTMINSTER BANK

Starting in December 1983, a set of five piggy banks were introduced by The National Westminster Bank to be given to young depositors at various intervals of their Piggy account balance levels. All five Piggies are mold marked "Wade England" on the underside of the base along with a removable, black rubber plug marked "NatWest." In February 1998 an additional Piggy, named Wesley, was added to the family of five.

WESTMINSTER PIGGY BANK FAMILY *1983 - 1998*
1. Woody measures 5" high and was given upon opening an account ($30, £12). **2. Annabel** measures 6-3/8" high and was given after the first statement with a balance of 25 pounds sterling or more ($35, £26).

3. Maxwell measures 6-3/4" high and was given after the second statement with a balance of 50 pounds sterling or more ($68, £45). **4. Lady Hillary** measures 7" high and was given after the third statement with a balance of 75 pounds sterling or more ($60, £40).

5. Sir Nathaniel measures 7-1/4" high and was given after the fourth statement with a balance of 100 pound sterling or more ($120, £80).

6. Wesley measures 5-3/4" high and is mold marked "Wade England" on the underside of the base. Wesley was given when opening a children's five year, 1,000 pound sterling bond. This bond was for children under the age of sixteen ($200, £130).

NATWEST PANDA MONEY BANK, *1989*

The Panda money bank was given as a gift to the under-seven year-old customers of the bank who opened a NatWest World Savers account. For every account opened, the National Westminster Bank donated £1.00 to the World Wide Fund for Nature.

Left:
NATWEST PANDA MONEY BANK *1989*
4-1/2" high and can be found with or without Wade England molded on the underside of the base ($34, £22).

IMPERIAL TOBACCO LIMITED, *1986*

In 1986, Imperial Tobacco Limited commissioned Wade to produce an appropriate figurine as a premium to help promote their brand of St. Bruno tobacco. The premium was a miniature figurine of a St. Bernard dog to be used as a key chain with the chain portion attached to the back of the head.

St. Bernard Dog measures 1-1/4" high by 7/8" along the base and is unmarked ($35, £25).

Whitbread Hopper. The pin badge measures 2-1/4" dia. and the ceramic frog measures 1-1/2" long. The frog is unmarked ($45 complete, £28 complete. (Frog only $25, £15).

WHITBREAD PALE ALE TRAIN, *1979*

For a short time between February and March of 1979, Wade was commissioned by the Whitbread International Belgium to manufacture a decanter in the form of a train engine and an ashtray in the form of the train's tender. In this very short run there were 140 engines and 70 tenders produced. After the short production run, all molds were destroyed in agreement with the contract.

J.W. THORNTON LTD.

Between 1984 and 1993 Wade produced a number of money banks for J. W. Thornton Ltd. manufacturers of candy and chocolate. The only figural money bank produced was Peter the Polar Bear in 1988-1989 but the company also commissioned Wade to produce a letter box type money bank as well as vintage van type money banks.

Left: Tender measures 4" high by 5" long and has Mark Type 46 on the base. **Right: Engine** measures 4-1/2" high by 8-3/4" long and has Mark Type 46 on the base ($1400 set, £800 set).

WHITBREAD HOPPER, *1987*

Enterprise Products, a company specializing in button badge assembly equipment commissioned Wade in 1987, to produce a ceramic frog to be attached to a metal pin badge by means of a double sided tape as an advertisement for Whitbread beers. Records indicate that only a few thousand frogs were produced. Due to the method of attachment of the two items, it is most often that the frog is found alone. The full value of the pin badge is only realized when both the pin and the frog are found together.

Peter the Polar Bear Money Bank measures 6" high and is unmarked. This was as special promotion for Thornton's Toffee ($35, £20).

223

Letter Box Money Bank measures 7" high by 4-3/4" dia. base and is unmarked. The money bank was produced in 1985 ($30, £20).

Vintage Van Money Bank measures 4-3/4" high by 8" long and is mold marked: Manufactured Exclusively for J. W. Thornton Ltd. Made in England. This van, produced in 1993 was just one of three van money banks produced for J. W. Thornton Ltd. by Wade ($70, £35).

SMITHS CRISPS

Between 1987 and 1988, Smiths Crisps, a popular brand of British potato chips commissioned Wade to produce a money bank to help promote the sale of their product.

Monster Munch Money Bank measures 6-1/2" high and has an impressed mold mark Wade England on the underside of the base ($150, £90).

GRANADA TELEVISION PROMOTIONS

Between 1988 and 1989 Granada Television commissioned George Wade & Son Ltd. to produce three miniature die-pressed houses based on the popular and long running British Television series Coronation Street. The three houses were all mold marked: Wade England.

In 1999, two popular characters from Coronation Street were produced by Wade in the form of salt and pepper shakers. Each figurine is transfer marked: ©GTV Ltd. '99. Wade England.

Left: **The Rover's Return** measures 1-7/8" high ($15, £12).
Center: **No. 9 the Duckworths** measures 1-5/8" high ($15, £12).
Right: **The Corner Shop** measures 1-5/8" high ($15, £12).

Left:
Left: **Vera** (pepper shaker) measures 4-3/4" high ($20, £12).
Right: **Jack** (salt shaker) measures 4-1/4" high ($20, £12).

"**MR. BEAR**" *circa mid 1980s*
7-1/2" high and is unmarked. This figurine was sampled for Barclays Bank but never went into full production (N.P.A.).

THE BOOTS COMPANY PLC, *1988 - 1989*

For a number of years Wade produced items to be sold in the gift department of the Boots Drug Stores. For Christmas 1988, Wade supplied Boots with Teddy Bear Bookends and a Teddy Bear Utility Jar.

BRIGHTON PAVILION GIFT SHOP, *1988*

The famous pavilion in Brighton was recreated in delicate slip cast porcelain models. There are two models to the set, a single, large dome and a smaller two-domed building. These were sold separately in the Pavilion Gift Shop. Collectors usually acquire the single dome and two of the smaller buildings forming a set of three to more resemble the actual Brighton Pavilion. These models are unmarked.

Boots Van Money Bank measures 5-1/4" high by 8" long and is unmarked. The money bank was produced in the mid 1990s ($50, £30).

Small Two Domed Building measures 1-7/8" high by 2" long ($25 each, £15 each). **Large Single Domed Building** measures 2-7/8" high by 2" in diameter ($25, £15).

BERTIE BADGER *1990*
4" high. This slip cast figurine was produced in a limited edition of 5,000 pieces for St. John's Ambulance Brigade. A number of these figurines are unmarked, however some are mold marked Wade ($225, £150).

225

LYONS TETLEY

Since 1990 Wade has produced a number of tableware items especially produced for Lyons Tetley. In most cases each piece was made available to collectors who sent in tokens along with a fee as described in the Tetley Collectables Teafolk catalogue.

Left: Brew Gaffer (salt) measures 4-1/8" high and is marked: Wade England ©Tetley GB Limited 1996. **Right: Sydney** (pepper) measures 3-3/8" high and is marked: Wade England ©Tetley GB Limited 1996. Both figural shakers were produced in 1996 ($56 set, £35 set).

Left: Brew Gaffer (salt) measures 3-1/2" high and has Mark Type 27B on the base. **Right: Sydney** (pepper) measures 3-3/4" high and has Mark Type 27B on the base. Both figural shakers were produced between 1990 and 1992 ($60 set, £40 set).

Left: Gaffer Money Bank measures 5-1/4" high and is marked: Made Exclusively for Lyons Tetley by Wade. The money bank was issued in 1992 ($65, £40). **Right: Gaffer Money Bank** measures 6" high and is marked: An Original Design for Tetley GB by Wade England ©Tetley GB Limited 1996. The money bank was issued in 1996 ($65, £40).

Left: Gaffer Cookie Jar measures 8-1/2" high and is marked: An Original Design for Lyons Tetley by Wade England. This cookie jar was issued in 1993 - 1994 ($65, £44). **Center: Gaffer Tea Caddy** measures 7-1/2" high and is marked: An Original Design for Tetley GB by Wade England ©Tetley GB Ltd 1998. This tea caddy was issued in 1998 ($50, £35). **Right: Gaffer Sugar** measures 4-3/4" high and is marked: An Original Design for Tetley GB by Wade England ©Tetley GB Ltd. 1999. This sugar was issued in 1999 ($40, £25).

Gaffer and Nephew Van Tea Caddy measures 5-3/8" high by 8-3/4" long and is marked: An Original Design for Lyons Tetley by Wade England. This tea caddy was a joint venture between Lyons Tetley and Esso Petrol that lasted from September 1994 to February 1995 ($150, £90).

Tetley Vintage Van Money Bank measures 5-1/4" high by 8" long and is marked: Manufactured Exclusively for Lyons Tetley Made in England. This van was a promotion exclusive to a special Cash & Carry store between March and November of 1990 ($85, £50).

HARRODS KNIGHTSBRIDGE, 1991 - 1996

For a number of years Wade produced a series of tableware items for Harrods of Knightsbridge. All the items were modeled in the shape of the Harrods doorman. A doorman cookie jar was issued in 1996. All items are transfer marked: Harrods Knightsbridge. The name Wade was not included in the back stamp.

Lyons' Vintage Van Money Bank measures 5-1/4" high by 8" long and has Mark Type 27B. It is also marked: Manufactured Exclusively for Lyons Tetley. This money bank was issued in 1990 ($95, £56).

1 2 3 4

1. Harrods Doorman Egg Cup measures 4" high and was produced in 1991 ($35, £20). **2. Harrods Doorman Money Bank** measures 6-3/4" high and was produced in 1993 ($50, £35). **3. Harrods Doorman** (salt shaker) measures 4-1/8" high and was produced in early 1990s ($25, £16). **4. Harrods Doorman** (pepper shaker) measures 4-1/8" high and was produced in the early 1990s ($25, £16).

Left:
5. Harrods Doorman Cookie Jar measures 11-1/4" high and was produced in 1996 ($60, £38).

SPILLERS FOODS LTD, *1991*

In 1991 Wade produced a single figurine in the form of a retriever dog which was used, a promotional item for the pet food supplier Spillers Foods Ltd.

Spillers Retriever measures 1-1/8" high by 2-1/8" long and is mold marked: Wade England ($20, £15).

DUNBAR CAKE DECORATIONS, *1992*

In 1992 Wade produced an all-over white glazed figurine of a bridal couple for Dunbar Cake Decorations. This figurine was modeled by Ken Holmes and, according to records, only a few thousand figurines were produced.

Bride and Groom measures 4-1/4" high and is mold marked Wade England on the base ($50, £24).

TRAUFLER, *1992*

In 1992, Wade Ceramics Ltd. produced a number of promotional figurines for Traufler, a British import company specializing in tableware. A number of designs distributed by the company featured farmyard scenes. To help promote these lines, Wade Ceramics Ltd. produced four animal figurines to complement the imported ware. All the figurines are unmarked.

1. **Hen Pepper Shaker** measures 3-5/8" high ($20, £14).
2. **Rooster Salt Shaker** measures 4-5/8" high ($20, £14).

3. **Small White Sheep** measures 1-5/8" high ($20, £14). 4. **Small Black Sheep** measures 1-5/8" high ($20, £14). 5. **Large White Sheep** measures approx. 2-3/4" high ($26, £18).

DEBENHAMS, *1993*

In 1993, the popular UK department store, Debenhams, commissioned Wade to produce a limited edition of 250 dog figurines. The dog was given the name Rex and originally came mounted on a wooden base.

Debenhams Dog "Rex" measures 5-3/8" high by 5-1/8" overall and is mold marked: Wade England ($140, £80).

MARKS AND SPENCER PLC

For a number of years Wade produced promotional items for Marks and Spencer PLC to contain milk chocolate coins. The Edward Bear money bank was such an item and was produced between 1995 and 1996.

Edward Bear Money Bank measures 6-1/8" high and is unmarked ($30, £18).

THE GLENTURRET DISTILLERY

Wade Ceramics Limited was commissioned by Glenturret Distillery to produce a limited number of 1,500 pieces of the distillery mouse catcher. The cat named Towser lived in the still house for nearly 24 years and caught 28,899 mice during her career. This record was listed in the Guinness Book of Records as a World Mousing Champion.

Towser measures 4-1/4" high and is marked: Exclusively Designed for Glenturret Distillery, Grieff, Scotland Wade ($35, £24).

TAUNTON CIDER PLC

Starting in 1974, Wade produced limited edition cider mugs for Taunton Cider PLC of Somerset. These mugs were presented by Taunton Cider as Christmas gifts to its key company contacts.

Taunton Cider has a collection of approximately 750 mugs, many of which date from the late 18th and 19th centuries. The annual Taunton Cider Christmas mugs are based on some of these designs.

Frog Mug measures 5" high by 5-1/8" diameter by 9" across the handles. The mug is marked: This frog mug is one of a limited edition of five hundred specially commissioned by Taunton Cider. It is copied from a 19th century original in the Taunton Cider Collection 1995. The base also has Mark Type 49 ($150, £85).

Frog Mug showing the location of the frog inside the mug.

229

EDDIE STOBART LTD., *1998*

In 1998 Wade Ceramics Ltd. was commissioned by Eddie Stobart Ltd., the well known U.K. haulage company, to produce a replica of one of their vehicles in the form of a money bank. This model truck was available through the Eddie Stobart Collectors Club and also through the Wade Collectors Club. This was a limited edition of 2,000 money banks.

The Stobart Haulage Truck measures 3-3/4" high by 2-1/2" wide by 10" long and is marked: Made Exclusively for Eddie Stobart Ltd by Wade Ceramics. This money bank was produced in 1998 in a limited edition of 2,000 pieces ($100, £65).

Atkinson Vintage Truck measures 4-1/2" high by 8" long by 2-3/4" wide and is marked: Made Exclusively for Eddy Stobart Ltd. by Wade Ceramics. This vintage truck was produced in a limited edition of 2,000 pieces and released in June/July 1998 ($78, £52).

CAPTAIN MORGAN *circa 1961*
7-3/4" long by 4-1/4" wide by 2-1/8" high with Mark Type 43 on the base ($75, £45). This boat shaped ashtray was produced as an advertising item circa 1961. "Captain Morgan" is a registered trade mark of Seagram United Kingdom Ltd.

BRITISH AIRWAYS
2-1/4" high by 5-1/8" overall and is unmarked. This very hard to find miniature decanter is in the form of a Boeing 747 and was issued in very limited quantities circa early 1990s. One side of the decanter is marked: Contains 50 ml. The Balvenie Single Malt Scotch Whisky Aged 10 Years 43% Vol. ($120, £80).

JOHN BULL *circa late 1980s*
9-1/2" high and is unmarked. Only a very small number of these promotional figurines were made to advertise Ansells John Bull Bitter beer ($250, £160).

RINGTONS LIMITED TEA MERCHANTS *(Opposite page)*

Ringtons Limited Tea Merchants has long been a major supplier of tea and coffee to the UK public. Although premiums and incentives have been part of Ringtons' sales procedures for many years, it is only since the early 1980s that Wade Ceramics Limited has produced promotional items for the company.

Money Bank with Teddy Bear was a sample that never went into production (N.P.A.).

MONMOUTHSHIRE BUILDING SOCIETY
6" high and is mold marked Wade. The squirrel money bank is holding a nut that reads: Monmouthshire Building Society. This figurine was produced in 1998 in a limited edition of 2,000 pieces ($60, £35).

Ringtons Delivery Van Money Bank measures 5-1/4" high by 8" long and is marked: Manufactured Especially for Ringtons Ltd. by Wade Ceramics ($110, £65).

PUSSER'S LTD.
These 5" high atomizers are just three of a set of nine designs. **Left: Lily** has Mark Type 27B on the base ($55, £30). **Center: Jasmine** is marked: Pusser's Ltd. Tortola, British Virgin Islands, Finest English Porcelain ($55, £30). **Right: Bougainvillea** has Mark Type 27B on the base ($55, £30).

RIDGWAYS OF LONDON
1" by 1-1/2" and is unmarked. This mini teapot key ring was used as a promotional item for Ridgways Tea ($45, £35). The mini teapots produced for Wade Watch Ltd. of Colorado, were produced from the same mold as the Ridgways mini teapot.

PETER ENGLAND ASHTRAY 1977 - 1978
7-1/4" wide by 7-1/4" across and has Mark Type 46 on the base. This ashtray was produced in a limited quantity of less than 1,000 pieces for Peter England Shirts of Wakefield, England ($90, £50).

Chapter 17
FIGURAL PIGGY MONEY BANKS, MISCELLANEOUS POSY BOWLS AND DISHES

circa late 1950s – 1994

"PIGGY" MONEY BANKS, *late 1950s - early 1960s*

In the late 1950s, Wade Heath & Co. Ltd. introduced a series of money banks in the form of pigs, generally known as "piggy banks." These money banks measure 5" high by 6-1/2" long and have Mark Type 19 on the underside of the belly. A variety of decorations were used, often employing similar decals as those used on the Harmony and Flair tableware made by Wade Heath in the 1950s. Additional decorations are illustrated in the black and white drawings.

Piggy Bank with unknown decoration ($120, £75).

A. decoration No. 6261 "Roses" on a yellow glaze. A similar style, decoration No. 6263 had "Violets" on a white glaze. **B.** decoration No. 6269 "Parasols" on a yellow glaze. **C.** decoration No. 6264 a solid black glaze with red eyes, nose and inside of ears. **D.** decoration No. 6262 "Stars" on a white glaze. **E.** decoration No. 6281 "Safeway" multi-colored on a white glaze. The reverse side of this piggy bank shows foot prints with the words "Watch your step, " a traffic light and a puppy sitting at the curb with the words "Paws at the kerb." ($120 each, £75 each).

Left:
BENGO MONEY BANK *circa mid 1960s*
6" high and is unmarked. This money bank was based on the character Bengo from the TV Pets series ($495, £280).

Right:
DOG KENNEL MONEY BANK *1987*
4-1/2" high by 5-1/4" long and is unmarked. This money bank was made by George Wade & Son Ltd. in 1987 ($45, £28). The design of this money bank was based on the earlier Walt Disney money banks of the 1960s.

SQUIRREL MONEY BANK *1998*
6" high and is mold marked: Wade. This money bank is from the same mold as that used for the Monmouthshire Building Society money bank ($38, £25).

FAWN MONEY BANKS *1960s - 1987*
Left: "Blow Up" Disney Bambi measures 4-1/2" high and is marked: Wade Porcelain ©Walt Disney Productions Made in England. This is not a money bank but is shown for comparison to the Fawn money banks ($200, £125). **Center: Bambi Money Bank** measures 4-3/4" high by 4-1/2" long and is marked: Made in England. This money bank was produced in the 1960s ($105, £60). **Right: Fawn Money Bank** measures 5-1/4" high by 5" long and has Mark Type 19 on the base. This money bank was produced in 1987 ($48, £30).

ANIMAL MONEY BANKS, *1994*

A set of four single glaze money banks representative of various farmyard animals. Each money bank is mold marked: WADE ENGLAND on the base.

TOADSTOOL MONEY BANK *1987*
5-1/2" high by 6" wide and is unmarked. This money bank was made by George Wade & Son Ltd. in 1987 ($68, £42). The design of this money bank was based on the earlier, 1950s Noddy money bank. The original molds were not reused for the 1987 money bank.

1. Pig money bank measures 4-1/2" high ($24, £16). **2. Frog** money bank measures 5" high ($30, £18). **3. Rabbit** money bank measures 6-3/4" high ($24, £16). **4. Cow** money bank measures 6" high ($24, £16).

TEDDY BEAR MONEY BANK *mid 1990s*
6-1/8" high and has Mark Type 27B on the base. This is a similar mold to the Marks & Spencers Edward Bear money bank ($24, £16).

PINK BEAR MONEY BANK *1999*
6-3/8" high and is marked: Wade. This money bank was sold at the 1998 Wade Fair at Ripley ($30, £20).

TIGER MONEY BANK *1997*
3-5/8" high by 7-1/4" long and has Mark Type 27A. The tiger money bank was made as a pre-production run for an order that was never realized. Of the 100 pieces produced, 75 were sold at the November 1997 Wade Extravaganza at Trentham Gardens and 25 money banks were sold at the Buffalo Jim Beam/Wade Fair in 1998 ($475, £270).

BLUE BEAR MONEY BANK *1999*
6-3/8" high and is marked: Wade. This money bank was sold at the 1998 Wade Fair at Ripley ($30, £20).

NOEL THE MONEY BANK BEAR *1997*
6-1/8" high and is marked: Christmas Teddy Wade Extravaganza Special 1997. This money bank was the November 1997 Wade Extravaganza special in a limited edition of 1,500 pieces ($24, £16).

SCOTTIE DOG MONEY BANK *1999*
Left: White Scottie Dog measures 6-1/4" high and is mold marked Wade ($36, £24). **Right: Black Scottie Dog** measures 6-1/4" high and is mold marked Wade ($36, £24). These money banks were sold at the Factory Shop, and were also included in the 1999 Goodie Boxes.

CAT MONEY BANK *1999*
6-1/2" high and is mold marked Wade ($36, £24). This money bank was sold at the Factory Shop, and was also included in the 1999 Goodie Boxes.

BRITANNIA MONEY BANK
5-1/4" high by 6-3/4" overall and is transfer marked Wade ($35, £24).

PIGGY MONEY BANKS *late 1990s*
Top: 1. Pink Piggy Money Bank measures 4-1/4" high and is marked Wade ($25, £18).
Bottom: 2. Blue Piggy Money Bank measures 4-1/4" high and is marked Wade ($25, £18). **3. White Piggy Money Bank** measures 4-1/4" high and is marked Wade ($25, £18). The piggy banks were issued at the 1997 Wade Extravaganza. Piggy banks with decorations other than illustrated exist.

Fried Green Tomatoes Money Bank measures 5-1/4" high by 6" in dia. and has Mark Type 27B on the base. This money bank was issued in 1992 in a limited number to coincide with the opening of the movie of the same name distributed by Rank Film Distribution in the U.K. ($210, £135).

CHINTZ PIGGY MONEY BANK *2000*
4-1/4" high and is marked Wade. This "one-of-a-kind" piggy money bank was given as a draw prize at the 2000 West Coast Wade Collectors Fair (N.P.A.).

Christmas Vintage Van Money Bank measures 5-1/4" high by 8" long and has Mark Type 27B. This money bank was sold at the Wade Store and at the 1998 Buffalo, New York, Jim Beam/Wade Fair ($100, £68).

MISCELLANEOUS POSY BOWLS AND DISHES, 1930s - 1960s

BUNNY NIGHT LIGHT *late 1930s*
This two part "Bunny" night light measures 4-1/2" high by 5-1/2" long and has Mark Type 5 on the base ($110, £65).

BUNNY ASHTRAY *circa late 1940s*
4" wide by 4-1/4" long and is marked: Wade Made in England. This "S" shaped ashtray is found with a variety of Wade figurines used as a decoration ($80, £50).

INDIAN HEAD DISH *1954*
3-3/8" diameter and is mold marked Wade England. This novelty item was decorated in a variety of glazes ($130, £70).

POSY BOWL WITH ANIMALS AND BIRDS, *circa 1940s early 1950s*

A number of animal figurines produced at the George Wade & Son Ltd. Pottery in the 1930s but not marketed, were put into storage during the war years. At the end of the war, these figurines were taken over by Wade Heath. By attaching the figurines to a base, along with an open mustard bowl from either the "Bramble" or early "Basket Ware decoration No. U. 4804" lines of tableware, "posy bowls" were created. These posy bowls were often decorated with small porcelain flowers around the rim. The "animal/mustard bowl" composites were all marked with Mark Type 10 in brown or green ink.

1. Drake Posy Bowl measures 2-1/4" high by 3-5/8 overall ($130, £85).

2. Drake Posy Bowl measures 2-1/4" high by 3-5/8" overall ($130, £85).

3. Duck Posy Bowl measures 3-1/4" high by 4" long ($130, £85).

4. Begging Dog Posy Bowl measures 3-1/4" high by 4" long ($145, £90).

5. Dachshund Posy Bowl measures 3-1/2" high by 3-1/2" long ($145, £90).

9. Kissing Bunnies Posy Bowl measures 2-3/4" high by 4" overall ($130, £85).

6. Doleful Dan Posy Bowl measures 4" high by 4" overall ($155, £100).

10. Mallard Posy Bowl measures 3-1/3" high by 4" long ($130, £85).

7. Rooster Posy Bowl measures 3-3/4" high by 4-1/4" long ($145, £90).

SWAN EGG CUP *circa mid 1950s*
Both egg cups measure 2-1/4" high by 3-1/2" long and are mold marked "Made in England." The egg cups have also been reported with a yellow glaze ($50 each, £35 each).

8. Squirrel Posy Bowl measures 2-3/4" high by 3-1/2" overall ($145, £85).

LOG POSY BOWL WITH SQUIRREL *1954 - 1959*
1-1/4" high by 4-3/4" long by 1-1/2" wide and is mold marked "Wade England" on the underside of the base. This posy bowl is found with either green or beige glazes and can also be found with a rabbit decoration ($20, £14).

237

"C" SHAPED LOG POSY BOWL WITH RABBIT *1954 - 1959*
1-1/4" high by 6" across and is mold marked "Wade England" on the underside of the base. This posy bowl is found with either green or beige glazes and can also be found with a squirrel decoration ($20, £14).

"S" SHAPED LOG POSY BOWL WITH RABBIT *1954 - 1959*
1-1/4" high by 6-1/2" overall and is mold marked "Wade England" on the underside of the base. This posy bowl is found with either green or beige glazes and can also be found with a squirrel decoration ($20, £14).

RABBIT BUTTERDISH and SQUIRREL BUTTERDISH *1955 - 1959*
Left: Rabbit Butterdish measures 2-1/4" high to the top of the rabbit by 3-1/4" dia. and is mold marked "Wade England" on the underside of the base ($30, £20). **Right: Squirrel Butterdish** measures 2-1/4" high to the top of the squirrel by 3-1/4" dia. and is mold marked "Wade England" on the underside of the base ($30, £20).

KOALA BEAR BUTTER DISH *1955 - 1959*
2-1/4" high to the top of the bear by 3-1/4" dia. and is mold marked "Wade England" on the underside of the base ($30, £20).

DOG DISHES, *circa 1957*

A set of colored dishes mounted with either a Spaniel or Terrier dogs. The dish measures 3-1/4" deep by 4" overall by 3" at its widest point. The dishes can be found in various glazes.

Left: Spaniel Dog Dish measures 1-5/8" high and has Mark Type 26 on the base ($48, £28). **Right: Terrier Dog Dish** measures 2" high and has Mark Type 26 on the base ($48, £28).

BLUE BIRD TREE TRUNK VASE *1957 - 1959*
This posy vase measures 4" from base to the top of the bluebird's wing by 2-1/4" dia. The vase has Mark Type 25 on the base. **Left: Green Vase** ($48, £28). **Center: White Vase** ($48, £28). **Right: Brown Vase** ($48, £28).

Left: Chimpanzee Tree Trunk Vase measures 3-1/8" high at the chimp by 3-5/8" overall. The vase has Mark Type 25 on the underside of the base and was issued between 1959 and 1960 ($48, £28). **Right: Koala Bear Tree Trunk Vase** measures 2-1/4" high to the top of the bear's head by 3-1/4" overall. The vase has Mark Type 25 in a recess in the base and was issued between 1957 and 1959 ($48, £28).

FAWN DISH *circa mid 1960s*
4-1/2" from back to front by 4" across by 2-1/4" high at the fawn. The mold mark "Wade Porcelain Made in England" appears on the underside of the base ($40, £26).

BLUE BIRD DISH *1958 - 1959*
5-3/4" long by 2-3/8" wide by 1-1/2" high and is mold marked: Wade Porcelain Made in England. This dish is decorated with a similar blue bird figurine as that used for the Tree Trunk Posy Vase ($28, £18).

CHERUB BOWL *1957 - 1959*
3-3/4" high with the bowl measuring 2" high by 4" in dia. at the rim. The posy bowl is mold marked with Mark Type 25 ($140, £95).

ASCOT BOWL *late 1950s*
1. Ascot Bowl measures 2-1/4" high by 3-1/4" in dia. and has Mark Type 25 ($90, £50).

2. Ascot Bowl. Color variation ($90, £50). The ascot posy bowl was designed by Paul Zalman circa 1957.

PEGASUS POSY BOWL *1958 - 1959*
4-3/8" high by 5-5/8" overall by 2-1/4" wide at its widest point. The bowl is mold marked with Mark Type 24 on the underside of the curved arch ($150, £85).

MERMAID POSY BOWLS *1955 - 1959*
Left: Small Mermaid Posy Bowl measures 2-1/2" high by 4" overall and is mold marked Wade England ($38, £22). This bowl was modeled by William Harper. **Center: Mermaid Bowl** measures 6" high by 11" overall and is unmarked ($175, £100). This bowl, modeled by William Harper never went in to production. **Right: Large Mermaid Posy Bowl** measures 3-1/4" high by 5-7/8" overall and is mold marked Wade England ($48, £30).

BUDDIES BUD VASE, *circa 1960*

The bud vases named Clarence and Clara were produced in the early 1960s and sold individually boxed.

Left: Clara measures 4-1/2" high and has Mark Type 19 on the base ($35, £20). **Right: Clarence** measures 4-1/2" high and has Mark Type 19 on the base ($35, £20).

Miscellaneous Prototypes by William Harper *mid 1950s*
1. **Pineapple Bowl** measures 4-1/2" by 3" and is unmarked.
2. **Tree Stump Lidded Box** measures 2" high by 3" in dia. and is unmarked. 3. **Lizard Ashtray** measures 3-1/2" high by 5" and is unmarked. 4. **Rose Box** measures 3" high by 4" across and is unmarked.

Covered Shore Crab Dish measures 3-3/4" wide by 3/4" high and is mold marked: Wade Porcelain Made in England ($50, £32). This dish, in the shape of a "Shore Crab," has a removable lid giving the dish various uses as a container for small items. This dish was produced in 1960 from a mold designed by William Harper.

5. **Austin Mini Ashtray** measures 1-3/4" high by 4-3/4" long.
6. **Scent Holder** measures 3-3/4" high. 7. **Pirate Head** measures approx. 4-1/4" high. 8. **Silhouette Viking Ship Tray** measures 4-3/4" long by 3-3/8" long. 9. **Queen of Spades Ashtray** measures 4" wide by 4-1/4" long. 10. **Jack of Diamond Ashtray** measures 4" wide by 4-3/4" long.

Covered Hedgehog Dish measures 4" overall by 2-3/8" wide by 2-1/4" high and is mold marked: Wade Porcelain Made in England ($65, £42). This dish has a removable lid formed by the back of the hedgehog, leaving a shallow dish with the head still attached. This dish was produced in 1961 from designs by William Haper.

Porsche Prototypes measure 1/2" high by 2-1/2" long and are unmarked. These cars were modeled in the early 1960s.

SEAGULL BOAT DISH *1961*
2-1/4" high to top of gull wing by 6" from bow to stern and has Mark Type 25 on the underside of the boat ($110, £70).

240

MAN IN A BOAT 1978 - 1984

There are two variations of this gift ware item both based on the earlier mold of the boat with a seagull decoration. In the earlier model the projection at the bow on which the sea gull perched remains. The later mold has this projection removed and has a differently designed reclining man. Both models measures 6" from bow to stern by 1-5/8" high at the bow and have Mark Type 25 on the base.

Left: Man in a Boat first issue with "seagull ledge" remaining ($115, £75). **Right: Man in a Boat** second issue with ledge removed ($95, £65).

BOULDRAY AND PEERAGE TRAYS, circa late 1960s - early 1970s

The Bouldray and Peerage trays were a reserved line supplied to clients by Wade as a special contract. Wade supplied only the porcelain tray with the client adding the additional metal portion of the decoration. Wade utilized the 1958 - 1965 Whimtray as the base for the metal decorations.

1. Elf Bouldray Tray measures 2-3/4" high. The tray is similar to Whimtray shape Type "A" and is mold marked: "Bouldray" Wade Porcelain 2 Made in England ($35, £20). **2. Bluebird Bouldray Tray** measures 3" high. The tray is similar to Whimtray shape Type "A" and is mold marked: "Bouldray" Wade Porcelain 2 Made in England ($35, £20).

WAGON TRAIN DISHES, 1960

Due to the popularity of the T.V. series "Wagon Train" in the 1960s, Wade produced two dishes using the two major characters from the series as decorations. The two characters were Seth Adams, portrayed by actor Ward Bond, and Flint McCullough, portrayed by Robert Horton. The dishes have an impressed mark on the base: Wade Porcelain made in England ©1960 by Review Studios. Both dishes measure 5-1/2" long by 5" wide.

Left: Wagon Train Flint McCullough ($100, £60). **Right: Wagon Train Seth Adams** ($100, £60).

3. Pekingese Peerage Tay measures 2-1/2" high. The tray is similar to Whimtray shape Type "B" and is mold marked: "Peerage" Wade Porcelain Made in England ($35, £20). Numerous other designs are to be found in both the Bouldray and Peerage trays.

LESNEY TRAYS, circa 1968 - 1975

These trays were a special reserve line manufactured by Wade for Lesney Industries Ltd., then the producers of the famous "Matchbox" toy cars, etc. A number of different size ceramic trays were produced on which some of the most expensive miniature veteran cars were mounted.

1. Santa Fe measures 2-1/2" high on a 6" by 3-1/2" base and is mold marked: An RK Product by Wade of England ($45, £30).

2. Lipton's Tea measures 2-3/4" high on a 6" by 3-1/2" base and is marked: An RK Product by Wade of England ($45, £30).
3. Player's Please Double Decker Bus measures 2-1/4" high on a 6" by 3-1/2" base and is mold marked: An RK Product by Wade of England ($45, £30).

4. Pike Tray measures 6" high by 3-1/2" long and is mold marked: An RK Product by Wade of England. The metal pike decoration is found in either green or white colors ($50, £30).

5. Goldfish Tray measures 2-1/4" high by 6" across and is marked: An RK Product by Wade of England ($40, £26).

6. Sports Car Tray measures 2-1/4" high on a 4-3/4" by 4-1/8" base and is marked: Lesney Made in England ($26, £18).

SOUVENIR DISHES, circa 1957

Wade reused the ceramic base from the Spaniel and Terrier dishes to be used as souvenirs with historical buildings mounted as decorations. Wade did not supply the metal decorations.

1. Houses of Parliament souvenir dish ($48, £20).

Top: 2. Tower Bridge souvenir dish ($48, £20). **3. Tower Bridge** souvenir dish ($48, £20).
Bottom: 4. Buckingham Palace souvenir dish ($48, £20).

242

5. Scottish Piper ($48, £20). 6. City of London ($48, £20).

7. Mermaid dish ($48, £20). Only the porcelain base of these souvenir dishes was made by Wade.

VIKING SHIP POSY VASE
Top: Viking Ship Posy Vase measures 3-1/2" high by 7-3/8" overall and is mold marked Wade Porcelain Made in England. This posy vase was issued between 1959 and 1965 ($26, £18).
Bottom: Viking Ship Posy Vase measures 3-1/2" high by 7-3/8" overall and is mold marked Wade Porcelain Made in England ($32, £22). This second version of the Viking Ship posy vase was made between 1976 and 1982.

BARGE POSY BOWL
Top: Barge Posy Bowl measures 2-1/2" at the highest point and 1-1/4" high at the bowl portion by 8" long and was produced in 1954. The recessed base has the mold mark "Wade England" and below that Reg. in GT. BRITAIN No. 871886 ($30, £20). **Bottom: Barge Posy Bowl** measures 2-1/2" at the highest point and 1-1/4" high at the bowl portion by 8" long and was produced in 1954. The recessed base has the mold mark "Wade England" and below that Reg. in GT. BRITAIN No. 871886 ($30, £20).

Barge Posy Bowl measures 1-5/8" high by 7-3/4" long and is mold marked Wade England. This second version of the barge posy bowl was produced in the early 1970s ($32, £22).

GUARDSMAN BRUSH HANDLE *mid 1970s*
3" high by 2-5/8" long and is mold marked: Registered No. 869473 Made in England ($30, £20). This brush handle is to be found with either blue or green glazes.

BOTTLE POURERS, *circa 1950s - 1980s*

Bottle pourers, either purely ornamental or used as advertising items, were produced by George Wade & Son Ltd. A small number were marked with a Wade Regicor transfer type mark, but most were either unmarked or had only the reserved line number impressed in the base.

1 2 3 4

1. Beefeater pourer measures 3" long and is marked: Wade Regicor Made in England ($40, £26). **2. Songbird** pourer measures 5" long and is unmarked ($90, £60). **3. Eagle** pourer measures 5-1/2" long and is unmarked ($90, £60). **4. White Horse** pourer measures 5" long, is unmarked and was produced circa 1954 ($30, £20).

5 6

5. Blue Horse pourer measures 2" wide by 4" long and is unmarked ($30, £20).

6. Bushbaby pourer measures 5" long and is unmarked ($90, £60). Other figural bottle pourers included a Trout.

MUGS, TANKARDS AND TOBY JUGS.

ROLL OUT THE BARREL TANKARD SOLDIER *1940*
6" high and has Mark Type 7 on the base. This tankard was first introduced in 1940 ($100, £55).

ROOSEVELT AND CHURCHILL TANKARD *circa 1942*
5-1/2" high by 7-1/2" across and has Mark Type 7 on the base. This tankard introduced circa 1942, has the wording "Let's Drink to Victory, Let's Drink to Peace" molded on the side of the tankard ($150, £85).

ROLL OUT THE BARREL TANKARD WINSTON CHURCHILL
1940
5-3/4" high and has Mark Type 7 on the base. This tankard was first introduced in 1940 ($100, £55).

Color variation of the Winston Churchill tankard ($150, £80).

BUNNY MUGS, *1996*

These mugs were a general line sold at the Wade Factory Shop and at the various fairs in the U.K. and the U.S.A. The mugs measures 4-1/4" high and are marked: Genuine Wade on the base. The one-of-a-kind bunny mugs were given away at the Seattle Jim Beam/Wade Fair as gifts.

Left: One-of-a-kind. Center: Production Model ($18, £6). Right: One-of-a-kind.

Left: One-of-a-kind. Right: One-of-a-kind.

McCALLUM JUGS, *circa 1950s*

These character jugs, which were produced in three sizes, were both hand-painted in multicolored versions with Mark Type 16 on the base or in the single all over amber glaze with Mark Type 14 on the base. The jugs were produced for D & J McCallum.

4. McCallum Jug measures 7" high ($150, £70).

1. McCallum Jug measures 2-1/4" high ($75, £45). **2. McCallum Jug** measures 4-1/2" high ($80, £50). **3. McCallum Jug** measures 7" high ($95, £60).

TOBY JIM JUG *circa mid 1960s*
4-3/8" high and has Mark Type 43A on the base ($130, £85). The design of this toby jug was based on the British comedian, Jimmy Edwards.

245

WADE HEATH CHARACTER JUGS, *late 1950s*

Records indicate that these character jugs had only a limited production run. Less than 750 pieces for the Pirate jug and 1,000 pieces for the Highwayman jug were produced. A small number of the Pirate jug and Highwayman jug were issued in an all-over copper lustre glaze. Samples of a third character jug in the form of a North American Indian were produced, but records indicate that it never went into production.

Copper Lustre Highwayman Character Jug ($160, £95).

Pirate Character Jug measures 6" high and has Mark Type 19A on the base ($245, £140).

SEAMAN MINI TOBY MUG *circa late 1940s - early 1950s* 2-7/8" high and has Mark Type 10 on the base ($45, £30).

FISHERMAN MINI TOBY MUG *circa late 1940s - early 1950s* 2-7/8" high and has Mark Type 10 on the base ($45, £30).

Highwayman Character Jug measures 6" high and has Mark Type 19A but with the word Highwayman substituted for Pirate ($245, £140).

HIGHWAYMAN MINI TOBY MUG *circa late 1940s - early 1950s* 3" high and has Mark Type 10 on the base ($45, £30).

Christmas Pins measure 2" in diameter. **Top: 1. Santa at the Chimney** ($5, £3). **2. Snowman Saluting** ($5, £3). **Bottom: 3. Snowman Smiling** ($5, £3). **4. Santa Walking** ($5, £3).

Christmas Pins measure 2" in diameter. **Top: 1. Santa with Sack of Presents** ($5, £3). **2. Santa Skating** ($5, £3). **Bottom: 3. Snowman** ($5, £3). **4. Holly and Bell Tree Decoration** measures 1-1/4" in diameter ($5, £3).

EGG DISHES

These decorated egg shaped porcelain boxes are believed to have been sold on the TV Shopping Channel. Each egg has Mark Type 27B on the base ($40 each, £25 each).

CHRISTMAS PINS AND KEY CHAIN, 1997

At the 1997 Wade Christmas Extravaganza a number of Christmas decorations, pins, and key chains were offered for sale. The decals were simply added to stock ceramic discs used mainly for industrial purposes. All items are transfer marked Wade Made in England.

1. Santa Key Chain measures 1-3/8" in diameter ($6, £4).

Right:
Christmas Tree Decorations measure 1-1/2" long ($5 each, £3 each).

FISH PLAQUES, *2001*

Some years ago Wade produced a series of ceramic fish plaques as a special order. The original intended use for these plaques was to be "tile stick ons" for the bathroom. A number of these plaques were discovered in storage by Wade, who subsequently sold them off in 2001.

Left: Fish measures 2-3/4" long by 2" wide and is unmarked ($8, £5). **Right: Starfish** measures 2-3/4" across and is unmarked ($8, £5).

FISH DECANTERS, *mid 1980s*

A small number of large fish decanters was produced by Wade in the form of a leaping fish. These decanters were produced as a proposed line for a potential client. Although a number of decanters were produced they never went into full production.

Salmon Decanter measures 10-1/2" high and is unmarked ($260, £150).

Trout Decanter measures 10-1/2" high and is unmarked ($260, £150).

BIBLIOGRAPHY

Books & Periodicals

Baker, Donna. *Wade Miniatures*. Atglen, Pennsylvania: Schiffer Publishing Ltd., 2000
Carryer, H. Straker. Personal communication.
Carryer, Iris Lenora. Personal communication.
Carryer, Iris Lenora. *"Searching for the Pony."* Privately published
Collect it! Finchampstead, Berkshire, UK: Collect it Ltd. May 2000 Issue.
Collect it! Finchampstead, Berkshire, UK: Collect it Ltd. March 2001 Issue.
Lee, Dave. *The Wade Dynasty*. Woking, Surrey, UK: The Kudos Partnership Limited, 1996.
Murray, Pat. *Wade Whimsical Collectables Fifth Edition*. Toronto, Ontario: The Charlton Press, 2000
The Wade Watch. Arvada, Colorado: Wade Watch Ltd. Various Issues.
The Official Wade Club Magazine. Burslem, Stoke-on-Trent, UK: Wade Ceramics Limited. Various Issues.
Wade's World. Burslem, Stoke-on-Trent, UK: Wade Ceramics Limited. Various Issues.
Warner, Ian and Posgay, Mike. *The World of Wade*. Marietta, Ohio: The Glass Press, Inc., dba Antique Publications. 1988.
Warner, Ian and Posgay, Mike. *The World of Wade Book 2*. Marietta, Ohio: The Glass Press, Inc., dba Antique Publications. 1994.
Warner, Ian and Posgay, Mike. *Wade Price Trends First Edition*. Marietta, Ohio: The Glass Press, Inc., dba Antique Publications. 1996.

Resource Centers

The Rakow Library, Corning Museum of Glass, Corning, New York, USA.
Toronto Reference Library, Toronto, Ontario, Canada.
The New York Public Library, Science and Technology Division, New York, New York, USA.
Ohio State University, Columbus, Ohio, USA.
The British Library, Newspaper Library, London, England.
The Patent Office, Public Record Office, Richmond, England.

Websites

http://www.wade.co.uk
http://www.cscollectables.co.uk
http://www.wadewatch.com
http://www.wadeusa.com
http://www.redrosetea.com
http://www.kswader.com

Index

A

Abbots Choice Decanters, 220
Absolutely Crackers, 138
Airedale (1930s), 43
Alfred, 212, 213
Alice in Wonderland, 162
Alphabet Train, 65
Alsatian (1930s), 43, 51
Amelia Bear, 157
American Eagle, 188
Andy Capp, 142, 175, 176
Andy Capp with Cigarette, 176
Andy Pandy, 204
Angel Figurines, 69
Angel Candle holder, 69
Angel Trays, 69
Animal Blow Ups, 74
Animal Collection, 197
Animal Figures, 44, 45, 46, 121,
AnimaLand, 186
Annabel Waiting for Christmas, 157
AquaLand, 188
Aquarium Set, 219
Archimedes, 85
Arthur Hare, 171
Arthur Hare Miniature Series, 172, 173
Arthur Hare Teenies, 173
Arthur Hare Whimsie, 174
Arthur Price, 218, 219
Arundel Bunny, 182
Arundel Cat, 182, 183
Arundel Chick, 182
Arundel Duck, 182
Arundel Pony, 183
Arundel Puppy, 183
Arundel Salmon, 188
Arundel Town Mouse, 188
Ascot Bowl, 239
Asprey & Co. Decanter, 216
Autumn Train, 203

B

Baby Bear, 56, 59, 153
Baby Bear in Pajamas, 161
Baby Panda, 56
Baby Straw, 203
Badger, 165
Baker, 60
Bally-Whim Village Set, 121
Bambi, 84

Bard of Armagh, 119
Bamm Bamm, 196
Barge Posy Bowl, 243
Bat Girl, 213
Batman, 212, 213
Barney, 196
Batman Boxed Set, 213
Batmobile, The, 213
Bear Ambitions, 141
Bear Ambitions (green), 142
Bears Just Want to have Fun, 159
Beatles Plaques, 69
Beggar man, 60
Begging Dogs, 56
Bengo, 68
Bengo Money Bank, 233
Bernie and Poo, 63
Bertie Badger, 225
Bertram Badger, 205
Betty, 196
Betty Boop Series, 176-181
Big Bad Wolf, 152, 202
Big Ears (1958-1960), 65
Big Ears (1998), 197
Bill and Ben and Little Weed, 204
Billy Bunter, 190
Bird Vases, 53
Bisto Kids, 218
BJ Promotions, 193
Blue Bird Dish, 239
Blue Birds, 47
Blue Bird Tree Trunk Vase, 238
Blynken, 59
Blyth Ceramics, 199
Boo Boo, 201
Boots Teddy Bears, 225
Boots the Rabbit, 147
Boots Van Money Bank, 225
Born to be a Big Brother, 149
Born to be a Daydreamer, 149
Born to be Cool, 149
Born to be Friends, 149
Born to be Loved, 149
Born to be Sleepy, 149
Bottle Pourers, 244
Bouldray Trays, 241
Brew Gaffer and Sydney series, 226
Bride and Groom, 228
Bridge, 219
Brighton Pavilion, 225
Britannia, 199
British Airways, 230

British Character Set, 66
British Lion, 197
Brown Bear (1930s), 45
Brown Bear Decanter, 221
Bruno Jnr., 68
Brutus, 200
Buddies Vases, 239
Budgerigar, 48
Budgerigar with Flowers, 48
Bulldog (1930s), 43
Bulldog (Walt Disney), 74
Bunnies, 56
Bunny Ashtray, 236
Bunny Night Light, 236
Burglar, 194
Burslem the Factory Cat, 151
Butcher, 60

C

Camel (1930s), 47
Camelot Series, 143
Camping Bear, 158
Camtrak, 210
Candlestick Maker, 60
Canterbury Tales, 67
Captain Morgan Ashtray, 230
Capuchin (1930s), 46
Cartoon Characters, 67, 183
Cat Dish, 77
Cat Family, 76
Cat and Fiddle (2000), 200
Catkins Series, 198, 199
Cat Woman, 213
Chamois Kid (1930s), 46
Championship Dogs, 78
Charlie Brown and Linus, 184
Charringtons Beer Toby Mugs, 216
Chee Chee, 68
Cheerful Charlie, 56
Cheeky Duckling, 52
Cherub Bowl, 239
Cheshire Cat, 162
Chicks, 55
Children of the World, 202
Child Studies, 72
Christmas Pins and Key Chain, 247
Christmas Puppy, 152, 153
Christmas Santa, 164
Christmas Tree Ornaments, 247
Christmas Vintage Van Money Bank, 235
Chuckles the Clown, 157

Cinderella, 167
Cinderella Ready for the Ball, 167
Clara, 65, 239
Clarence, 168, 239
Clorinda, 167
Cockatoos (1930s), 48
Collectania, 214
Collecteenie, 214
Collectus, 214
Collect it! Bear Cub, 214
Collect '99 Teddy, 213
Collector, The, 205
Comic Animal Figures, 147
Comic Irish Pigs, 117
Connoisseur's Collection, 81, 82, 83
Coronation Street Figurines, 224
Cotswold Collectables, 193
Covered Hedgehog Dish, 240
Covered Shore Crab Dish, 240
Crouching Monkey, 58
Crouching Rabbit, 53
Crunchie the Foal, 166
Curling Stone Decanter, 221

D

Dachshund, 52
Dan Murphy, 120
Danny Boy, 117, 118
Daddy Bear, 153
Dartmoor Pony (1930s), 45
Debenham's Dog Rex, 228
Dennis the Menace, 193
Dinosaur Set 1 (1993), 141
Dinosaur Set 2 (2001), 141
Disney Blow-Ups, 86, 87
Disney Hat Box, 83, 84, 85
"Disneys" (1981-1987), 85
Disney Money Banks, 87
Disney Reissues, 86
Diver, 219
Dixie, 201
DMG Collectable Car, 215
Dog Decanter, 219
Dog Dishes, 238
Dog Family, 76
Dogs & Puppies Series, 76, 77
Dog Kennel Money Bank, 233
Dog Pipe Rests, 78
Doleful Dan, 56
Dolphins, 188
Donald Duck (1937), 41
Donk-E, 187
Donkey & Cart Posy Bowl, 115
Dora, 65
Dormouse, 162
Double Budgerigars, 48
Double Bunnies, 56
Dougal, 210
Dougie Mac, 159
Dracula, 155

Dribbles the Dog, 147
Droopy Jnr., 68
Drum Box Series, 65
Duck Family, 55
Dumbo, 84
Dustbin Cat, 63
Dwarf Salt & Pepper Shakers, 41

E

Easter Bunny, 218
Edward Fox, 172
Eileen Oge, 117, 118, 120
Elephant Family, 76
Elephant Train, 63
Elephant with trunk down, 55
Elephant with trunk up, 55
Ella, 164
Egg Dishes, 247
Emily, 157
English Setter, 56
Ermine (1930s), 46
Exotic Fish Wall Plaques, 68

F

Fairy Godmother, 167
Fantasia, 84
FantasyLand, 187
Fat Controller (1985-87), 72
Fat Controller (2002), 185
Father Christmas, 212
Fawn Dish, 238
Fawn Money Banks, 233
Felicity Squirrel, 172
Felix the Cat, 197
Fifi, 68
Fire Cracker Pig, 131
Fireside Friend, 151
Fish Decanters, 248. 249
Fish Plaques, 247
Fish Porter, 66
Fish Waiter, 143
Fizzy the Fawn, 163
Flicka, 49
Flintstones, The, 196
Flo, 142, 176
Flo with Cigarette, 176
Flowers Brewmaster, 217
Flying Birds, 115
Fox and the Hound, 85
Fred, 196
Fred at your Service, 204
Fred's Christmas Surprise, 204
Fred's Tasting Time, 204
Friar Tuck, 189
Fried Green Tomatoes Money Bank, 235
Frog Family, 75
Frog Mug, 229
Frost-E, 187

G

Garfield, 183
Gengar, 148
Gentleman Rabbit, 205
G&G Collectables, 201
Ghost of Judy, 194
Giant Panda (1939), 51
Gingerbread Children, 215
Gingerbread Man, 215
Gingy, 64
Giraffe (1930s), 46
Giraffe Family, 75
Gnasher, 193
Goldilocks, 59, 153
Goldfinches, 48
Goosey Gander (1999), 200
Granada Television Promotions, 224
Grebe (1930s), 49
Gretel, 64
Grey Haired Rabbit, 152
Guardsman Brush Handle, 243
Guinness Promotional Figurines, 218

H

Hamms Bear Series, 195, 196
Hansel, 64
Happy Families Series, 74, 75, 76
Harpy, 65
Harrods Doorman, 227
Hattie the Squirrel, 147
Hector, 168
Henry, 164
Heron, 47
Highwayman Character Jug, 246
Hippo Family, 75
Hippopotamus (mid 1930's), 57
Holly Hedgehog, 171
Honey Bunch Bears Set 1, 144
Honey Bunch Bears Set 2, 144
Horse (1930s), 47
Horse Sets (1974-1981), 78
House of Brick. 152
House of Straw, 152
House of Wood, 152
Huckleberry Hound (1959-1969), 71
Huckleberry Hound (1998), 201
Humpty Dumpty (1998), 200
101 Dalmations, 84
Huntsman Fox, 205

I

ICI Man, 217
I'm a Wade Collector, 205
I'm On My Way, 214
Indian Head Dish, 236
In The Forest Deep Series, 205
Irish Animal Figurines, 121
Irish Character Figures (1970s-86), 117

Irish Character Figures (1990s), 118
Irish Cottages, 116, 117
Irish Donkey, 115
Irish Duck Posy Bowl, 115
Irish Emigrant, 119
Irish Song Figures (1962-86), 119, 120
Irish Song Figures (1990s), 120
I've a Bear Behind, 59

J

Jack the Ripper, 212
Jem, 65
Jigglypuff, 148
Jim Beam Figurines, 205-210
John, 169
John Bull, 230
Joker, The, 213
Jonah and the Whale, 63
Judy, 194
Jumbo Jim, 63

K

Kangaroo (1997), 155
Kathleen, 117, 118
Keenan Antiques Figurines, 190, 191
Key Kollectables, 203
Kitten on the Keys, 63
Knight Templar, 150
Koala Bear, 156
Koala Bear Butter Dish, 238
K.P.Friars, 221
KSWader Fantasy Series, 192
KSWader Figurines, 192

L

Lady and the Tramp, 83
Large Dartmoor Pony, 45
Larry & Lester, 113
Larry & Lester Bookends, 114
Laughing Rabbit, 53, 57
Lawyer, 66, 194
Leprechaun and Wheel Barow, 191
Leprechaun on a Snail, 191
Leprechaun on a Toadstool, 114
Lesney Trays, 242
Letter Box Money Bank, 224
Library Bear, 160
Lighthouse, 219
Lil' Devil, 169
Lil' Easter Time, 170
Lil' Uncle Sam, 170
Little Bo Peep (1999), 200
Little Crooked Paddy, 119
Little Horrors, 147
Little Jack Horner, 201
Little Miss Giggles, 214
Little Miss Muffet, 60, 201
Little Red Riding Hood (1999), 202

Lois Lane, 212
Long Arm of the Law, 194
Looby Loo and Teddy, 204
Lucky Leprechaun on Acorn, 112
Lucky Leprechaun on Pig, 112
Lucky Leprechaun on Rabbit, 112
Lucky Leprechaun Cobbler, 112
Lucky Leprechaun Pot of Gold, 112, 113
Lucky Leprechaun Tailor, 112, 113
Lyon's Tetley, 226, 227

M

Mabel Lucie Atwell Characters, 66
Madam Mim, 85
Madison Mouse, 155, 156
Mad Hatter, 162
Maid Marian, 189
Major, 168
Mama Bear, 59
Man in a Boat, 241
Ma Straw, 203
Mayflower, 64
McCallum Jugs, 245
Merlin as a Hare Trumps, 85
Mermaid, 187, 212, 219
Mermaid Posy Bowls, 239
Mickey Mouse, 41
Mickey Mulligan, 119
Millennium Bear, 165
Minikins Series A, 64
Minikins Series B, 64
Minikins Series C, 64
Mini Mice, 191
Mini Rabbits, 191
Mini Teapots, 215
Minnie the Minx, 193
Miscellaneous Premiums, 138
Mischief the Chimp, 170
Miss Fluffy Cat, 65
Mitzi, 68
Mole, 165
Molly Malone, 117m 118, 119
Money Banks, 232-235
Monster Munch Money Bank, 224
Morris Mole, 205
Mother MacCree, 117, 118, 120
Mouse Family, 75
Mr. Bump, 214
Mr. Freeze, 213
Mr. Happy, 214
Mr. Jinks (1959-1969), 71
Mr. Jinks (1997), 201
Mr. Magoo, 183
Mr. Plod, 65, 197
Mr. Snow, 214
Mrs. Darling, 212
Mummy Bear, 153
My Fair Ladies Set 1, 139
My Fair Ladies Set 2, 139, 140
My Fair Ladies Liquor Containers, 140

Myths & Legends, 161

N

Nativity Set, 148
Nennie, 154
New Vic Toad, 165
New York Tourist, 158
Nibbles, 169
Nod, 59
Noddy Series (1958-1960), 65
Noddy Series (1998), 197
Noddy Prototypes, 65
Novelty Animal Figures, 63
Nurseries, 61
Nursery Favourites (1972-1981), 61, 62
Nursery Favourites (1990-1991), 62
Nursery Rhyme Collection, 200
Nursery Rhyme Figurines (1949-1958), 59, 60

O

Old Man, 71
Olive Oyl, 200
Once Upon a Time Bear, 160
Oops the Bear Series, 160, 161
Open Mouthed Duckling, 53
Orinoco, 183
Oscar the Christmas Bear, 156, 157
Oswald Owl, 205
Our Little Angel, 166
Out and About, 157
Owl (1930s), 49
Owl Family, 75

P

Paddington Bear, 210
Paddington's Snowy Day, 211
Paddy Maginty, 117, 118
Paddy Reilly, 117, 118
Painted Ladies Series, 110
Panda Bear Plaque, 159
Panda Money Bank, 222
Panther (1930s), 45
Pantomime Series, 155
Parrot (1930s), 49
Pa Straw, 203
Pearly King, 66
Pearly Queen, 66
Pebbles, 196
Pedro, 168
Peerage Trays, 241
Pegasus, 187
Pegasus Posy Bowl, 239
Pekingese Dogs, 74
Pelican (1930s), 49
Penguin, The, 213
Penguin Family, 54
Pepi, 68

Percy (TV Pet), 68
Percy (1985-87), 72
Percy (2002), 185
Peter England Ashtray, 231
Peter Pan, 169, 212
Peter the Polar Bear Money Bank, 223
Pex Fairy, 111
Phil the Fluter, 117, 118, 119
Pig Family, 75
Pig Family Cruet Set, 54
Piggy Money Banks, 232
Pig Styles Range, 170
Pikachu, 148
Pink Irish Elephants, 116
Pirate, 212
Pirate Character Jug, 246
Pixie, 112, 201
Plaques and Medallions, 114
Playful Deer, 57
Playful Kittens, 57
Playful Lamb, 57
Pluto, 51
Pluto's Pup, 51
Pocket Pals, 146
Pogo, 111
Pokemon Series, 148
Poison Ivy, 213
Polar Bear (1930s), 45
Policeman, 194
Polliwhirl, 148
Polocanthus, 194
Pongo, 52
Poorman, 60
Popeye, 200
Poppa Bear, 59
Poppy, 168
Posy Bowls, 236-238
Prairie Dog, 164
Premiums and Promotions, 122, 123
Prince Charming, 167
Priscilla the Pig, 147
Prisoner, 194
Psyduck, 148
Punch and Judy Series, 194
Pup in Basket, 52
Puppy Dishes, 77
Puppy Love Collection, 164
Pusser's Ltd., 231

Q

Quacker the Duck, 166
Quack Quack Family, 55
Queen of Hearts, 162

R

Rabbit Butter Dish, 238
Rabbit Family, 54, 75

Rattie, 165
Rattie and Mole, 165
Razor Back Pig, 79
Red Rose Tea Promotions:
 Can. Prom. (1967-1973), 124
 Can. Prom. (1971-1979), 125, 126
 Can. Prom. (1981), 127
 Can. Prom. (1982-1984), 127
 Can. Prom. (1985-1986), 129
 U.S.A. Prom. (1983-1985), 128
 U.S.A. Prom. (1985-1995), 129
 U.S.A. Prom. (1990-1996), 129
 U.S.A. Prom. (1996-1998), 130
 U.S.A. Prom. (1998-2002), 130
 U.S.A. Prom. (2002), 131
Revenge, 64
Rhinocerous Ashtray, 116
Richleigh Promotions, 202
Richman, 60
Riddler, The, 213
Ridgeways of London, 231
Ringtons Delivery Van, 231
Robbie Burns, 166
Robin, 213
Robin Hood, 189
Robins, 188
Robertson's Gollies, 217
Roll Out the Barrel Mugs, 244
Roly Poly Rabbit, 166
Rose of Tralee, 117, 118
Rosie the Kitten, 162
Ruddy Duck, 71
Ruffles the Bear, 168
Rufus, 156
Rule Beartannia, 145
Rupert and the Snowman, 211
Rupert Bear, 210

S

Sailor, 60
Salada Tea Promotion, 128
Sam (Mabel Lucie Atwell), 66
Sammy the Seal, 52
San Francisco Mini Mansions, 110
Santa in a Chimney, 202
Santa Hedgehog, 205
Santa's Flight, 185
Santa's Helper, 169
Santa Maria, 64
San the Fat Slag, 199
Sarah (Mabel Lucie Atwell), 66
Scooby Doo, 201
Scottie Dog, 53, 154
Scrappy Doo, 201
Seagull Dish, 240
Seahorse, 219
Sealion Corkscrew, 70
Seattle Westie, 154
Sharps Easter Egg Promotion, 218
Shelby, 164

Sheriff of Nottingham, 189
Sherwood Forest Series, 189
Shoal of Fish, 198
Sid theSexist, 199
Sidney, 164
Signal Toothpaste Promotion, 217
Silver State Specialties, 195
Simon, 68
Skip, 169
Slow Fe, 73
Slow K, 73
Smiling Frog, 153
Smudger, 154
Snail, 219
Snippets, 64
Snoopy, 184
Snoopy Happy Holidays, 184
Snoopy Hugging Woodstock, 184
Snoopy Kennel Money Bank, 184
Snow Children, 152
Snow Man, 151, 212
Snow Man Salt & Pepper, 152
Snow Woman, 151
Snow White Brooches (1930's), 41
Snow White & the 7 Dwarfs (1938), 41
Snow White & the 7 Dwarfs, 88
Soldier, 60
Sooty, 211
Sophisticated Ladies, 140
Souvenir Dishes, 242, 243
Spaniel (1930s), 43
Spaniel Dog, 151
Spillers Retriever, 228
Spirit Containers, 71, 72
Spring Train, 203
Squirrels, 56
Squirrel Butter Dish, 238
Squirrel Money Bank, 233
Star of the County Down, The, 119
St. Bruno Pipe Tobacco Prom., 223
Stilton the Mouse, 169
Straw Family, 203
Stieno, 164
Stobart Haulage Trucks, 230
Summer Train, 203
Sumo, 168
Super Girl, 212
Survival, 150
Sweep, 211
Sword in the Stone, 85

T

Tailor, 60
Tailwarmer Squirrel, 205
Taurus the Bull, 197
Tedd-E Bear Internet, 186
Tedd-E Bear Wade Handbook, 187
Teddy Bear Plaques, 158, 159
Teenage Pottery, 69, 70
Teen Straw, 203

Terrier (1930s), 43, 51
Tessie Bear, 197
Tetley Vintage Van, 227
Thief, 60
Thisbe, 167
Thistle and the Rose Chess Set, 220
Thomas the Tank Engine (1985-87), 72
Thomas the Tank Engine (2002), 185
Three Little Pigs Series (1995), 152
Tiger Family, 75
Tiger Money Bank, 234
Timid Mouse, 154
Tinker, 60
Tinkerbell, 169
Tinny the Mouse, 147
Tiny Clanger, 211
Tiny Treasures Collection Set 1, 212
Tiny Treasures Collection Set 2, 212
Tiny Treasures Collection Set 3, 212
Toad of Toad Hall, 165
Toadstool Money Bank, 233
Toby, 194
Toby Jim Jug, 245
Toby Jugs, 216, 246
Togetherness, 151
Tom and Jerry (1973-1979), 72
Tom and Jerry (1998), 197
Tom Smith Party Crackers :
 Animates, 132
 Bird Life, 135
 British Wildlife, 133
 Cat Collection, 136
 Christmas Time Crackers, 137
 Circus Animals, 132
 Farmyard Animals, 133
 Hedgerow, 137
 Safari Park, 132
 Sealife, 137
 Snow Life, 136
 Tales from the Nursery , 136
 Village of Broadlands, 134
 Wildlife, 134
 World of Dogs, 135
 World of Survival, 134
 Your Pets, 135
Tortoise (mid 1930's), 57
Tortoise Ashbowls, 74
Tortoise Family, 73
Toucan (1930s), 49
Town Cryer, 185
Towser, 229
Toy Box Series, 157
Toy Soldier, 157
Traufler Figurines, 228
Travelhare Series, 174
Traveling Badger, 157
Traveling Frog, 158
Treasures, 63
Truly, 148
Trunky, 65
T.T. Tray, 68

Tubby the Bear, 147
Tufty, 193
TV Pets (1959-1965), 68
21st. Century Keepsakes, 204

V

Van Hallen Clowns, 163, 164
Van Hallen Penguins, 163
Van Hallen Seals, 163
Viking Ship Posy Bowl, 243
Village Store Series, 109, 110
Vintage Van Money Banks, 224, 225, 227, 235

W

Wade Animal and Bird Figures, 44-49
Wade Baby, 156
Wade Classical Collection, 198
Wade Figures:
 Alice and the Dodo, 36
 Alf & Peggy, 33
 Ann, 39
 Anita, 34
 Anton, 33
 Argentina, 23
 Barbara, 35
 Betty, 28
 Carmen, 26
 Carnival, 34
 Carole, 25
 Cherry, 25
 Claude, 27
 Colorado, 22
 Conchita, 24
 Curls, 37
 Curtsey, 36
 Cynthia, 35
 Daisette, 24
 Dawn, 25
 Delight, 27
 Dolly Vardon, 34
 Dora, 38
 Dyllis, 32
 Elf, 27
 Frolic, 32
 Girl with Headscarf, 32
 Gloria, 33
 Gnome with Flowers, 35
 Grace, 26
 Harriet, 30
 Helga, 24
 Hille Bobbe, 22
 Humoresque, 31
 Iris, 26
 Jean, 36
 Jeanette, 31
 Joan, 38
 Jose, 35
 Joyce, 22

 Juliet, 30
 June, 30
 King Henry VIII, 38
 Madonna, 23
 Maria Theresa, 27
 Mimi, 39
 Old Nanny, 22
 Pan, 31, 32
 Pavlova, 29
 Peggy, 22
 Phyllis, 28, 29
 Phyllis (lamp version), 29
 Pompadour, 28
 Princess Elizabeth, 29
 Queen Elizabeth I, 38
 Romance, 34
 Seated Lady, 38
 Sonia, 32
 Spanish Lady Handle, 37
 Springtime, 25
 Strawberry Girl, 27
 Sunshine, 31
 Susan, 31
 Swan Dancer, 23, 24
 Tessa, 27, 28
 Tessa (mirror version), 28
 Welsh Lady Handle, 37
 Zena, 22, 26
Wade Heath Character Jugs, 246
Wade Heath Rabbits, 52
Wade Watch Mini Teapots, 215
Wade Wildfowl, 70
Wagon Train Dishes, 241
Water Life Set 1, 143
Water Life Set 2, 143
Weasel, 165
Welcome Home, 151
West Coast Collectors Fair figurines, 215
West-E, 187
Westminster Piggy Bank Family, 222
Whimsies (1953-1959), 89, 90, 91, 92
Whimsies (1971-1984), 93, 94, 95, 96, 97
Whimsie-in-the-Vale Village, 108
Whimsie-Land Key Rings, 104
Whimsie-Land Series, 103, 104
Whimsie-on-Why Village Set 1, 105
Whimsie-on-Why Village Set 2, 106
Whimsie-on-Why Village Set 3, 106
Whimsie-on-Why Village Set 4, 107
Whimsie-on-Why Village Set 5, 107
Whimsie Reissues, 100, 101
Whimsie Special Issues, 101
Whimtrays (1958-1965), 101, 102
Whimtrays (1971-1987), 102
Whimtrays (1987-1988), 103
Whisky, 68
Whitbread Hopper, 223
Whitbread Pale Ale Train, 223
White Rabbit, 162
Whoppas (1976-1981), 79

Widda Cafferty, 119
William Harper Prototype Figurines, 58, 67, 240
Wilma, 196
Wimpy, 200
Wind in the Willow Series, 165
Wizard of Oz Series, 192
Woodpecker (1930s), 47
Woodstock, 184
"World of Survival" Series, 80, 81
Wynken, 59

Y
Yacht Wall Plaques, 114
Yogi Bear (1959-1969), 71
Yogi Bear (1997), 201
Y2K Elephants, 190

Z

Zebra Family, 76
Zoo Lights, 67
Zoo Light With Baby, 67
Zoo Lights with Metal Figurines, 68
Zoo- Mazing Collection, 149